MADE IN U·S·A·

AN AMERICANIZATION IN MODERN ART,
THE '50s & '60s

Sidra Stich

UNIVERSITY ART MUSEUM UNIVERSITY OF CALIFORNIA, BERKELEY

UNIVERSITY OF CALIFORNIA PRESS BERKELEY LOS ANGELES LONDON

University of California Press
Berkeley and Los Angeles, California
University of California Press, Ltd.
London, England
© 1987 by
The Regents of the University of California

Library of Congress Cataloging-in-Publication Data

Stich, Sidra.
Made in U.S.A.

Bibliography: p.
Includes index.
1. Art, American—Exhibitions. 2. Art, Modern—
20th century—United States—Exhibitions. 3. United
States—Popular culture—Pictorial works—Exhibitions.
I. University of California, Berkeley. University
Art Museum. II. Title.
N6512.S664 1987 709'.73'074019467 86-24979
ISBN 0-520-05756-2 (alk. paper)
ISBN 0-520-05757-0 (pbk. : alk. paper)

Printed in Japan

1 2 3 4 5 6 7 8 9

Acknowledgment is made for permission to repro-
duce the following poems:

"Digression on 'Number 1,' 1948," from *The Col-
lected Poems of Frank O'Hara*, by Frank O'Hara,
edited by Donald Allen, published by Alfred A.
Knopf, Inc. Copyright © 1971 by Maureen Gran-
ville-Smith, Administratrix of the Estate of Frank
O'Hara.

"On First Seeing Larry Rivers' *Washington Crossing
the Delaware* at The Museum of Modern Art,"
from *Meditations in an Emergency*, by Frank O'Hara,
published by Grove Press, Inc. Copyright © 1957
by Frank O'Hara. Reprinted with permission of
Grove Press, Inc.

The book serves as a catalogue for
an exhibition organized by
the University Art Museum, Berkeley,
and shown at

University Art Museum
University of California
Berkeley, California
April 4–June 21, 1987

The Nelson-Atkins Museum of Art
Kansas City, Missouri
July 25–September 6, 1987

Virginia Museum of Fine Arts
Richmond, Virginia
October 7–December 7, 1987

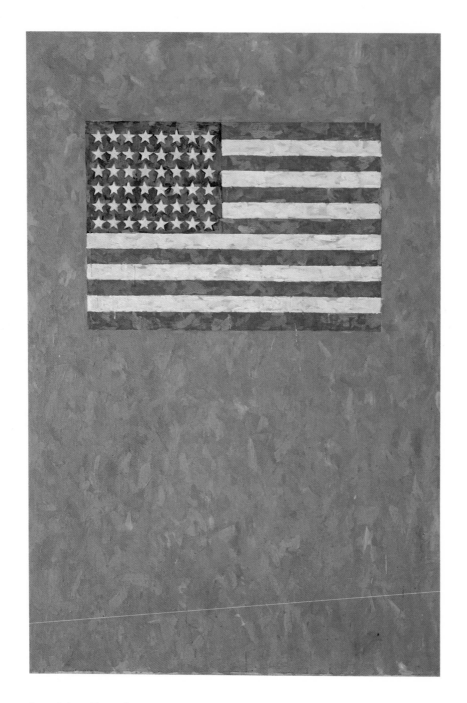

Jasper Johns, *Flag on Orange Field, II* (page 20).

Illustrations

Works preceded by an asterisk
are included in the
MADE IN U.S.A.
exhibition.

Foreword

The fifties and sixties were complex and exciting decades in American history and American art. An important aspect of the period was the emergence of an outstanding body of paintings and sculptures that unabashedly embraced American mass culture and featured a conspicuously American imagery. Traditional national symbols, the physical environment, favored products, mass media, popular myths, and contemporary political events served as sources of inspiration for subject matter and new modes of compositional display. In offering a rich contextual explication of the iconography of a wide range of postwar American works, *MADE IN U.S.A.* reveals the broad diversity of approaches to American themes and issues.

The University Art Museum is pleased to provide the opportunity for greater appreciation and enhanced understanding of this art and the period that shaped it. A project of this scope, of course, represents the efforts of many people and institutions. On behalf of the trustees and staff of the museum, I express deep gratitude to the lenders whose generosity has made this exhibition possible and whose enthusiasm for the project has served as a source of encouragement throughout the years of its development. Special thanks are also due to Marc F. Wilson, director of The Nelson-Atkins Museum of Art, and Paul N. Perrot, director of the Virginia Museum of Fine Arts, whose cooperation has greatly facilitated the planning and execution of the exhibition's tour.

In preparing this book we have been exceedingly fortunate to have worked with the University of California Press, its director Jim Clark, and its able and patient staff. The press's mark of quality is imprinted on the project and for this we are extremely appreciative.

Generous grants from the National Endowment for the Humanities, National Endowment for the Arts, Luce Fund for Scholarship in American Art, a program of The Henry Luce Foundation, Inc., Best Products Foundation, A.T.&T. Foundation, and California First Bank provided the necessary financial support, and we are most grateful to these organizations.

This project was conceived of by Sidra Stich, senior curator at the University Art Museum. She contributed the main essay to this book, selected the exhibition, diligently secured loans, and supervised all aspects of the project. Her efforts and dedication have made this a notable undertaking.

James Elliott
Director
University Art Museum, Berkeley

The organization of the exhibition *MADE IN U.S.A.* and the publication of this book have involved the assistance, advice, and cooperation of many people. Private collectors were extremely generous in sharing their art and providing enriching information. I am deeply grateful to those who have lent works to the exhibition. Artists were also most helpful in discussing their work or the period, or in assisting with loans. I am especially indebted to Robert Arneson, Rudolf Baranik, Robert Bechtle, Tony Berlant, Jake Berthot, Bruce Conner, Allan D'Arcangelo, Wally Hedrick, George Herms, Jess, Jasper Johns, Ray Johnson, Allan Kaprow, Edward Kienholz, Alfred Leslie, Gladys Nilsson, Jim Nutt, Claes Oldenburg, Robert Rauschenberg, Edward Ruscha, Peter Saul, George Segal, May Stevens, Wayne Thiebaud, Robert Watts, and Tom Wesselmann.

My research was enhanced by conversations with individuals who participated in the American art world of the 1950s and 1960s, and with scholars who specialize in the postwar era. For this I extend thanks to Richard Abrams, Dennis Adrian, Don Baum, Richard Bellamy, Irving Blum, Peter Boswell, Ernest A. Busche, Mary Schmidt Campbell, Leo Castelli, John Coplans, Wanda Corn, Robert Dean, Todd Gitlin, Harold Glicksman, Barbara Haskell, Ruth Horwich, Richard Hutson, Thomas A. Leonard, Lawrence Levine, Kathleen Moran, Michael Rogin, Peter Selz, John Weber, and William S. Wilson.

For their time and kindness in facilitating loans and providing documentation, I owe a large measure of gratitude to the following: Thomas Ammann Fine Art (Monica Burri), Betty Asher, Leo Castelli Gallery (Lisa Martizia), Sarah H. Cooke, Terry Dintinfass, Virginia Dwan, Allan Frumkin, Joni Gordon, Nora Halpern, Wanda Hansen, Joseph A. Helman, Nick Howey, Sidney Janis Gallery, Phyllis Kind Gallery (William H. Bengtson), Margo Leavin, Louis K. Meisel Gallery, Olivia Motch, Reinhard Onnasch, Richard L. Palmer, Cora Rosevear, William S. Rubin, Salander-O'Reilly Galleries, Sonnabend Gallery (Antonio Homem), Frederick Voss, and David White.

During the course of planning this project, I have enjoyed the support and assistance of the entire staff of the University Art Museum. I particularly wish to thank James Elliott, director; Ronald Egherman, deputy director; Mary Ellen Murphy, development director; Edith Kramer, curator of film; Nina Hubbs, head of installation and design; Arnold Sandrock, business manager; Barbara Berman, publicist; and Jane Kamplain, registrar. For their attention to the myriad of details associated

Acknowledgments

with preparing the texts and securing loans and photographs, I am extremely grateful to Joan Perlman, Eve Vanderstoel, and Marijke van Doorn. I have also had the good fortune of having a superb assistant, Elizabeth Boone, who has worked with diligence, efficiency, and good humor on all aspects of this project.

Colleagues at the museums on the tour of the exhibition have been most helpful and delightful to work with. My sincere thanks to Marc F. Wilson and Deborah Emont Scott at The Nelson-Atkins Museum of Art, and Paul N. Perrot, Richard B. Woodward, and Frederick R. Brandt at the Virginia Museum of Fine Arts.

For her sustained interest in this project, Mary Jane Hickey of the Henry Luce Foundation deserves special mention.

The publication of this book is the result of the care and expertise of the University of California Press. I particularly thank Amy Einsohn for her insightful, sensitive editing, Steve Renick for his outstanding design, Marilyn Schwartz for her skillful supervision of the production, and Laird Easton for his general assistance. To Jim Clark, whose unfailing confidence in this project and personal encouragement have been a source of strength throughout, I am profoundly grateful.

Lastly, I thank Ben H. Bagdikian, James Breslin, and Thomas Schaub, whose essays add significantly to the content of this book, and Moira Roth for her constructive reading of the text, her continued enthusiasm for the project, and her warm friendship.

PHOTOGRAPH CREDITS

Thomas Ammann Fine Art, Zurich: 151. Jörg P. Anders, Berlin: 112. Art Gallery of Ontario, Toronto: 75. William H. Bengston, Chicago: 143, 180. Ben Blackwell, Berkeley: 6, 10, 56, 66, 72, 144, 149. Jon Blumb, Lawrence, Kansas: 179. Rudolph Burckhardt, New York: 103, 124. Rudolph Burckhardt, courtesy Leo Castelli Gallery, New York: 158, 190. Leo Castelli Gallery, New York: 36. Geoffrey Clements, New York: 76, 107, 145, 192. Charles Cowles Gallery, New York: 104, 150. Bevan Davis, courtesy Leo Castelli Gallery, New York: 152, 153. D. James Dee, courtesy David McKee Gallery, New York: 14. The Detroit Institute of Arts: 181. W. Drayer, Zurich: 89. eeva-inkeri, New York: 41. Thomas Feist, New York: 33. Chuck Garner, Vermillion Photographic, Phoenix: 80. Hickey and Robertson, Houston: 22. Sidney Janis Gallery, New York: 132. Jochen Littkemann, Berlin: 35. Alfred Lutjeans, Los Angeles: 154. Robert R. McElroy, New York: 101. Joseph Maloney, New York: 91. Robert E. Mates, New York: 88, 177. Louis K. Meisel Gallery, New York: 49. Robert Miller, Portland, Oregon: 170. The Museum of Modern Art, New York: 18, 127. Otto E. Nelson, Ithaca, New York: 171. William Nettles, Los Angeles: 95. Douglas M. Parker, Los Angeles: 32, 55, 67, 169, 173. Eric Pollitzer, New York: 8, 16, 17, 43, 81, 98, 129, 131, 178, 191. Eric Pollitzer, courtesy Leo Castelli Gallery, New York: 23. Nathan Rabin, New York: 13, 118. Nathan Rabin, courtesy Allan Frumkin Gallery, New York: 92. Rheinisches Bildarchiv, Cologne: 100, 139, 195. Terry Richardson, Charleston, South Carolina: 57. Walter Rosenblum, South Hadley, Massachusetts: 184. Friedrich Rosenstiel, Cologne: 194. Paul Ruscha, Los Angeles: 50. Salander-O'Reilly Galleries, Inc., New York: 113. Sandak, Inc., New York: 188. Manu Sassoonian, New York: 42. Schenck and Schenck, New York: 68. Marc Schuman, Glenwood Springs, Colorado: 120. Harry Shunk, courtesy Leo Castelli Gallery, New York: 7. Shunk-Kender, New York: 196. Squidds & Nunns, Los Angeles: 26, 29, 77, 116, 117, 166. Statens Kunstmuseer, Stockholm: 111, 193. Jerry L. Thompson, Amenia, New York: 78, 146. Roland I. Unruh, Miami: 94. Tom Van Eynde, Chicago: 47, 93, 126, 135. Malcolm Varon, New York: 182, 183. Tom Vinetz, New York: 165. Wadsworth Atheneum, Hartford, Connecticut: 102. Robert Watts, Bangor, Pennsylvania: 79. David Webber, Boston: 15, 189. Ellen Page Wilson, Phoenix: 121. Dorothy Zeidman, New York: 9, 11, 12.

LENDERS TO
MADE IN U.S.A. EXHIBITION

Robert E. Abrams
Akron Art Museum, Akron, Ohio
Allen Memorial Art Museum, Oberlin College,
 Oberlin, Ohio
The Stephen S. Alpert Family Trust
Art Gallery of Ontario, Toronto
Lawrence and Evelyn Aronson
The Art Institute of Chicago
Ruth Askey
Rudolf Baranik
Robert H. Bergman
Jake Berthot
John Bransten
The Edward R. Broida Trust, Los Angeles
Carolina Art Association, Gibbes Art Gallery,
 Charleston, South Carolina
Richard V. Clarke
Harold Cook
William N. Copley
Charles Cowles Gallery, New York
Susan Dakin
Allan D'Arcangelo
Roger I. Davidson
The Detroit Institute of Arts
Norman Dolph
Robert Duncan
Mr. and Mrs. Alan Englander
Betty and Monte Factor
Fort Worth Art Museum, Fort Worth, Texas
Allan Frumkin Gallery, New York
Diana Fuller
Mr. and Mrs. Raymond Goetz
Foster Goldstrom
The Grinstein Family
Hood Museum of Art, Dartmouth College,
 Hanover, New Hampshire
Walter Hopps
Mrs. Ruth Horwich
Marian B. Javits
Jasper Johns
Herbert F. Johnson Museum of Art, Cornell
 University, Ithaca, New York
Ray Johnson
Margo Leavin Gallery, Los Angeles
Sydney and Frances Lewis
Lewis & Clark College, Portland, Oregon
David Lichtenstein
Mead Corporation Collection, Dayton, Ohio
Miami University Art Museum, Oxford, Ohio
The Museum of Modern Art, New York
Walter and Anne Nathan

National Gallery of Art, Washington, D.C.
National Museum of American Art, Smithsonian
 Institution, Washington, D.C.
National Portrait Gallery, Smithsonian Institution,
 Washington, D.C.
The Nelson-Atkins Museum of Art, Kansas City,
 Missouri
Neuberger Museum, State University of New
 York at Purchase
Newport Harbor Art Museum, Newport Beach,
 California
Claude Nutt
Jim Nutt
Odyssia Gallery, New York
Claes Oldenburg
Joan and Jack Quinn
Scot Ramos
Robert Rauschenberg
Faith Ringgold
Larry Rivers
Jane and Ruth Root
Mary Lou Rosenquist
Edward Ruscha
Santa Barbara Museum of Art, Santa Barbara,
 California
The Schomburg Center for Research in Black
 Culture, New York Public Library
Robert Shapazian
Smith College Museum of Art, Northampton,
 Massachusetts
Ileana and Michael Sonnabend
Sonnabend Gallery, New York
Stanford University Museum of Art, Stanford,
 California
Allan Stone Gallery, New York
Marc and Livia Straus
Wayne Thiebaud
Mr. and Mrs. Burton Tremaine
University Art Museum, University of California,
 Berkeley
Virginia Museum of Fine Arts, Richmond
Wadsworth Atheneum, Hartford, Connecticut
Sam Wagstaff
Walker Art Center, Minneapolis, Minnesota
Washington University Gallery of Art, St. Louis,
 Missouri
The Frederick R. Weisman Foundation of Art, Los
 Angeles
Marcia S. Weisman
Whitney Museum of American Art, New York
William S. Wilson
Laura-Lee W. Woods
Anonymous lenders

Sidra Stich

An
Americanization in
Modern Art, the
'50s & '60s

U · S · A ·

Introduction

Although the focus on American themes and subjects in American art of the 1950s and 1960s has been generally recognized, art historians and critics have not yet set this body of work in a cultural context that elaborates upon the nature and significance of its iconography. When in the mid-fifties, Larry Rivers, Jasper Johns, and Robert Rauschenberg first exhibited paintings featuring George Washington, the American flag, and mass media images, critical commentary emphasized the artists' abandonment of the prevailing tendency toward abstraction. Subject matter was treated as a Dadaist joke or an arbitrary aspect of the dialogue between art and life. Similarly, appreciations and critiques of the assemblages and collages by Bruce Conner, George Herms, Ray Johnson, Edward Kienholz, and H. C. Westermann focused on their formal strategies or outrageous content with only tacit or generalized regard for the contextual implications of the subject matter. Because art critics defined groupings by stylistic determinants, the shared iconographic tendencies, the artists' telling shift away from images associated with European culture and toward images allied with American culture, passed largely unrecognized.

By the early sixties, the presence of archetypal American images shaped by contemporary American mass culture was impossible to ignore. The works of Allan D'Arcangelo, Robert Indiana, Roy Lichtenstein, Claes Oldenburg, James Rosenquist, George Segal, Andy Warhol, and Tom Wesselmann provoked critics to define and name the "new" trend. Sometimes including and sometimes overlooking fifties precedents, critics variously christened the art New Realism, Popular Image Art, Common Object Art, Factualism, Neo-Dadaism, American Dream Painting, Sign Painting, Anti-Sensibility Painting, and Cool-Art. They ultimately settled on Pop Art, a term coined by Lawrence Alloway to describe British painting of the 1950s that incorporated American mass media imagery.[1] Critical attention to the emerging art was extensive, immediate, and impassioned—both for and against. The unprecedented fervor and excitement about the new American art spread to gallery dealers, museum curators, collectors, and the popular press.

Although the artists themselves formed no organized group or movement, many in the art world gave considerable attention to defining a group ethos and identifying which artists did or did not belong. Of even greater concern were issues about the quality of the art and intention of the artists. The machined appearance, deadpan expression,

and mass culture imagery of postwar American art provoked endless heated controversies: Is it art? What does it mean? Does it sufficiently transform its sources to be considered art? Is it optimistic or pessimistic, satirical or celebratory of American culture? The following sampling of comments suggests the nature and diversity of the debate.

The truth is, the art galleries are being invaded by the pinheaded and contemptible style of gum-chewers, bobby soxers, and, worse, delinquents. . . . Save us from the "uncharmers," or permutations thereof, the Rosensteins and Oldenquists! (Max Kozloff, "Pop Culture, Metaphysical Disgust, and the New Vulgarians," *Art International*, March 1962.)

"Entertaining" is the right word, for the show [the *New Realism* group exhibition at the Sidney Janis Gallery, 1962] does not often transcend visual social comment: a sort of red, blue and yellow journalism. . . . [The art] is of course founded on the premise that mass culture is bad, an expression of spiritual poverty. (Brian O'Doherty, "Art: Avant-Garde Revolt," *New York Times*, October 31, 1962.)

Pop art derives its small, feeble victories from the juxtaposition of two clichés: a cliché of form superimposed on a cliché of image. And it is its failure to do anything more than this that makes it so beguiling to talk about—that makes pop art the conversation piece *par excellence*—for it requires talk to complete itself. Only talk can effect the act of imaginative synthesis which the art itself fails to effect. (Hilton Kramer, statement in "Symposium on Pop Art," December 13, 1962, The Museum of Modern Art, New York; text printed in *Arts Magazine*, April 1963).

I have heard it said that pop art is not art, and this by a museum curator. My feeling is that it is the artist who defines the limits of art, not the critic or the curator. . . . Pop art is a new two-dimensional landscape painting, the artist responding specifically to his visual environment. The artist is looking around again and painting what he sees. . . . If we look for attitudes of approval and disapproval of our culture in the art, or satire or glorification of our society, we are oversimplifying. (Henry Geldzahler, ibid.)

[The new artists] share an intense passion for direct experience, for unqualified participation in the richness of our immediate world, whatever it may have become, for better or worse. For them this means a kind of total acceptance; they reject nothing except all of our previous aesthetic canons. . . . They want us to share with them their pleasure and excitement at feeling and being, in an unquestioning and optimistic way. (Alan R. Solomon, *The Popular Image*, exhibition catalogue, Washington Gallery of Modern Art, 1963.)

[Pop art] is essentially a mild, unrebellious comment on the commonplace made by picturing it without any pretense of taste or orthodox technical skill. . . . Ten, 20 or 50 years ago, any artist would have been snubbed for such unimaginative, unintellectual literalism. . . . [Pop art] esthetics often turn out to be a bag of raucous gimmicks that merely assault the nerves. ("Pop Art—Cult of the Commonplace," *Time*, May 3, 1963.)

The reason these works leave us thoroughly dissatisfied lies not in their means but in their end: most of them have nothing at all to say. . . . The interpretation or transformation of reality achieved by the Pop Artist, insofar as it exists at all, is limp and unconvincing. It is this want of imagination, this passive acceptance of things as they are that makes these pictures so unsatisfactory at second or third look. They are hardly worth the kind of contemplation a real work of art demands. (Peter Selz, "Pop Goes the Artist," *Partisan Review*, Summer 1963.)

What is disturbing the spectator is that the most banal sights and objects of daily life are presented barely transformed as works of art. But it is not only the apparent lack of transformation which is disturbing. Another source of uneasiness lies in the fact that all these objects are overly familiar, we see them everywhere in many forms all the time, and we have considered them to be advertisements, useful tools of machinery, edibles, comic strips, signs, *papier maché* jokes, like the imitation dog's feces your ten-year-old may put on the bottom stair or like the dumbbell made of balloons. Art was traditionally meant to transport one beyond banality, beyond over-insistent daily sights. The present identification of the banal with art is perhaps like hearing that the kid around the corner has been made president of General Motors; one says, "Who, that guy? I went to camp with him, he was a dope! It can't be true." (Cleve Gray, "Remburgers and Hambrants," *Art in America*, December 1963.)

Despite all the quips and cranks, the wrangling and equivocations, a set of basic commonplaces about postwar Americanist art emerged and has remained with us. The central catch phrases refer to the art's fundamental association with mass production and commercial techniques, and its reference to everyday objects and common images.

Within critical discourse, however, there have been two notable efforts to move beyond early formulas and bromides. The first involves an emphasis on the art's formal qualities. Robert Rosenblum laid the foundation for this approach in "Pop Art and Non Pop Art" (1964), and Suzi Gablik explored its parameters in *Pop Art Redefined* (1969).[2] Among the compositional features they identify are the use of simple regularized forms and flat unmodulated color areas, the presentation of emblematic

imagery, and the adoption of impersonal machine-like surfaces. Such attention to form allowed critics to postulate a bond between postwar American art and abstraction and modernist theories, thereby rebutting earlier views of the return to figurative imagery as a retrograde countermodernist tendency. Curiously, then, the American artists, though quite distinctive in their concerns with representational imagery and cultural specificity, were embraced under the formalist umbrella.

The second approach is based on analyses of postwar history. Studies by Eva Cockcroft, Serge Guilbaut, William Hauptman, Jane de Hart Mathews, and David Shapiro and Cecile Shapiro examine the relationship between Cold War politics and Abstract Expressionism to show how the art became a propaganda weapon and to explore the influence of the new American liberalism, with its accent on anti-communism, on the character and reception of vanguard American abstraction.[3] A few critics and scholars have used a similar approach to discuss the generation that succeeded Abstract Expressionism. Most notably, in "American Painting During the Cold War" (1973) Max Kozloff establishes the framework for viewing Color Field painting and Pop Art in the context of American political ideology, and Moira Roth views the early work of Jasper Johns, John Cage, Merce Cunningham, and Robert Rauschenberg from the perspective of McCarthyism in her essay "The Aesthetic of Indifference" (1977).[4]

The following study focuses on works of American art from the 1950s and 1960s, taking an iconographic and contextual approach in order to explore the character and historical dimensions of preeminently American images. Chapter groupings concentrate on major themes and permit the delineation of shared tendencies in the artists' choice and treatment of subject matter. The iconographic approach also allows the consideration of a wide range of art and crosscurrents that go beyond such stylistic categorizations as Proto-Pop, Assemblage, Pop, Photorealism, and Conceptualism. This study shows the beginnings and expansions of the attention to American mass culture in postwar art. It moves well beyond the usual Pop Art focus and concentration on the early sixties and on New York to include art of the fifties and late sixties and to recognize the equally significant contributions of California and Chicago artists who were simultaneously creating art derived from and related to American mass culture.[5] Because the term Pop Art so often refers to a limited body of art and has acquired derogatory, pejorative, and frivolous connotations, it has been purposely avoided.

In sum, it is time to reexamine clichés that have come to be associated with the postwar development of art that has a conspicuously American identity. With the perspective of time, it is possible to gain a deeper understanding of the cultural context and sociopolitical dynamics that directly influenced or indirectly shaped the subject matter and presentational mode of this art. It is also possible to realize more fully the art's aesthetic strength and its importance with reference to the mainstream of modernism, especially as this encompasses a shift from a European to an American axis and a defiance of salient modernist precepts.

NOTES

1. Alloway has stated that the date often cited as the first use of the term *pop art*—1954—is too early and that his original reference was to "the products of the mass media, not to the works of art that draw upon popular culture." See "The Development of British Pop," in *Pop Art*, ed. Lucy R. Lippard (New York and Washington, D.C.: Praeger, 1966), 27.

 It is worth noting that though British Pop artists used imagery from American mass culture, they did so from an imaginative or vicarious basis rather than an actual familiarity with American culture. The fascination with America and the desire to rebel against staid academic British art led to the creation of British Pop Art. For discussions of this movement, see John Russell and Suzi Gablik, *Pop Art Redefined* (New York and Washington, D.C.: Praeger, 1969), and Mario Amaya, *Pop Art . . . and After* (New York: Viking, 1965).

2. Rosenblum's essay was first published in *Art and Literature* (Lausanne) 5 (Summer 1964): 80–95; it was reprinted in *Canadian Art* 2 (January 1966): 50–54. For Gablik's views, see Russell and Gablik, *Pop Art Redefined*, 9–20.

3. See Eva Cockcroft, "Abstract Expressionism: Weapon of the Cold War," *Artforum* 12 (June 1974): 39–41; Serge Guilbaut, *How New York Stole the Idea of Modern Art: Abstract Expressionism, Freedom, and the Cold War*, trans. Arthur Goldhammer (Chicago and London: University of Chicago Press, 1983); William Hauptman, "The Suppression of Art in the McCarthy Decade," *Artforum* 12 (October 1973): 48–52; Jane de Hart Mathews, "Art and Politics in Cold War America," *American Historical Review* 81 (October 1976): 762–87; and David Shapiro and Cecile Shapiro, "Abstract Expressionism: The Politics of Apolitical Painting," *Prospects* 3 (1977): 175–214.

4. See Max Kozloff, "American Painting During the Cold War," *Artforum* 11 (May 1973): 43–54; and Moira Roth, "The Aesthetic of Indifference," *Artforum* 16 (November 1977): 46–53.

5. Most discussions and exhibitions of postwar American art focus on artists who were living in New York and either neglect or treat separately non–New Yorkers. For example, only one non–New York artist (Wayne Thiebaud) was included in the United States section of the seminal *New Realists* exhibition of 1962. The Guggenheim exhibition *Six Painters and the Object* (1963) also had an exclusively New York focus, although it acquired a conspicuous appendage (*Six More*) of West Coast artists when on display at the Los Angeles County Museum of Art. The New York bias still prevails: only New Yorkers were represented in the Pop Art section of *Blam! The Explosion of Pop, Minimalism, and Performance, 1958–64* at the Whitney Museum of American Art in 1984.

U · S · A ·

The Cultural Climate in America after World War II

"I did not think of culture as anything *national*, and in any case American culture had no real status in the eyes of anyone in the 1940s."[1] This comment by Norman Podhoretz, a social and literary critic, exemplifies what once was a widely held attitude about American culture. The country had a reputation of being vulgar, on the one hand, and innocent on the other. Its art was commonly described as derivative and provincial. Measured against the prevailing standard of evaluation—European culture and European art—America and its endeavors were considered inferior. But in the postwar years, such opinions changed dramatically.

As America moved into a position of political and economic leadership, newfound pride in the American way of life and American culture flourished. At the same time, America's most familiar icons and a host of images shaped by the dynamics of contemporary American life became the subject matter of art. A new breed of artists sought to capture the vitality of the world around them, the world of Middle America and common experience. They unabashedly called attention to tastes and images that were decidedly American and conspicuously vernacular: movies, comic strips, convenience foods, advertising, suburbia, traffic congestion, highways, brand-name products, billboards, supermarkets, and television. They also created art that reflected American postwar affluence, consumerism, technological prowess, commercialization, conformism, mass media, civil unrest, urban poverty, and Cold War tensions.

The new art countered both European iconographic conventions and the reigning mode of abstraction. Beyond setting forth a distinctly different type of imagery, the new art revolutionized attitudes about image creation and image presentation, often deriving inspiration from the American systems of mass production and mass communications. To be sure, this was not the first time that artists turned to American culture for their imagery, but the approach was distinctive. Unlike Precisionist paintings of the 1920s and 1930s that idealized machine technology and depicted settings in pure, austere terms, mid-century art did not hesitate to show or exaggerate the actual and often disturbing character of things. And unlike Social Realist art, which took a polemic tone, or Regionalist art, which was rooted in a fervid nationalism and parochialism, the new art favored equivocal presentations steeped in irony, absurdity, and paradox.

This mid-century focus on a visibly American subject matter followed directly on the heels of the emergence of New York as a leading international

art center, and of Abstract Expressionism as the heir to European modernism. Abstract Expressionism had engendered an outspoken and self-conscious concern about establishing an American identity for art: that is to say, the recognition of a body of art as the product of American artists, living in America, and producing an art of equivalent or superior value to European art. But in its imagery and subject matter, Abstract Expressionism eschewed discernible reference to America, focusing rather on personal and universalist evocations or imagery from a Jungian mythic store. Abstract Expressionist artists cultivated an alienation from immediate circumstances and avoided national expression, though artists at times pointedly derived inspiration from the American landscape and American Indian art. Franz Kline, for example, saw an expression of life's dynamic energy in the American urban setting; Barnett Newman extolled the pure, abstract language and mystery of Northwest Coast Indian designs; and Jackson Pollock praised the plastic qualities and universal vision of Southwest Indian art.[2] These artists thus embraced the American environment and America's cultural heritage, effectively marking its place within and its contribution to the universal and mythic. But they steered clear of stamping their paintings with images that were manifestly American.

Despite an antipathy to explicitly American images, discussions among Abstract Expressionist artists often centered on establishing distinctions between European and American art. At the now famous Studio 35 conference, held in 1950, this issue was a main topic. Artists sought to define the American character of their work, in the process asserting its importance by comparison with European precedents. The term *School of New York*, which served as the title of an exhibition organized by Robert Motherwell in 1951, further encouraged comparison, if not rivalry, with the much admired School of Paris. This spirit tempered other exhibitions that included American and European contemporary art, and became a commonplace in art criticism in the 1950s.[3] Critics who supported Abstract Expressionism not only elevated it to national and international prominence by advocating its primacy in comparison with the European modernist tradition, but also figured strongly in promoting a labeling of the art as American, even as they adamantly dissociated the art from contemporary American culture.

For Harold Rosenberg, one of the leading postwar critics, the Abstract Expressionist artists responded only to themselves. The canvas became their world, and in this world they could enjoy complete freedom to engage in an individual existential struggle: Painting became an act of personal liberation.[4] The use of an abstract vocabulary imbued the art with an archetypal, timeless quality that further distanced it from the actuality of life. Although the subject matter did not draw on American topics, Rosenberg characterized the spirit in national terms. In the essay "Parable of American Painting" (1954), he named two opposing conditions: "Redcoatism," the reliance on European models and blindness to native terrain, and "Coonskinism," the break with foreign tradition and the search for new, often instinctual approaches. Of course, the conventional Redcoats were defeated by the pioneering Coonskins, whose spirit was for Rosenberg epitomized by the Abstract Expressionists.[5] In a later article on Jackson Pollock, Rosenberg went so far as to compare Pollock with Daniel Boone, claiming that his adaptation of a frontiersman posture was a way to challenge "European aesthetic superiority and snobbishness."[6] For Rosenberg, Abstract Expressionism was a vitalizing, independent *American* art.

Unlike Rosenberg, who sought to proclaim America's separateness from Europe, the critic Clement Greenberg was determined to assert a direct line of descent. He promoted the new American art as the next stage in a historical progression involved with the purification of the medium to its viable essence. In the seminal article "American Type Painting" (1955), he described correspondences with European precedents, showing how Abstract Expressionism had assimilated and extended the major features of modernism.[7] American art was thus saved from a provincial tradition and took its place at the helm of vanguard activity. The key to its success was abstraction—pure and simple painting untainted by formulated ideologies and free from imitative or illusionistic tendencies. Attainment of this absolute was the ideal of modernism, and Abstract Expressionism represented an advanced stage in the quest.

Both Greenberg and Rosenberg considered the Abstract Expressionist artists to be nobly alienated. Alienation expressed a despair with the state of modern society and ensured that art would not be contaminated either by the vulgarities of industrialism or by common taste.[8] Since these were particular dangers in America, it was especially necessary for American artists to remain apart from their immediate environment. In this isolation Greenberg again viewed American artists as continuing and surpassing the example of their European predecessors: "Isolation, alienation, naked and revealed unto itself, is the condition under which the

true reality of our age is experienced. . . . The alienation of Bohemia was only anticipated in nineteenth-century Paris; it is in New York that it has been completely fulfilled."[9] At times, however, Greenberg used broadly American characterizations to distinguish the virtues of the new American art. In discussing the paintings of Jackson Pollock, for example, he invoked Faulkner and Melville "as witnesses to the nativeness of such violence, exasperation and stridency."[10]

Artists and critics alike were thus intent on establishing an American identity and an American context for Abstract Expressionism, even though the art itself was expressly premised on a universalist ideology and imagery.

Concurrent with the emergence of Abstract Expressionism within the realm of vanguard art was a burgeoning interest in the history of American culture. Before World War II most major universities offered but a few courses in American studies. Suddenly, with the burst of postwar confidence in America, full-fledged American studies programs became ubiquitous. (Before 1945 there were twenty-nine such programs; by 1956 there were eighty-two across the country.) Publishers launched books on American literature, history, and art, and the promotion of American culture in the popular press increased apace. As noted by John Walker, director of the National Gallery, in his introduction to one of the new books—*Three Hundred Years of American Art* by Alexander Eliot—there was also a flurry of exhibitions of American painting, and museums made notable expansions in their collections of American art. The American preoccupation was so pronounced that Walker suggested appending to Whistler's well-known comment "Art is upon the town!" the phrase "Especially American art."[11]

The signs of this new passion for American art were all about. In 1951 the first training center for the study of American art and culture was established at the Henry Francis Dupont Winterthur Museum; in 1954 the Metropolitan Museum of Art mounted *Two Centuries of American Painting*, a comprehensive exhibition that filled twenty-four galleries; in December 1956 a *Time* cover story, accompanied by eight pages of color reproductions, championed American art; in summer 1957 the Metropolitan Museum *Bulletin* heralded the opening of eight permanent, newly renovated galleries for American painting; and during the winter of 1958 Madison Square Garden hosted *Art:USA:58*, a grandiose display of twentieth-century American art (1,540 paintings and 300 sculptures).

Clearly, America was experiencing an unprecedented pride in the discovery of its heritage as well as an urgency to assert its cultural leadership. To examine this situation, a benchmark symposium, "Our Country and Our Culture," was organized in 1952 by *Partisan Review*, the leading vanguard journal of the period.[12] Twenty-four well-known intellectuals were invited to discuss the new attitude toward America and the issue of mass culture. Although the symposium did not address the visual arts per se, and although the participants' attitudes differed considerably from those of the emerging generation of artists who turned to American mass culture, the symposium underscored telling aspects of the mid-century preoccupation with America.

In itself, the use of the possessive *our* in the title suggests an identification with and affirmation of America. As the symposium editors note, the end of hostility and estrangement corresponded with international circumstances: "Europe is no longer regarded as a sanctuary: it no longer assures that rich experience of culture which inspired and justified a criticism of American life. The wheel has come full circle, and now America has become the protector of Western civilization, at least in a military and economic sense."[13] America had acquired a prestigious new image and new power, and its culture was consequently to be valued, recognized for its Americanness. American culture was also to be "defended against Russian totalitarianism"—a phrase that marks a turning away from the sacrosanct model of European culture and a turn toward the Cold War opposition of the U.S. and the USSR. Of concern to the symposium's organizers, then, were both America's assertion of leadership in cultural affairs and a consideration of the nation's culture within the context of the Cold War.

The *Partisan Review* editors also proclaimed a new relationship between the writer/artist and American culture:

For better or worse, most writers no longer accept alienation as the artist's fate in America; on the contrary, they want very much to be a part of American life. More and more writers have ceased to think of themselves as rebels and exiles. They now believe that their values, if they are to be realized at all, must be realized in America and in relation to the actuality of American life.

All but a few of the symposium's participants agreed with this premise. However, this extraordinary rapprochement with American culture—a "corrective of the earlier extreme negation"—also

posed a danger: the relinquishing of the revered American tradition of critical nonconformism. Could an artist "be a part of American life" and yet maintain an independent, oppositional voice? For the editors of *Partisan Review*, the principal issue here was the potential contaminating effect of mass culture: "The enormous and ever-increasing growth of mass culture confronts the artist and the intellectual with a new phenomenon and creates a new obstacle: the artist and intellectual who wants to be a part of American life is faced with a mass culture which makes him feel that he is still outside looking in."

Most participants in the symposium shared the elitist assumption that mass culture was inferior and a viable threat to high culture. Serious creative pursuits, they cautioned, had to be kept above and beyond mass culture and its tawdry products: Hollywood movies, Coca-Cola, television, supermarkets, soda fountain luncheons, *Time*, *Life*, comic strips, mass journalism, and advertising were mentioned by name. Respondents echoed the views Clement Greenberg had expressed in his influential article "Avant-Garde and Kitsch" (1939): A clear separation had to be maintained between kitsch (the German term for inferior, synthetic culture) and the avant-garde.[14] No one seriously suggested that mass culture was anything other than contemptible and antagonistic to high culture. Nevertheless, the symposium recognized the growing potency and power of mass culture in postwar America, and articulated a sense of urgency about addressing the issue overtly.

The *Partisan Review* symposium was widely discussed in artistic circles. As if in direct response to it, the generation of artists that followed the Abstract Expressionists began to explore the various issues that the intellectuals had raised. While focusing on American culture and the actualities of American life, however, these artists retained the spirit of rebels, often adopting an outrageous, individualistic posture that upended or questioned conventional mores and traditional images. They effectively affirmed America as a theme but used this affirmation as a provocation. Moreover, unlike the *Partisan Review* participants, these artists boldly rejected the old-line division between high and mass culture, recognizing that in postwar America such demarcations were blurring as mass culture became more widespread. Rather than approach mass culture as an abhorrent obstacle, they reveled in its vitality, enthusiastically welcoming its products as subject matter and adapting mass production techniques to their creative processes and imagery. The

art of the 1950s and 1960s bears witness to both the centrality and the expansiveness of American mass culture in the postwar period.

During the postwar years new technologies and business practices made American society more mass-oriented, and a larger proportion of the population identified with the goals, values, and amenities of the mass "middle." Advancements in mass distribution and mass communications facilitated the rapid dispersion of goods and information across state and regional boundaries. Giant nationwide organizations flourished; national chains and franchises dotted the landscape; brand-name merchandising and uniform packaging prospered; promotional campaigns gained sophistication in targeting broad markets; the new interstate highway system expedited long-distance hauls; and urbanization spread beyond center city limits. In addition, the mass media—the forum in which ideas, images, experiences, and values are shaped—extended their purview. The media's capabilities were enhanced by various technological advances: the perfection of television electronics, the development of portable broadcasting cameras, the automation of typesetting, and the inception of satellite transmissions. And the media's powers were concentrated by entrepreneurial reorganizations, such as corporate consolidations, more vigorous network control, and institutionalized wire services.

As a result of these patterns of growth, the American federation of individual states and diverse regions was becoming more homogeneous and unified—at least on the surface. A clarified sense emerged of *an* American way of life, of an *American* mass culture. A vast majority of the population felt itself united by a common experience and a common orientation. Middle America had opened outward, broadened its numbers and scope, extended its boundaries, and imprinted its character upon the nation.

Although the new mass order had taken root in the United States after World War I, it was not until after World War II that it entered a phase of energetic expansionism. And although a similar situation existed in Europe, mass culture had advanced far more rapidly in the United States. As a hybrid form of democracy crossed with free-market capitalism, mass culture seemed peculiarly American, a rebuff of European aristocratic tradition and communist economics.

While the new order thrived, experts sought to probe and analyze contemporary American mass culture from every perspective. Commentaries appeared continually in all the major media, and the

new paperback format expanded the market for studies of the newly emerging national character, its values and behaviors. A broad readership wrestled with the analyses offered in *The Lonely Crowd* (1950) by David Riesman (with Nathan Glazer and Reuel Denney), *The Organization Man* (1956) by William H. Whyte, Jr., *The Hidden Persuaders* (1957) and *The Status Seekers* (1959) by Vance Packard, and *Growing Up Absurd* (1960) by Paul Goodman. A reiterated theme concerned the forfeit of individualism to collectivism. For example, David Riesman contrasted "inner-directed" people, individuals who were guided by an internalized set of values and goals, with "other-directed" people, those guided by outside opinions. Americans of the new middle, Riesman contended, exemplified the other-directed character: they strived to belong and to keep up with or surpass their peers. Moreover, they relied heavily on the mass media as a source of direction: "Increasingly, relations with the outer world and with oneself are mediated by the flow of mass communication."[15] The mass media were thus implicated in the changes of behavior that resulted from the replacement of direct experience by secondary, filtered experience.

In his bestseller, Whyte concurred with Riesman about the new dominance of a group orientation, but he focused on depicting the value conflict between the old Protestant ethic of self-reliance, thrift, and hard work, and the new organizational ethic that fostered belongingness, consumption, and leisure. The good "organization man" sublimated self to group and subscribed to majority patterns. Whyte, like Packard and others, showed how consumer practices and the advertising and public relations efforts developed to encourage consumerism were an integral aspect of the new collectivism. As Riesman suggested, a major revolution "associated with a shift from an age of production to an age of consumption" was in process.[16]

With the spread of mass culture and the attention paid to it, it is not surprising that artists began to explore this realm. Hardly had Abstract Expressionism reached its prime, when a new generation of artists countermined with conspicuously American subject matter and an explicit conjuring of mass culture, including both its most mundane and its most disturbing features. Hamburgers and car crashes, movie stars and atomic bombs, American flags and race riots, suburban homes and ghetto neighborhoods—all became viable subjects. This dramatic change from a European to an American iconography also initiated a joyous exploration of the manmade and the machine-made, and of commercial art. Dismissing traditional prejudices against certain images, styles, or creative processes, these artists turned to the actualities of life, to commonplace tastes and topics.

The new attitudes marked a break with the abstract language of the preceding generation, with the axiomatic theories of modernism, and with the snobbish denigration of mass culture by liberal intellectuals. In the most general terms, the shift was from a subjective art, separated from life and premised on originality, to an objective art, bound to life and based on borrowed or reproduced imagery, manufactured materials, and mechanical techniques. Emotional expression, especially the angst-laden mood that typified Abstract Expressionism, was foresaken in favor of an impersonal mode allied with mass merchandising and mass media. Deadpan delivery, irony, paradox, and humor were used as tools of provocation. By masking their own opinions, the artists made it impossible for viewers to gauge whether endorsement, ridicule, or aversion was intended.

The art celebrated America and American life despite—or because of—its absurdities; but it also posed a confrontation, at times permeated by uncertainty, doubt, and denial. Artists called attention to the world around them—the world that was known, familiar, and part of the collective, mass middle of contemporary America—without making apologies for it or presuming themselves to be outside or above it. Unlike the *Partisan Review* participants who sought to belong yet feared getting too close to mass culture, these artists embraced mass culture without prejudicial reservations. And unlike artists and critics who emphasized universality, these artists had no qualms about emphasizing American culture. Their designs were not motivated by nationalism, for their art had no basis in political proselytizing, but by an enthusiastic openness, often tempered by a desire to dramatize given conditions in order to foster a re-viewing of common images, subvert conventional conceptions, or awaken public concern.

In these endeavors, many artists were inspired by independent thinkers like John Cage and the Beat poets, who likewise faced, and faced up to, life in all its complexity, incongruity, and irrationality. For Cage the preeminent value of art was affirmation: "an affirmation of life—not an attempt to bring order out of chaos nor to suggest improvements in creation, but simply to wake up to the very life we're living."[17] Advocating receptivity and discovery, Cage exulted in the quotidian, in the continuous indeterminacy within the flux of

actual life as experienced, not life as it should or might be. Always open to the possibilities of change, Cage refused to think in terms of absolutes or rigid oppositions. As he stated in an essay on Jasper Johns, "The situation must be Yes-and-No not either-or. *Avoid a polar situation.*"[18]

The Beat poets expressed a similar affirmation of raw, unstructured vitality, though they concentrated more on the underbelly of the culture, and their receptivity was pierced by a restless longing to find something meaningful within the chaos and conformity of the modern condition. Like Cage, they refused to submit to the constraints of the increasingly hierarchical and technocratic society, and they refused to abide by idealizing suppositions. For the Beats, exposing the trivial, sordid, and futile within the everyday environment served as a weapon in their battle to discredit materialistic values and blind Americanist pretensions.

Central to the approach of both the Beats and Cage was the denial of boundaries and the exaltation of an unfettered involvement with life. This spirit above all was shared by artists of the fifties and sixties, as they transgressed conventional separations between art and life, commercial and fine art, high and mass culture, and called attention to fundamental, familiar aspects of America whether glorious or offensive. Theirs was an art that laid bare evidence about unity and dissension in America during a period of growth and change.

In this era of transitions, the place of art and the role of the artist in American society were also redefined. Interest in art, previously the province of the privileged few, moved well outside the confines of elite coteries. During the 1950s a veritable culture boom prevailed in which art flourished, prospered, and gained broad popularity. Art became big news, with coverage of artists and exhibitions, art trends, art sales, and art books evolving into a routine beat in the popular press and a staple special feature on television. Art also became big business. Commercial galleries proliferated, as growing numbers of Middle Americans became feverish collectors and investors. Speculation in contemporary art was particularly intense, and the publication of art books and reproductions (posters, postcards, and the like) escalated to unprecedented levels and impressive profits. America became a nation of culture consumers for whom art was not just an object of beauty that provided sensory pleasure, but a commodity.[19] The nature of museums changed as well. Once sanctified depositories of art, they now ran bookshops and restaurants; offered lectures, tours, and film programs; and promoted grand-scale exhibitions and membership af-

filiation through high-powered public relations campaigns.[20]

The generation of artists that emerged after World War II were both conditioned by and responsive to this environment. The romantic vision of the artist as an outsider, maligned and downtrodden, alienated from a world that did not appreciate his talent, was no longer valid. Artists were now college-educated and engaged in a commercial profession. Allan Kaprow neatly encapsulated the change in his insightful article "Should the Artist Become a Man of the World?": "If the artist was in hell in 1946, now he is in business."[21] And artists were not only in business but also in the limelight, bedecked by the glitter of Hollywood and backed by the merchandising of Madison Avenue. As never before, they achieved celebrity status, their names becoming widely recognized outside art circles and topping guest lists of important dinner parties and public events. No longer did young American artists expect to live without fame or fortune or recognition during their lifetime. As Larry Rivers observed, "For the first time in this country, the artist is 'on stage.' He isn't just fooling around in a cellar with something that maybe no one will ever see. Now he is there in the full glare of publicity."[22]

Consumerism, commercialism, and the celebration of celebrity—the prevailing character of the art community reflected the general postwar climate in America. Although the nascent American focus in art can be variously attributed to the newfound attentiveness to immediate circumstances, to the interest in mass culture, to the loss of a European ideal, and to the desire to assert an American preeminence, it must also be viewed within the context of Cold War politics. The Truman Doctrine, enunciated in 1947, marked a significant change not only in American foreign policy but in the nation's conception of the world. Universalism, which posited that all peoples were part of one world, gave way to a polarized view of the world as two camps, nations for or against communism. Without question, the communist-led coup in Hungary in 1947, the Soviet invasion of Czechoslovakia in 1948, the establishment of the People's Republic of China in 1949, and the outbreak of the Korean War in 1950 were foreboding. Even more threatening was President Truman's announcement on September 23, 1949, that the Soviet Union had exploded an atomic bomb. Now either side could initiate strikes that could lead to global destruction. As Harold C. Urey, a Nobel laureate in physics, stated, "There is only one thing worse than one nation having the atomic bomb—

that's two nations having it."[23] The emergence of nuclear-armed superpowers made the Cold War all the more ominous. And the arms race accelerated; by 1953 both the U.S. and the USSR had tested the much more deadly hydrogen bomb. (Britain joined the frightful competition for superior strategic capability by exploding its first hydrogen bomb in 1957.)

Anti-communism soon became a new political ideology that ruled foreign policy and affected many domestic decisions as well. A broad spectrum of the general public became preoccupied with identifying fellow citizens who might be sympathetic to the communist philosophy. Senator McCarthy conducted public witch hunts, contending that a communist conspiracy had infiltrated even the U.S. State Department. A series of well-publicized espionage trials—Alger Hiss (1949–50), Dr. Klaus Fuchs (1950), and Julius and Ethel Rosenberg (1950–53)—intensified the inquisitorial mood. The frenzy of patriotism also inspired mountains of propaganda that emphasized the superiority of the American democratic system over the Soviet communist system. Even after McCarthy had been discredited in 1954, Americans' fear of communism remained strong, reaching new crescendos in response to the Soviet suppression of Polish and Hungarian uprisings in 1956, the launching of *Sputnik* in 1957, Fidel Castro's victory in Cuba in 1959, the Bay of Pigs fiasco and the erection of the Berlin Wall in 1961, the Cuban missile crisis in 1962, and the ongoing strife in Indochina.

As America increased its involvement in international political and military affairs, it also actively engaged in foreign aid and international trade to promote the superiority of the free enterprise system.[24] The exporting of American taste, American products, and more generally the American way of life advanced America's influence and image, particularly as these exports offered a marked contrast with the Soviet economic system, products, and way of life.

The Cold War thus shaped a new national consciousness predicated on an intense concern with communism and a related preoccupation with American supremacy. In this historical context the turn in art to American culture is all the more significant. Artists did not emphasize an American idiom to serve jingoist ends, though they were inspired by cultural currents and at times responsive to political issues. Their art stands not as propaganda but as a telling reflection of America's postwar obsession with expressing, defining, analyzing, promoting, and criticizing its Americanness.

NOTES

1. Norman Podhoretz, *Making It* (New York: Random House, 1967), 83.
2. See Barnett Newman, "The Ideographic Picture" (New York: Betty Parsons Gallery, 1947), quoted in Maurice Tuchman, *The New York School* (Greenwich, Conn.: New York Graphic Society, 1977), 105. Jackson Pollock, "Statement," *Arts and Architecture* 61 (February 1964): 14, quoted in Tuchman, *New York School*, 116.
3. Three exhibitions of note are *Young Painters in the United States and France* at the Sidney Janis Gallery (October 1950), and the complementary exhibitions of 1955—*The New Decade: 22 European Painters and Sculptors* at The Museum of Modern Art, New York, and *The New Decade: 35 American Painters and Sculptors* at the Whitney Museum of American Art, New York. For a detailed discussion of the rivalry between European and American art, see Serge Guilbaut, *How New York Stole the Idea of Modern Art*, trans. Arthur Goldhammer (Chicago and London: University of Chicago Press, 1983).
4. Harold Rosenberg, "The American Action Painters," *Artnews* 51 (December 1952): 22–23, 48–50.
5. Harold Rosenberg, "Parable of American Painting," *Artnews* 52 (January 1954): 60–63.
6. Harold Rosenberg, "The Search for Jackson Pollock," *Artnews* 59 (February 1961): 35.
7. Clement Greenberg, "American Type Painting," *Partisan Review* 22 (Spring 1955): 179–96.
8. Clement Greenberg, "The Present Prospects of American Painting and Sculpture," *Horizon* 16 (October 1947): 20–30.
9. Clement Greenberg, "The Situation of the Moment," *Partisan Review* 15 (January 1948): 82–83.
10. Greenberg, "Present Prospects," 26.
11. John Walker, introduction to Alexander Eliot, *Three Hundred Years of American Art* (New York: Time, Inc., 1957), viii.
12. *Partisan Review* 19 (May–June, July–August, September–October 1952): 282–326, 420–50, 562–97; reprinted as *America and the Intellectuals* (New York: Partisan Review Press, 1953).
13. This and subsequent quotations are from the editors' introduction, *Partisan Review* 19 (May–June 1952): 282–86.
14. Clement Greenberg, "Avant-Garde and Kitsch," *Partisan Review* 6 (Fall 1939): 34–39. During the postwar era Dwight Macdonald took up Greenberg's polemics in "A Theory of Mass Culture," *Diogenes* 3 (Summer 1953): 1–17; and "Mass Cult and Midcult," parts 1, 2, *Partisan Review* 27 (Spring 1960): 203–33; (Fall 1960): 589–631.
15. David Riesman with Nathan Glazer and Reuel Denney, *The Lonely Crowd* (1950; rev. ed. Garden City, N.Y.: Doubleday Anchor, 1953), 37.
16. Ibid., 20–21.
17. Cage comment from 1957, quoted in Calvin Tomkins, *The Bride and the Bachelors* (New York: Viking, 1965), 73.

18. John Cage, "Jasper Johns: Stories and Ideas," *A Year from Monday: Lectures and Writings by John Cage* (Middletown, Conn.: Wesleyan University Press, 1969), 79.

19. For a discussion of the art boom, see Alvin Toffler, *The Culture Consumers: Art and Affluence in America* (New York: St. Martin's Press, 1964).

20. See Neil Harris, "Museums, Merchandising, and Popular Taste: The Struggle for Influence," in *Material Culture and the Study of American Life*, ed. Ian M. G. Quimby (New York: W. W. Norton, 1978), 140–74.

21. Allan Kaprow, "Should the Artist Become a Man of the World?" *Artnews* 63 (October 1964): 34.

22. Rivers, quoted in Dorothy Gees Seckler, "The Artist in America: Victim of the Culture Boom?" *Art in America* 51 (December 1963): 28.

23. Urey, quoted in Eric F. Goldman, *The Crucial Decade and After* (New York: Vintage, 1960), 100.

24. The beginnings of an official policy to send economic aid abroad dates to the Truman Doctrine (1947) and Marshall Plan (1948). At the same time, large American corporations began increasing their exports, granting foreign franchises, and establishing overseas subsidiaries.

MADE IN

U · S · A ·

American Icons

When Larry Rivers painted *Washington Crossing the Delaware* [Fig. 1] in 1953, he heralded a new direction in American art. Subverting abstract, modernist conventions and using a national cliché as his subject matter, Rivers challenged the status quo of the avant-garde. It was a gesture on the order of Marcel Duchamp's painting of a mustache on a reproduction of Mona Lisa (1919), but one that conspicuously shifted the context from European to American culture. With utter bravado, Rivers meant to monumentalize an event from American history as Delacroix had done for France in *Liberty Leading the People* and Tolstoy for Russia in *War and Peace*.[1] His choice of Washington crossing the Delaware as subject matter was inspired by the grand nineteenth-century painting by Emanuel Leutze [Fig. 2], which is well known to millions of Americans through its widespread appearance in grade-school textbooks.

For Rivers to adopt this story and pictorial source was heresy: a blatant affront to the purist ideals of Abstract Expressionism, a bold announcement of a nationalistic theme, and a return to history painting, a long-forsaken mode. Rivers compounded his heresy by composing from sketches and doing programmatic research instead of adhering to an intuitive, spontaneous process; by choosing a theme that was mundane and trite rather than sublime; and by adopting a schema that was figural and narrative rather than abstract and poetic. Moreover, he proferred an image steeped in patriotic valor, and did so at the height of McCarthyism and just after the election of a new war-hero president. The outrageousness of it all was calculated and intentional. As Rivers explained: "I was energetic and egomaniacal and what is more important, cocky and angry enough to want to do something no one in the New York art world would doubt was *disgusting*, *dead* and *absurd*."[2]

Rivers's Washington is an unpretentious, somewhat perplexed figure, standing alone in an otherwise empty boat in the middle of an icy river. Dressed in everyday garb, bearing no markings of rank, he appears more like an ordinary person than a general. His stature is further compromised by the patches of paint that blur his image and confound his spatial positioning. Like the scattering of soldiers, horses, and bystanders, he appears to float in space. None of the figures are precisely depicted nor cohesively arranged. The overall impression is a humdrum, confused embarcation quite unlike Leutze's careful and theatrical presentation. At the center of Leutze's canvas is the American flag and

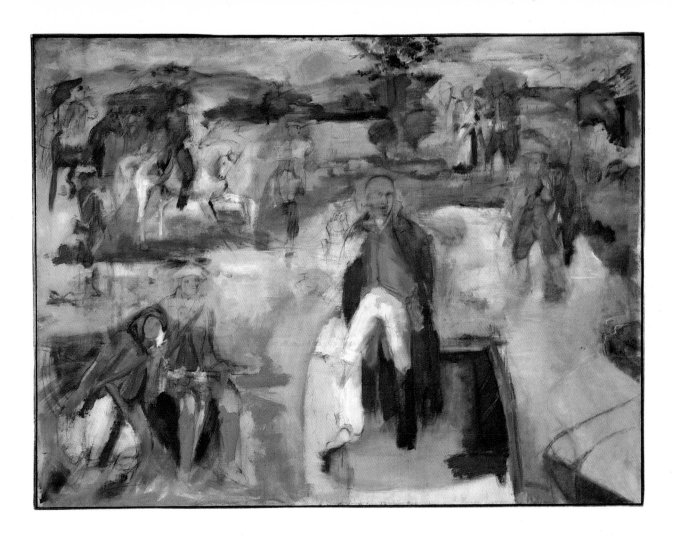

*FIG. 1. Larry Rivers, *Washington Crossing the Delaware*, 1953. Oil on canvas, 83⅝″ × 111⅝″. The Museum of Modern Art, New York. Given anonymously.

FIG. 2. Emanuel Leutze, *Washington Crossing the Delaware*, 1851. Oil on canvas, 149″ × 255″. The Metropolitan Museum of Art, New York. Gift of John Stewart Kennedy, 1897.

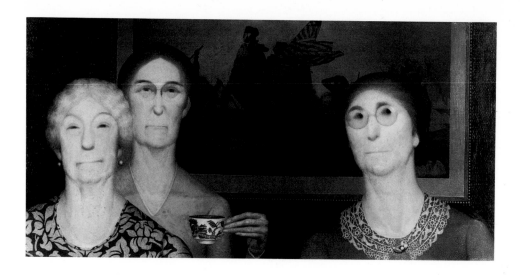

FIG. 3. Grant Wood, *Daughters of Revolution*, 1932. Oil on masonite, 20″ × 40″. Cincinnati Art Museum. The Edwin and Virginia Irwin Memorial. © Wood/V.A.G.A., New York.

General Washington, future leader of the new democracy, in full uniform and posed in a pompous Napoleonic stance. All around him people struggle against the wind and icy waters, but he seems oblivious, disinterested. Rivers's commonsense reimagining of the event pointedly defies Leutze's mythic aggrandizement: "What I saw in the crossing was quite different. I saw the moment as nerve-wracking and uncomfortable. I couldn't picture anyone getting into a chilly river around Christmas time with anything resembling hand-on-chest heroics."[3] Debunking the esteemed paradigm, Rivers offers a humanized version of history, something closer to an actual event.

The choice of any academic painting as a model was sure to scandalize the reigning avant-garde. But Leutze's composition was not just *any* painting. It was a painting about American heroism, a painting that had just the year before (in 1952) been the object of widespread public attention during a celebration that marked the 175th anniversary of the famed river crossing. For this celebration, the canvas had been put on display at the site (Washington Crossing Park, Pennsylvania) in an exhibition that opened on George Washington's birthday to a grand fanfare of national media coverage. *Time* and *National Geographic*, among other popular periodicals, ran special stories on the event, illustrated

with large-scale photographs of the painting, and numerous newspaper articles appeared.[4] As stated in a *New York Times* editorial, a key purpose of the display was to spark a new wave of patriotism. Indeed, the planners of the event hoped for a reprise of the patriotic fervor elicited by the painting in 1932, when it had been called into service as the centerpiece of the bicentennial celebration of George Washington's birth. Interestingly, that earlier commemoration had produced a satiric rejoinder: Grant Wood's *Daughters of Revolution* (1932)[Fig. 3], which spoofs the zealous adoration of *Washington Crossing the Delaware* by such super patriots as the Daughters of the American Revolution.[5]

Thus, Rivers was in effect repeating history by providing a parodic encore to a special exhibition of Leutze's *Washington Crossing the Delaware*. And although Rivers's iconoclastic attitude was not shared by the regionalist Wood, both renounced affected expression and sought to show instead the more commonplace, devoid of pretentions.

While the anniversary of the crossing provided the reason for the special exhibition of Leutze's tableau, the climate at mid-century was ripe for such a celebration. The Cold War and Senator McCarthy's vituperative anti-communist campaign had placed the issue of patriotic expression uppermost in the

minds of many Americans. Overt evidence of patriotism became a national obsession, if not a personal necessity. Just as display of the "official" painting of *Washington Crossing the Delaware* served as a foil for appropriate obeisance, so too did creation of a new *Washington Crossing the Delaware* carry political implications. Rivers was well aware of this. He recognized, albeit jestingly, that by painting such a subject he was "in the eyes of Senator Joe McCarthy . . . at least a patriot."[6] With due irony, he both acceded to and subverted McCarthyist demands for decisive patriotic expression, doing so by playing off an established, venerated national icon.

But the idea of patriotism was itself absurd to Rivers. Leutze's *Washington Crossing the Delaware* reminded him of all the amateurish plays he had seen in grade school, "dopey" productions that nonetheless expressed a love of country.[7] Rather than being totally serious, they were both serious and ridiculous—the tone that Rivers sought to capture in his painting. By avoiding a straightforward statement and riddling the imagery with ambivalence, Rivers was able to arrive at a simultaneously exultant and mocking attitude, a provocative approach toward a subject charged with intrinsic, patriotic significance.

His approach is complicated further by his paradoxically revolutionary and conventional stance. Even as he plays the vanguard artist who upsets existing standards, he reaffirms forsaken traditions. Just such an admixture of individualism and conservatism, dubbed the Spirit of '76, was described by *Time* in its Independence Day issue of 1953 as the prevailing postwar sensibility. In its cover story on George Washington, *Time* depicted the national hero as a man who embraced the unlikely combination of rebellious individualism and reverent conservatism, and who charted his life in the vitalizing tension between the two. According to *Time*, America was experiencing a teeming revival of this Spirit under the newly elected President Eisenhower, a devoted patriot who reanimated the conservative side of the national character.[8] The attitudes Rivers conveys toward the imagery of Washington crossing the Delaware stand thus as an artistic manifestation of the reborn Spirit of '76, albeit one in which irony displaces pious reverence.

In its tensioned dualism and its bold presentation of a distinctly American subject, Rivers's painting is a benchmark in the history of contemporary art. Abandoning an absolutist orientation and abstraction, Rivers concentrates attention on the reviewing of a traditional icon. The painting establishes an art related to American culture but liberated from the trappings of idealism and the weight of the polemics of social reform, two features common to earlier art with an American focus.

Although Rivers's painting became a cause célèbre, another young artist was pursuing a similar path in the early fifties. Roy Lichtenstein, too, was painting American history subjects using earlier art and magazine illustrations as source material, and he, too, was challenging the heroics of Abstract Expressionism and traditional American art by recreating familiar cliché images in a light-hearted manner.[9] Typical of his approach is his Leutze-inspired *Washington Crossing the Delaware* (ca. 1951) [Fig. 4], with its simplified, naive style and comical representation of a nobelized event.

While American history emerged as an iconographic interest in the early 1950s, it did not become a central aspect of the postwar Americanization in modern art. There were, however, occasional forays of note, like Alex Katz's assembly of *Washington Crossing the Delaware* cutouts [Fig. 5], created as the decor for a play by Kenneth Koch. Koch's witty parody on how America won the revolution, written in 1956 in response to Rivers's painting, was first performed publicly in 1962 at the Maidman Theatre in New York. Both the play and Katz's enlivened cutouts, designed with a folk art and billboard character, were imbued with the spirit harbingered by Rivers. Indeed, this spirit of provocation, in one form or another, became a mainstay of the many, quite diverse images that emerged during the fifties and sixties.

Among the American icons that achieved preeminence in postwar art was the American flag, the quintessential symbol of America's national identity. Taking the flag as a point of departure, artists created a range of compelling flag compositions that underscore and disrupt the flag's given formal and symbolic qualities. The prominent appearance of the U.S. flag in postwar art emphatically indicates a shift within the sphere of vanguard art from European to American culture, and the forthright entry of American imagery into the pantheon of artistic icons. In contrast to the universalist imagery of Abstract Expressionism, representations of the flag proclaim cultural specificity. Such art bears witness to a newfound cultural confidence that, if not laying claims to a cultural supremacy, imprints the glaring stamp of America on American art.

The flag is a very special American image: the symbol of nationhood, of patriotic feelings and national values. Depictions of the flag, especially depictions that disturb or reduce the flag's sacrosanctity, therefore instantaneously incite strong

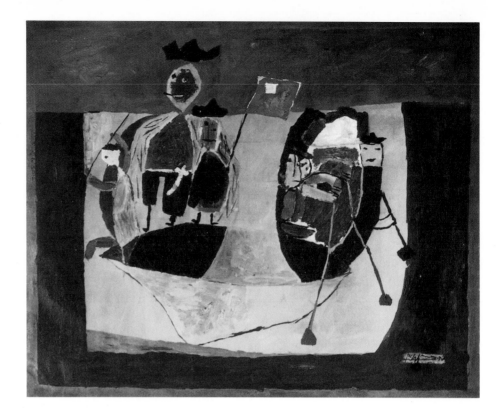

FIG. 4. Roy Lichtenstein, *Washington Crossing the Delaware*, ca. 1951. Oil on canvas, 26″ × 32″. Private collection.

FIG. 5. Alex Katz, *Washington Crossing the Delaware*, 1961. Cutouts for Kenneth Koch's one-act play *George Washington Crossing the Delaware*, acrylic on wood, oil on wood, china. National Museum of American Art, Smithsonian Institution, Washington, D.C. Gift of Mr. and Mrs. David K. Anderson, Martha Jackson Memorial Collection.

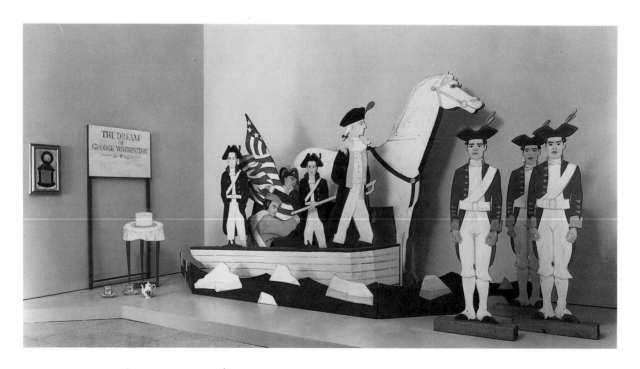

responses. During the chilliest periods of the Cold War, the flag was endowed with added weight, denoting American glory, national power or hyperbolic patriotic conviction, and civic pride.

At the helm of the postwar exploration of the flag-as-art icon was Jasper Johns. His preoccupation with the flag, which began in 1954, entered the realm of public discourse with his flag exhibition at the Leo Castelli Gallery in 1958. The flag appealed to Johns as a given, preformed design and familiar image, a known quantity and yet something "seen and not looked at, not examined."[10] To provoke a reexamination of this all-too-familiar image, Johns varied the flag's essential attributes—color, shape, texture, medium, size, and design elements—and developed forceful spatial displays [Figs. 6–9]. He pushed to the limits the signifying features of the flag's design by creating situations that skew the usual visual character of the flag and render its symbolic meaning ambiguous. For example, when the flag's coloration is reduced to white or transformed to gray, the image must struggle to assert itself lest it disappear into a ghostly, monochromatic field; when the flag is set upon a bright orange plane, its visual strength is challenged; when the icon is depicted over a newspaper foundation or with collage interference, its formal and reverential quality is compromised; when the stripe zone is elongated or the number of stars increased, the established meaning of the symbolic pattern is confounded; when the flag is flattened and contained within a frame or hardened into a metal sculpture, it becomes an imprisoned, rigid object effectively hiding within itself. Such presentations not only compel a re-looking at a known icon but also transform that icon into a paradoxical entity. The well-defined symbol becomes an intriguing complex of contradictory impulses. Johns's flags bear the semblance of autonomous art objects, but are also upended national symbols. In addition to the manipulations that negate the flag's conventional appearance and venerated symbolism, Johns's flags are expressionless in manner. Their inexpressiveness itself is a disturbing force.

Johns began his flag paintings just as the country was about to emerge from the national hysteria induced by Joseph McCarthy. Patriotic expression was a highly emotional issue. Fears about communism had escalated into general paranoia, with demonstrations of unwavering loyalty being demanded and then scrutinized as part of McCarthy's suspicious, tyrannical inquests. For several years the country had read about McCarthy's activities in the press and listened to him on the radio. From April to June, 1954, people were also able to watch the Army-McCarthy hearings on television. For the first time, the proceedings of a U.S. Senate investigation were broadcast live to the entire nation, and millions sat transfixed day after day by McCarthy's increasingly theatrical tirades.[11] Though McCarthy was finally discredited, his intense scrutiny of patriotism and obsession with communism provoked an exaggerated attentiveness to American values. Congress even passed a law to revise the pledge of allegiance. The old pledge had served since 1892, but now, to distinguish the American pledge from any Soviet counterparts, the words "under God" were added. With full media fanfare, President Eisenhower signed the legislation authorizing the new pledge on Flag Day 1954.[12] Pledging allegiance, saluting the flag, was serious business.

Although the flag acquired a defensive significance under the reign of McCarthyism, it was also a prime index of the prideful nationalism that held sway under Eisenhower. Eisenhower had campaigned as the archetypal patriot, emphasizing his war record as a leader in the defense of American freedoms and his staunch support of traditional middle-American values. His exemplary affirmative Americanism engendered expressions of down-home patriotism. These prevailed throughout his administration, becoming especially pronounced around 1955, once the full flush of the economic boom was felt and a pervasive feeling of well-being took root in Middle America. Outright declarations of an upbeat American spirit included the painting of mailboxes in "American blue" and perennial small-town festivities in which everything in sight was decorated with flags and festooned in red, white, and blue. The nation was in the throes of self-indulgent display, and flag-waving was a ubiquitous ritual.

Considering the sociopolitical climate, the irony of Johns's flag paintings is extraordinary. These paintings affirm and deny an Americanness. They address the issue of patriotic display—indeed, they denote a total devotion to and obsession with the flag image—but they refuse to make an unequivocal statement about it. They reiterate the stability of the banner's design even while laying siege to its signifying features. But they also treat the flag as the site of subterfuge, concealment, and obfuscation, raising doubts about its integrity as a sanctified symbol.

Notably, the flags convey a sense of conformity, as if creativity and individual will have been sublimated or forced to comply with a prescribed norm. Though such compliance insinuates the ideological coercion of McCarthyism, equally relevant is the type of conformity discussed by

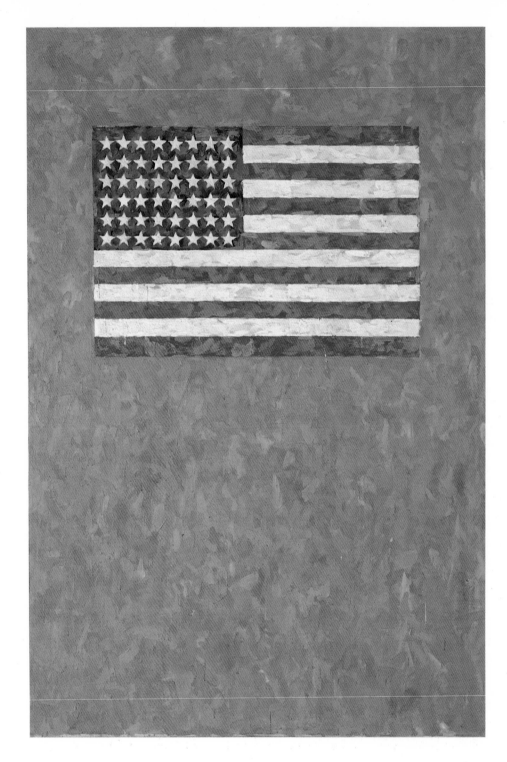

★FIG. 6. Jasper Johns, *Flag on Orange Field, II*, 1958. Encaustic on canvas, 54″ × 36¼″. Private collection.

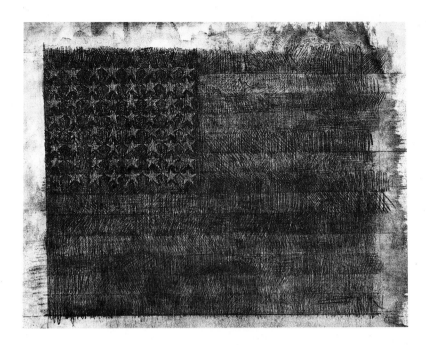

*FIG. 7. Jasper Johns, *Flag*, 1955.
Pencil on paper, 6⅝" × 8¾".
Collection of the artist.

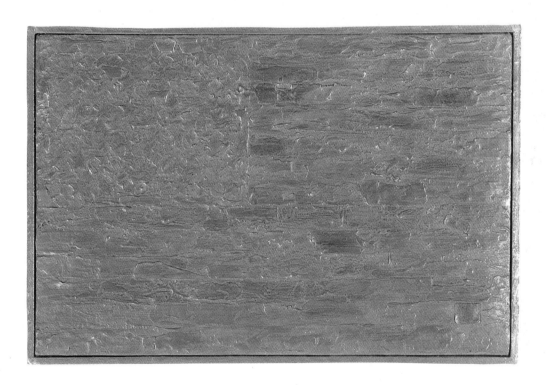

*FIG. 8. Jasper Johns, *Sculpmetal
Flag*, 1960. Sculpmetal on canvas and
wood, 13¼" × 19⅞" × 1½". Collection
of Robert Rauschenberg.

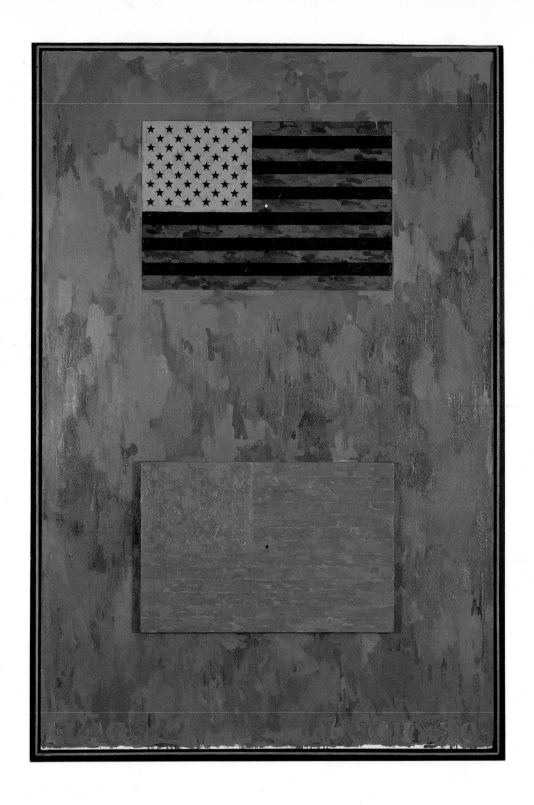

★FIG. 9. Jasper Johns, *Flags*, 1965.
Oil on canvas with raised canvas,
72″ × 48″. Collection of the artist.

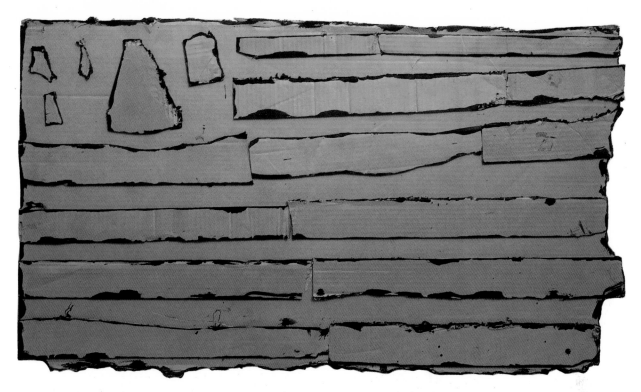

*FIG. 10. Claes Oldenburg, *Flag*, 1960. Construction with cardboard, 22″ × 38″ × 1½″. Collection of John Bransten.

William Whyte, Jr., in *The Organization Man*. In Whyte's view the new social ethic that prevailed in postwar America held the group to be the source of creativity, "belongingness" to be the ultimate need of the individual, and "individualism *within* organizational life" as the highest good.[13] Weighing the dangers of redundancy, inertia, self-destruction, and monotony against the beneficence of the security and brotherhood of the organizational system, Whyte concludes his book with the warning that contemporary man "must *fight* The Organization. . . . The demands for his surrender are constant and powerful, and the more he has come to like the life of the organization the more difficult does he find it to resist these demands, or even to recognize them."[14] Johns's paintings set forth this conflict between submission to and resistance against a given. What is more, he does so using the prime symbol of the preeminent organizational system. His are not conformist flags but flags that take conformity as a point of departure for re-presentation and re-viewing—for an expression of nonconformity.

At the same time that Johns was making his flag paintings in New York, Wally Hedrick was creat-ing a series of flags in San Francisco. His compositions also display the icon flattened and exaggerated in a flag-as-painting format, but a second element, a word or image, is overlaid on the flag. For example, PEACE appears across the surface of the flag in a painting from 1953–54. The reference is to the armistice signed by North Korea in July 1953. Hedrick's intention, however, was not to celebrate the truce, but to condemn the war and American military involvements, for which the flag served as a call to arms. The work was also a refusal to pledge allegiance to the reigning Abstract Expressionist credo that pictorial images should be abstract and mystical, that art and politics should not be mixed.[15]

Whereas Hedrick focused on the symbolism of the flag and Johns on its formal design, for Claes Oldenburg the flag was part of a search for American archetypes, images that were or might be infused with the vitality of the immediate environment in all its disorder, disjunctiveness, and contrariety.[16] He treated the flag as an everyday object rooted in ordinary experience. In *Flag* (1960) [Fig. 10], the gritty, decaying atmosphere of urban

★FIG. 11. Claes Oldenburg, *The Old Dump Flag*, 1960. Scrap wood, 8¾" × 10¾" × 2⅞". Collection of the artist.

slums is captured in the jagged fragments of torn cardboard with their blackened edges and irregular shapes. This is a flag neither silken nor richly colored but fabricated out of debris and the scraps of American affluence. Bearing the somber tones of a bleak existence, rendered as a common object, endowed with the makeshift ambiance of a transient situation, it is a flag of life on the fringes of urban America, a flag to be raised not as an empty or idealized symbol but as a direct image of American culture.

This same orientation prevails in Oldenburg's driftwood flags of 1960 [Figs. 11 and 12], created during a summer on Cape Cod, capital of New England Americana and beachcombing frivolity. In Provincetown flags are everywhere—on homes, ships, shops, clothing, and souvenir items—testaments to both traditional patriotic faith and vacuous contemporary clichés. Oldenburg's flags capture both aspects and affirm an acute responsiveness to the seaside environment as well. Composed of weatherbeaten materials inventively assembled to suggest stars and stripes, these flags hail the life-and-death character of nature, the awesomeness of survival under harsh conditions. They also manifest a delight in discovery and a witty engagement with simple, found treasures. These flotsam banners are not abstract or austere emblems but images "literally made of the ordinary world," imbued with a humanistic spirit and good-humored affirmation of life.[17] Their rawness riles against the idea of art being separate from life, or pictorial icons as being sacred or staid museum pieces.

In 1960–61 Oldenburg also produced a set of plaster flags, misshapen, crude images [Fig. 13] designed to defy both the lyrical, decorative tendencies of modern art and the precisioned finish of machine-made merchandise. These very individualized tasteless objects assert an unfettered instinctive expression and relate to the cheaply made products sold in street carts or inner-city five-and-dime stores. Indeed, Oldenburg created these flags and other similarly "vulgar" objects to sell in his art environment–business establishment, *The Store*, an enterprise that functioned both as a museum of popular culture and as a merchandizing outlet for commodity art objects. In this environment, art objects lost their precious, esoteric trappings, and common objects gained artistic value. As part of *The Store* production, the plaster flags appeared as mundane objects that were inextricably and overly bound to American commerce. They also attested to art as having an American identity and broad public appeal.

In creating these American flags, Oldenburg was neither defamatory nor chauvinistic in attitude. He sought instead to denote a "double view both for and against" American culture.[18] Like so many artists of the period, his intent was to reveal the actualities of life and to assert an exuberance for living, to encourage a more open and open-minded way of seeing. His approach befit the celebratory mood that prevailed in the early sixties when, after eight years of Eisenhower's statesmanlike complacency, John F. Kennedy reenergized the nation, sparking new confidence in the American way of life. Proclaiming a New Frontier and premising his inaugural address on the theme "Let us begin anew," Kennedy set forth an outright challenge to the nation. The young president's adventurous message, wit, and glamorous appearance inspired new hope and new ideals for change and progress. Urging Americans to respond to poverty, injustice, and urban decay, Kennedy sought to ignite a new altruism and a new patriotic fervor. He offered the seduction of alternative possibilities, and, in the face of escalated Cold War tensions, he presented an image of renewed strength, courage and new leadership.

Kennedy and his vision of Camelot inspired a burst of exuberance. America was again reaffirming its Americanness, pressing ahead and asserting its prowess. The political and social atmosphere was supportive of innovation and receptive to a joyous abandonment of staid or stifled expression. Oldenburg's flags are a vivid index of this climate and pose an interesting counterpoint to Johns's American flags of the Eisenhower fifties.

★FIG. 12. Claes Oldenburg, *Heel Flag*, 1960. Heel nailed to scrap wood, string, 5⅜" × 9½" × 1½". Collection of the artist.

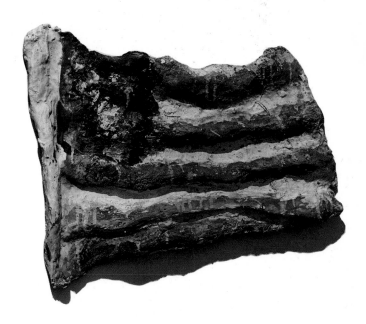

FIG. 13. Claes Oldenburg, *U.S.A. Flag*, 1960. Plaster, 24" × 30" × 3½". Collection of the artist.

Amid the outburst of revivified patriotism in the sixties, artists expanded the flag iconography and produced a diverse range of eccentric images. Again, flag-waving patriotism was not the motive. Rather the appearance of the flag was consonant with an intensified focus on America, a focus that embraced concern as much as jubilance, ambivalence not blind allegiance.

In *Little Flag Painting* (1961) [Fig. 14] by Jake Berthot, for example, a totally unconventional image appears. An intermingling of the stars and stripes displaces the proper arrangement of the constituent elements, and a muddy tonality overwhelms the classic red, white, and blue. This is a flag that shatters the structure that had come to define it, a flag that undermines its essential symbolic nature, a flag that is sullied and chaotic. At the time, Berthot was an emerging artist seeking to come to terms with Johns and abstraction, on the one hand, and with the dissonance between social reality and its representation in textbook ideals, po-

litical rhetoric, and television sitcoms, on the other.[19] In the early sixties many Americans began to look beyond civics-class homilies and idealized fantasies of domestic bliss. Berthot created his flag to reflect the upheaval and confusion that such awakenings aroused.

In the assemblage art of George Herms—which included numerous U.S. flags—the image of the stars and stripes expresses an indefatigable identity with America despite an unshakable despair and restlessness. Herms's flag imagery testifies to an active commitment to America—a refusal to escape or remain silent—as well as a longing for something meaningful. Like the Beat poets, artists, and musicians with whom he was associated, Herms rebelled against conformity and urged an open, questioning attitude. Disillusioned with reasoned thinking, he took a confrontational stance toward American culture, an anarchistic attitude to materials, and a freewheeling, poetic approach to iconography. In *Flag* (1962) [Fig. 15], Herms's use of

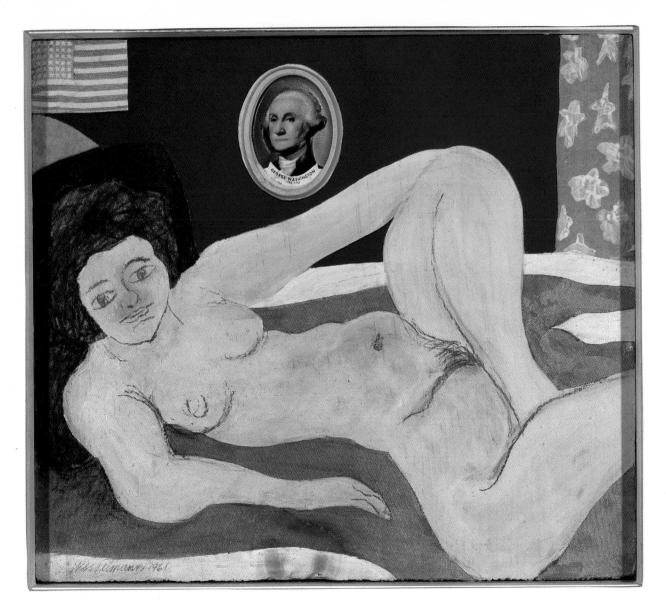

★FIG. 16. Tom Wesselmann, *Little Great American Nude #6*, 1961. Acrylic and collage on board, 10″ × 11½″. Collection of Mr. and Mrs. Alan Englander.

waste materials and his disordering of the flag's strict patterning denote a freedom within and release from the constraints of the given system. The full-length vertical red field, clotted with white spots and banded by blue and white stripes is constructed from the back seat of a car, an old ice tray separator, and a broken head lamp.[20] This conglomerate of disparate objects, charged with disruptions and mired in confusion, is an outrageous facsimile of a flag that expresses both an alienation from symbolic American ideals and a nonjudgmental receptivity to the gut-level reality of life in a disorienting, often incomprehensible, society. Herms's merger of junk materials and Old Glory connotes a situation of futility and faith, collapse and sustenance, with hope residing in the power of individualized expression, in a personal vitality that defies indifference.

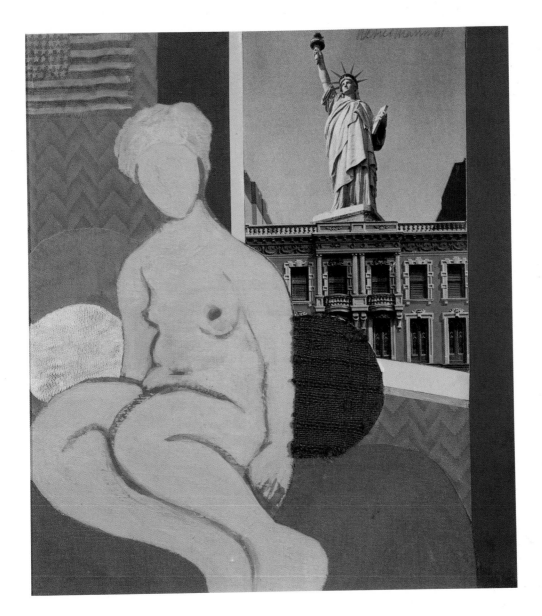

*FIG. 17. Tom Wesselmann, *Little Great American Nude #7*, 1961. Acrylic and collage on board, 8¾" × 7⅞". Collection of Mr. and Mrs. Alan Englander.

Pursuing yet another course of exploration, Tom Wesselmann used the flag as the thematic, visual, and symbolic feature of a series of compositions titled the *Great American Nude* [Figs. 16 and 17]. Humor abounds as star-patterned wallpaper, striped draperies, red upholstery with blue pillows, and interspersed photographic reproductions of George Washington, the Statue of Liberty, the federal seal, or the flag itself establish an excessive, unequivo-cally American identity for the nude. Wesselmann forthrightly usurps the European iconography of the nude and re-presents her as an American icon, quite at home in her bourgeois American setting and bearing the mark of American greatness.

In Wesselmann's paintings, the nude and her setting are depicted in the depersonalized, promotional style of contemporary advertising. Her curvaceous body is flatly painted, and she is usually

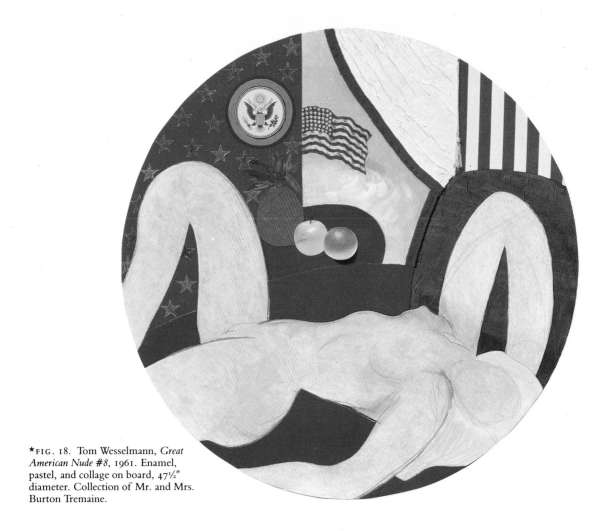

*FIG. 18. Tom Wesselmann, *Great American Nude #8*, 1961. Enamel, pastel, and collage on board, 47½" diameter. Collection of Mr. and Mrs. Burton Tremaine.

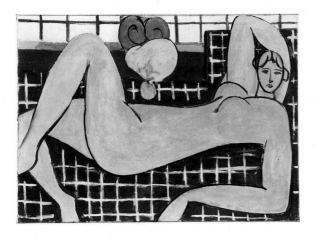

FIG. 19. Henri Matisse, *Large Reclining Nude*, 1935. Oil on canvas, 26" × 36½". The Baltimore Museum of Art. The Cone Collection, formed by Dr. Claribel Cone and Miss Etta Cone of Baltimore, Maryland.

faceless or further objectified as a sexual torso by croppings that cut off her limbs and head. Her pose often recalls Ingres's tantalizing odalisques, the exotic goddesses surrounded by accouterments of pleasure, or Matisse's sensuous, decorative nudes. But the female figures in Wesselmann's paintings are significantly different. For example, the subject in *Great American Nude #8* (1961) [Fig. 18] unabashedly confronts the viewer, blatantly exposes herself as a commodity, whereas the seductive temptress in Matisse's *Large Reclining Nude* (1935) [Fig. 19] alluringly manifests her sexuality. Lounging on living room couches and usually splayed out in erotic postures, Wesselmann's nudes carry innuendos of the slick, cool, stilted soft-porno photography that Hugh Hefner made famous—and socially respectable—in his *Playboy* centerfolds.

Hefner began publishing *Playboy* in 1953, capitalizing on the domestic pornography industry that

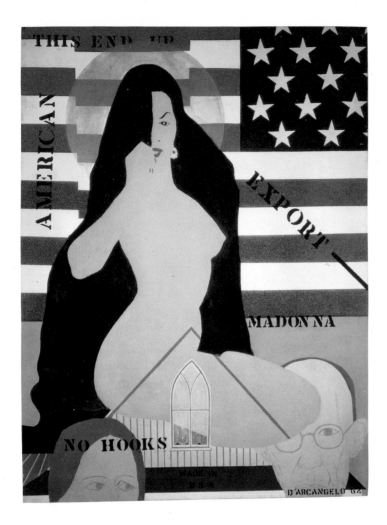

FIG. 20. Allan D'Arcangelo, *American Madonna #1*, 1962. Acrylic on canvas, 60″ × 45″. Collection of the artist.

had flourished during World War II and on a loosening of America's attitudes toward nudity and sexuality. This change in mores was confirmed by the Kinsey report (*Sexual Behavior in the Human Female*, 1953), which revealed a surprising discrepancy between middle-Americans' sexual practices and their professed puritanical morality. *Playboy* promoted the idea that sex was not merely an aspect of life but of lifestyle, a badge of upward mobility and material success.[21] The centerfold playmate was presented as a commodity object, a showpiece of perfected glamour and fantasy, and yet as the "girl next door," a woman one could meet in a typical American town. The magazine also included pages of quality fiction, sociological studies, and respectable advertisements—a far cry from underground pornography magazines. Its editorial content and its availability at corner newsstands and in neighborhood drugstores made it at-

tractive to a wide readership. With *Playboy* sexuality became a major American business and an acknowledged part of American culture and the American dream—at least the male version of the dream. In the wake of this phenomenon, Wesselmann's *Great American Nude* series claims the nude as an appropriate subject for American art and sets forth her image in clearly Americanized terms. As in *Playboy*, the nude appears as a status symbol, associated with the good life in America.

This message is even more pointedly pronounced in Allan D'Arcangelo's *American Madonna #1* (1962) [Fig. 20], where a *Playboy*-type nude, set against an American flag and sanctified by a golden halo, is rendered as the reigning American icon. She has superseded both the Virgin Mary—a venerated image of European art—and the pious couple in Grant Wood's *American Gothic*, a favored national image that had come to epitomize provincial

America. Despite the humor, the composition testifies to significant cultural changes: the shift from humility and piety to glamour and commercialism; from folksiness and small-town insularity to artificiality and big-city bravado; from sexual austerity to permissiveness and exploitation. The new American icon conveys an assertive, even haughty, aura conditioned by the mass media and intended for product promotion. As evinced by the mode of display and the stenciled labels MADE IN U S A and EXPORT, the image is a packaged commodity, an enticing sales pitch in the peddling of American culture on the international market. America was no longer a land of innocence, and its culture no longer stood in the shadow of European tradition. To the nation's catalogue of American icons, the postwar artists had added a new entry: the American nude.

Other favored new icons in postwar art were similarly intended to disrupt conventional thinking, both about art and America. Johns, for example, complemented his revisualization of the flag with a series of map paintings (1960–63). Again, it was not just any map or flag that Johns painted, but only and repeatedly the U.S. map and U.S. flag. As with the flag, he chose a familiar image, though one not common within the realm of art, and then confounded its usual appearance and subverted cartographic logic and geographic verisimilitude. These maps undermine the very purpose of maps and compel viewers to reconsider the image and its commonplace meaning.

The first *Map* (1960) was a small (8″ × 11″) composition created by Johns's overpainting on a school notebook map that his friend Rauschenberg had given him. With expressive paint markings he obliterated most of the Eastern states and destroyed all the meticulous codes mapmakers use to convey information. In the large-scale maps that followed, Johns's slashing brushstrokes and paint drips efface state and national boundaries and eradicate all or parts of the identification labels that he had carefully, though irregularly, stenciled in place [Fig. 21]. The coloration also defies any precisioned ordering system or definitional rigor, though the limited choice of hues (red, yellow, and blue, or shades of gray) implies a code, perhaps an ironic substitute of an aesthetic code for a carto-

graphic one. Repeatedly, the image of the U.S. map is simultaneously affirmed and denied, present and absent. There is the sense that a system and rigor once existed but have fallen into a state of chaotic disarray.

Although Johns expressly rules against a reading of the map in terms of conventional schemata, especially as these define and isolate individual entities, the resulting image faithfully represents the blurring of local boundaries in the postwar period. With the advent of national television networks and press syndicates, transcontinental highways and jet air travel, and coast-to-coast advertising and distribution of mass-produced goods, state and regional distinctions were disappearing. The artificial divisions and perimeters that had been established long ago remained but were largely nonfunctional and somewhat nonsensical. Territorial integrity had given way to interconnections; parts had largely yielded to the whole: and even the whole had opened outward through America's escalating involvement in international affairs. Moreover, the admission to statehood of Alaska and Hawaii in 1959 rendered obsolete the old maps that showed only the contiguous forty-eight states. Thus Johns's design, which reflects the nation's unbounded, destructured, interactional condition in the early sixties is conceptually more accurate than a traditional map.

In tandem with the revisualizations of such traditional images as the U.S. map and U.S. flag, a variety of artists continued the direction initiated by Rivers with his *Washington Crossing the Delaware*. Their provocative depictions of U.S. presidents also spurred a rethinking about the relation between America's past and present.

For Edward Kienholz, it was the absurd dress of the first president that inspired his parody portrait, *George Warshington in Drag* (1957) [Fig. 22]. His image emphasizes the standards for stylish men's clothing in the Revolutionary period, clothing that some two centuries later resembles nothing so much as outfits for transsexual costume balls. Kienholz not only pokes fun at the Founding Fathers' preposterous dress standards, but uses the change in dress codes as a premise in an indictment of narrow-minded moral judgments, hypocritical moral standards, and suppressed sexuality in American society. The painting is by no means a revisionist biography (indeed, the first president was said to be quite a lady's man), but rather a portrait of contemporary social issues and a counterbalance to traditional paintings that lionize national heroes.

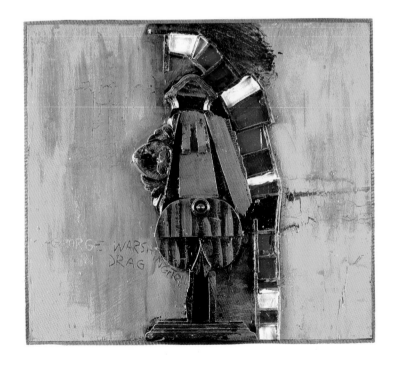

*FIG. 21. Jasper Johns, *Map*, 1962. Encaustic and collage on canvas, 60″ × 93″. Collection of Marcia S. Weisman.

*FIG. 22. Edward Kienholz, *George Warshington in Drag*, 1957. Painted wood on plywood, 32½″ × 36″ × 3″. Collection of Walter Hopps.

FIG. 23. Roy Lichtenstein, *George Washington*, 1962. Oil on canvas, 51" × 38". Collection of Jean Christophe Castelli.

In a quite different way, Roy Lichtenstein subverts, or at least recontextualizes, the ideal and heroic in his portrait of *George Washington* (1962) [Fig. 23] by presenting a comic-strip version of the well-known Gilbert Stuart image. Bold outlines, stark simplification, flat shadows, and benday-dot tonality assert the imprint of the mechanical style of commercial art and the mundane character of a widely published reproduction. The depiction undermines an effete academic orientation toward portraiture and an elitist attitude toward art, showing, paradoxically, that comic-strip stylization is comparably formal and austere. Indeed the depiction seems quite at home in the traditional wooden frame that served as the source of inspiration for the portrait,[22] and there is a certain appropriateness in the use of a comic-strip style, a mode closely identified with American culture, for a painting of the nation's first president. The mass production

character of Lichtenstein's depiction, moreover, is not so foreign to Stuart's portrayal, for the latter was actually made in multiples for widespread circulation. Records indicate that Stuart re-created over sixty studio copies of the famous painting he initially made from life, and that the copies became so popular that they were referred to as Stuart's "hundred dollar bills."[23] In that Lichtenstein used a mutant engraving of Stuart's work that he had found in a Hungarian newspaper, the stages of replication and appropriation are further layered.[24]

Stuart's image of Washington, represented by a photographic reproduction, also dominates Wesselmann's *Still Life #31* (1963) [Fig. 24], where again it highlights a curious bonding between traditional and contemporary American culture. As in his *Great American Nude* series, Wesselmann trumpets America, this time Americanizing the European still-life theme by conjoining a Cézannesque fruit arrangement with a portrait of Washington, a radiator—an indication of central heating, thus an index of American affluence—and a television set, the altarpiece of the postwar American home. The American items convey an immediate and decisive national identity that rivals, if not overwhelms, the residual marker of European culture. Humor notwithstanding, the boast of American cultural superiority bespeaks the assertive and at times aggressive spirit of supremacy that America indulged in during the early sixties.

In a related composition, *Still Life #28* (1963), Wesselmann features a portrait of Lincoln to promote an emphatic American impression. Lincoln's visage, like Washington's, was well known outside the United States and thus had prime value as an American icon of international legibility. Rauschenberg, too, featured Lincoln's image, using a photograph of the familiar Lincoln Memorial statue, in a 1958 painting *Lincoln* [Fig. 25]. In contrast to Wesselmann's witty invocation of the president's portrait, Rauschenberg's somber composition shrouds Lincoln's image behind a blackened veil, a reminder of his assassination and the country's dark history during the Civil War. This reminder is all the more significant in light of the civil strife over school integration in Little Rock, Arkansas, during September 1957, when armed troops intervened in a Southern racial crisis for the first time since the days of Reconstruction. Televised broadcasts brought the state troopers' brutality directly into people's homes and shocked the nation. Rauschenberg's funereal portrayal of Lincoln conjures the bitter memories and fearful premonitions evoked by the violence in Little Rock.

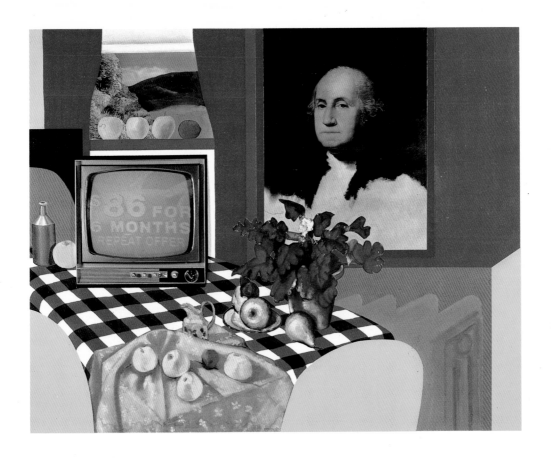

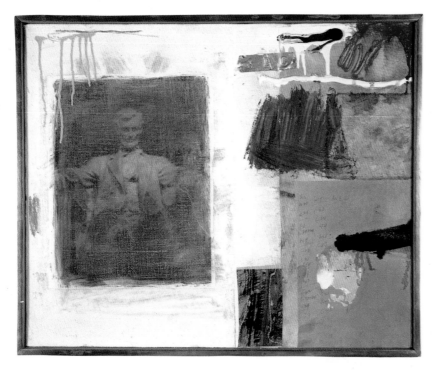

*FIG. 24. Tom Wesselmann, *Still Life #31*, 1963. Collage, oil, TV on canvas, 48″ × 60″ × 10¾″. The Frederick R. Weisman Foundation of Art, Los Angeles.

*FIG. 25. Robert Rauschenberg, *Lincoln*, 1958. Oil and collage on canvas, 17″ × 20⅞″. The Art Institute of Chicago. Gift of Mr. and Mrs. Edwin E. Hokin.

FIG. 26. Robert Rauschenberg, *Factum I*, 1957. Combine painting, 61½" × 35¾". The Museum of Contemporary Art, Los Angeles. Acquired from the collection of Count Giuseppe Panza di Biumo.

Rauschenberg also set forth images of present-day leaders: Eisenhower in *Factum I* and *II* (1957) [Fig. 26]; the presidential candidates Kennedy, Stevenson, and Nixon in the *Dante's Inferno* series (1959–60); and Kennedy again in a group of paintings from 1964 [Fig. 27]. The latter works are particularly compelling in that they capture Kennedy's charismatic image and reflect the potency of the mass media in making that image indelible in the public consciousness, an icon in its own time.

Kennedy was the premier media president, a leader who engaged both print journalism and television to communicate ideas and shape his image. Politicians' flirtation with television had begun during Eisenhower's first campaign, in 1952. Eisenhower was the first presidential candidate to announce his decision to run for office on television, the first candidate to develop a television strategy for the nominating convention (which was the first to be telecast live), and the first candidate to campaign on television with spot commercials designed by a major advertising agency (Batten Barton Durstine and Osborn). Running-mate Richard Nixon's "Checkers" speech (broadcast live, coast to coast) further revealed how effective television could be in reversing public opinion. Throughout the Eisenhower years, the mass media, particularly television, increasingly became a part of the American political process.

With the campaign and presidency of John Kennedy, the vast national and international power of television clearly emerged. Kennedy, a consummate showman, became television's "first great political superstar."[25] He used the media and the media used him. From his four televised debates with Nixon during the presidential campaign, to his televised news conferences and photographic sessions at the White House and Hyannis Port, Kennedy's presidency was a media phenomenon. The country was inundated with visual images of its president, some reproduced so often that they became national emblems—the contemporary equivalent of Gilbert Stuart's portraits of George Washington.

Rauschenberg used one of these very familiar images of the handsome, young president, the determined, vigorous orator. By enlarging a media photograph and transferring it onto canvas by a silkscreen process, Rauschenberg intensified the original's graininess and blurriness, producing an image that resembles a newspaper illustration or a television transmission. Rauschenberg's placement of Kennedy's portrait in the midst of a barrage of unrelated images also suggests a newspaper or news magazine layout, or the programming of the evening television news, which juxtaposes disparate topics with no continuity or coherence. Painted after the assassination, these compositions exemplify Kennedy's vitality and America's dynamism, but the image of the slain president is also a reminder of both American glory and national tragedy. The compositions epitomize the frenzied, disjunctive nature of American society and convey the tensions, uncertainty, and irrationality of modern life.

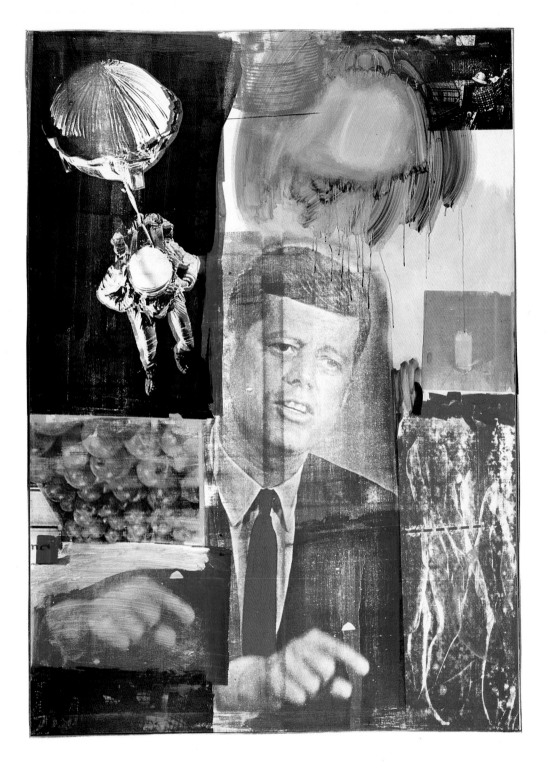

*FIG. 27. Robert Rauschenberg,
Retroactive I, 1964. Oil and silkscreen
on canvas, 84" × 60". Wadsworth
Atheneum, Hartford, Connecticut.
Gift of Susan Morse Hilles.

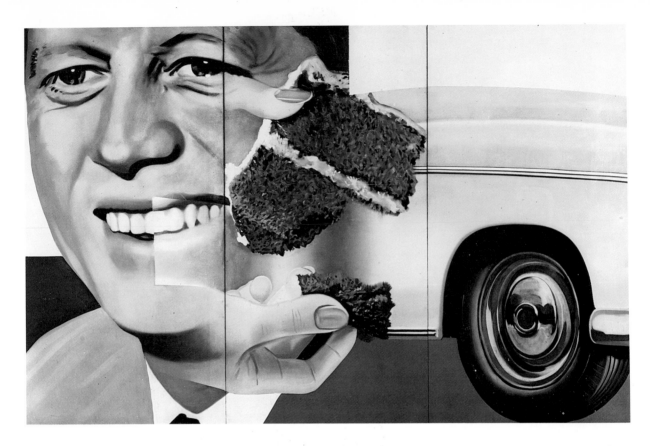

FIG. 28. James Rosenquist, *President Elect*, 1960–61. Oil on masonite, 84″×144″. Musée National d'Art Moderne, Centre Georges Pompidou, Paris.

Rauschenberg's depictions of Kennedy give vivid evidence of the potential of both mass media exposure and American-style advertising to reduce an image to a commonplace cliché or instantly elevate it to the status of legend. Although Eisenhower moved the presidency into the realm of professional advertising, during Kennedy's administration, when the president's image acquired the immediate recognizability and finely tuned promotional character of a highly successful Madison Avenue advertisement, the merger of advertising and politics was solidified. James Rosenquist calls explicit attention to this relationship in his painting *President Elect* (1960–61) [Fig. 28]. Within a billboard-like display, Kennedy's smiling face is set alongside advertisement images for a packaged cake mix and a shiny Chevrolet. His visage, treated as a product advertisement becomes a symbol of the mythicized contemporary American lifestyle. Here, as in Rauschenberg's compositions, the president's image acquires an iconic presence and serves as a multivalent signifier of the postwar era.

With all the media hype, the presidency came to seem like a public relations spectacle, with the chief executive being marketed as a packaged product rather than an individual elected because of his character and political platform. Kienholz provokes awareness of this issue in his assemblage *Untitled American President* (1962) [Fig. 29], which shows the nation's leader as a headless generic figure wearing an American flag and sporting a bicycle-seat hat atop its milk-can torso. It is a homespun image comprised of a few striking traits, but also a hollow-shell personage devoid of physical substance and human features. By representing the president as a titular display object, perfectly suited for broad public appeal and promotional photographs, Kienholz cleverly satirizes the thrust of contemporary American politics while providing a fitting presidential icon for an image-conscious age.

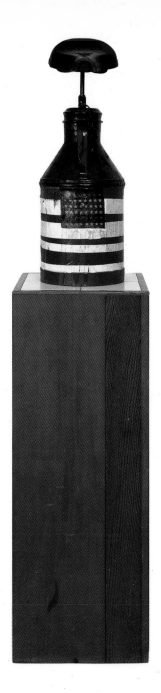

★FIG. 29. Edward Kienholz, *Untitled
American President*, 1962. Paint,
fiberglass, milk can, and bicycle seat,
25″×9″×9″. Collection of Ruth
Askey.

Closely entwined with the postwar expansion of
the mass media and advertising was the nation's ex-
traordinary economic growth. Complementing
America's long-standing image as a land of plenty
was its new image as "the affluent society." Mil-
lions of Middle Americans delighted in their new
affluence and became preoccupied with the con-
spicuous display of wealth. Having money and
freely spending it became primary aspects of the
American identity. During the Eisenhower admin-
istration, the government even promoted spending
through a massive advertising campaign aimed at
staving off a recession. Slogans like "Buy, Buy,
Buy, It's Your Patriotic Duty," and "Think Pros-
perity—Have Prosperity," were broadcast in the
media and plastered on billboards throughout the
country.[26] Money was no longer simply a desirable
or necessary medium of exchange, but an end in it-
self and a cornerstone of American life.

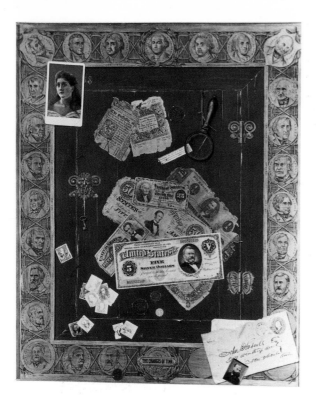

FIG. 30. John Haberle, *Changes of Time*, 1888. Oil on canvas, 23¾" × 15¾". Private collection.

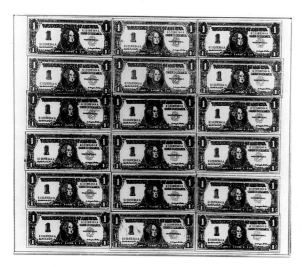

FIG. 31. Andy Warhol, *One Dollar Bills*, 1962. Silkscreen on canvas, 24" × 30". Hessisches Landesmuseum, Darmstadt.

Money had been adopted as an art image by such late-nineteenth-century American artists as William Harnett, John Peto, and John Haberle, who used *trompe l'oeil* illusionism to wryly depict real and counterfeit dollars [Fig. 30].[27] Even then, fascination with wealth was a notable national attribute. The reappearance of cash and coin in postwar American art reflects, and often critiques, both the national focus on wealth and the new financial market for art, especially American art. In Andy Warhol's dollar-bill paintings of 1962 [Fig. 31], row after row of silkscreened bills or displays of dollars casually strewn about suggest plentitude and excess. The depictions also equate creating or buying art with making money, thus calling attention to the commercialization of art and the role played in this by American dollars.

Whereas Warhol replicated the dollar's actual appearance, other artists used American currency as a point of departure for comic imitations. Phillip Hefferton, for example, variously remodeled the presidential portrait on the face of the dollar bill. *Sweet Funk* (1963) [Fig. 32] shows Washington's face being transformed into a brick wall, literally monumentalized; *Sinking George* (1962) features the president vanishing from view, submerged by the ocean; and *Poo Poo* (1963) represents the founding father in a vanity portrait, his hair hanging down over one eye. Hefferton's paintings lampoon the reverence accorded American money and the iconographic fixity of a mass production society. Using coins as his imagery, Robert Arneson similarly offers witty revisions, audaciously replacing the solemn presidential heads with informal depictions of his own visage. In *In God We Trust* (1965) [Fig. 33], for example, Arneson's own mustached profile, adorned with sunglasses and a sailor's cap, is substituted for Washington's on the face of an oversized quarter fabricated in ceramic.

The frivolity in these images echoes the general celebration of the American spirit during the increasingly affluent postwar era. Moreover, it establishes humor as an ingredient in American art. The imagery of money and its unconventional presentation injected levity into America's identity as a rich capitalist society and undercut traditions of iconographic seriousness.

National monuments comprise another set of classic American images developed by postwar artists. For Hefferton, money again provided a source. From the backs of dollar bills he usurped

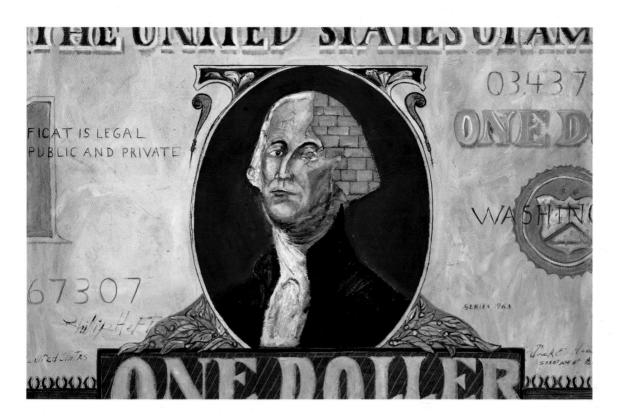

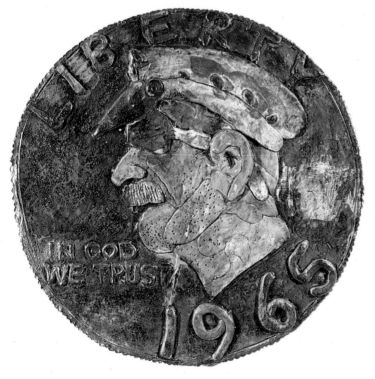

*FIG. 32. Phillip Hefferton, *Sweet Funk*, 1963. Oil on canvas, 57″ × 88″. Collection of Susan Dakin, courtesy of Newspace, Los Angeles.

*FIG. 33. Robert Arneson, *In God We Trust*, 1965. Ceramic, 16⅜″ diameter. Collection of Allan Stone Gallery, New York.

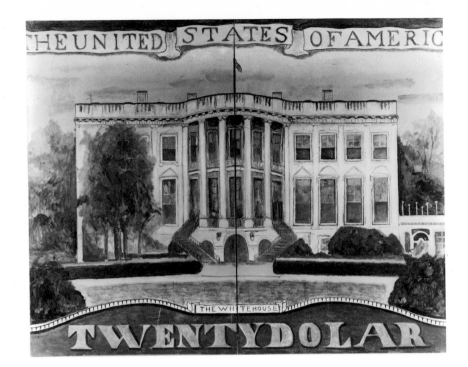

FIG. 34. Phillip Hefferton, *White House*, 1963. Oil on canvas, 84″×108″. Collection of Robert A. Rowan.

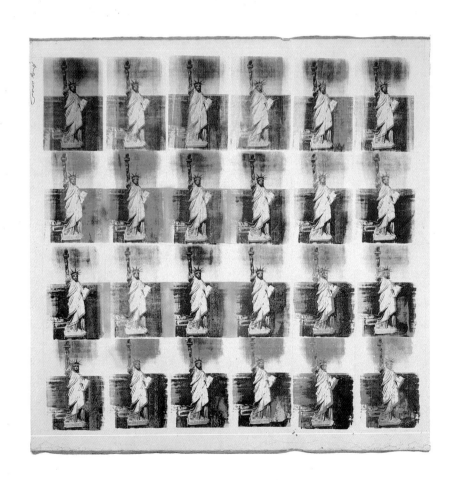

FIG. 35. Andy Warhol, *Statue of Liberty*, 1963. Acrylic and silkscreen on linen, 78″×80″. Marx Collection, Berlin.

images of the White House [Fig. 34], U.S. Treasury, and Capitol, and portrayed them as lifelike rather than austere. Whereas a whimsical tone prevails in these depictions, a note of grandeur issues from the appearance of the Statue of Liberty in Rauschenberg's art. The Liberty monument was a premier element in Rauschenberg's pictorial vocabulary, making early appearances by means of photographs in his combine paintings *Charlene* (1954), *Canyon* (1959), and *Forecast* (1959). In his silkscreen conglomerate-image compositions of 1963–64, the Statue is confirmed as a favored subject, prevailing as a vital signifier of American culture. (See *Estate* [Fig. 45] and *Choke* [Fig. 46] in the next chapter.) Throughout Lady Liberty conveys a note of stability within the paintings' world of flux and disruption, upholding traditional American values in the face of images that defy or skew them.

In his *Statue of Liberty* painting of 1963 [Fig. 35], Warhol, in contrast, isolates the image, amplifying and simultaneously deflating its visual and symbolic impact through repetition. As his depiction suggests, within the realm of mass culture famous monuments are widely reproduced and often known only through poor-quality illustrations. They then become familiar images that everyone can identify by name, but they also become neutralized entities devoid of affective value. Even as marketing and promotion strategies use redundancy and saturation to publicize the form of a national icon, its symbolic content fades into the background.

Image neutralization is even more emphatically pronounced in Richard Artschwager's *The Washington Monument* (1964) [Fig. 36]. Artschwager exaggerates the benign, mute quality and graininess of newspaper photographs by painting his image in grisaille on cheap textured celotex board. Austere and awesome, the monument seems an eerie, ghostly presence, as though a memorial to—or of—a lost, dead civilization. Here, too, a traditional American icon is rendered so as to provoke contemplation about American culture, its past with reference to its present, its glories within the scope of its prevailing difficulties.

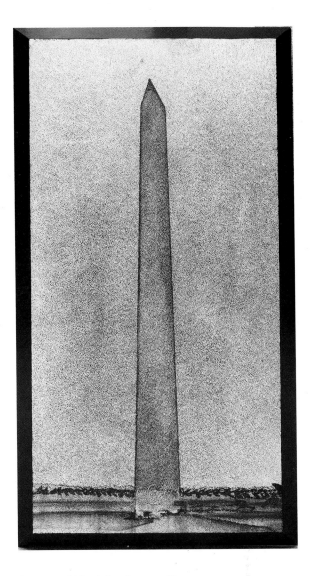

★FIG. 36. Richard Artschwager, *The Washington Monument*, 1964. Charcoal and liquitex on celotex, 47″ × 26″. Collection of Norman Dolph.

NOTES

1. Rivers later described his painting with reference to Duchamp's *Fountain*, a readymade urinal: "In relation to the immediate situation in New York, the *George Washington Crossing the Delaware* was another toilet seat—not for the general public as it was in the Dada show, but for the painters." Larry Rivers, "Discussion of the Work of Larry Rivers," *Artnews* 60 (March 1961): 54. In an interview with James Thrall Soby (*Saturday Review* 38 [September 3, 1955]: 24), Rivers also stated that reading Tolstoy's *War and Peace* directly stimulated his desire to create an American history painting. Archival records at the Museum of Modern Art, New York, indicate his comparison with Delacroix's painting as well.

2. Interview with Rivers in Frank O'Hara, *Art Chronicles 1954–1966* (New York: Braziller, 1975), 112.

3. Ibid.

4. *Time* 60 (December 22, 1952): 45; Albert W. Atwood, "Today on the Delaware, Pennsylvania's Glorious Revolution," *National Geographic* 102 (July 1952): 15. For a complete history of the anniversary celebrations and media coverage, see Ann Hawkes Hutton, *Portrait of Patriotism: "Washington Crossing the Delaware"* (Philadelphia: Chilton, 1959), 161–77.

5. For a fascinating discussion of Wood's *Daughters of Revolution*, see Wanda M. Corn, *Grant Wood: The Regionalist Vision* (New Haven and London: Yale University Press, 1983), 98–101.

6. Rivers, "Discussion," 54.

7. Larry Rivers with Carol Brightman, *Larry Rivers: Drawings and Digressions* (New York: Crown, 1979), 59.

8. *Time* 62 (July 6, 1953): 11–17.

9. Rivers's painting was exhibited at the Tibor de Nagy Gallery, New York, December 8, 1953–January 9, 1954, and acquired by the Museum of Modern Art in 1955. Lichtenstein's "history" paintings were exhibited at the John Heller Gallery in New York in 1951, 1953, 1954, and reviewed in *Artnews* 51 (January 1952): 67; 52 (February 1953): 74; 53 (March 1954): 18, 63; and *Art Digest* 29 (February 15, 1954): 22. In the March 1954 *Artnews* review, Lichtenstein's compositions were described in terms applicable to Rivers's painting: "a version of an American historical painting as reproduced in a grammar school textbook" and "the sophisticated manner . . . applied to the corny."

10. Johns, quoted in Walter Hopps, "An Interview with Jasper Johns," *Artforum* 3 (March 1965): 33.

11. For a probing analysis of the McCarthy era with reference to Johns and other artists see Moira Roth, "The Aesthetic of Indifference," *Artforum* 16 (November 1977): 46–53.

12. See Paul A. Carter, *Another Part of the Fifties* (New York: Columbia University Press, 1983), 114–16.

13. William H. Whyte, Jr., *The Organization Man* (New York: Simon & Schuster, 1956), 7, 11.

14. Ibid., 404.

15. Hedrick discussed this image with the author in an interview, July 6, 1984. The *Peace* flag was included in an exhibition at the New Mission Gallery in San Francisco, 1962, and then published by John Coplans in "Wally Hedrick: Offense Intended," *Artforum* 1 (May 1963): 29; and again by Lucy R. Lippard in *Pop Art* (New York: Praeger, 1966), 21. The present whereabouts of this and other Hedrick flag paintings is unknown.

16. See Barbara Rose, *Claes Oldenburg* (New York: Museum of Modern Art, and Greenwich, Conn.: New York Graphic Society, 1970), 62. Oldenburg also used the flag as a thematic image in several happenings such as *Stars* (performed at the Washington Gallery of Modern Art, Washington, D.C., April 24–25, 1963) and *Washes* (performed at Al Roon's Health Club, New York, May 22–23, 1965; filmed under the title *Birth of the Flag*, June 4–7, 1965).

17. Oldenburg, quoted in Rose, *Oldenburg*, 53.

18. Ibid., 62.

19. Conversation with the author, February 1986.

20. *Flag* is one of a group of assemblages that Herms made out of a Packard that he owned. When the car died, he used it—and anything in it—to create a series, which was the subject of an exhibition.

21. See *Time* cover story, "*Playboy*'s Hugh Hefner," 89 (March 3, 1967): 76–78.

22. According to the artist's dealer, Leo Castelli, Lichtenstein retrieved this frame, which had been left in the gallery after its removal from a Dubuffet painting, and created the George Washington portrait especially for it.

23. John Wilmerding, *American Art* (New York: Penguin Books, 1976), 50.

24. Letter to the author from Leo Castelli, November 28, 1984.

25. This description is offered by David Halberstam in his excellent analysis of the media's role in the 1950s and 1960s, *The Powers That Be* (New York: Dell, 1980), 494.

26. See Carter, *Another Part of the Fifties*, 36–37.

27. For a good discussion of these nineteenth-century paintings, see Robert F. Chirico, "Language and Imagery in Late Nineteenth Century *Trompe l'oeil*," *Arts* 59 (March 1985): 110–14.

In the nineteenth century, artists set forth a romantic, transcendentalist view of the American landscape. The country was depicted as a natural paradise with a rich virginal terrain, suggestively full of promise and untouched by human hands. Paintings propagated the myth of America as an idyllic wonderland. By the end of the century, artists like the Ashcan group had turned to the urban milieu, conveying impressions of its vitality as well as its ugliness. While capturing the vigorous life of the American city, they also revealed the drab, grim character of the changing American environment. In Social Realist art of the 1930s, the bleakness of life in the increasingly industrial, increasingly urban society was even more pronounced. Big-city crime, corruption, and squalor became central themes of compositions meant as critical commentaries. A counterposition was taken by the Precisionists, who saw classic beauty in the new American landscape. The majesty that was once to be seen only in nature was now visible in manmade structures: skyscrapers, bridges, train engines, water tanks, silos, and grain elevators. From a very different perspective, a positive impression of the American landscape was also advanced by the Regionalist painters. They repudiated modernity, especially its effects within the cities, and instead concentrated on the pure, simple virtues of rural life. Their farmland scenes were intended to exemplify the true, untainted American spirit and veritable American landscape.

In contrast to these predecessors, the Abstract Expressionist painters did not care to depict either rural or urban landscapes. To be sure, artists such as Jackson Pollock, Barnett Newman, Mark Rothko, and Franz Kline derived inspiration from the vast expanses of space in the American west, the awesomeness of the sublime in the American wilderness, and the turbulence of the American city. But this cohort of artists retreated from the particularities of the American landscape and the banalities of the everyday. Espousing an abstract, metaphoric, universal language, they dismissed matters of temporal and spatial specificity.

Rejecting this approach, the next generation returned to the subject of an expressly American environment. Their art calls attention to characteristic aspects of the mid-century American prospect: the congestion and exhilaration of the urban milieu, the comfort and conformity of suburbia, and the fascination and monotony of the highway. Emphasizing the manmade and machine-made, these artists openly exposed the most banal and alienating aspects of the contemporary setting, its many complexities and contradictions.

Cities, Suburbs, and Highways—The New American Landscape

FIG. 37. Claes Oldenburg, *The Street*, 1960. Installation, Judson Gallery, Judson Memorial Church, New York.

While urban growth had been steady throughout the twentieth century, during the postwar period grandiose metropolises emerged. Municipalities spread outward, and outlying areas were brought closer to the cities by ambitious road networks. Over two-thirds of the population lived in urbanized hubs that came to surpass in size, grandeur, and power all previous notions of mass communities. No longer was the untamed wilderness or the small village the source of American pride. Now the city-suburb-highway complex epitomized the glory and greatness of the nation's landscape and lifestyle. The manufactured landscape, seat of progress and commerce, had attained supremacy.[1]

By 1949 the federal government realized that the explosive and largely unplanned growth of metropolitan centers had created a host of land-use problems and a national housing shortage. To fund the redevelopment of badly deteriorated inner cities, Congress passed the first urban renewal act. During the early 1950s "renewal" began with the outright demolition of old, decaying neighborhoods. When this bulldozer approach proved untenable, new legislation, enacted in 1954, promoted the rehabilitation of inner cities. But the glut of urban slums and the shortage of affordable housing were never adequately redressed.

During the late fifties and early sixties, urban renewal efforts were focused on the rehabilitation of downtown city centers. The goal was to make American cities more attractive and more exciting, in hopes of stemming the massive exodus of the middle class to the suburbs. Virtually every major American city experienced a spate of new construction: office buildings and apartment buildings, hotels and plazas, culture centers and shopping centers. As *Time* magazine noted in 1962 in one of two cover stories on the "renaissance" of the American city, the nation was in the midst of "the biggest building boom in metropolitan history."[2] Without question, the boom revivified many cities but also exacerbated urban congestion, pollution, traffic, and crime. The creation in 1965 of a cabinet-level department to deal with housing and urban development was perhaps a step in the right direction, but only a step.

In many of the Happenings performed by Allan Kaprow, Claes Oldenburg, Lucas Samaras, and Robert Whitman during the late fifties, the urban environment's everyday chaos was a prime subject. These performances often focused on the marginality of life in the slums and the malaise of tenement-dwellers who were not reaping the benefits of American prosperity. In *The Street* (1960) [Fig. 37], Oldenburg developed the subject of the decaying slum into an environmental installation.[3] Composed of crude, charred, and ragged elements— some taking shape as buildings, objects, and people, others appearing more like miscellaneous debris, and all strewn about in an utterly unstructured, unkempt jumble—the work captures the brutal harshness of urban squalor. Oldenburg commented, "If you're a sensitive person, and you live in the city, and you want to face the city and not escape from it, you just have to come to grips with the landscape of the city, with the dirt of the city, and the accidental possibilities of the city."[4] Refuting the practice of the Abstract Expressionist generation, Oldenburg did not translate his experience of New York's Lower East Side into universal terms or a formalist vocabulary. Rather, he directly conveyed the actualities of his experience.

In *Upside Down City* (1962) [Fig. 38], Oldenburg moves away from the raw, death-ridden ambience of *The Street* and the environment of the slums, but he retains the image of the city as a landscape of physical and psychological disorder. Here, he chooses to focus on the skyscraper, an architectural form born and nurtured in America. From the late-nineteenth-century engineering of tall, sleek buildings in Chicago, to the 1930s construction of skyscraper conglomerates like Rockefeller Center, to

*FIG. 38. Claes Oldenburg, *Upside
Down City*, 1962. Dyed muslin, spray
paint, and newspaper stuffing,
118″ × 60″ × 60″. Walker Art Center,
Minneapolis. Art Center Acquisition
Fund.

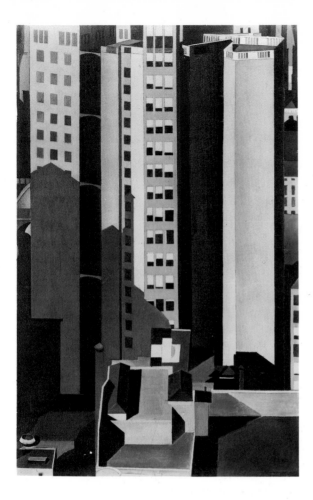

the postwar fascination with monolithic glass towers, the skyscraper had established itself as a defining feature of the urban American landscape. These tallest of downtown monuments signified American technological and economic prowess, cosmopolitan splendor and prosperity. Literally and figuratively, they were the pinnacle of the manufactured landscape.

In paintings from the twenties and thirties by artists like Charles Sheeler [Fig. 39] and Georgia O'Keeffe, the image of the skyscraper appeared as an emblem of harmony and order, the pride of American modernism, and the hope of a new age. In contrast, Oldenburg's *Upside Down City*, while still showing the skyscraper's dominance over the

urban environment, denotes the skyscraper community as a topsy-turvy world where nothing is as it should be. Irrationality, not harmony and order, prevail. The limp buildings have soft, organic forms and hang downward, suspended from clothespins and hangers like wash on a line. Yet their anthropomorphic (phallomorphic) shapes would seem to possess the potential for reanimation. Suggesting both chaos and vitality, collapse and expectation, these buildings exemplify the city's dormant life force and procreative energy. Indeed, this sculpture was made for a performance piece whose general theme was the American consciousness, its specific theme rebirth and renewal.[5]

A far more sober mood prevails in Richard Artschwager's *High Rise Apartment* (1964) [Fig. 40]. His is an imposing structure typical of the newly erected grand-scale apartments advertised in the Sunday newspapers; in fact, a real estate ad was the actual source of his image. Described in grandiloquent terms, such buildings were the pride of urban American life. They were also the residential archetype of modernist design, the regularizing patterns and unadorned structures conveying the impression of order, clarity, and efficiency. Although the soaring verticality of the modernist skyscraper was replaced by a broadened bulk and stolid massiveness, these edifices possess the proud mark of a bare-bones, functionalist aesthetic premised on a no-nonsense geometric rigor.

Artschwager's cool, precise rendering of the isolated image befits both modernist concepts of design and realtors' publicity strategies, but the mode of display endows the image with a disturbing austerity. The building appears an island unto itself, bereft of any association with surrounding buildings, neighborhood people, or the natural environment. Its large, inhuman scale overwhelms all individual concerns, and the repetition of standardized design elements connotes homogeneity and uniformity. Based on the harmonious conformity of interchangeable and indistinguishable units, the building's plan is an architectural analogue of the social system of the "lonely crowd." The grayness of Artschwager's composition further dehumanizes these living quarters, imbuing the building with an oppressive, ghostly aura. The gray newsprint tonality may be read as referring to both the mechanistic, mass production character of everyday visual material in postwar American culture and the dirty, bleak, smoggy atmosphere of the urban environment. Artschwager's painting thus offers a range of conflicting impressions, intentionally irritating and fundamentally bound to an expression of uncertainty and uneasiness.

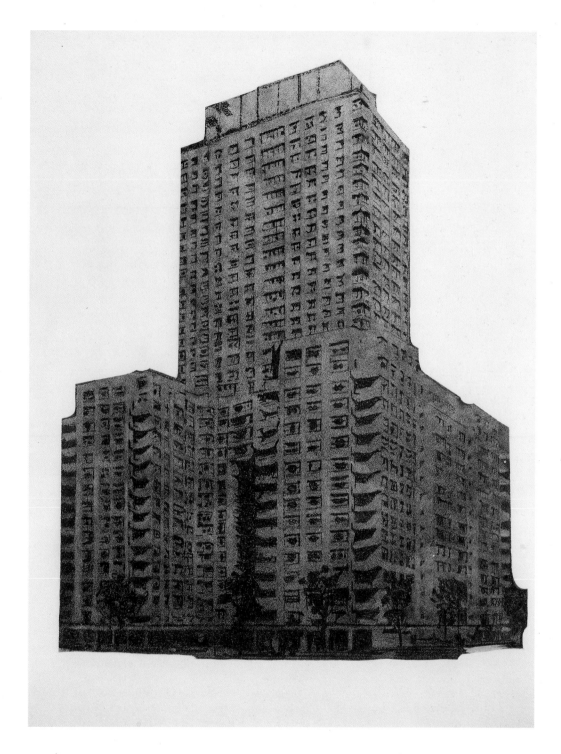

FIG. 40. Richard Artschwager,
High Rise Apartment, 1964. Liquitex
on celotex with formica, 63″ × 48″ ×
4½″. Smith College Museum of Art,
Northampton, Massachusetts. Gift of
Philip Johnson.

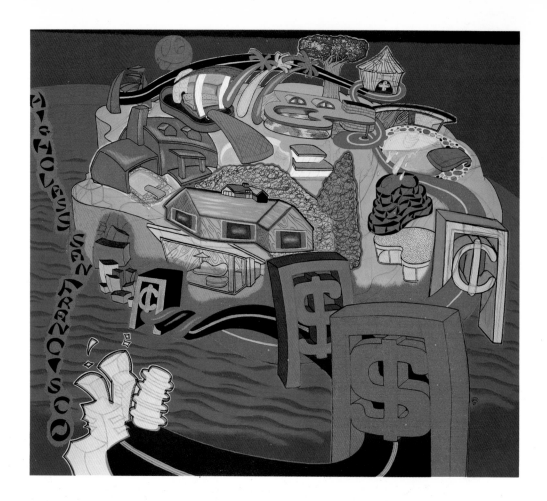

★FIG. 41. Peter Saul, *High Class San Francisco*, 1967. Oil on canvas, 64″ × 72″. Courtesy of Allan Frumkin Gallery, New York.

Quite at the other end of the spectrum in terms of urban architecture and spirit are the affluent enclaves of mythic California: sprawling mansions of personalized design with swimming pools, gazebos, and exotic foliage. In *High Class San Francisco* (1967) [Fig. 41], Peter Saul satirizes this aspect of the American dream. His oversized houses are garishly colored, and many have outlandishly anthropomorphic and eroticized features. But the eroticization, rather than suggesting renewal as in Oldenburg's city, implies the absurdity of West Coast excess. The substitution of dollar-and-cent signs for the city's bridge towers and highway trusses humorously confirms the stereotype of San Francisco as a commonwealth of prosperous extravagance.

In marked contrast, the compositions of Romare Bearden show the urban ghetto, where neither prosperity, frivolity, nor architectural order exist. Creating collages from magazine cutouts, Bearden emphasizes the disarray, overcrowding, and blight within the black ghettos. Yet, the scale discrepancies, spatial dislocations, image intersections, and jagged rhythms suggest that these neighborhoods pulse with a powerful energy. Sometimes this takes the form of frenzied activity, as in *Childhood*

*FIG. 42. Romare Bearden, *Childhood Memories*, 1965. Collage on board, 15¼″ × 11½″. Collection of Richard V. Clarke.

*FIG. 43 (*below, left*). Romare Bearden, *Backyard*, 1967. Collage of paper and synthetic polymer paint on composition board, 40″ × 30″. Collection of Marian B. Javits.

*FIG. 44 (*below*). Romare Bearden, *Black Manhattan*, 1969. Collage of paper and synthetic polymer paint on composition board, 25⅜″ × 21″. The Schomburg Center for Research in Black Culture, New York Public Library.

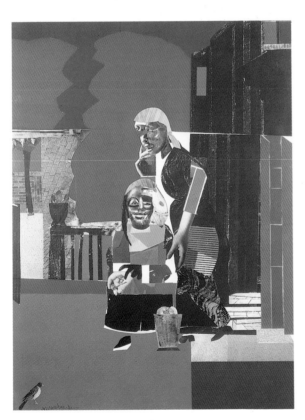

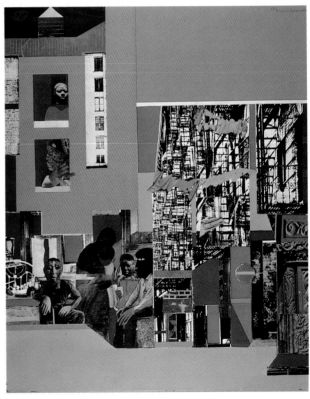

CITIES, SUBURBS, AND HIGHWAYS 51

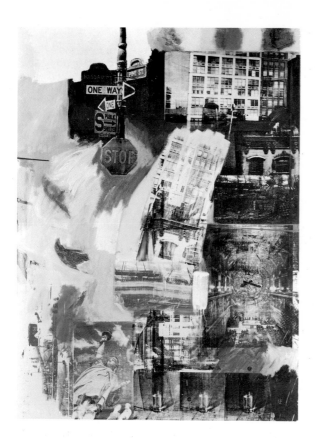

FIG. 45. Robert Rauschenberg, *Estate*, 1963. Oil and silkscreen on canvas, 95¾″ × 69¾″. Philadelphia Museum of Art. Gift of the Friends of the Philadelphia Museum of Art.

Memories (1965) [Fig. 42]; other times it translates into unremitting, invincible strength—sustenance in the face of adversity, as in *Backyard* (1967) [Fig. 43] and *Black Manhattan* (1969) [Fig. 44]. Residents survive, and even thrive, within the ghetto, despite their need and anguish, by indulging in the dynamics of the bustling street, by banding together, or by seeking shelter in the prisonlike tenements.

Bearden's collages underscore the distance between America's black ghettos and mainstream America, the America of advantage and affluence. This "other America," the America of poverty and discrimination, thrust its way into the national consciousness in the 1960s.[6] The civil rights movement and inner-city rioting in Los Angeles, Newark, Detroit, Cleveland, Boston, New York, and some fifty other cities called attention to social inequities and broad patterns of racism. For black artists, it was a time of soul-searching and reflec-

tion. Groups like Spiral, which Bearden helped found in 1963, provided a forum for discussions on the role and nature of black art.[7] A black consciousness emerged that encouraged the creation of art expressly referring to black experience and black concerns. Bearden's pioneering collages exemplify the initial phase of this consciousness in their celebration of black life and exposure of slum realities.

Whether focusing on the ghetto or the urban downtown, many artists sought to convey the frenzied, tensioned urban atmosphere. Of particular note is the series of silkscreen paintings Robert Rauschenberg made in 1963–64 [Fig. 45]. These compositions reflect the hyperdynamic rush of disorienting sensations that overload the atomized American city. There is a surfeit of visual and emotional stimuli, an overabundance of activity and information—a myriad of confusion. The forceful energy and excitement of Rauschenberg's urban America also houses disturbing indications of social unrest. In *Choke* (1964) [Fig. 46], for example, images of city buildings collide with a jumble of other, largely indecipherable, images and exuberant but effacing brushstrokes. The disorder recalls the bulldozing of dilapidated areas and the subsequent boom in new construction, which gave many American cities carrying out urban renewal projects the "bombed-out look" that *Time* termed a status symbol.[8] But the degree of chaos and the presence of a U.S. Army helicopter call to mind the role of armed troops in dispersing civil rights demonstrations and quelling ghetto riots. Urban disorder, thus, may be a sign of civic refurbishment or social upheaval; typically, Rauschenberg makes no attempt to cohere such opposing interpretations. His art alludes to a multiplicity of discordant perceptions, ideas, images, sensations, events, and experiences. It captures the ongoing social change and turmoil but defeats rational dialectics and polemics.

The chaos is compounded by a cacophony of wayward street signs. One-way arrows are positioned upsidedown or sideways, pointing in opposite directions, offering contradictory messages about paths of movement. The commotion of arrows announces that there is no regulating system in this urban anarchy, no prescribed path, no *one* way. And although the Public Shelter sign offers hope of asylum, its upside-down position and reminder of nuclear disaster only reinforce the pervasive disorder.

Choke conveys the congestion that was threatening to suffocate cities, and as the barrage of signs suggests, traffic control was a major problem.

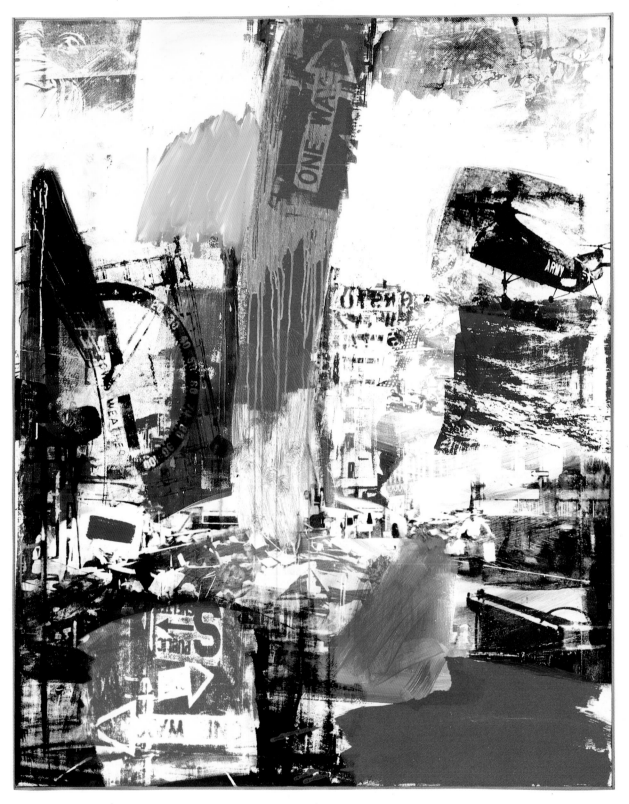

★FIG. 46. Robert Rauschenberg, *Choke*, 1964. Oil and silkscreen on canvas, 60″ × 48″. Washington University Gallery of Art, St. Louis. Gift of Mr. and Mrs. Richard K. Weil.

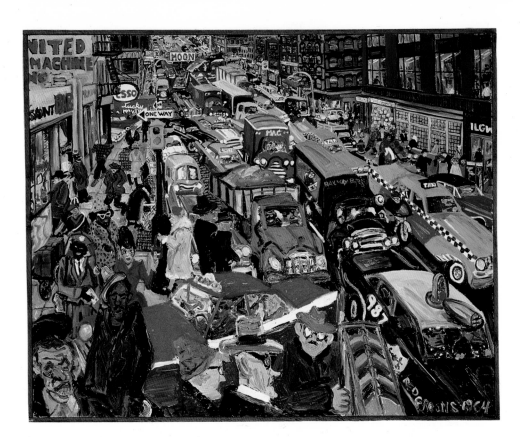

*FIG. 47. Red Grooms, *One Way*, 1964. Oil on canvas, 96″ × 96″. Collection of Walter and Anne Nathan.

Faced with too many vehicles and outmoded road networks, cities turned to a new breed of urban technocrats, the traffic engineers. These transportation wizards transformed the cities, typically by changing main avenues of commerce into one-way thoroughfares and by clotting roadways with a surfeit of directional markers.[9] As Rauschenberg's imagery suggests, the reroutings and new signs, like urban renewal, promised improvement but also increased urban chaos. The title *Choke* also reads as a punning reference to the mechanism that reduces a carburetor's air intake to provide a rush of pure fuel for extra power. By analogy, the engine that drives the city may secure new energy—or may explode into flames—as its air supply is constricted.

In *One Way* (1964) [Fig. 47], Red Grooms also directs attention to the teeming vitality of city experience. Inspired by the congestion of Seventh Avenue in New York City, Grooms shows the chaos and crowdedness of a busy street in which cars, trucks, buses, taxis, pedestrians, and garment workers wheeling racks of merchandise are jammed together, barely able to move. The portrayal exemplifies the nightmare of downtown traffic. And yet, the bright, festive coloration and jaunty mode of depiction delineate a lively world

where things are happening and people busily participate in a thriving economy. Though the woman picking through a trash basket denotes the have-not side of the American dream, the overall impression is celebratory. By making the humdrum seem theatrical, Grooms takes an affirmative approach, revealing both positive and negative aspects of everyday urban American life.

Like Rauschenberg, Grooms shows an urban environment—its buildings, roadways, and vehicles—notably marked by signs. Whether informational or promotional, signs are characteristic, conspicuous—and conspicuously American—aspect of the national landscape. New York's Times Square is the ultimate sign extravaganza, world renowned for its bedazzling marquees, spectacular neon, and animated billboards. As Richard Estes indicates, in paintings like *Welcome to 42nd Street (Victory Theater)* (1968) [Fig. 48] and *Gordon's Gin* (1968) [Fig. 49], signs dominate the setting, virtually reshaping the buildings and declaring the prominence of commercialism. Movie theaters have garish facades adorned with pennants, placards, and flashing lights; the storefront advertisements and billboards are oversized, excessive displays.

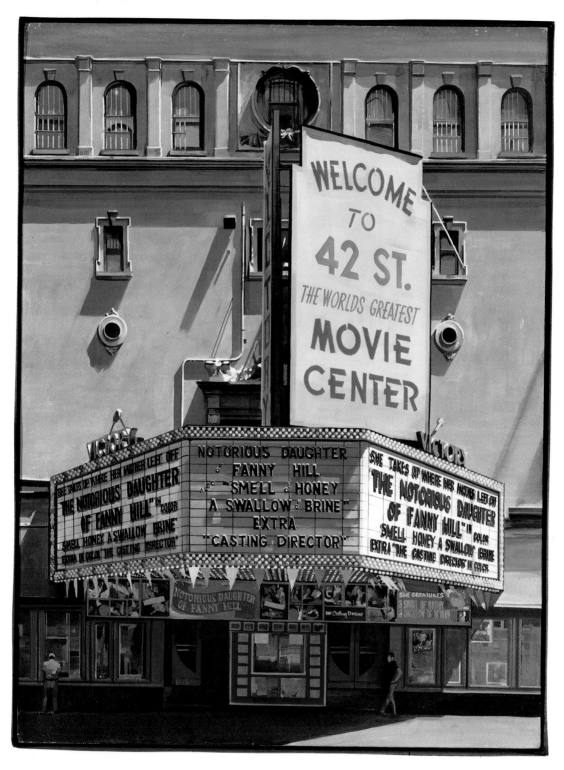

★FIG. 48. Richard Estes, *Welcome to 42nd Street (Victory Theater)*, 1968. Oil on masonite, 32″ × 24″. The Detroit Institute of Arts. Gift of the Friends of Modern Art in honor of the Detroit Institute of Arts Centennial.

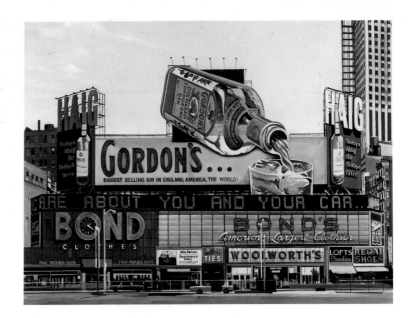

FIG. 49. Richard Estes, *Gordon's Gin*, 1968. Oil on masonite, 25″ × 32½″. Private collection.

Estes's Times Square paintings also show the degraded state of one of America's proud landmarks, the tainted actuality of the American dreamscape. After World War II, in New York and many other cities, once-glorious theaters and first-rate movie houses became sex palaces, and the fantastic wonderlands deteriorated into strips of flophouses, cheap bars, and geegaw marts. By the late sixties, many of Times Square's most famous signs—the Pepsi-Cola waterfall, Wrigley's fish, Camel's smoking cigarette, and Maxwell House's dripping coffee cup—had been replaced by equally bombastic but far less inventive advertisements for gin and whiskey. The displays were still spectacular, but the wholesome American character was gone.

Using a depersonalized photographic style, Estes describes the changed landmark in vivid detail but forestalls a judgmental attitude. His pristine, glistening surfaces and omission of the dense crowds and traffic, which are as much a part of Times Square as the signs, produce a dispassionate impression even as they endow the imagery with a visual beauty and uncustomary stillness. The paintings have the semblance of reportorial truth but are unsettlingly removed from reality.

Comparable to New York's Times Square in epitomizing American signs is the towering Hollywood landmark in Los Angeles. High on a hilltop overlooking the movie capital, the block letters stretch across the landscape with all the flamboyance of an Oscar-winning production and all the advertising power of a premier Madison Avenue venture. In *Hollywood Study* (1966) [Fig. 50], Ed-

ward Ruscha shows the sign as an image that has totally displaced the city, a majestic monument fading into a movie-perfect sunset.[10] The depiction affirms the visual and ideational power of signs and their prominent place within the American landscape.

As more Americans took to the road, and there were more roads to take to, outdoor advertising proliferated. Most notable was the increasing number of gargantuan billboards. The word *billboard* was coined in America in the 1850s, and billboards became a big business operation in the 1920s and 1930s.[11] Designed to be perceived in a flash, their simple messages and eye-catching imagery are a form of advertising expressly related to the fast pace of American highways and urban life.

For the artist James Rosenquist, the billboard served as a prime source of inspiration. His paintings embrace the overblown, artificial style of billboard advertisements and the fragmentary, disjunctive dynamics of rapid-glance perception. His images are big, bold, extravagant; colors are acidic and synthetic or photographically grayed; juxtapositions are abrupt and absurd to an extreme; the scale is monumental; and there is no context or explanatory matter to facilitate analysis or synthesis.

Using the all-American clichés from advertising as his image vocabulary, Rosenquist stamps his paintings with the mark of America's consumer culture. The Hollywood smile, lipstick imprint, juicy orange, and shiny chrome headlight in *Morning Sun* (1963) [Fig. 51] or the car door, globe, and Franco-American spaghetti in *Louis D. Brandeis on*

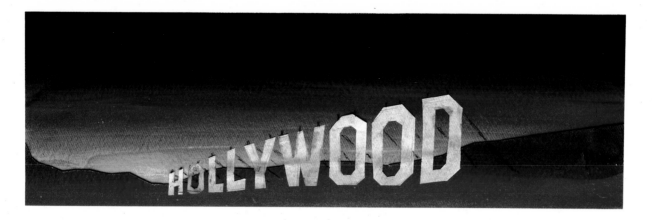

*FIG. 50. Edward Ruscha,
Hollywood Study, 1966. Tempera and
collage on paper, 6⅞″ × 21¾″.
Collection of the artist.

FIG. 51. James Rosenquist, *Morning
Sun*, 1963. Oil on canvas with vinyl
appendage, 78″ × 66″. Collection of
Mary Lou Rosenquist.

*FIG. 52. James Rosenquist, *Louis D. Brandeis on Democracy (Untitled)*, 1965. Oil on canvas, 48⅛″ × 44¼″. National Museum of American Art, Smithsonian Institution, Washington, D.C. Gift of Container Corporation of America.

Democracy (Untitled) (1965) [Fig. 52] all have the polished veneer and intensity of promotional aesthetics. Each assemblage of images conveys an impression of abundance and prosperity. And yet, discord prevails in the irrational mixture of food, car, and human imagery, natural and mechanical figurations, cool and sensuous depictions. More important than the individual images (or their interpretation) is the overall effect of pictorial inundation and the punch of simultaneous exhilaration and disorientation. Rosenquist's compositions—not unlike those of Oldenburg, Rauschenberg, Bearden, and others—point up the disjunctive dynamics that, as much as changes in the appearance of particular buildings or signs, were a characteristic feature of the contemporary urban environment in America.

While cities became sprawling hubs of frenzied activity, America's spick-and-span suburbs offered an alternative. By 1960 one-third of the nation, roughly 60 million people, lived in suburban communities. The exodus to suburbia had begun after World War II, when returning veterans, faced with the urban housing shortage and encouraged by government-backed mortgages and new commuter highways, fled the dirty, vice-ridden cities or the rural backwaters. Suburbs were the latest American frontier, the promised land where the middle class could realize the American dream—buying a new single-family house and a capacious new car and leading a well-rounded family life in a relaxed, wholesome nonurban environment.

The evolution of the suburbs rapidly re-formed the visual and physical character of the American landscape and radically revised Middle America's lifestyle. The changes were well documented and scrutinized, virtually at the same time as they were taking place. Commentaries in the popular press, including cover stories in *Newsweek* (April 1, 1957) and *Time* (June 20, 1960), tended to celebrate the suburbs as a great American achievement. Conversely, studies like John Keats's *The Crack in the Picture Window* (1956) denounced everything suburban as uniformly dreary, and William Whyte's *The Organization Man* (1956) named suburban life

as one of the systems that was fostering social conformity and a loss of individuality. A wealth of fictional accounts took up suburban life—some critical and some flattering, some satirical and many comic. Among the novels were *The Man in the Gray Flannel Suit* (1955) by Sloan Wilson, *Rally Round the Flag, Boys* (1957) by Max Shulman, and *The Wapshot Chronicle* (1957) by John Cheever. The numerous films about suburban life included *Rebel Without a Cause* (1955), *The Tunnel of Love* (1958), and *Please Don't Eat the Daisies* (1960), while television offered a rash of family sit-coms, such as "Father Knows Best," "Ozzie and Harriet," "Leave It to Beaver," and "The Donna Reed Show."

The archetype of suburbia is a complement of mass production houses of standardized style—the "ranch" or variant Cape Cod, stucco bungalow, or split-level—tidily arranged on uniformly sized lots within a regularized street grid. This classic model was formulated by William J. Levitt in his "development cities" in Long Island, New York (1947), Bucks County, Pennsylvania (1951), and Trenton, New Jersey (1965). In the early fifties, the Levitt

Company built a new home every fifteen minutes and sold each for $7,090.00—a price well within the reach of the average American.[12] Barely had the first Levittown been completed when Levitt-type communities sprang up in Lexington, Massachusetts, and Richmond, California, in Portland, Oregon, and in Philadelphia, Los Angeles, Detroit, San Francisco, Dallas, Denver, Chicago, and Seattle. As never before, a new kind of national unity and uniformity was evolving, with houses and communities in all regions of the United States having essentially the same character and appearance.

The suburban phenomenon is well represented in paintings of the postwar period that depict the stereotypic Levitt-type house. In a series created by Joe Goode in 1963–64, penciled images of common suburban houses appear as barely visible tracings on small pieces of paper set upon disproportionately large painted fields of monochrome color [Fig. 53 and 54]. The renderings, derived from real estate listings, show vague impressions of single-family dwellings that are physically and emotion-

★FIG. 54. Joe Goode, *The Most of It*, 1963. Oil on masonite, 23¾" × 23¾". Private collection, courtesy of Charles Cowles Gallery, New York.

ally detached from their neighborhoods. Placed on empty canvases, these residential islands of isolation epitomize the paradox of suburban life: each household boasts the privacy of its own yard and lot, but these sequestered protectorates are circumscribed by vacuity and loneliness. By depicting each house as a small, insignificant, and ephemeral entity, Goode also raises questions about the strong value Middle America places on the house as a status symbol.

In Richard Artschwager's *Tract Home* paintings [Fig. 55], a series begun in 1964, the cliché subdivi-sion house typifies mass production uniformity and anonymity. These gray "little boxes" are the domestic analogues of organizational belongingness and self-effacing conformity, showing none of the American spirit of individualism that is so pronounced in paintings of houses by earlier artists like Edward Hopper or Andrew Wyeth. Even as the bold framing sets off these houses as esteemed, desired objects, it emphasizes their packaged, mass-manufactured character.

Like Goode, Artschwager based his images on real estate advertisements. In mimicking a low-

quality newspaper illustration, copying a poor copy, he recapitulates the prominence of imitations, duplicates, and facsimiles in contemporary American life, with its dependence on assembly-line and printing press productions. Ironically, however, his is a precisely crafted handmade creation with the look of a machine-perfect reproduction.

The real estate reference also alludes to the unprecedented activity in the housing market. Realty sections of newspapers became routine reading for many Americans. In the late 1950s one of every five Americans moved in a given year, making the nation a society of transients.[13] Although a portion of these relocations were job-related, for many families the move to a bigger house in a better neighborhood was an important symbol of status. Millions who purchased Levitt-type houses jumped at the chance to move whenever their income leapfrogged. A framed ashen picture of a tract home thus becomes an ironic memento of the typical first house purchased, the first rung on the socioeconomic ladder of success.

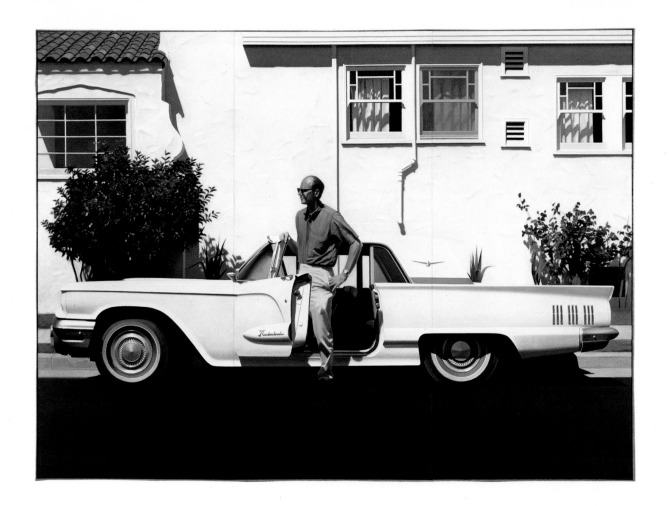

*FIG. 56. Robert Bechtle, *'6o T-Bird*, 1967–68. Oil on canvas, 72″×98¾″. University Art Museum, University of California, Berkeley.

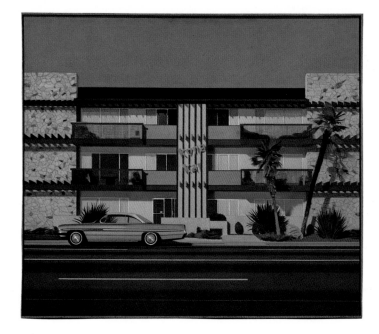

*FIG. 57. Robert Bechtle, *Kona Kai*, 1967. Oil on canvas, 45″×52″. Carolina Art Association, Gibbes Art Gallery, Charleston, South Carolina.

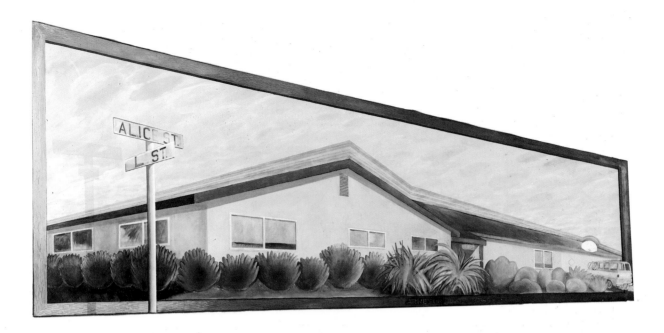

FIG. 58. Robert Arneson, *1303 Alice Street, Viewed (as if it were a Billboard) From the Corner of L and Alice*, 1968. Magna on canvas, 108"–48" × 216". Collection of the artist.

In Robert Bechtle's *'60 T-Bird* (1967–68) [Fig. 56] a stucco bungalow, a mass production type common in suburban California, is mated with the suburbanites' second-most-prized possession: a classic American car, long and sleek, sporting polished chrome and prominent tail fins. The photographic mode of presentation suggests a snapshot taken for the family album to commemorate the accomplishments embodied in the ownership and display of these two prerequisites to a comfortable lifestyle far removed from the hyperenergized, tumultuous city. But the detailed precision, flatness, and neutralizing half-toned shadows confer a bland regularity and airless sterility on the suburban order.

The compounding of homogeneity and uniformity is even more conspicuous in Bechtle's *Kona Kai* (1967) [Fig. 57], a depiction of the box-style, mass production design of the generic low-rise apartment building. Each housing unit exactly duplicates every other unit, and not a single personalizing feature challenges the imposed architectural and residential standard of conformity. Everything is picture-perfect, as if this were not housing meant to be lived in but an image meant to be looked at, a display object whose value lay in its outward appearance. Americans had grown accustomed to seeing such carefully arranged, surface-oriented depictions in mass media photography and had also adopted these standards for their own environments. Bechtle's photographic style exaggerates the pictorial, extroverted character of suburban living and emphasizes the suburbanites' pride in projecting this impression.

In a good-humored way, Robert Arneson parodies the notion of house as image in *1303 Alice Street Viewed (as if it were a Billboard) From the Corner of L and Alice* (1968) [Fig. 58]. Representing a classic subdivision ranch model as an endless expanse—a landscape unto itself—with rainbow roof and blazing sun/basketball hoop, Arneson perfects the house into the natural paradise of the pristine American wilderness. Here is the ultimate aggrandizement and glorification of the suburban dream house, complete with a station wagon in the driveway. Here, too, is clear evidence of the postwar artists' focus on American culture, American values, American subject matter, and an American approach to pictorial representation.

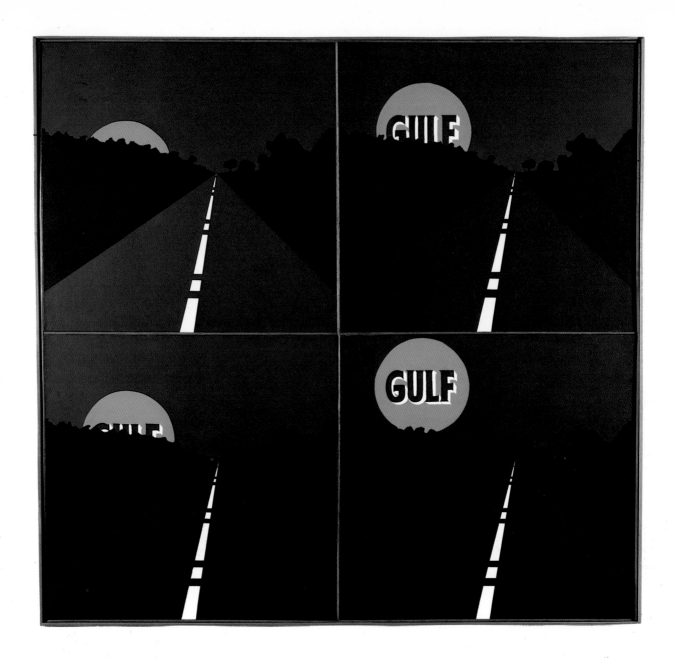

In the postwar period, the highway joined metropolitan centers and suburban enclaves as a prime element of the new manmade American landscape. In 1956 Congress authorized the most ambitious road construction project ever: a nationwide interstate highway system. Over 40,000 miles of high-speed, limited-access roadways were scheduled for priority construction. The project appealed to the nation's pride in its up-to-the-minute technological skills and its centuries-old pioneering instincts. The new road network also bore the stamp of the Cold War, for it was financed by the defense bud-

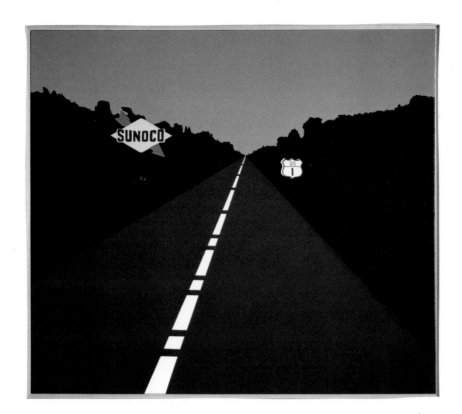

★FIG. 60. Allan D'Arcangelo, *U.S. Highway 1* [panel 2], 1963. Acrylic on canvas, 70″ × 81″. Collection of the artist.

get and designed to provide efficient transportation routes in the event of attack. In a cover story on the proposed interstate system, *Time* boasted that road building was "really *the* American art," and that the highway was a "true index of our culture."[14] The new highway system signaled an America on the move and in the lead.

Whereas the old highways were tree-lined winding paths that curved by houses as they entered towns and cities, the new highways were straight stretches of white-lined asphalt that cut across barren landscape. The freeways all looked the same, and the roadside scenery was uniform from coast to coast: standardized road signs, national-brand gasoline stations, commercial billboards, chain restaurants and motels. These pathways of regularity would bring about new linkages between urban, suburban, and farm regions, new connections that contributed to the effacement of regional differences in postwar America.

In his highway paintings, Allan D'Arcangelo vividly represents the American landscape as a no-place / every-place environment dominated by an invading roadway. These anonymous settings have no geographical referents, no marks of season or climate. A perfect geometric path of asphalt punc-

tuated by road markings and gasoline signs defines a landscape in which nature has given way to human intervention. Flat unmodulated color planes with sharp contours and little detail—a style inspired by the industrial techniques of commercial art—pronounce this to be a world shaped and transformed by man.

In *Full Moon* (1963) [Fig. 59], the conflation of a Gulf sign and the moon sums up the triumph of the synthetic over the natural. Here nature is overwhelmed by an immense advertising logo, which has become a source of light and a point of orientation. In navigating unfamiliar terrain, the modern motorist turns to commercial guideposts rather than the sun or moon; advertising is the lodestar for the new American explorer. And, as D'Arcangelo's waxing Gulf moon suggests, gasoline signs begin to function as destinations, not just markers along a road.

A haunting disequilibrium pervades these artificial and lifeless scenes. Signs, not people, populate the landscape, and the vegetation appears as a blackened, vapid mass. Unnatural and eerie, too, is the light, as in the combined night scene and daytime blue sky in *U.S. Highway 1* (1963) [Fig. 60]. But the disturbing imagery represents not so much

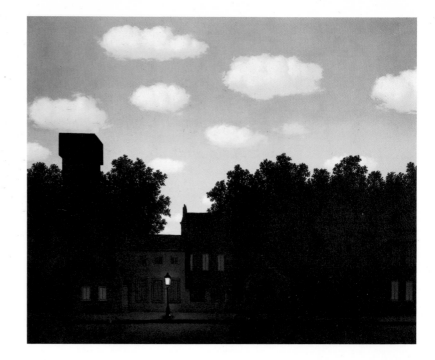

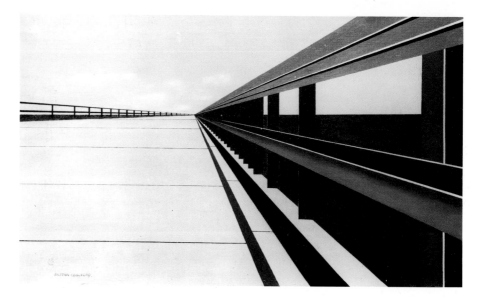

the fantastical—a world beyond the realm of reality—as the surreality within the reality of the everyday American environment. Particularly with the expansion of the highway system, the American landscape became increasingly dehumanized and denaturalized. Millions of commuters drove alone in their private cubicles, isolated from outside conditions and from other motorists. The commute procession was another example of the "lonely crowd," people surrounded by people with whom they had no meaningful contact.

The surrealistic mood and lighting in D'Arcangelo's paintings suggest a comparison with René Magritte's *The Empire of Light* series [Fig. 61]. Yet unlike European Surrealist works, the highway paintings are not concerned with the enigma of the imaginary in dreamscapes, but with the familiar, experienced actuality of the American landscape.

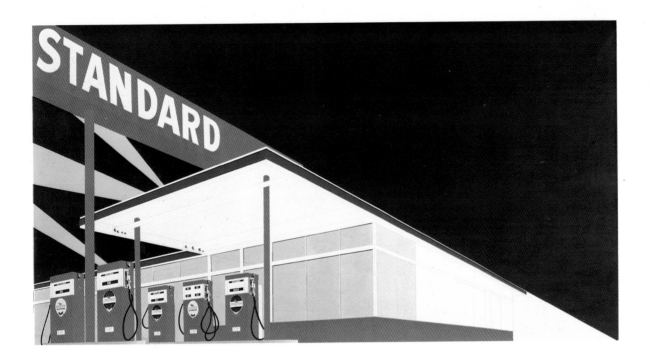

FIG. 63. Edward Ruscha, *Standard Station, Amarillo, Texas*, 1963. Oil on canvas, 65″ × 121⅝″. Hood Museum of Art, Dartmouth College, Hanover, New Hampshire. Gift of James J. Meeker in memory of Lee English, Class of 1958.

D'Arcangelo's preoccupation with the actuality of modern America invites an alternative comparison with Precisionist paintings, for example, Ralston Crawford's *Overseas Highway* (1939) [Fig. 62]. For Crawford the highway signified the beneficence of industry and the beauty of mechanized culture, the promise of a utopian future. In his turn D'Arcangelo adopts this aggrandized image, but his depictions express anxiety not adulation. His disquieting impressions of this prime emblem of America's achievement are intended to arouse concern about the quality of life in contemporary American culture.[15] D'Arcangelo shared neither the idealism of the Precisionist painters nor the proselytizing tone of Social Realist commentators nor the existential angst of the Abstract Expressionists. Merging the commercial arts' matter-of-fact mode and Surrealism's expressive disorientation, he hoped to provoke a reappraisal of the nation's trajectory.

As D'Arcangelo's paintings of the Gulf and Sunoco signs document, gasoline stations were integral parts of the highway ecosystem, oases that welcomed the wayfaring road vehicles with fuel, maps, snacks, and bathrooms. In *Standard Station, Amarillo, Texas* (1963) [Fig. 63], Edward Ruscha depicts the gas station as a monumentalized edifice, an apotheosized shrine. The motorists' castle appears as a beacon in the landscape, its form soaring forth in space; a majestic canopy suggests a royal progress; and the antiseptic whiteness emits a sanctified aura, a divine glow. In front, rows of gas pumps stand like palace sentinels or honorific totems. There are no traces of human presence, only these robotic mannequins. Hollywood-style spotlights augment the building's ceremonial importance, and the grandiose brand-name marquee announces the corporate avatar who rules this haven. The building's design sustains a new standard for highway architecture, quite in keeping with the criteria of uniformity, conformity, and promotionalism that are pridefully proclaimed by the Standard appelation.

The gas station first appeared as an icon representing American culture in the 1920s. In paintings

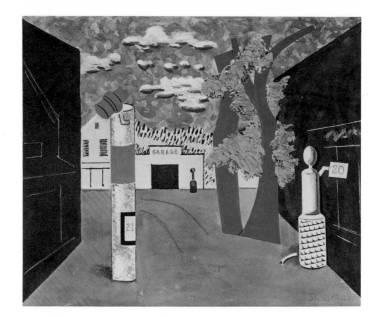

FIG. 64. Stuart Davis, *Town Square*, 1925–26. Watercolor on paper, 11¾″ × 14¾″, The Newark Museum, Newark, New Jersey.

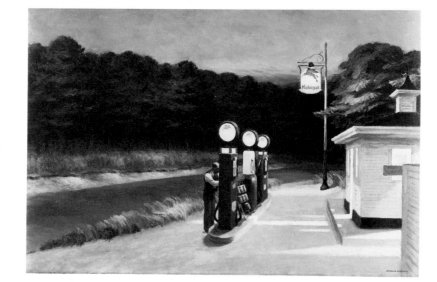

FIG. 65. Edward Hopper, *Gas*, 1940. Oil on canvas, 26¼″ × 40¼″. The Museum of Modern Art, New York. Mrs. Simon Guggenheim Fund.

like *Town Square* (1925–26) [Fig. 64] and *Garage Lights* (1931–32), Stuart Davis repeatedly used the image of streetside gas pumps and village gas stations to express the vitality of American life. For Edward Hopper, in contrast, the gas station signified modernity's intrusion into the bucolic landscape [Fig. 65]. Ruscha's image shares something of Davis's celebratory tone (albeit twisted by irony) and Hopper's disquiet at the denaturalized environment (albeit without his romantic longing for a paradise lost). But Ruscha's portrait is distinctive in its presentation of a packaged image that bears the imprint of organizational America's franchising of

the roadside. Franchising is a classic American institution geared to facilitate the controlled regional or national marketing of a product.[16] In the 1950s and 1960s the number of franchised outlets and companies multiplied—fast-food chains, motels, gas stations—and regularization efforts intensified. Franchised businesses across the United States displayed cookie-cutter uniformity as parent companies rigorously standardized virtually all aspects of their operations: the architectural design of buildings, signs and logos, services and product lines, promotion campaigns and advertising jingles. The franchise outlets were not only to sell the line of

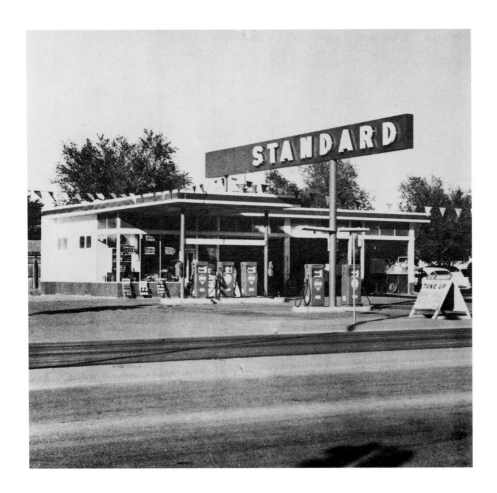

FIG. 66. Edward Ruscha, *Standard Station, Amarillo, Texas*, from the book *Twentysix Gasoline Stations*, first edition, 1963.

products but also to reinforce the fixed identity of the brand name. As national franchise outlets replaced local mom-and-pop businesses, the old-style farrago of local color gave way to a patchwork of familiar clones. North and south, east and west, the roadscape became a homogenized commercial zone.

If *Standard Station, Amarillo, Texas* ironically glorifies a standard gas station, Ruscha's *Twentysix Gasoline Stations* (1963), a travelogue of photographs, focuses full attention on the mundane actuality of gas stations.[17] The book, which includes the photographic source for the *Standard Station* painting [Fig. 66], shows a series of equally common and humdrum gas stations along U.S. Route 66 between Los Angeles and Oklahoma City (Ruscha's adopted and native hometowns). These vistas neatly counter the idealized vision of the American landscape portrayed in travel brochures and civic-booster campaigns. Like Jack Kerouac's cult novel *On the Road* (1957) or songs like "Route 66" (1946) or "King of the Road" (1964), Ruscha's photographs attest to the dominance of the road as an

American image and mobility as a characteristic aspect of American life. But in Ruscha's pictures the road is not a metaphor for freedom or an escape route away from the doldrums of the workaday world; the road is little more than a conveyor belt that runs through a repetitive, vacuous, monotonous environment. And travel is no longer an adventure yielding novel perceptions as much as it is an excursion to replicas of the already known and familiar. Even the variations in Ruscha's collection of images tend only to confirm the experience of organized familiarity in the American landscape and the identity of America as a land of manmade banalities. Ruscha explored these themes further in subsequent photo books, among them *Some Los Angeles Apartments* (1965), *Every Building on Sunset Strip* (1966), and *Thirtyfour Parking Lots in Los Angeles* (1967).

In *Looking East on 4th and C, Chula Vista* (1967) [Fig. 67], John Baldessari likewise records the nondescript character of American street settings. Using a photograph taken from inside a car, Baldessari displays the ugliness and ordinariness of the

*FIG. 67. John Baldessari, *Looking East on 4th and C, Chula Vista*, 1967. Phototransfer, acrylic on canvas, 60″ × 45″. Courtesy of Sonnabend Gallery, New York, and Margo Leavin Gallery, Los Angeles.

*FIG. 68. Vija Celmins, *Freeway*,
1966. Oil on canvas, 17½″ × 26½″.
Collection of Harold Cook.

typical vista, replete with telephone poles, electric wires, and smoggy skies. His silkscreen transfer enlargement, reproduced in black and white without cropping or editing, intensifies the bleakness of the view. The bold-letter caption which simply identifies the precise site affirms that this is a documentary portrayal meant to emphasize commonplace facts and raw particularities, not idealized generalizations or utopian myths about the American landscape.

Baldessari's verité approach parallels the midsixties reaction against the major media's adoption of slick Madison Avenue aesthetics and artful styles of presentation. These were the years when the alternative press emerged. From the groundbreaking *Los Angeles Free Press*, which began publishing in 1964, to the numerous neighborhood papers and underground publications that appeared soon thereafter, the alternative press was dedicated to the investigation of American life, including its under-

side and unappealing aspects. It presented the unadorned truth about topics that were generally censored, ignored, or abbreviated on network television or in mainstream newspapers and magazines. Although Baldessari did not assume the inflammatory tone or overtly politicized stance that tended to prevail in the alternative press, his composition evinces a similar effort to document and demystify, to get beneath the constructed and contrived facades that typified mass media representations.

Concern with the particularity of an ordinary, familiar place in all its mediocrity also shapes Vija Celmins's painting *Freeway* (1966) [Fig. 68]. Using a photograph of a highway scene as a base, Celmins exactingly paints the dreary everyday vista of asphalt, roadside buildings, and signs. Here again, the perspective is that from inside a car, with the dashboard and windshield emphasizing the mediated, detached quality of a motorist's experience

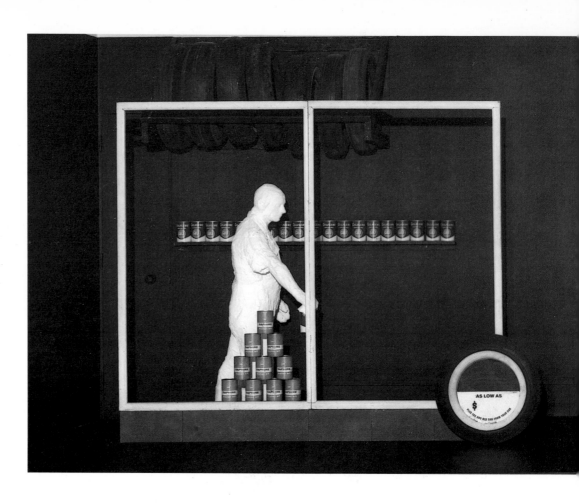

of the landscape. Like most highway paintings of this period, the composition depicts the denaturalized quality of the American landscape as well as the dissociative relationship between people and the environment.

Hermetic insularity similarly characterizes those of George Segal's assemblage sculptures that depict figures in settings related to road travel: *Bus Riders* (1962), *The Bus Driver* (1962), *The Gas Station* (1963) [Fig. 69], *The Bus Station* (1965), *Man Leaving a Bus* (1967) [Fig. 70], and *Parking Garage* (1968). These tableaux show typical aspects of America's automotive culture, with real props capturing the flavor of actual environments. The figures are lifelike, having been cast from human models, and yet their stark whiteness and frozen postures endow them with a ghostliness. They are phantom people, simultaneously present and ab-

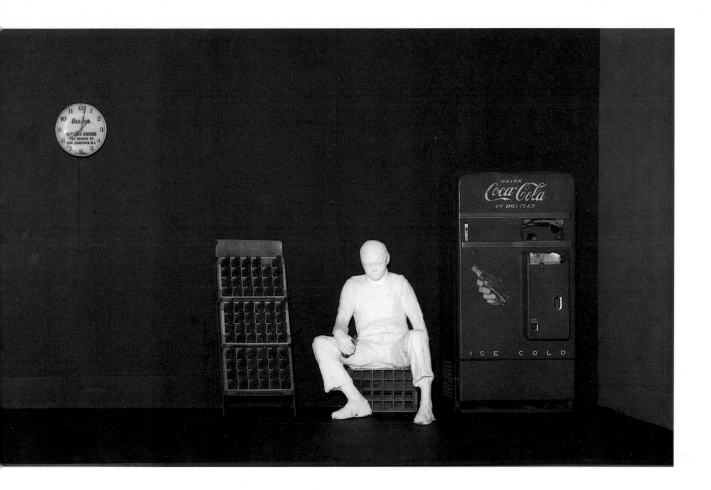

sent, on the scene but disconnected from their habitats. And although the casts were formed from specific individuals, the figures appear as generic, anonymous personages. In these settings life is comfortable but deadened: individuals have no meaningful interpersonal contact and go about the business of life by enacting repetitive routines. These are settings and people untouched by either the jubilance of John Kennedy's Camelot fantasy or the turmoil of civil rights, assassinations, and Vietnam protests. They exemplify a business-as-usual mentality; conditioned by time and habit, they are unmoved and unaffected by changing circumstances. Paradoxically, they also represent the static stalwartness of American culture: not the survival of the fittest, but the survival of the most steadfast.

Segal's classical views of American culture and the American environment are not motivated by nostalgic longing for a foresaken, appealing past but by a recognition of subjects, sites, images, and qualities that are distinctly American despite the progress of time. In *Man Leaving a Bus*, for example, it is not just any bus but a yellow school bus, a common fixture in communities throughout the country. And in *The Gas Station*, the inclusion of a Coke machine, Bulova clock, and Gulf oil cans endows the setting with a time-honored, unequivocally American character. Thus these sculptures, like so much of the art of the fifties and sixties, represent not only a shift from abstraction to an art rooted in everyday life but also a turning away from European iconography to themes, images, and experiences typical of contemporary American life. The postwar artists, in exploring the landscape of America's cities, suburbs, and highways, recognized the rich resources for creative expression in American culture.

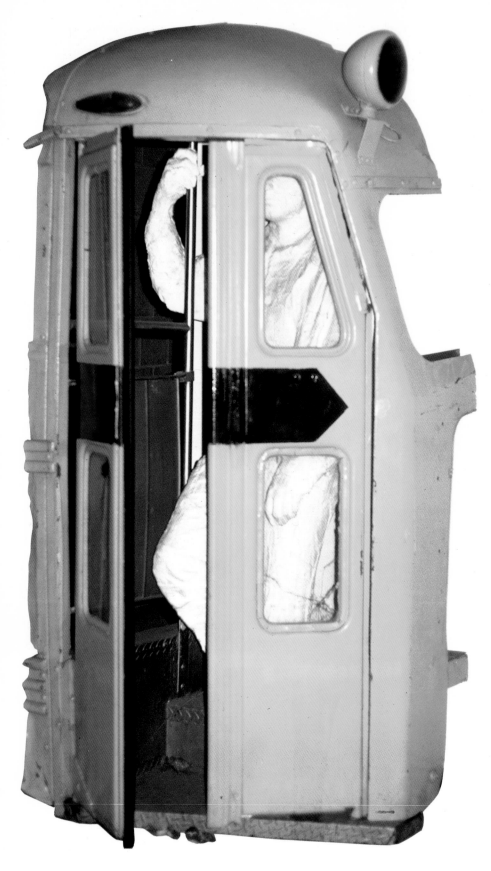

NOTES

1. See Alan Trachtenberg, Peter Neill, and Peter C. Bunnel, *The City: American Experience* (New York: Oxford University Press, 1971), ix–x.

2. *Time* 79 (March 23, 1962): 17. Over the next few years, *Time* ran five long articles on the city; see *Time* 80 (September 28, 1962): 56–69; 81 (March 15, 1963): 24–35; 84 (July 31, 1964): 11–18; 84 (November 6, 1964): 60–73; 87 (March 4, 1966): 29–33.

3. *The Street* was shown in New York first at the Judson Gallery, Judson Memorial Church, January 30–March 17, 1960, and then in a second version at the Reuben Gallery, May 1960.

4. Oldenburg, in an interview with Robert Pincus-Witten (April 1963), quoted in Barbara Rose, *Claes Oldenburg* (New York: Museum of Modern Art, and Greenwich, Conn.: New York Graphic Society, 1970), 32.

5. The performance *World Fair II* was enacted May 25 and 26, 1962, as one of the theatrical events presented in the back room of *The Store*.

6. In his influential book *The Other America* (New York: Penguin, 1963), Michael Harrington describes and analyzes the poverty culture of postwar America.

7. For a detailed discussion of Spiral and early activities within the black art community, see Mary Schmidt Campbell, *Tradition and Conflict: Images of a Turbulent Decade, 1963–1973* (New York: The Studio Museum in Harlem, 1985), 45–48.

8. *Time* 84 (November 6, 1964): 70.

9. When Henry A. Barnes, one of the most aggressive traffic engineers, became the traffic commissioner of New York City in 1962, he warned that he intended to make radical changes. (See *Time* 79 [January 12, 1962]: 43.) Holding to his promise, he made most of the city's major avenues one-way, transformed and increased the signs, and proposed an elaborate electronic control system.

10. The original Hollywood sign, constructed in 1923, was a real estate development advertisement for what was then a rather sparsely settled community. The original sign read "Hollywood Land," but the "Land" segment slid down the hillside in 1945. At that point, the Chamber of Commerce adopted the remainder as a local monument. Images of the Hollywood sign appear variously in Ruscha's work. In addition to the series of collages, of which *Hollywood Study* is one, the sign appears in a screenprint version, published in 1968, that has attained widespread popularity.

11. As noted by Daniel J. Boorstin in *The Image: A Guide to Pseudo-Events in America* (New York: Atheneum, 1978), 199.

12. Jeffrey Hart, *When the Going Was Good! American Life in the Fifties* (New York: Crown, 1982), 31.

13. "The New America: Suburbia-Exurbia-Urbia, The New Breed," *Newsweek* 49 (April 1, 1957): 34.

14. "The New Highway Network," *Time* 69 (June 24, 1957): 92.

15. See the artist's statement in *D'Arcangelo: Paintings of the Early Sixties*, exhibition catalogue (Purchase: Neuberger Museum, State University of New York, College at Purchase, 1978), n.p.

16. For a discussion of franchising as an American institution, see Daniel J. Boorstin, *The Americans: The Democratic Experience* (New York: Vintage Books, 1974), 428–34.

17. *Twentysix Gasoline Stations* was first published by the artist in 1963, with subsequent editions in 1967 and 1969. The first edition comprised four hundred numbered copies; the second edition, five hundred unnumbered copies; and the third, three thousand copies.

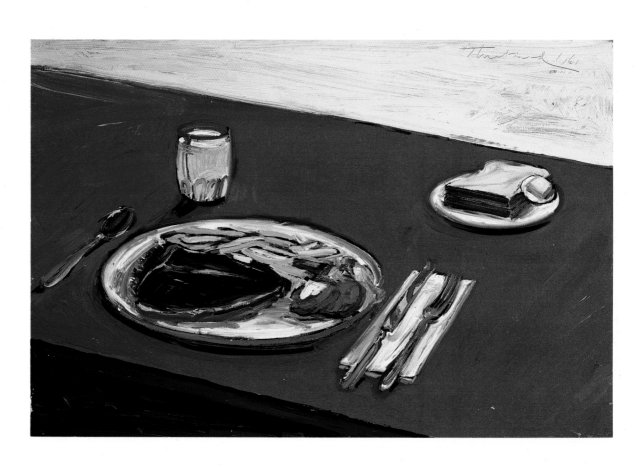

★FIG. 71. Wayne Thiebaud, *Trucker's Supper*, 1961. Oil on canvas, 20½″ × 30⅛″. Collection of the artist.

Hamburgers, hot dogs, french fries, corn on the cob, ice cream cones, popsicles, Coca-Cola, Campbell's Soup, and corn flakes are decidedly American foods enjoyed by a great majority of the population regardless of age, class, sex, or geographical location. Such foods are signatures of American culture, evidence of popular taste as well as of culinary customs, eating habits, and skill in advertising and marketing. With the postwar proliferation of brand-name promotions, convenience foods, fast-food chains, national distribution networks, and giant supermarkets, food became a paramount part of America's image.

Typical American foods abound in the art of the 1950s and 1960s, and depictions offer rich evidence of American marketing strategies and American consumer preferences. The art is distinctive in its mechanized commercial appearance, its manifestation of the character of postwar affluence, and its presentation of provocative new images. At the same time, using food as subject matter follows a long tradition in art. Throughout history, artists have featured food items, both delicacies and staples, in feast scenes, mythological narratives, emblematic designs, portraits, and still lifes. Within the modernist period, Cubist painters provided an iconographic update with wine and drink images in compositions expressly associated with bohemian cafés and French culture.

The food imagery developed in postwar American art continues in the path of such precedents, but its source is specifically American, not European, and it is pointedly derived from mass culture, not bohemian milieus. For example, in *Trucker's Supper* (1961) [Fig. 71] by Wayne Thiebaud, the represented meal exemplifies the standard fare served in any diner anywhere in the United States: steak and french fries garnished by a leaf of iceberg lettuce and slivers of hothouse tomato topped by mayonnaise, two slices of processed white bread and a packaged pat of butter, accompanied by a glass of milk. While the menu is heartland American, the food and the plates, glass, flatware, and folded paper napkin epitomize an institutional standardization and anonymity that is equally characteristic of American dining. As Thiebaud has observed, "I think the big difference in America as compared to Europe is that the food here is the same wherever you go, even down to the napkins and salt and pepper shakers on the restaurant tables."[1] His diner spread exaggerates that sameness, and the isolation of a single meal on a countertop articulates the loneliness of a trucker whose workdays are a series of routine meals eaten alone in some all-too-familiar roadside restaurant. Yet the

American Food and American Marketing

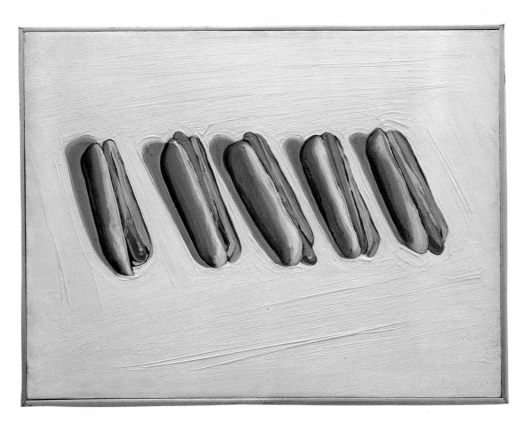

*FIG. 72. Wayne Thiebaud, *Five Hot Dogs*, 1961. Oil on canvas, 18″ × 24″. Collection of John Bransten.

routine dullness and institutionalized conformity are contradicted by the lush exuberance of Thiebaud's brushwork, which suggests an unembarrassed love of familiar American food and everyday American culture. Like most American painters in the 1950s and 1960s, Thiebaud rejected elitist attitudes that viewed American mass culture as inferior or unappealing.

In several of his paintings of hot dogs, Thiebaud reaches the core of popular American food taste and deflates received notions about appropriate art imagery, especially those conventions based on European standards and culture. The hot dog is the paragon of the easy-to-prepare, easy-to-eat-on-the-run foods for which America is famous. In contrast to the European tradition of leisurely, formal eating, Americans have developed easygoing eating habits, favoring snacks and hand-held meals that can be quickly consumed. While Europeans sit at dining tables eating their sausages off china plates, Americans munch their hot dogs while standing, participating in some other activity, or watching a baseball or football game. Hot dogs are also a staple of the picnics that mark the three na-

tional summer holidays and the weekend barbecue. And the typical American hot dog is produced in a typically American way: processed in mechanized food plants, assembled into quantity packages, cooked in large numbers, and marketed at franchised food outlets or snack food concessions that place a premium on rapid, quantity service.

To paint a hot dog in 1961, during the Kennedy era of high-flying pride in American culture, was to capture the prevalent national spirit. In *Five Hot Dogs* (1961) [Fig. 72], Thiebaud exemplifies this ebullient spirit by treating the hot dog as an ennobled object, worthy of full, unadulterated attention and center-stage presentation on a pure white ground. The densely pigmented surface and succulent brushwork make tangible the food's richness. The presence of five hot dogs denotes plentitude, while the careful differentiation of each of the five preserves their individuality. The image is implicitly a glorious statement about America. And yet, the starkness of the rendering and the assembly-line-perfect alignment seem an unsettling reminder of the rigors of conformity. Thus a strain of ambivalence riddles the imagery, tempering its celebratory tone.

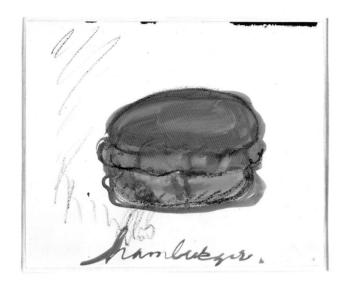

FIG. 73. Claes Oldenburg, *Hamburger*, 1961. Gouache and crayon on paper, 11″ × 14″. Private collection.

FIG. 74. Claes Oldenburg, *Two Cheeseburgers with Everything (Dual Hamburgers)*, 1962. Burlap soaked in plaster, painted with enamel, 7″ × 14¾″ × 8⅝″. The Museum of Modern Art, New York. Philip Johnson Fund.

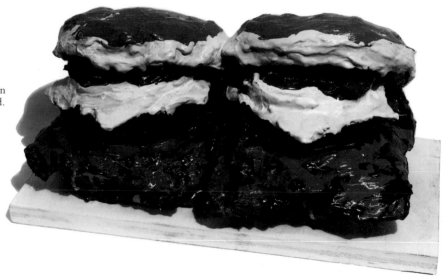

Quite equivalent to the hot dog as an archetypal symbol of American food is the hamburger. Claes Oldenburg develops the iconography in various drawings [Fig. 73]; in a series of painted plaster sculptures: *Two Cheeseburgers, with Everything (Dual Hamburgers)* (1962) [Fig. 74], *Hamburger with Pickle and Olive* (1962), and *Hamburger* (1963); and in a mammoth fabric exemplar, *Giant Hamburger* (1962) [Fig. 75]. Though rich and sensual in appeal, Oldenburg's hamburger imagery shows none of the classical restraint of Thiebaud's hot dogs. His utterly fanciful, lumpy, garishly colored plasters and gargantuan cloth model subvert sculpture con-

ventions of purity, control, or beauty. His imagery goes beyond the sensually appetizing to the sexually provocative. No holds barred, Oldenburg celebrates life—human life, American life, everyday life—by serving up hamburgers that are larger than life.

The size and rich excess of Oldenburg's foodstuffs recall the burger franchises' competitive boasts about the softest bun or the biggest patty. With creative panache Oldenburg effectively trumps even the most extraordinary advertising claims by creating the biggest, most towering, best-stuffed hamburgers of the era. Hyperbole and

FIG. 75. Claes Oldenburg, *Giant Hamburger*, 1962. Painted sail cloth stuffed with foam, 52″ × 84″. Art Gallery of Ontario, Toronto. Purchase, 1967.

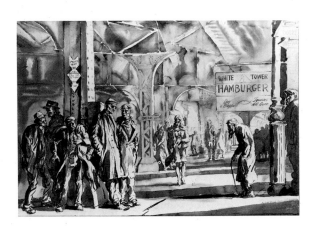

FIG. 76. Reginald Marsh, *White Tower Hamburger*, 1945. Ink on paper, 26¼″ × 39¾″. Whitney Museum of American Art, New York. Anonymous gift.

extravagant overstatement, the keynotes of American advertising, bear particular relevance to the hamburger's special place in postwar society. Though long popular in the American diet, hamburgers became a highly profitable growth sector in the American economy as a result of the marketing efforts of some of the nation's most successful, high-production chain restaurants.

Among the first and biggest of the burger-war belligerents was White Tower, which spread its outlets throughout urban centers and promoted quantity consumption with the slogan "Buy a Bagful, Towers All Over." The chain developed a limited menu—starring the hamburger—and offered quick service and inexpensive products, the perfect combination for working Americans. Reginald Marsh's *White Tower Hamburger* (1945) [Fig. 76] records the notable presence of the chain in the urban landscape, though he uses the company slogan as an ironic point of departure for a commentary on American poverty.

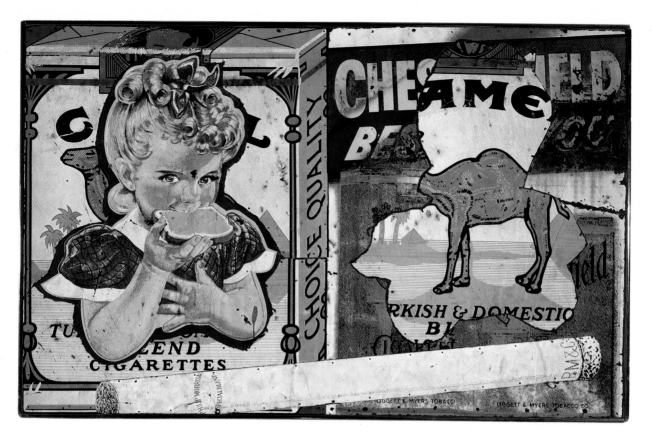

★FIG. 77. Tony Berlant, *Camel Burger*, 1963. Metal collage, 25½″ × 40¾″. Collection of Joan and Jack Quinn.

As highway traffic increased, a new kind of culinary establishment emerged: the fast-food drive-in. The leader here, born in 1954, was McDonald's. This champion chain soon became a multi-million-dollar operation, and by 1972 its more than 1,000 franchises showed gross annual sales that exceeded $300 million. Even more adroitly than White Tower, McDonald's exploited the appeal of quantity consumption.[2] Advertisements and signs at every outlet publicized a running tally of the number of hamburgers sold, and the figure rapidly reached mind-boggling heights. While McDonald's was indisputably the largest hamburger chain, a chorus of serious competitors—Burger King, Roy Rogers, Wendy's, and the like—matched McDonald's toteboard promotion with their own fanfare about their burgers' unequaled size or the tantalizing extras and variants that they offered. Hamburger restaurants, hamburger advertising,

and hamburgers themselves were thus a dominant aspect of postwar American life. The resonance of this is found in Oldenburg's hamburger imagery.

In a comic parody of both the American hamburger obsession and American merchandising creativity, Tony Berlant's composition *Camel Burger* (1963) [Fig. 77] promotes a distinctive permutation. Using advertising signs, Berlant concocts a burger variant composed of the well-known package imagery from Barbara Anne white bread and Camel cigarettes. The Camel imagery provides a witty substitute for ham, which of course is not an ingredient in hamburgers, and, more generally, the substitution of advertisements for food pronounces Madison Avenue's vital influence on the contemporary American palate. Berlant even alludes to the fierce competition between brand names by juxtaposing Camel and Chesterfield advertisements on one side of his sandwich.

*FIG. 78. Claes Oldenburg, *French Fries and Ketchup*, 1963. Vinyl and kapok, 10½″ × 42″ × 44″. Whitney Museum of American Art, New York. Fiftieth Anniversary gift of Mr. and Mrs. Robert M. Meltzer.

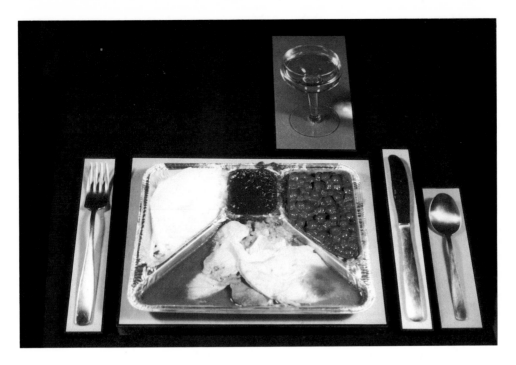

FIG. 79. Robert Watts, *TV Dinner*,
1965. Photo lamination, latex, paint,
7" × 9" × 1¼". Collection of the artist.

Cofeatured with hamburgers at the fast-food chains are french fries, which also entered the realm of art through several of Oldenburg's sculptures. Although potatoes are not a uniquely American food, distinctly American is the phenomenon of potatoes cut into sticks, embellished with ketchup (a red-blooded American product), and designed to be eaten with one's fingers. Fast-food french fries represent a triumph of modern food technology, for they are standardized, geometric morsels, perfected with artificial preservatives and food coloring. Oldenburg monumentalizes this variant of potatoes in *French Fries and Ketchup* (1963) [Fig. 78], a sculpture whose precisioned vinyl forms parody the synthetic, preprocessed character of contemporary American food.

Not just potatoes, but a wide variety of foods were affected by applied technology. During the postwar period, packaged, instant, frozen, and processed foods were increasingly available for home consumption and increasingly preferred. On-the-go Americans welcomed foods that could be purchased in advance and meals that required little preparation. Home freezers, which facilitated food storage, contributed to the creation of a new, very American type of packaged, convenience food: the TV dinner. Named for Middle America's favorite at-home pastime, these pop-in-the-oven,

all-in-one meals attained immediate success.[3] The assemblages of Robert Watts [Fig. 79] introduced the new form of home cooking to art. Using partitioned plates and photographic images of food and plastic materials, he conveys the assembly-line flavor of the meal, its denaturalized ingredients and machine-measured nourishment. Watts's designs affirm the inventiveness and absurdity of America's application of technology to food, the nation's insatiable appetite for mechanization and organizational efficiency.

Paralleling the development of convenience foods and the explosion of fast-food restaurants was the proliferation of ice cream stores. The ice cream cone—an edible, prefabricated American invention—made ice cream a portable commodity. The cone had first appeared at the St. Louis World's Fair in 1904. In the fifties the suburban glut of nationally franchised outlets featuring soft custards (Dairy Queen and Carvel) or hard ice cream in an unprecedented variety of flavors (Howard Johnson's and Baskin-Robbins) brought new stature to the veteran food favorite, and ice cream entered the realm of American big business.[4] The new ice cream stores were the latest cousin of the popular old-fashioned ice cream parlors, which sold extravagant concoctions made to order, and the franchised street vendors, who sold a multitude of

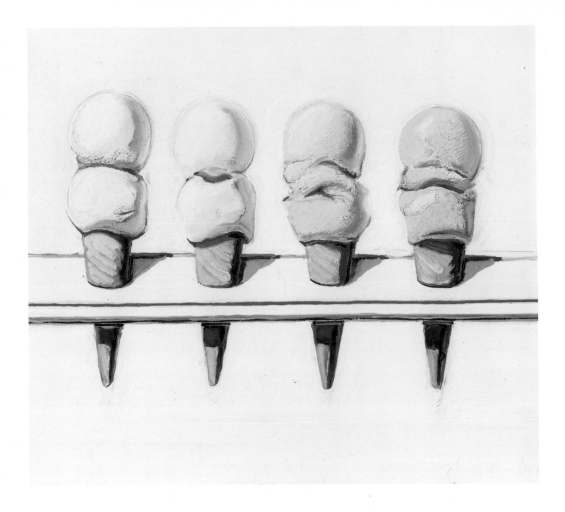

FIG. 80. Wayne Thiebaud, *Four Ice Cream Cones*, 1964. Oil on canvas, 14″×18″. Phoenix Art Museum. Museum purchase, COMPAS Funds.

popsicles—another American innovation (first produced in 1921) that facilitated the mass merchandising of ice cream.

Both Thiebaud and Oldenburg pay homage to the ice cream industry and its emphasis on grand size, richness, and variety. Thiebaud's *Four Ice Cream Cones* (1964) [Fig. 80], for example, shows a diversity of flavors in double-scoop cones rendered with lush, impastoed surfaces that simulate the excessive butteriness of American ice cream. Translating the imagery into sculpture, Oldenburg further exaggerates the cones' traits. In his *Floor Cone* (1962) [Fig. 81], a mammoth, corpulent object of exotic pistachio color lies on the floor like a car in a showroom (the inspiration for the design), and in *Giant Ice Cream Cone* (1962) a seductively textured object of a mint-lemon swirl flavor hangs in the air like a tantalizing fantasy. Oldenburg carries the rage for new synthetic flavors to a burlesque extreme in the animal-skin patterns and fake-fur materials of *Soft Fur Good Humors* (1963) [Fig. 82]. Not unlike Meret Oppenheim's surrealist *Fur-Lined Tea Cup* (1936), Oldenburg's use of fur perturbs taste and touch sensations, though it also reflects the tendency of American businesses to relentlessly persevere in expanding a successful product line. Oldenburg's mélange of fake ingredients celebrates American ingenuity but also gives pause, provoking an awareness of how America's economic, technological, scientific, and corporate prowess continually threatens to transgress the rational and the natural.

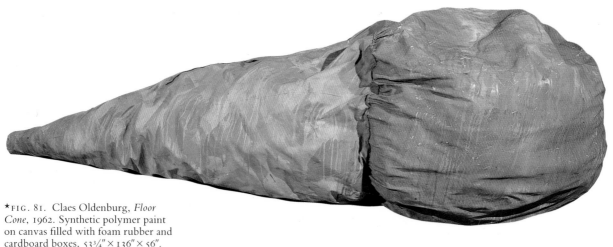

*FIG. 81. Claes Oldenburg, *Floor Cone*, 1962. Synthetic polymer paint on canvas filled with foam rubber and cardboard boxes, 53¾″ × 136″ × 56″. The Museum Modern Art, New York. Gift of Philip Johnson.

*FIG. 82. Claes Oldenburg, *Soft Fur Good Humors*, 1963. Fake fur filled with kapok, painted wood, four units, 19″ × 9½″ × 2″ each. Collection of Roger I. Davidson.

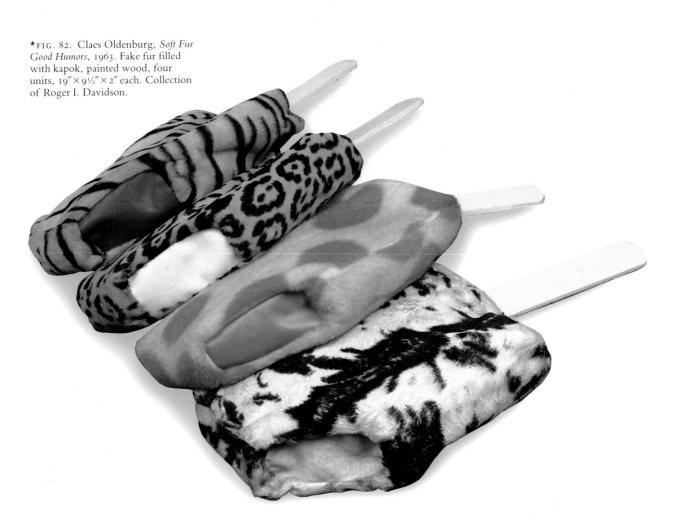

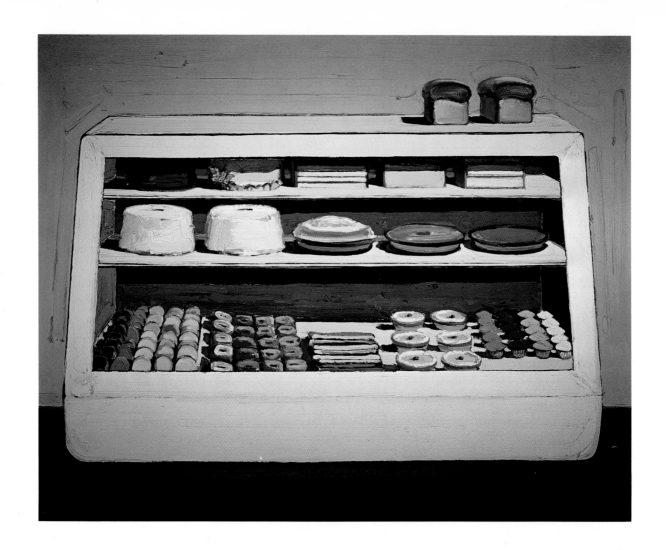

★FIG. 83. Wayne Thiebaud, *Bakery Counter*, 1961–62. Oil on canvas, 55″×72″. Collection of Foster Goldstrom.

FIG. 84. Claes Oldenburg, *Pastry Case, I*, 1961–62. Enamel paint on nine plaster sculptures in glass showcase, 20¾″×30⅛″×14¾″. The Museum of Modern Art, New York. The Sidney and Harriet Janis Collection.

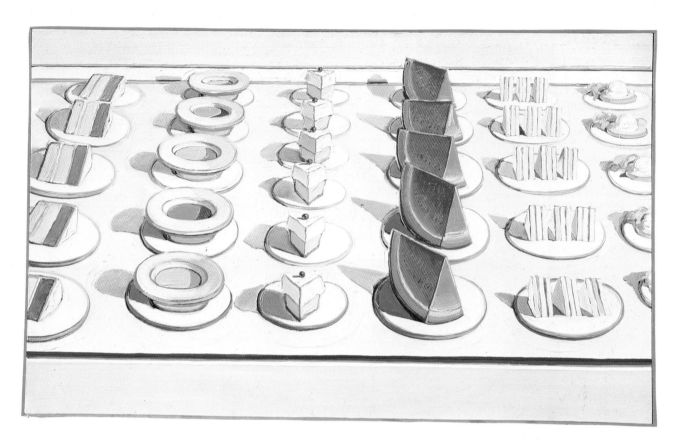

★FIG. 85. Wayne Thiebaud, *Lunch Table*, 1964. Oil on canvas, 36″ × 60″. Stanford University Museum of Art. Gift of the Committee for Art at Stanford.

America's craving for other cloyingly rich desserts is made palpable in numerous compositions, among them Thiebaud's *Bakery Counter* (1961–62) [Fig. 83], a painting of donuts, éclairs, tarts, cupcakes, layer cakes, and pies—all laden with mounds of sugary toppings—and Oldenburg's *Pastry Case, I* (1962) [Fig. 84], a sculpture presenting ice cream sundaes, pies, cookies, a candy apple, and cake—all oozing with sauces and frostings. The surfeit of sucrose splendor, the sheer quantity and variety of candy-coated confections denote abundance. These are the in-between-meal and after-dinner bonuses of a prosperous society that enjoys the luxury of eating well, often, plentifully, and extravagantly. The seductive displays also articulate the bonds between prosperity, mass marketing, and consumerism.

In paintings that depict a variety of food items arranged in cafeteria-style alignments, Thiebaud reiterates the notion that America is a land of milk and honey, a country of endless resources. In *Lunch Table* (1964) [Fig. 85], for example, the self-service display of such Middle American food favorites as layer cake, soup, lemon meringue pie, watermelon, sandwiches, and cottage cheese salad exudes an impression of plentitude. The lush appearance of the food, the oversized portions, the overall indication of quantity—all evidence farm productivity and supermarket supply, social well-being and mass affluence, in decidedly American terms.

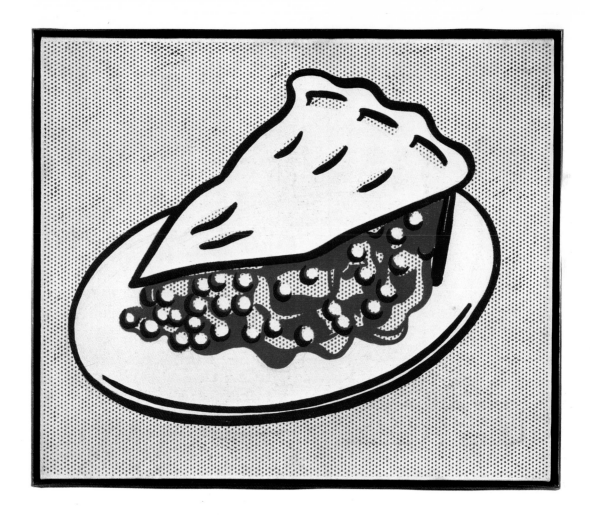

*FIG. 86. Roy Lichtenstein, *Cherry Pie*, 1962. Oil on canvas, 20¼″ × 24¼″. The Sydney and Frances Lewis Collection, courtesy of Virginia Museum of Fine Arts.

As opposed to the seduction of excess, Roy Lichtenstein seeks the impact of a spare, stark image in *Cherry Pie* (1962) [Fig. 86]. A classic American pastry, part of the George Washington legend, is shown in America's signature colors (red, white, and blue) in comic-strip style. Adapting techniques from commercial illustration and simulating a benday-dot pattern, Lichtenstein establishes the image as a product of a mass communications culture premised on mechanized standardization and simple, clear messages. Like illustrations in chain restaurants' menus, on supermarket packages, or in magazine advertisements, Lichtenstein's slice of cherry pie has the rich visual appeal of contemporary aesthetics geared toward commodity promotion. Stylized and compelling in its isolation and boldness, *Cherry Pie* bears the mark of Madison Avenue's preeminence in postwar American society.

In addition to depicting generic comestibles, many artists featured brand-name products in their compositions. During the fifties and sixties household

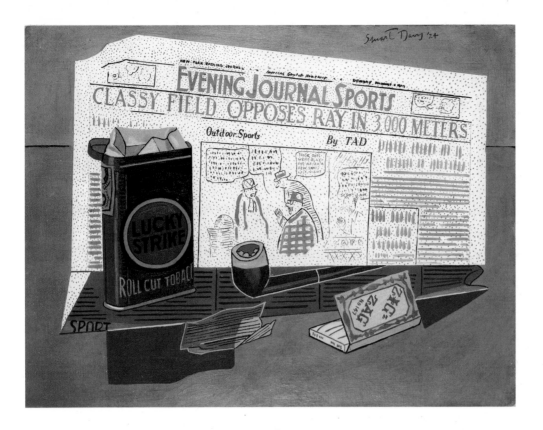

FIG. 87. Stuart Davis, *Lucky Strike*,
1924. Oil on paperboard, 18″ × 24″.
Hirshhorn Museum and Sculpture
Garden, Smithsonian Institution,
Washington, D.C.

brand names and promotion of product images
based on package design and advertising strategies
came to the forefront. The proliferation of self-
service stores and boxed, wrapped, canned, and
bagged products left the public to rely on the fa-
miliarity of brand names that promised consistent
quality. Packages were designed not simply as
functional coverings but as persuasive inducements
to consumers. Inventive shapes and brightly col-
ored containers were critical to individuating a
product and allowing instant recognizability. In
competitive lines, where diversity and the lure of
new products were constant, a strong fixed image
was seen as the key to success.

Brand names had first emerged in the mid-
nineteenth century.[5] In the 1950s the extraordinary
expansion of advertising stimulated by television
fed the brand-name phenomenon. Americans were
inundated with ads for particular products—on
television, in newspapers and magazines, on bill-
boards and trains, on bus and taxi placards, and in

store windows. In 1962 *Time* reported that the typ-
ical American was exposed to an average of 1,600
ads a day and that the dollar volume of advertising
in the United States had doubled in the preceding
twelve years.[6] By mid-century advertising had be-
come one of America's leading industries, creating
products' reputations, enforcing brand-name loy-
alty, and establishing consumerism as the Ameri-
can way of life.

Precedents for the depiction of brand-name
products in American painting were set in the
1920s by artists like Stuart Davis and Gerald Mur-
phy, who used such imagery to assert the Ameri-
can character of their work. In various composi-
tions they infused an iconography inspired by the
French Cubists with American-brand tobacco, cig-
arette papers, and safety matches [Fig. 87]. In one
case, Davis made a radical departure from Cubist
themes by adopting the American disinfectant
Odol as his subject matter. In this painting and
others, the full product label, the signature package

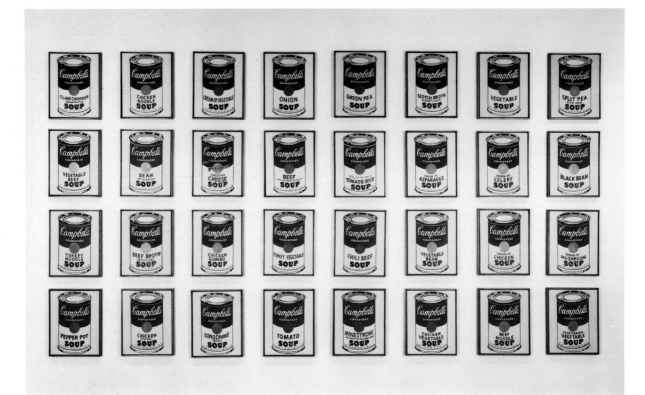

FIG. 88. Andy Warhol, *Soup Cans*,
1962. Acrylic on canvas, thirty-two
panels, 20″ × 16″ each. Collection of
Irving Blum.

design, and even the advertising slogan are point-
edly defined. The French Cubist painters, in con-
trast, occasionally included the brand name of an
aperitif or brandy, but more frequently showed a
nameless bottle of wine or a generic bottle labeled
vin. Within the American compositions, the prod-
uct image is fully displayed in all its promotional
splendor, envisioned as a commodity shaped and
supported by advertising. The paintings display the
salient American tendency to view the everyday
world in terms of commercial brand-name
products.[7]

Mid-century art made the brand-name phenom-
enon a priority issue, raising awareness about a di-
verse range of related considerations. In 1961 and
1962 Andy Warhol developed the Campbell's Soup
Can imagery in a series of thirty-two paintings
[Fig. 88]. Campbell's was a telling choice. A pi-
oneer in the convenience food industry, Campbell's
condensed soup ("just add water") exemplified the

theory of product expansion. Within the compa-
ny's first seven years, the original tomato soup of
1897 was augmented by nineteen other varieties.
Even with the postwar competition of freeze-dried
and frozen soups, Campbell's held its command of
the market, developing new products and, in 1958,
extending its operations overseas. Indeed, the late
fifties witnessed a surge of international activity for
veteran American food processors like Campbell's
who took advantage of the growing "taste for Yan-
kee food" abroad and "the status appeal of a 'Made
in U.S.A.' label."[8]

In addition to its entrepreneurial record, Camp-
bell's understood the marketing value of using a
simple eye-catching label for all its varieties of
soup. Aggressive advertising kept the label indeli-
bly fixed in the public's mind over generations.
Repetition and uniformity were the basic ingredi-
ents of Campbell's continuous ad campaign. Post-
ers and placards were placed where they would be

seen often. Though these signs were changed frequently, their basic look remained constant, so much so that the company came to be called "America's most *consistent* advertiser."[9] The familiar red-and-white can was invariably accompanied by copy that encouraged quantity consumption ("Why not order a few cans right now?" in 1910) and habitual usage ("Have you had your soup today? Once a day . . . *every* day . . . Soup—Campbell's, of course!" in 1958).[10] Campbell's Soup is thus a classic example of superior skill in brand-name packaging, marketing, and advertising.

Warhol's paintings exaggerate the key features of Campbell's success: package standardization and visual imprinting through repetition. His *Soup Cans* amplifies the power of a strong fixed package design and brand-name image, even as such uniformity reduces to virtual insignificance the individual character of any particular variety of soup, of any one item in the series. Sameness rules and packaging reigns supreme. Indeed, the container's contents are irrelevant to the package's design, which conceals the now-invisible product. Warhol exaggerates these packaging features by treating the soup cans as flattened facades, surface-oriented images that give no hint of what is inside or even that there is an inside. In several paintings that depict torn Campbell's Soup labels [Fig. 89], he presses the irony, showing only a tin can beneath the celebrated label—not soup, just another package.

Warhol's duplication aesthetic—the creation of paintings that are purposely devised as reproductions of mass production images—places no value on originality or uniqueness in an image's facture or design. Rather, uniformity and quantity, standardization and replication, are the paramount virtues. Although the first series of *Soup Cans* was hand painted, subsequent versions were made by a silkscreen stencil process that allowed Warhol to duplicate an image one hundred or two hundred times on a single canvas. Derived directly from the economics of mass production, Warhol's aesthetic also captures the spirit of the nascent age of automation. In the early sixties computers first became a significant factor in American life, and automation first became a topic of public conversation.[11] Simultaneously, the introduction of a production-line photocopier in 1960 made possible the creation of high-volume, rapid, inexpensive duplicates of printed material. The new computer and photocopier technologies provoked a radical rethinking about the nature of human and machine activity, and the relative status of original and copied material. Warhol's paintings bear a close affinity with the new automated techniques in espousing a type

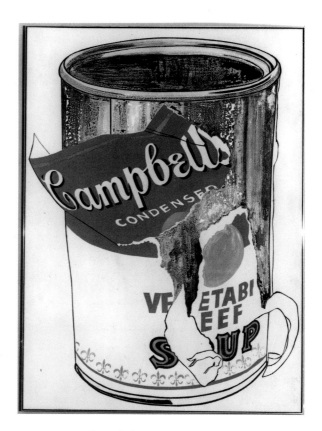

FIG. 89. Andy Warhol, *Big Torn Campbell's Soup Can*, 1962. Acrylic on canvas, 72″ × 54″. Kunsthaus Zurich.

of creativity in which the form, content, and production of imagery acquire a robotic character. His assertive use of duplication—especially multiples that have the uneven, quick-printing quality of photocopies—further assaults traditional notions of the "original" art object.

With their focus on quantity production and brand-name promotion, Warhol's Campbell's Soup Can paintings refer to the achievements of American capitalism. And yet, in an interview conducted in 1963, Warhol ironically observed that America's democratic free-enterprise ethic was creating an odd similarity between the ostensibly opposite capitalist and communist systems:

Someone said that Brecht wanted everybody to think alike. I want everybody to think alike. But Brecht wanted to do it through Communism, in a way. Russia is doing it under government. It's happening here all by itself without being under a strict government: so if it's

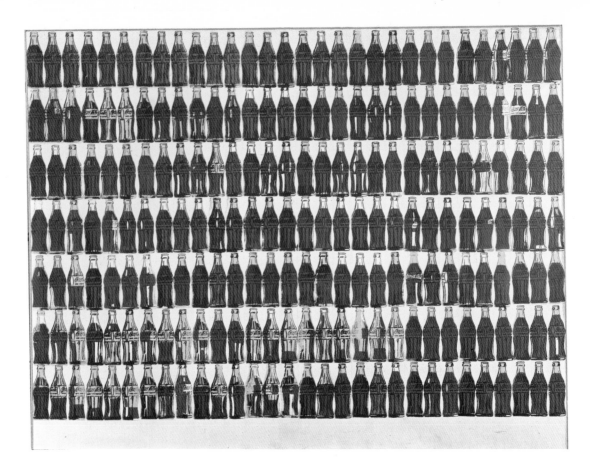

working without trying, why can't it work without being Communist? Everybody looks alike and acts alike, and we're getting more and more that way.

I think everybody should be a machine.[12]

Despite the Cold War rhetoric and America's proclamations about individual expression as a distinguishing attribute of democracy, Warhol proposes conformity as *the* modern American theme. His paintings show how conformity is abetted by mass production technology and advertising strategies, the former resulting in the standardization of prod-

ucts, the latter contributing to the standardization of habits.

Warhol soon expanded the principle of assembly-line likeness beyond soup cans to a wide range of other subjects, including products, people, and events. The painting *210 Coca-Cola Bottles* (1961) [Fig. 90], with its bottle-after-bottle, row-after-row imagery is exemplary. It captures the essence of mechanical replication and monotony, the endless, multitudinous yield of American manufacturing. It also captures the reality of Coca-Cola's production record. In 1961 Coke was sold in 115 countries, bottled in 1,700 plants throughout

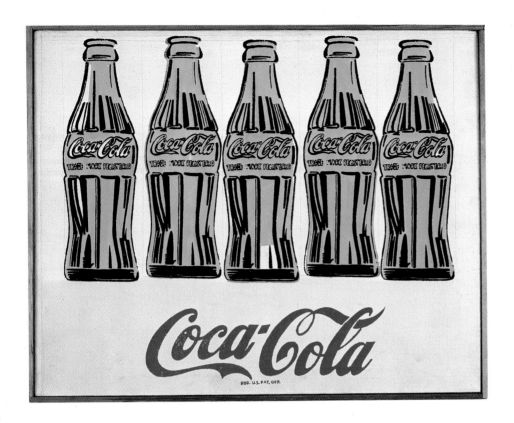

FIG. 91. Andy Warhol, *Five Coke Bottles*, 1962. Silkscreen on canvas, 16″ × 20″. Private collection.

the world, and purchased at a rate of over 65 million servings each day.[13] There is thus nothing hyperbolic in Warhol's portrayal.

Coca-Cola commanded a sizable percentage of the soft-drink market by creating and maintaining a loyal following of customers, both individuals and businesses. Like Campbell's, Coca-Cola's production and marketing efforts were targeted at instilling strict consumer loyalty, precisely the kind of allegiance that Warhol described as mechanistic conformity. Within the product design itself, there was also a long history of rigorous compliance with a set standard. The Coca-Cola company developed a distinctive image for its product—a barreled bottle and scripted logo—and then regulated and promoted these trademarks as much as the product itself. In *Five Coke Bottles* (1962) [Fig. 91], Warhol emphasizes these familiar registered trademark features while exaggerating their formulaic character.

During the Cold War, Coca-Cola was also an emblem of the American way of life. It affirmed the glories of capitalism in the face of the communist challenge. As *Time* observed in a 1950 cover story on Coca-Cola (the first cover to display a consumer product rather than a portrait of a person), Coke was "simpler, sharper evidence than the Marshall Plan or a Voice of America broadcast that the U.S. [had] gone out into the world to stay."[14] The Coca-Cola company did not simply export its product, it opened franchised bottling plants all over the world, carrying abroad both the American production system and the prestige of a brand-name American label. The success of Coca-Cola established a worldwide taste for an American product while affecting global sameness on American brand-name terms.

Warhol's one-image, one-commodity, one-brand-name paintings suggest Coca-Cola's hegemony and its implication of American supremacy. Though the appearance of a successful brand-name product seemingly proclaims the superiority of America's commercial free-enterprise system, Warhol's paradoxical depictions show that this system also produces monopolistic uniformity and regimentation rather than competitive diversity and freedom.

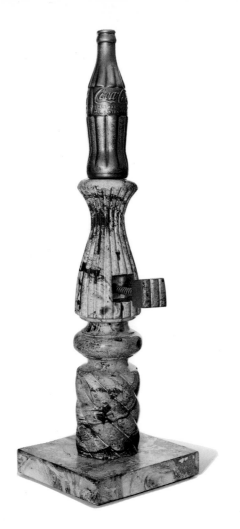

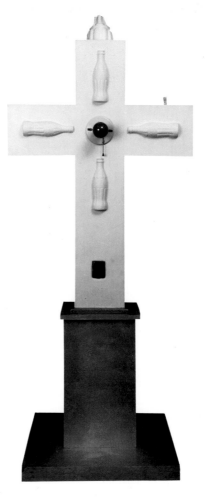

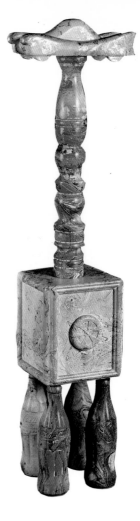

FIG. 92. H. C. Westermann, *Pillar of Truth*, 1962. Painted wood and cast aluminum, 24⅝″ × 10″. Private collection.

FIG. 93. H. C. Westermann, *White for Purity*, 1959–60. Fortified plaster, glass, wood, metal, and various materials, 44½″ × 29″. Collection of Gilda and Henry Buchbinder.

★FIG. 94. H. C. Westermann, *Trophy for a Gasoline Apollo*, 1961. Painted wood and glass, 33″ × 6″ × 6″. Collection of Jane and Ruth Root.

The supremacy of Coca-Cola is also the subject of H. C. Westermann's sculpture *Pillar of Truth* (1962) [Fig. 92]. Setting a Coke bottle atop a marble pedestal whose fluted, wasp-waisted forms parody both classical design and the trademark shape of the Coke bottle, Westermann pays homage to the deified status of Coca-Cola. With special regard for the product's celebrated package, the sculpture ironically establishes Coke's parity with the gods of classical Western civilization. The mock-honorific title also makes witty reference to the company's advertising slogan, "It's the *real* thing." Westermann's hyperbolic elevation of the carbonated beverage captures the tone of promo-

tions used to bolster the sale of Coke as well as the sanctity of America's adoration of this consumer commodity. In Westermann's *White for Purity* (1959–60) [Fig. 93], Coca-Cola attains full-blown spiritual immortality through an alliance with a crucifix and a covering of white paint that enhances the aura of the product's hallowed untouchability. The potency of the Coke bottle's image is further strengthened by its familiar form being played off against such other established signs as the ampersand, dollar sign, cent mark, question mark, exclamation point—and a red light that deflates the reverential mythologizing of this icon of American culture.[15]

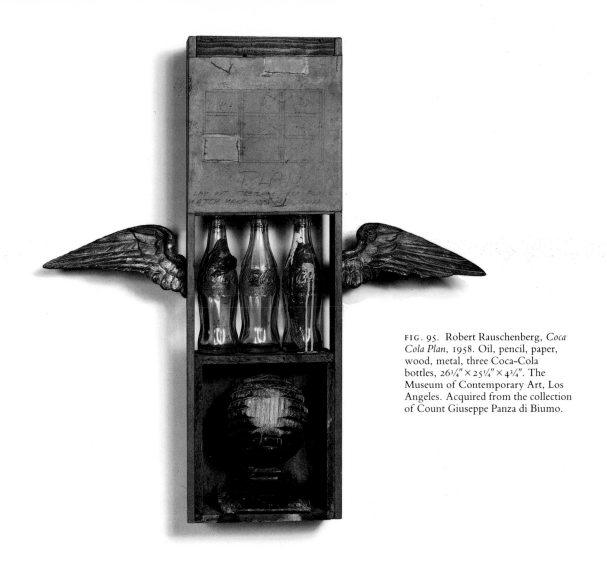

FIG. 95. Robert Rauschenberg, *Coca Cola Plan*, 1958. Oil, pencil, paper, wood, metal, three Coca-Cola bottles, 26¾" × 25¼" × 4¾". The Museum of Contemporary Art, Los Angeles. Acquired from the collection of Count Giuseppe Panza di Biumo.

When in a third Coca-Cola sculpture, Westermann pairs America's premier bottles with a deified car—a classic Detroit model with a long, sleek body and expansive fins—he manifests an equivalence between two of America's greatest passions. The nation's number-one soft drink, a signature on-the-road refreshment, takes its place within the ludicrous but provocative *Trophy for a Gasoline Apollo* (1961) [Fig. 94]. The trophy forms a compressed emblem of the stereotype of America as a materialistic, hedonistic nation. Like *Pillar of Truth*, it also unapologetically places American mass culture on a par with, or at least as a direct descendant of, the revered traditions of ancient civilizations.

In contrast to Westermann's presentation of Coke as a glorified object, Robert Rauschenberg shows Coca-Cola bottles and advertising signs as discards, part of the debris in America's urban landscape. In such combine paintings as *Curfew* (1958), *Coca Cola Plan* (1958) [Fig. 95], and *Dylaby* (1962), the disposable Coke products suggest the abundance and wastefulness of runaway consumerism, and also call to mind the socioeconomic imbalance that John Kenneth Galbraith analyzed in *The Affluent Society* (1958). Galbraith argued that the surface impression of affluence in America belied the gap between private opulence and public squalor. While big business became rich from the

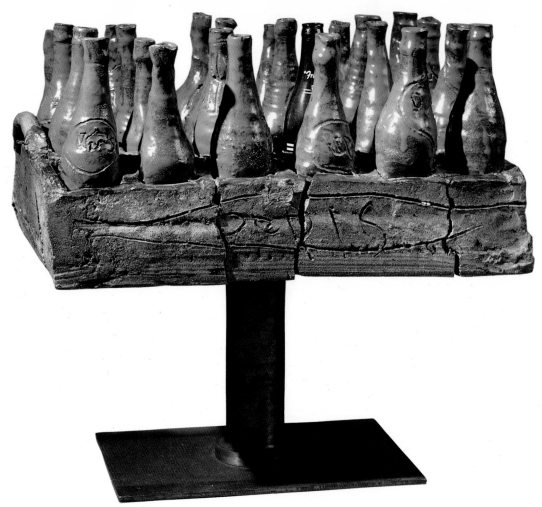

production of consumer goods, it glutted the market with throwaway materials and did nothing to allay the problems associated with excess production and consumption.

Rauschenberg's Coke imagery exemplifies the dualities within affluence and yet it is also a reminder of a simple pleasure shared by diverse sectors of the population—old and young, rich and poor, black and white. Moreover, the bottles' placement as focal images, often within altarlike niches, endows them with a majestic aura. In *Coca Cola Plan* the bottles are apotheosized by their encasement between a pair of angelic (or imperialistic) bird wings above a global sphere. In this universe of junk materials, Coke is an ironically honorific object. Significantly, this combine also marks a distinctly American appropriation of the European-based tradition of the found object.

Although Coca-Cola was the brand-name soft drink most often represented in the art of the fifties and sixties, Oldenburg in some plaster objects of

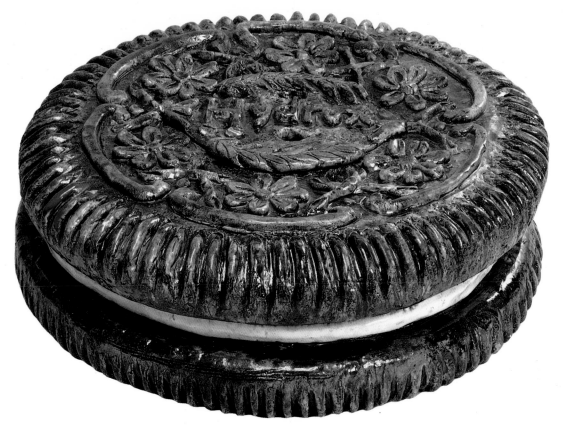

*FIG. 97. Robert Arneson, *Hydrox*, 1966. Glazed ceramic, 6″ × 20½″ diameter. Collection of Diana Fuller.

1961 and Robert Arneson in *Case of Bottles* (1963) [Fig. 96] alternately used Pepsi-Cola and 7-Up as their subject matter. Both artists present the familiar brand-name insignia or bottle as expressly misshapen, crude, and notably handmade, in defiance of the precisioned, standardized aesthetic of mass production and its ideal of conformity. Each of Arneson's many ceramic bottles has its own distinctive character, in contrast to the one storebought glass 7-Up bottle placed in their midst. Thwarting brand-name exclusivity and rejecting regimented assembly-line standards, Arneson's sculpture becomes a humorous counterpoint to Warhol's Coca-Cola paintings. His use of Pepsi, rather than Coke, and his intrusive display of a 7-Up bottle within a Pepsi case mockingly allude to the intense rivalry within the soft-drink industry.

Similarly, Arneson's series of Hydrox sculptures (1966) [Fig. 97] recalls the rivalry between Hydrox and Oreo, while also focusing on another veteran product of American processed-food ingenuity.

Hydrox had developed its cream-filled sandwich cookie in the early twentieth century. The all-in-one icing-and-cake product was perfect for mass production and packaged marketing. With its name emblazoned directly on it, each cookie became its own advertisement. Arneson's sculptures duplicate the exact likeness of the commercial product, but in oversized or double-decker versions. Like Oldenburg's food sculptures, these mammoth edibles affirm the stereotype of everything being bigger and better in America. Their size also advises that a big business outlook had come to prevail in the food industry. During the 1950s, for example, the Sunshine Company, Hydrox's manufacturer, had greatly expanded its baking operations, instituted an aggressive million-dollar advertising campaign, and entered the Fortune 500.

In yet another approach to the brand-name phenomenon, Larry Rivers parodies the contrivances and pretentiousness of the product identities developed by manufacturers and their advertising

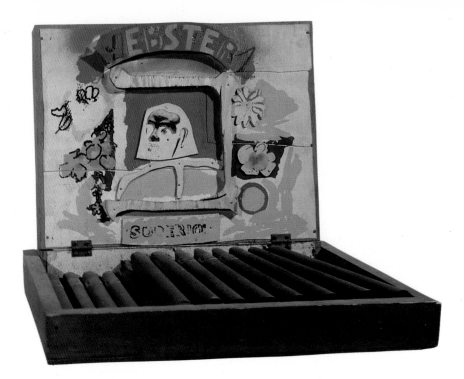

*FIG. 98. Larry Rivers, *Webster and Cigars*, 1966. Mixed media and collage on wood, 13¼″ × 16″ × 13¼″. Collection of the artist.

agents. In order to distinguish a product or establish an image for it, manufacturers often selected a name whose frame of reference could be exploited—and ultimately displaced—by the product. With due regard for the absurdity of such trademark appropriations as Camels, Dutch Masters, and Webster's, Rivers gives evidence of the transformation of an exotic animal, a Rembrandt painting, and a portrait of an American statesman into icons of commerce [Fig. 98]. Rivers also parodies the self-aggrandizement of commodity advertising: the use of classifications like *superior* or *deluxe* to describe inexpensive merchandise and the use of national or foreign prestigious figures to identify basically commonplace products. Rivers's choice of imagery also reveals the odd cultural associations that some brand names embody, as in the adoption of a North African dromedary or group of Dutch syndics for American products.

Despite these oddities, brand names often become such strong signifiers of their manufacturer's homeland that they effectively serve as cultural emissaries. This is the theme of Rivers's *The Friendship of America and France (Kennedy and de Gaulle)* (1961–62) [Fig. 99]. Here Rivers also implies that international goodwill is promoted as much by the exchange of mundane products as by high-level presidential politics. Even though the Kennedy style gave America a certain cultural cachet in the minds of Europeans, Rivers ironically suggests that things like American cigarettes (much coveted by European smokers) and brand-name commerce lay at the root of American-European relationships. Without question, the proliferation of American brand names contributed to international perceptions of America's economic, political, and social strength during the postwar era.

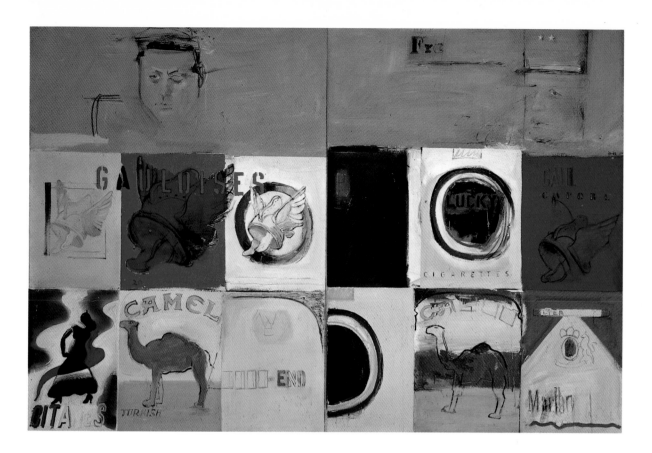

*FIG. 99. Larry Rivers, *The Friendship of America and France (Kennedy and de Gaulle)*, 1961–62. Oil on canvas, 51½″ × 76½″ × 4⅜″. Collection of Marc and Livia Straus.

Camels, Hydrox, Pepsi, 7-Up, Coke, and Campbell's—as images in postwar art, all call attention to American tastes, values, and achievements, while presenting a viable alternative to the European standards that had long dominated art. In addition, these images signify the American brand-name phenomenon, an institution central to capitalism (in marked contrast to communism) and inextricably allied with the flourishing consumerism of postwar America.

A consumer ideology had first been enunciated in the United States in the 1920s. But not until the 1950s did consumerism become a pronounced part of American life.[16] The new ideology marked a dramatic shift from the entrenched Protestant ethic, which was premised on thrift and moderation. Encouragement to consume was facilitated by the growth of mass media, especially television, where a surfeit of ads promoted all sorts of products, and a stream of quiz programs (like "The Price is Right" or "The Big Payoff") sanctioned excessive spending and material acquisitiveness. In addition, the federal government itself advocated spending, at first to complement the high volume of production that was a part of the postwar boom, and then to stave off a recession. Unleashing a national offensive, spearheaded by the slogan "You Auto Buy," President Eisenhower in 1958 transformed consumer buying into an American duty.[17] Big-ticket items like cars, houses, and appliances and weekly supermarket purchases were both targets of the general directive to buy rather than save. Instead of denying or postponing the pleasures of ownership, Americans were urged to go out and experience the national prosperity firsthand.

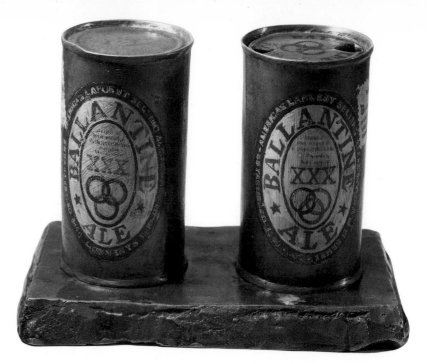

FIG. 100. Jasper Johns, *Painted Bronze*, 1960. Painted bronze, 5½″ × 8″ × 4¾″. Museum Ludwig, Cologne.

The consumer spirit coupled with the postwar cultural consciousness produced a change in the art world as well. Where there was previously little interest in vanguard art, now there was enthusiasm and a thirst for buying. Major collectors numbered around two dozen in 1945, about two hundred in 1960, and over two thousand in 1970. The gallery system kept pace: in New York alone the coterie expanded from around twenty in 1960 to more than two hundred in 1970.[18] Even more significant was the emergence of an active American "art market" that involved a broadening spectrum of buyers whose considerations were monetary as well as aesthetic. Contemporary art entered the world of big business, acquiring notable value as an article of commerce.

Consumerism within American culture, if not explicitly within the art world, inspired Jasper Johns's *Painted Bronze* (1960) [Fig. 100], a pair of handpainted bronze Ballantine ale cans made in response to a remark by Willem de Kooning about gallery owner Leo Castelli's ability to sell anything—even beer cans. The bonds between art and commerce, and the issue of art as commerce, were also addressed head-on by Claes Oldenburg's *Store* project [Fig. 101]. *The Store* was both a studio-workshop and a commercial business set up in a working-class neighborhood and open to the general public on a regular basis for two months (December 1961 through January 1962). Within *The Store*, Oldenburg functioned as artist, manufacturer, salesman, promoter, and manager—a veritable one-man show in which he played all the roles involved in the making and selling of art. In many

ways, *The Store* actualized Oldenburg's sensitivity to commercialization in American culture and in the contemporary art world. As he once wryly commented: "I am for Kool art, 7-Up art, Pepsi art, Sunkist art, 39 cents art, 15 cents art."[19]

The art objects in *The Store* included commonplace merchandise—food, clothing, and souvenir items—as well as advertising signs and sales tags. A preparatory sketch, *7-Up with Cake* (1961) [Fig. 102] encapsulates the mixture, with an American flag affirming the umbrella Americanness of the enterprise. All of Oldenburg's merchandise, however, was crude, deliberately fragmented and sloppy, and one-of-a-kind. His goods, on the one hand, boldly parodied machine technology, reveling instead in the sensuous and expressive richness of handmade creativity. But as products, on the other hand, they subverted highfalutin conceptions of art as pure, beautiful imagery of esoteric or metaphysical import. *The Store*, moreover, poked fun at the art gallery convention of placing works in frames or on pedestals in an austere environment. Oldenburg suspended his pieces from the ceiling, nailed them to the walls, or haphazardly placed them on the floor, on tables, and in the windows. The effect was that of a chaotic, crowded neighborhood variety shop where buying and selling were part of the social hustle-bustle of everyday life. *The Store* faithfully captured the flavor and ambiance of East Second Street, New York City, in all its vulgarity and vitality, its poverty and barter-business intensity. In a curious way, *The Store* referred to both the sustained blight of poverty and Middle America's obsessive consumerism.

FIG. 101. Claes Oldenburg, *The Store*, 1961. Installation, 107 East Second Street, New York.

*FIG. 102. Claes Oldenburg, *7-Up with Cake*, 1961. Mixed media, collage on paper, 15″ × 20″. Collection of Mr. and Mrs. Burton Tremaine.

FIG. 103. Claes Oldenburg, *The Store*, 1962. Installation, Green Gallery, New York.

Oldenburg's second version of *The Store* was installed at the hub of the uptown gallery ghetto on Fifty-Seventh Street in September 1962 [Fig. 103]. The display was much sparser and more orderly, and the exuberant objects seemed almost refined. The painted plasters were joined by gargantuan food items that lent an aura of fantasy and prosperity to the exhibition. This *Store* also caught the atmosphere of its neighborhood, resembling a speciality boutique or showroom where the well-heeled could shop for a sought-after treasure. This was the realm of consumerism as the satisfaction of desire, where buying and selling were leisurely activities nurtured by values other than necessity. This time, then, Oldenburg's parody targeted upper-middle-class American materialism and the sales orientation in the art world.

To capture both the spirit of contemporary art and of consumerist culture, a group exhibition organized by the Bianchini Gallery in 1964 focused specifically on *The American Supermarket*. As *Life* magazine noted in its color spread on the exhibition, it was "a triumphant collision of art and life."[20] It was also a popular success, receiving three thousand visitors in the first two weeks. The exhibition featured brand-name processed products, fruits, vegetables, meats, cheeses, sandwiches, breads, bakery sweets, soft drinks, beer cans, and the like made out of chrome, wax, wood, plaster, bronze, and plastic. Included were the simulated cartons for Brillo, Campbell's Tomato Juice, and Kellogg's Corn Flakes [Fig. 104] by Andy Warhol ($350 each), cases of chrome cantaloupes by Robert Watts ($125 by the piece), and slices of painted bronze watermelon by Billy Apple ($500 each).[21] Items were available in multiples, all methodically stacked, shelved, or cased with appropriate promotional signs and prominently displayed price tags. An impression of plenty and variety abounded.

The supermarket is another typically American creation, distinctive from the open-air markets and speciality shops of other cultures.[22] With its self-service organization and its inventory of prepackaged, fixed-price items, it is an enterprise consonant with the convenience-oriented lifestyle and commercially bound economy of modern America. Though supermarkets were already prosperous by 1950, growth in the suburban population, national food output, and food merchandising and advertising all promoted the dizzying expansion of supermarkets' number, size, and scale of operation.[23] A single store, like the Super Giant in Rockville, Maryland, that served 25,000 customers a week in 1964, stacked its shelves with 7,500 different food items, including 22 kinds of baked beans.[24] In the absence of salespersons, these self-service commodity palaces rely on brand-name familiarity and the appeal of package persuasion to move inventory. These superstores also promote pure consumerism, with displays to encourage shoppers to purchase more than necessary and to select giant-sized or multipack products.

While the Bianchini exhibition was telling in its celebration of the American supermarket, a broader reflection of the values associated with the supermarket is depicted in much of the art of the period. In a synoptic way, for instance, Warhol's *Boxes* exemplify the notions of high-volume sales, commodity abundance, and package primacy. Once again, Warhol conveys that mass consumption is as much a matter of package appeal as product appeal.

★FIG. 104. Andy Warhol, *Brillo, Campbell's Tomato Juice, and Kellogg's Corn Flakes Boxes*, 1964. Silkscreen on wood, 10″ × 19″ × 9½″; 20″ × 20″ × 17″; 25″ × 21″ × 17″. Private collection, courtesy of Charles Cowles Gallery, New York.

*FIG. 105. Peter Saul, *Icebox*, 1960.
Oil on canvas, 69″ × 58½″. Courtesy
of Allan Frumkin Gallery, New York.

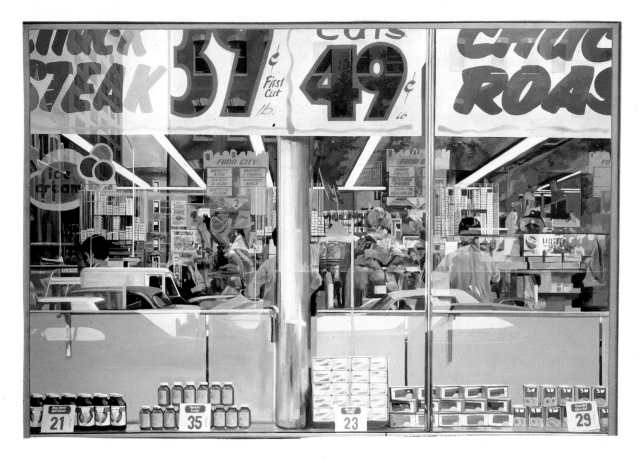

*FIG. 106. Richard Estes, *Food City*,
1967. Oil on masonite, 48″ × 68″.
Akron Art Museum, Akron, Ohio.
Museum Acquisition Fund.

The essence of the supermarket also underlies Peter Saul's painting *Icebox* (1960) [Fig. 105]. By filling his Freezo-rama to the gills with an assortment of commodities that include a hide-a-bed, a table lamp, and anatomical parts, Saul parodies the indiscriminate panoply of products stocked by supermarkets and the dense clutter of their spatial layouts. The excessive amassments of a single item mimic the overindulgent quantity buying provoked by bargain sales, and his comic speech balloons suggest some absurd self-advertising scheme. Rather than specify known products, Saul spoofs the brand-name concept by his blurred labels and cleverly nonsensical designations, such as "Brand 4" and "Pry."

Saul's painting vivifies sociology's clichés about American consumerism as having become out of control during the 1950s and 1960s. Vance Packard and other social commentators tended to blame the increasingly sophisticated manipulative techniques employed by advertisers. But Arthur Miller, in

The Price, placed America's spending mania in a disquieting, psychoreligious context. His protagonist Solomon muses: "You see the main thing today is—shopping. Years ago a person, he was unhappy, didn't know what to do with himself—he'd go to church, start a revolution—something. Today you're unhappy? Can't figure it out? What is the salvation? Go shopping!"[25] For whatever reasons, many Middle Americans considered shopping second only to watching television as the leisure activity of choice.

Richard Estes's paintings of storefronts show how the shopping habit is encouraged by window displays and promotional signs. The glass frontages, which dissolve the boundary between exteriors and interiors, make the products more immediate, more accessible, almost tangible. Estes exaggerates the disorienting-reorienting power of the windows and their display appeal. In *Food City* (1967) [Fig. 106], windows give visual access to the entire store and its profusion of commodities, and

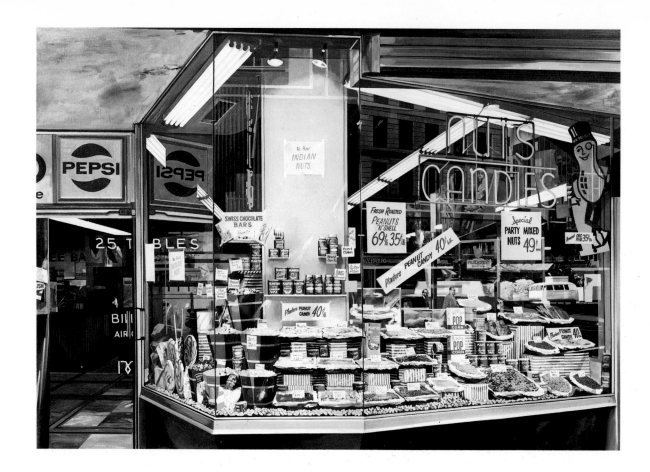

FIG. 107. Richard Estes, *The Candy Store*, 1969. Oil and synthetic polymer, 47¾″ × 68¾″. Whitney Museum of American Art, New York. Purchased with funds from the Friends of the Whitney Museum of American Art.

in *The Candy Store* (1969) [Fig. 107], the glass showcases an abundant sampling of the available merchandise. The prominent price tags, which boldly advertise bargains and specials, testify to the centrality of prices in the American consumer economy. In no other culture are prices blazoned with such forthrightness and verve.

Another aspect of American consumerism is the curious mix of conspicuous consumption—purchases motivated by quantity, size, or extravagance—and conformist buying, the desire for commodities that adhere to mainstream tastes. In *The Organization Man*, William Whyte called the latter "inconspicuous" or "other-directed" consumption and cited as evidence a newspaper ad for Gimbel's department store:

The 'Booming Middle Class' is taking over—and no longer are we living up to the Joneses (Chauncey Montague Jones et familia)—we're living down to the Joneses (Charlie Jones and the wife and kids). It's bye-bye, upstairs chambermaid—ta, ta, liveried chauffeur—good riddance to the lorgnette, limousine, and solid-gold lavatory. The new Good Life is casual, de-frilled, comfortable, fun—and isn't it marvelous. Gimbel's is all for the bright, young, can't-be-fooled Charlie Jones.[26]

For Whyte, the urge to *buy* like everyone else was inextricably bound to the urge to *be* like everyone else. Consumer me-too-ism, nurtured by advertising, was another example of the organizational mentality of postwar American society. Even as Americans moved up the economic ladder, they re-

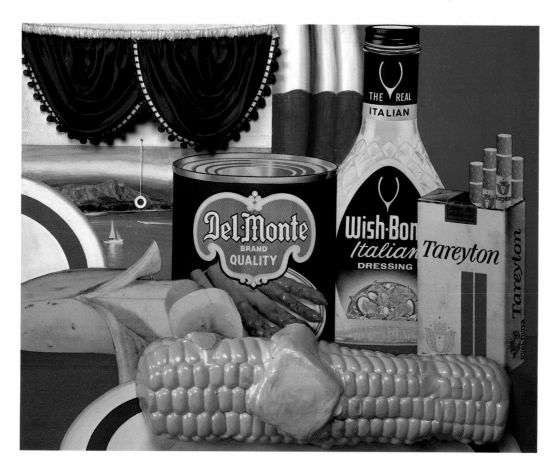

*FIG. 108. Tom Wesselmann, *Still Life #24*, 1962. Acrylic polymer, collage, and assemblage on board, 48″ × 59⅞″ × 7⅞″. The Nelson-Atkins Museum of Art, Kansas City, Missouri. Gift of the Guild of the Friends of Art.

tained the habits of conformist buying and the consumer preferences of the mass middle.

It is precisely this sensibility that Tom Wesselmann portrays in his *Still Life* paintings. From the array of food on the tables (Americanized versions of European fruit and flower arrangements) to the room furnishings and window views, the imagery exemplifies the Middle American Good Life. These are the homes of middle-class Americans whose purchases have been well conditioned by mainstream and mass media values. In *Still Life #24* (1962) [Fig. 108], the Del Monte canned asparagus, Wishbone salad dressing, and corn on the cob would meet a Charlie Jones's conception of eating pleasure, based on convenience foods and established brand names, and the design of the curtain would satisfy Mrs. Jones's ideal of interior decor, based on advice from a popular magazine like *Ladies' Home Journal*. Even greater conventionality rules the kitchen in *Still Life #30* (1963) [Fig. 109], though the pink G.E. refrigerator denotes a token assertion of individuality or an attempt to upgrade according to the latest fashion, and the framed reproduction of Picasso's *Seated Woman* signifies the middle class's burgeoning interest in modern art.

Like so many of the paintings of the period, Wesselmann's still lifes affirm the high American standard of living. The variety, size, and quantity of the fresh, canned, and packaged foods give evidence of agricultural abundance, factory productivity, and a thriving consumer economy.

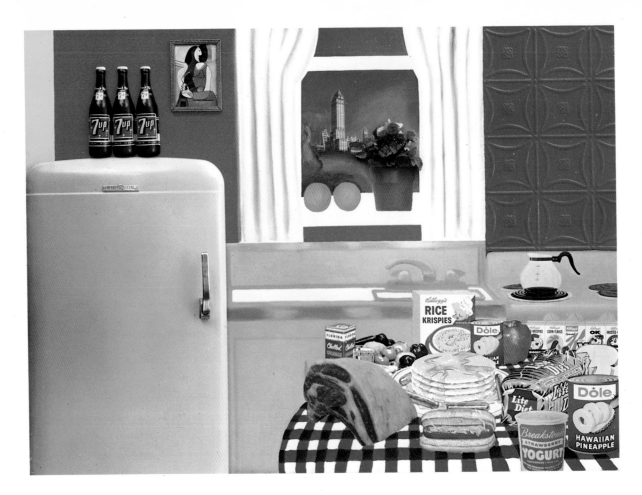

★FIG. 109. Tom Wesselmann, *Still Life #30*, 1963. Oil, enamel, and synthetic polymer paint on composition board with collage of printed advertisements, plastic artificial flowers, refrigerator door, plastic replicas of 7-Up bottles, glazed and framed color reproduction, and stamped metal, 48½″ × 66″ × 4″. The Museum of Modern Art, New York. Gift of Philip Johnson.

Although Wesselmann undermines the seriousness of a celebratory tone by his excessive use of clichés, absurd pastiches, and ironic advertising cut-outs (images from subway posters and other promotional materials), an upbeat Americanism prevails. Indeed, these compositions mirror the national mood, an exuberant patriotism enspirited by the new young president. In the Kennedy years, America's international prestige was a national preoccupation, especially the superiority of American life and the American economic system compared to Soviet life and the communist system. Without taking a political stance, American artists pay tribute to this superiority by focusing attention on precisely that realm in which America was un-

equivocally the world leader. While the USSR suffered scarcity and stagnation, the U.S. excelled in the production of food and consumer goods. While the USSR struggled to feed its own people, the U.S. exported its surplus manufactures abroad. And while Soviet workers scrimped to buy generic products from state-controlled stores, Americans freely chose from a variety of prestigious, brightly labeled brand-name goods.

Artists' representations of food and American-style marketing thus highlight a realm of unequalled American success and prowess. The imagery exudes a material well-being, a semblance of comfort, the glorious side of American affluence. And yet, the exaggerations and parodies provoke

awareness of a disquieting underside—the excesses and conformity, the denaturalization and commercial dominance. Above all, it is this dualism that makes the images so visually intriguing and historically important.

NOTES

1. Thiebaud, quoted in John Coplans, *Wayne Thiebaud*, exhibition catalogue (Pasadena, Calif.: Pasadena Art Museum, 1968), 26.
2. Daniel J. Boorstin, *The Americans: The Democratic Experience* (New York: Vintage, 1974), 432; and "The Burger That Conquered the Country," *Time* 102 (September 17, 1973): 84.
3. The first TV dinner—turkey, sweet potatoes, and peas—appeared in American markets in 1954.
4. Baskin-Robbins, for example, began in 1945 in California. In 1948 it franchised its operations and adopted the thirty-one-flavor concept (one for each day of the month). By the mid-sixties there were more than 400 Baskin-Robbins stores throughout the country.
5. The subsequent development of advertising agencies advanced the brand-name phenomenon and redoubled attention to product design. As Boorstin notes, "the first campaign to feature a staple food that was nationally branded, boxed in individual packages, and ready for consumption" was organized for the National Biscuit Company's "Uneeda Biscuit" in 1899. Boorstin, *The Americans*, 147.
6. *Time* 80 (October 12, 1962): 85.
7. In *Babbit* (1922) Sinclair Lewis denotes this tendency in his main character, an upwardly mobile Middle American who processes his experience and aspirations through brand-name products.
8. *Time* 84 (November 20, 1964): 66–67; and *Time* 84 (July 31, 1964): 58–59. By 1964 Campbell's had plants in Britain, Italy, Belgium, France, Mexico, and Australia.
9. Initially, Campbell's ads appeared on trolley car posters, first in one out of every three trolleys in New York City, and within three years in 378 cities throughout the country. For a discussion of the company's history, see David Powers Cleary, *Great American Brands* (New York: Fairchild, 1981), 53–59.
10. Warhol seems to have abided by the Campbell's Soup advertising message. In a 1963 interview, he recalled, "I used to drink it. I used to have the same lunch every day, for twenty years. I guess, the same thing over and over again." Gene R. Swenson, "What Is Pop Art?" *Artnews* 62 (November 1963): 26.

11. In an article discussing the "coming of age of automation," *Time* declared that "1961 was, above all, the year that automation took hold of the economy and shook it from top to bottom," *Time* 78 (December 29, 1961): 50. The term *automation* was coined in 1946, and computers were first marketed in 1950. There were 20 computers in service by 1954; 1,250 by 1957; and 35,000 by 1967. William E. Leuchtenberg, *A Troubled Feast: American Society Since 1945* (New York: Little, Brown, 1973), 44.
12. Warhol, in Swenson, "What Is Pop Art?" 26.
13. Statistics provided by Coca-Cola, Atlanta, Georgia. For a history of Coca-Cola's development, see *Time* 55 (May 15, 1950): 28–32; Cleary, *Great American Brands*, 61–74; and Craig Gilborn, "Pop Iconology: Looking at the Coke Bottle," *Icons of Popular Culture* (Bowling Green, Ohio: Bowling Green University Press, 1970), 13–28.
14. *Time* 55 (May 15, 1950): 28.
15. According to a survey conducted in 1949, only one in four hundred persons was unable to identify a picture of a Coke bottle. E. J. Kahn, *The Big Drink* (New York: Random House, 1960), 155–56.
16. For a discussion of the history of consumerism, see Stuart Ewen, *Captains of Consciousness: Advertising and the Social Roots of the Consumer Culture* (New York: McGraw Hill, 1976).
17. Paul A. Carter, *Another Part of the Fifties* (New York: Columbia University Press, 1983), 35–38.
18. Figures on collectors and galleries from Steven W. Naifeh, *Culture Making: Money, Success, and the New York Art World*, Princeton University Undergraduate Studies in History 2 (Princeton: Princeton University, 1976), 107 and 81.
19. Claes Oldenburg, *Store Days* (New York: Something Else Press, 1967), 41.
20. *Life* 57 (November 20, 1964): 138–44.
21. The exhibition also included "non-art" display replicas of foodstuffs made by commercial artists. The "art" and "non-art" items were set side by side without distinction.
22. Like many other American business practices, supermarkets spread to Europe in the 1950s and 1960s, part of what *Time* called "a second renaissance"—this one under the American influence. *Time* 80 (July 13, 1962): 16.
23. In its cover story on A & P, the leader in the industry, *Time* noted that "next to General Motors, the A & P sells more goods than any other company in the world," *Time* 56 (November 13, 1950): 89. For a detailed report on supermarkets, see Rom J. Markin, *The Supermarket: An Analysis of Growth, Development and Change* (Pullman: Washington State University Press, 1963).
24. "Prosperity—1964. It's Unprecedented," *Life* 57 (October 16, 1964): 36.
25. Arthur Miller, *The Price* (New York: Viking, 1968), 41.
26. Ad in the *New York Times*, January 10, 1954; quoted in William H. Whyte, Jr., *The Organization Man* (New York: Simon & Schuster, 1956), 313.

U · S · A ·

American Mass
Media

The extraordinary impact of the mass media on American culture in the period after World War II cannot be overestimated. Only hyperboles like "media explosion" or "media revolution" are adequate to describe the dynamic technological developments in the print and electronic media, and the effects of these new modes and patterns of communication on human perception and experience. As never before, newspapers, magazines, comics, movies, radio, and television inundated the environment with messages and images. The mass media became not only a major presence in the everyday life of everyday Americans but also a major power in American society. Far more than just providing entertainment and news, the media influenced events and ideas, determined tastes and choices, and established models and myths.

Television, which burst on the scene like a meteor, was the central force of change. Within a few short years, television became a dominant part of American culture. In 1947 only 75,000 homes had television sets; by 1967 over 95 percent of American homes had at least one—55 million sets in all. Americans also spent more of their leisure time, of which they had more to spend, watching television. By 1956 an estimated 75 million adults watched television for an average of over eighteen hours a week. Although television initially had an adverse effect on the public's interest in radio, movies, and newspapers, it ultimately served as a catalyst, reinvigorating the other media and amplifying the mass media explosion.

In *Understanding Media: The Extensions of Man* (1964) and other books, Marshall McLuhan, the leading exegete of the media age, hailed the advent of the "global village." The modern media would create a new state of connectedness, he explained, by enabling millions of people to simultaneously see a given image and to witness events as or just after they occurred. Remote environments, historical circumstances, and public personages would acquire new immediacy and unprecedented familiarity. As the bounds of experience were extended, individuals would become less isolated.

The mass media did open up the larger world to the American audience, but electronic experiences were secondhand and flat compared to in-the-flesh experiences. The mechanically reproduced images enabled audiences to see people and events, but at a distance and from a prescribed point of view. Direct engagement yielded to vicarious involvement, and interpersonal, active communication was replaced by an impersonal, passive receptivity. On the one side of the screen was a programmed voice

and panoply of packaged images, on the other an anonymous audience.

As programmers began to exploit the visual richness of the new electronic medium, they shied away from extended narrative or analytical interpretations in favor of glance-oriented presentations that had immediate eye appeal. Information was arranged in brief, simple units: a single image, a thirty-second spot, a highly edited segment, a flash message. The brevity and simplicity of the images in turn allowed rapid cutting from topic to topic. This quick-cut style soon became the norm for news, entertainment, and advertising, and effectively blurred distinctions between them. The intermingling of live and taped materials, scripted and extemporaneous performance, on-site and studio settings, casual and formal appearances compounded the indeterminacy. Everything seemed equally real and equally present, though the meaning of such terms as *real* or *present* had become ambiguous.

As commercial enterprises largely dependent on advertising, the mass media were a vehicle for the marketing of products, people, and ideas. The contemporaneous rise of public relations activities in the public and private sectors amplified this promotional aura. There were great profits to be made through the media as well as great advantages to be gained from media exposure.[1] The expanded range and influence of the mass media, particularly television, also opened up new opportunities for achieving celebrity status. American audiences became fascinated by celebrities, and would-be celebrities became obsessed with obtaining media coverage.

While commercial and publicity activities imbued the media with a promotionalist character, news activities imparted an objective tone. In reaction against the muckraking style of journalism that held sway prior to World War II, in the 1950s the media expressly sought to convey a cool, factual stance. The news presentations featured dramatic visual material, but the reporting, especially on television, was purposely neutral, adhering to a consensus attitude. As broadcast journalist Howard K. Smith observed in 1966, "I find an almost excessive lack of bias on television. We are afraid of a point of view. We stick to the American belief that there is an objectivity."[2] In the mainstream press and on television, correspondents avoided stating any opinions or judgments, at least until 1968, when Walter Cronkite stunned the nation by expressing his doubts about the wisdom of government policy in the Vietnam War.[3] Throughout the

fifties and sixties, the public thus became accustomed to seeing the world through the dispassionately impartial mode of news on the one hand, and the seductive, commercial mode of advertising on the other. Often, however, and particularly as production techniques became more sophisticated, the two modes borrowed from one another and from the formula genres of mass media entertainment: comedy, action-adventure, and fantasy.

The pronounced focus of American mass media coverage was American: American lifestyle, American products, American celebrities, American sports, American music, American cinema, and American politics. International news and information about foreign cultures were given short shrift. Henry R. Luce had in the 1920s and 1930s developed a model for the Americanist mass-market magazine. *Time* (founded in 1923) and *Life* (founded in 1936) sought both to ennoble America and to develop a unified national voice.[4] Eschewing regional concerns, Luce's publications spoke to and about the country as a whole, reflecting and shaping a mainstream American ethos. These widely read publications were influential in promoting a national identity and thereby accelerating the Americanization of America. During the postwar years, television even more effectively defined the national character and enunciated mainstream values and standards.

The expansion of the media also enabled a greater spectrum and proportion of the population to share a common pool of information and images. But this pool became progressively more uniform as the major media's dependence on advertisers and ratings demanded that programming appeal to the mass middle. Diversity further diminished due to consolidations in the media industry. Many independent local and regional newspapers and radio and television stations were acquired by larger organizations. Others, unable to remain competitive in the new marketplace, went out of business. Now a few large publishing chains, national broadcasting networks, wire services, and syndicated features dominated.[5] Frequently, the same news story or photograph appeared in virtually identical form in various periodicals and on all three networks. One upshot of the media revolution was the notable degree of repetition, replication, saturation, and uniformity.

The mass media dramatically changed the way people saw, thought about, and experienced the world. The generation of artists who emerged during the postwar media explosion responded in turn by creating art that proposed radically new ideas

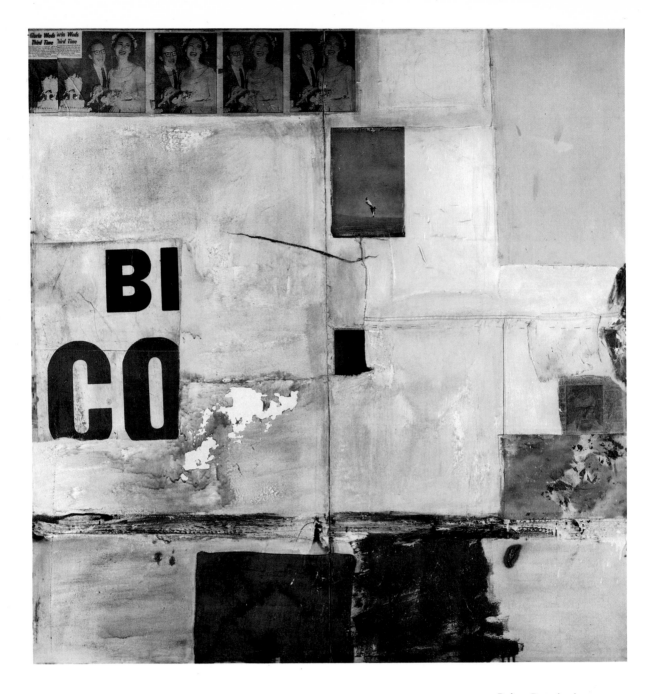

FIG. 110. Robert Rauschenberg, *Gloria*, 1956. Oil and paper collage on canvas, 66¼″ × 63¼″. The Cleveland Museum of Art. Gift of The Cleveland Society for Contemporary Art.

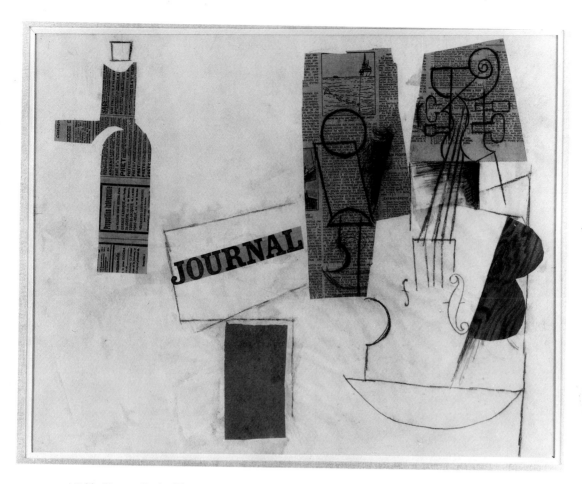

FIG. 111. Pablo Picasso, *Bottle, Glass
and Violin*, 1912–13. Charcoal with
pasted papers, 18½″ × 24⅝″. Moderna
Museet, Stockholm.

about pictorial representation and visual percep-
tion. For example, in *Gloria* (1956) [Fig. 110],
Robert Rauschenberg follows in the line of collage
experimentation inaugurated by the Cubists and
Dadaists. But Rauschenberg's choice of a newspa-
per photograph of Gloria Vanderbilt and his four-
fold repetition of the illustration herald new inten-
tions and techniques.

In a Cubist composition such as Picasso's *Bottle,
Glass and Violin* (1912–13) [Fig. 111], newspaper
cuttings provide texture, reference to the café mi-
lieu that Parisian artists inhabited, verbal content
(the masthead *Journal* names a particular publica-
tion and is the generic word for newspaper), and
imagery that is not mimetic or invented but a frag-
ment of reality itself. The use of everyday mate-
rials also asserts a new attitude toward artistic crea-
tivity and a new dialectic between art and life.

Dadaist collages, such as Hannah Höch's *Cut with
the Kitchen Knife* (1919) [Fig. 112], similarly bor-
row pictorial and typographic elements from news-
papers and magazines but to create trenchant anar-
chistic statements. Using such techniques as
fragmentation, recombination, and juxtaposition,
Dada artists gave intensified expression to the dis-
order and irrationality they perceived in modern
society.

Although Rauschenberg's collage builds upon
these premises, his imagery refers to America's fas-
cination with social celebrities. The headline "Glo-
ria Weds Third Time" brings into focus an ironic
interplay between various kinds of repetitions: re-
marriage, mass production, and media replication.
Unlike a portrait, a newspaper photograph appears
in multiples and functions as expendable, throw-
away matter. The news photo thus subverts both

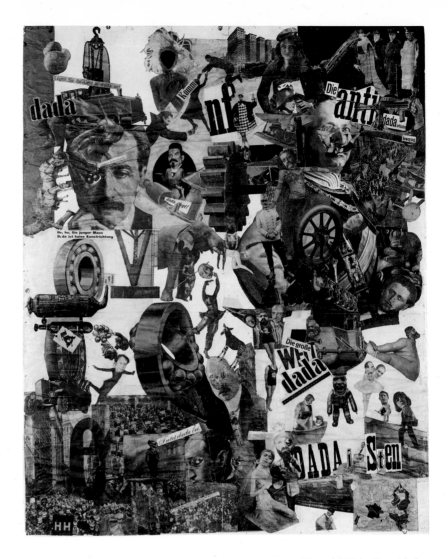

FIG. 112. Hannah Höch, *Cut with the Kitchen Knife*, 1919. Collage of pasted papers, 44⅞″ × 35½″. Nationalgalerie, Staatliche Museen, Berlin.

the idea of a unique visual representation or an exclusive experience and the notion of permanence. Rauschenberg's repetition also alludes to the surfeit of mass media information and the redundancies therein. And unlike the Cubists' use of newspaper fragments or the Dadaists' media amalgamations, Rauschenberg's appropriation of the complete news photograph retains and emphasizes the original iconographic content. The Cubist and Dadaist typographic focus and proclivity to fracture images here gives way to an interest in the iconic integrity of the borrowed image.

While European art provided one source for the development of mass media imagery in postwar American art, notable precedents in American art from the 1920s and 1930s provide more relevant parallels in terms of image presentation and content. Of particular significance are compositions by Gerald Murphy and Stuart Davis. In *Within the Quota* (1923) [Fig. 113]—a work designed as the backdrop for a ballet production—Murphy parodies the charged telegraphic style of tabloid journalism as well as the tabloids' penchant for sensationalist coverage of romance, crime, disaster, and

FIG. 113. Gerald Murphy, backdrop
for the ballet *Within the Quota*, 1923.

scandal.[6] His pastiche incorporates exaggerated
headlines in a grand-scale format that packs an im-
mediate emotional and visual punch. The pointedly
American content and extravagantly American pre-
sentation prefigure the postwar generation's inter-
est in the condensed, compelling imagery of
American comic strips, advertisements, and mov-
ies. Murphy's composition is also prototypic in its
upbeat attitude toward American mass culture and
in its treatment of the newspaper image not as a
motif but as the art object itself.[7]

A comparably simplified, direct pictorial style
was adopted by Davis in *Lucky Strike* (1924) [Fig.
87]. Using an unfragmented newspaper page as
subject matter, he highlights such favored Ameri-
can mass media features as comics and sports and
displays the assertive layout common to American
dailies. Like Murphy, Davis thus brings a new per-
spective to American art by introducing the mass
media as a subject and mass communications tech-
niques as a presentational mode.

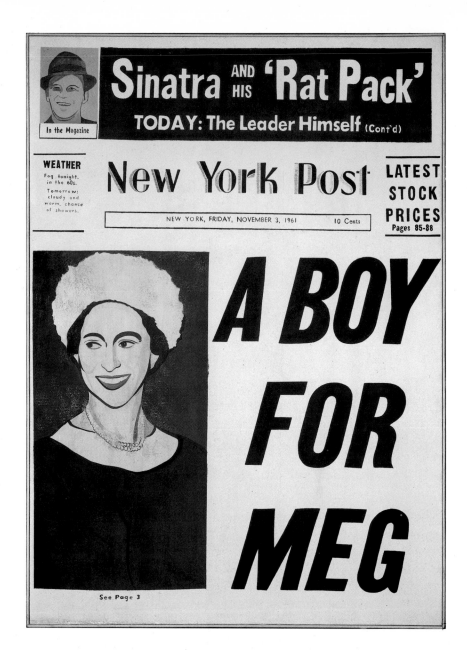

Andy Warhol's *A Boy for Meg* (1961) [Fig. 114], exemplifies the thrust of the postwar mass media orientation in art. Taking the front page of a tabloid as his image, Warhol makes no attempt to change the contents or to obscure the fact that he is offering an exact copy of a mass media product as a work of art. The painting duplicates its newspaper source, nullifying conventions of image originality and allowing the tabloid image to "speak" for itself. The tabloid's format—the mechanical reproduction of bold headlines and photos—aims at instant mass communication. In classic tabloid style, this page-one story concerns a personal event in the life of a celebrity, here a member of the British royal family, who is referred to by a chummy nickname. A single photograph is paired with a three-word exclamatory message set in a typeface that heightens the momentous, hot-off-the-press tone. *A Boy for Meg* transparently conveys both the character and content of this species of mass media communication.

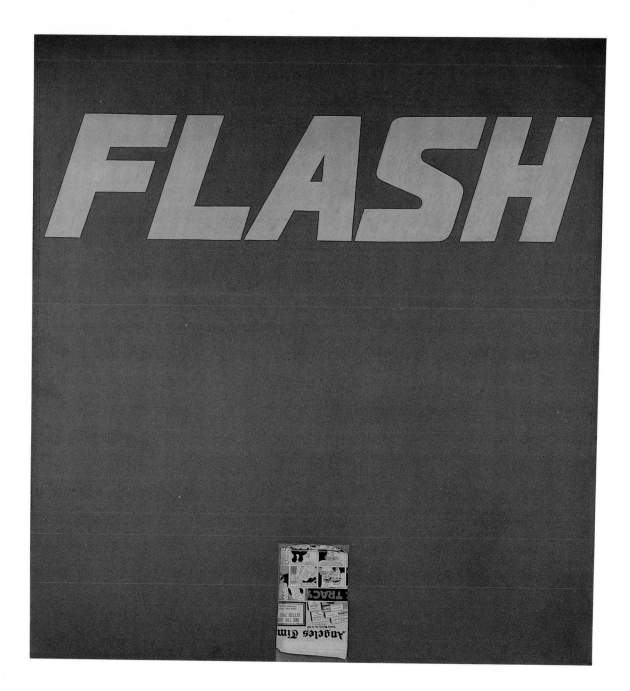

In his painting *Flash, L.A. Times* (1963) [Fig. 115], Edward Ruscha offers an ironic comment on the absurdity of the media's tendency to exaggerate and confound news with entertainment or promotional conceits. Ruscha's point of departure, however, is not a tabloid but the very respectable, conservative *Los Angeles Times*. The speeding, bright yellow FLASH isolated upon a dark field indicates something important and unexpected, something urgent and consequential. But all that appears is a trifling bit of data, a fragment of a newspaper's comics page, an upside-down cutting whose content is incomprehensible and whose figures are indiscernible. The fragment of newsprint ridicules the notion that newspapers are a site for serious discourse, suggesting instead that theatrical display and hyperbole are the essence of mass media communication.

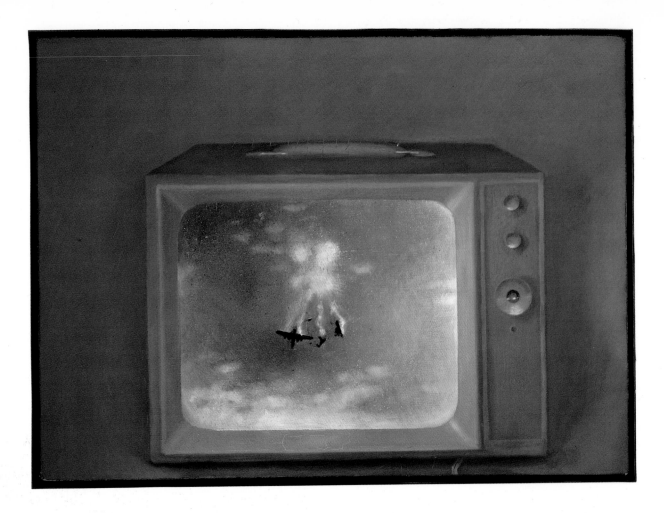

Despite the inherent visual and emotional power of the mass media, their potency is often undermined by the sheer quantity of information, the repetition, and the poor quality of replication. Television in particular effects a desensitization, as its electronic blur reduces the steady stream of images to the same size and texture. Vija Celmins's painting *T.V.* (1965) [Fig. 116] counterposes this prosaic dullness against the medium's theatricality. The composition depicts a television set in the midst of an empty space. All is colored in bland gray tones, the familiar tonality of a black-and-white television transmission. On the screen is the image of violent airplane warfare or an airplane explosion, the type of image frequently shown in television movies or adventure programs, and occasionally on news broadcasts. But the dullness of the grays, the matter-of-fact presentation, the detachment of the event from its context, and the containment of the scene in a framed box distance and deaden the subject. The viewer is exposed to the event, but this experience is indirect and without consequence, for the screen confers a neutral aura upon both the images it represents and the viewers' actual environment. Distinctions between the represented settings and the real world, between fiction and news, between past and present dissolve into a pervasive gray haze. Demarcations of time and place are subsumed within a continuous flow of familiar, nonparticularized sensations.[8]

Without question, television also greatly affected viewers' sense of history, society, and self. Perhaps the most pointed example of this influence was the role television played after the assassination of President Kennedy. For four days millions of Americans lived next to their television sets. All regular programming and commercials were suspended, and the major networks provided twenty-four-hour coverage of the events. Together but separately Americans watched real events unfold: interviews were held, evidence was discovered, unedited statements were made, and the principal suspect was murdered on camera. The mass public was witness to a historic crime, the ultimate instance of detached experience that had the impact of absolute presence and primacy. Moreover, the events were so vividly presented and yet so unbelievably shocking that one questioned if they were real or just staged for television. The repeated showings of the relevant videotapes, the repetition of the facts and suppositions induced an obsessive anxiety and a mesmerizing calm. During those long November days, television functioned as a supreme national communications medium, as an opiate, and as a domestic command post.

Inspired by television coverage of the assassination, Edward Kienholz sought to convey a sense of television's potency in his assemblage *Instant On* (1964) [Fig. 117]. The simulated television set is made of junk materials, an old gasoline can and antenna. This use of junk both undercuts art's pretense to beauty and monetary worth and devalues the role that television had come to assume in American life. The discarded materials also denote material impermanence and human mortality, which go against the grain of America's emphasis on the new, the youthful, and the immortal. Although a confrontation with death is a persistent theme throughout Kienholz's work, the combination of junk materials and the Kennedy experience is especially trenchant.[9]

Direct reference to the assassination occurs on the facade of the gasoline can, where a mock television screen shows pictures of the event: a view of the president's car and the book depository building. Though these images barely reveal signifying details, they were shown so often on television that they serve as instant reminders of the assassination. Television's limitless capacity to develop such cliché images is reaffirmed by the title *Instant On*, which also refers to the assemblage's light bulb. When the bulb is on, the face of Lee Harvey Oswald appears in the window of the Dallas warehouse.

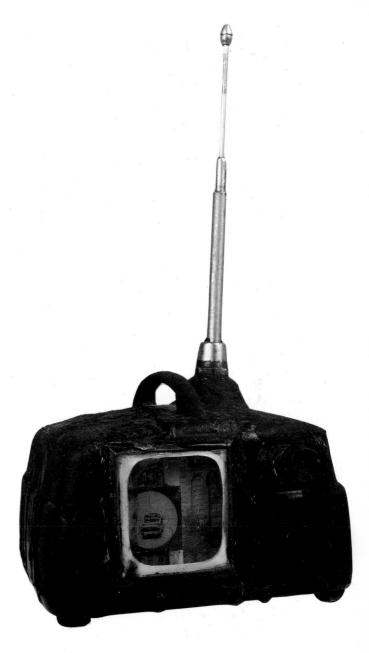

★FIG. 117. Edward Kienholz, *Instant On*, 1964. Fiberglass and flock, electric blanket control, photographs, and antenna, $11'' \times 6'' \times 6''$. Collection of Betty and Monte Factor.

In a related assemblage, *Six o'Clock News* (1964) [Fig. 118], also made just after the assassination, Kienholz focuses more explicitly on the character of television news. Here, a rusted metal container equipped with oversized knobs and a two-ear antenna assumes the identity of a television set, and a toy Mickey Mouse head fills the news anchor's spot. The presence of Walt Disney's animated hero alludes to the popularity of cartoons and comics in American culture and the great success of the television program "The Mickey Mouse Club." But casting the merrymaking rodent as a news commentator brands the network evening news as a simplistic, frivolous, "Mickey Mouse" operation conducted by a corporate puppet whose role is to entertain the viewers. Indeed, until 1963 the nightly network news was only a fifteen-minute interlude, with reporters who did little more than identify the stream of visually impressive images. For Kienholz, American television was basically a giant money-making operation that aimed only to please. Though there was a diversity of channels, all stations covered the same stories and offered the same shallow scripts, which were recited by the parrot-announcers. The implications of this situation frightened Kienholz, reminding him of how the Nazis had used radio to establish and reinforce conformity to the fascist party line.[10]

In her painting *Prime Time* (1967) [Fig. 119], May Stevens also suggests the potential tyranny of television. She couples a brightly lit but blank television screen with a complacent figure—an Orwellian Big Brother or Big Daddy—twin symbols of the authoritarianism and control that can be exerted over a passive population that unquestioningly submits to a "closed attitude towards the world."[11] Even when there is no picture on the screen, the television set diffuses an imposing presence, almost a godlike power. Like the archetypal domineering father, the television is accorded a full measure of dutiful reverence. As Stevens suggests, its oppressive capacity is all the more potent because the medium precludes any dialogue or discussion. Children-viewers simply sit and passively acquiesce to the received body of ideas and values.

Another aspect of television's power in contemporary American life is suggested by Warhol in his painting *$199 Television* (1960) [Fig. 120]. Here the focus is on the omnipotence of consumerism, and the television is shown to be a prime commodity item. In accordance with American custom, the commodity is designated by its brand-name insignia and the sales price hints at a bargain. The image thus highlights television's fundamental character

FIG. 119. May Stevens, *Prime Time*, 1967. Oil on canvas, 52¾" × 42½". Edwin A. Ulrich Museum of Art, Wichita, Kansas. The Wichita State University Endowment Association Art Collection.

FIG. 120. Andy Warhol, *$199 Television*, 1960. Oil on canvas, 62¼" × 49½". Collection of Kimiko and John Powers.

as a commercial medium and the symbiotic relationship between television and advertising.

Television's inordinate power to create new tastes in entertainment is most vividly evident in the case of sports. With baseball, for example, the televising of games, beginning in the late forties, greatly enlarged the audience for the sport and shifted its base from a local to a national level. Baseball, long nicknamed the national pastime, became an at-home spectator sport for many Americans. Television broadcasts also enhanced the profitability of team franchises, as the beloved summer game was transformed into a multi-million-dollar enterprise entwined with major commercial sponsorship and full-scale publicity activities.

By increasing the popularity of professional sports, television created a demand for extended and more visual sports coverage in the print media. As David Halberstam notes in *The Powers That Be*, the sports boom caused by television propelled the faltering magazine *Sports Illustrated* from a debt-ridden loser to a perennial sales champion.[12] The magazine, like many newspapers, provided the new audience of sports fans with large-scale photographs of the amazing feats of their favorite players and with pictorial coverage of the latest sports events.

FIG. 121. Robert Rauschenberg, *Brace*, 1962. Oil and silkscreen on canvas, 60″ × 61″. Collection of Robert and Jane Meyerhoff.

FIG. 122. Ellen Lanyon, *Ya Ya Yogi*, 1962. Oil on canvas, 60″ × 48″. Private collection.

Beginning with combines like *Odalisk* (1955–58) and hallmarked in photo silkscreen paintings like *Brace* (1962) [Fig. 121], Rauschenberg incorporates baseball, notably mass media renderings of the sport, into his panoply of American images. *Brace* focuses on Roger Maris (identifiable by his #9 Yankee jersey), who achieved national celebrity in October 1961 by breaking Babe Ruth's home run record, set in 1927. Interest in this record, amplified by the possibility that Maris's teammate Mickey Mantle might also break it, spurred widespread attention to baseball and extensive media coverage. Rauschenberg's image aptly reflects baseball's special prominence in American culture during the suspenseful 1961 season.

Ellen Lanyon's paintings of baseball players also direct attention to the nature of athletic activities. Her large-scale painted replications of newspaper photographs capture the essence of sports journalism with its high-intensity stop-action mode of display. While such news photographs accentuate a heroic moment of extraordinary skill, their blurriness and the flattening of the pictorial elements into surface patterns often diminish the significance of the nominal imagery. Lanyon's *Ya Ya Yogi* (1962) [Fig. 122], for example, shows the catching dexterity that made Yogi Berra a sports superstar as well as the visual potency of a sports photograph as an abstract composition. The red-white-and-blue banner in the otherwise black-and-white image exaggerates the design character of the painting and, moreover, sets the composition squarely in an American context.

While Lanyon formalizes still photography's split-second freezing of moving action, in *Baseball* (1962) [Fig. 123], Warhol merges the static quality

FIG. 123. Andy Warhol, *Baseball*, 1962. Oil, ink, and silkscreen on canvas, 91½″ × 82″. The Nelson-Atkins Museum of Art, Kansas City, Missouri. Gift of the Guild of the Friends of Art and a group of Friends of the Gallery.

of a newspaper photograph and the movement of film or television kinetics. Experiments with time-lapse photography that would translate movement into a series of still images began in the nineteenth century, Eadweard Muybridge and Etienne Jules Marey becoming well-known practitioners. While chronophotography inspired artists like Marcel Duchamp and the Futurists to create paintings that showed the passage of a figure over time through space, Warhol explores something different. He effects the sensation of a filmstrip sequence of individual frames without, however, denoting progressive action. Here, just the repetition of the exact same single frame unfolds. Warhol has thus delineated a new mass media-inspired form of depicting action, in the process adding an American note to an aesthetic rooted in European modern art. Characteristically, his images offer the irony of action that goes nowhere, action that is purely for show

and bound to a process of mechanical repetition.

Perhaps to even a greater extent than baseball, football was transformed by television. Football's more continuous, more aggressive action better matched the pace and spirit of programs that television audiences were accustomed to watching, and the game rapidly emerged as a favored network offering, a rival to baseball as America's leading sport. The 1966 contract between CBS and the National Football League to televise football games as prime-time weeknight fare was a clear indication of football's popularity.

In *Echo* (1962) [Fig. 124], Rauschenberg uses the action of a football game to manifest vividly the mass media's transformation of the way we see and experience life. With dynamic brushstrokes he combines a newsphoto of a dramatic scrimmage with an image of urban construction and a car key. The sports image conveys the essence of media

FIG. 124. Robert
Rauschenberg, *Echo*, 1962.
Oil and silkscreen on canvas,
60″ × 36″. Private collection.

photography: its immediacy, graininess, the zoom-lens distortions. The frozen frame also discloses details that are otherwise indiscernible, like the position of a football amid a scramble of bodies. But as Rauschenberg suggests by his interruption-riven composition, the visual bombardment of disparate elements and perceptual disorder characterize media coverage—especially television coverage—of sports events. The game's linear progress is constantly and abruptly conjoined with commercials, newsbriefs, and extraneous announcements. Replays and human interest spots further distort the continuity of time, place, and subject. Thus the simple unity of a constricted real-life event gives way to a hodgepodge of broken segments and incongruous juxtapositions.

★FIG. 125. Wayne Thiebaud, *Football Player*, 1963. Oil on canvas, 70″ × 24″. Virginia Museum of Fine Arts. Gift of the Sydney and Frances Lewis Foundation.

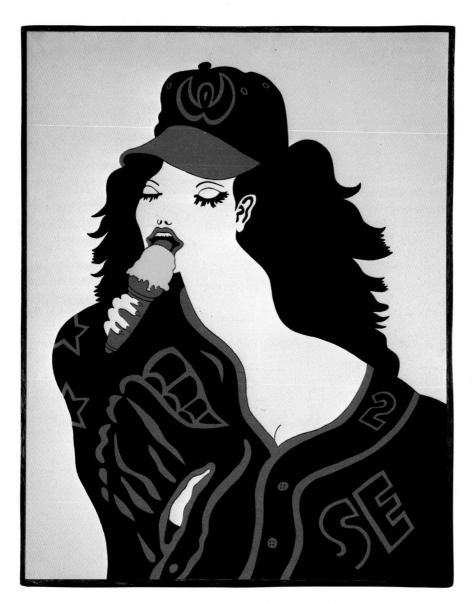

Concentrating on the individual sports hero, Wayne Thiebaud in *Football Player* (1963) [Fig. 125] sets the contemporary athlete in a time-honored art historical context. He portrays the modern-day model of physical excellence with all the directness and intensity, the classical symmetry and self-containment of the Greek monuments to golden-age athletes. But he also invests this modern titan with theatrical effects gleaned from commercial art and photography. The staged positioning of the image, its isolation within a stark white space, and the phosphorescent red-orange highlights from artificial lumination move the hero off the playing field and into the realm of advertising and publicity. The portrayal exaggerates the figure's physical prowess and charismatic presence—the key requisites for merchandising and commercial success.

As Karl Wirsum suggests in *Baseball Girl* (1964) [Fig. 126], the commercialization of sports greatly enhanced its popularity. His image of a sideline fan forgoes concern with the game and attends to the crowd-pleasing core of American sports: costumed pageantry, snack foods, hero worship, and eroticism. Wirsum overtly depicts sexuality as a prime aspect of sports appeal and pokes fun at the mainstream media's veiled treatment of this theme. His style cleverly exaggerates the mannerisms of media promotional techniques, making the image all the more potent and absurd.

The lionization of sports figures was symptomatic of television's expanded role in creating media celebrities. In the 1950s television joined and soon transcended Hollywood and the print media in shaping America's preoccupation with celebrities.

In America celebrity status is not for the most part based on inherited class or wealth.[13] Rather, celebrity is conferred on people whose achievements acquire sufficient publicity; publicity then sustains and advances the celebrity status it has awarded. Networks of mass communication that circulate information to a vast number of people on a daily basis are the cornerstone of such publicity activity. Indeed, the mass media and the public relations industry are natural symbionts. The media are not only outlets for the star system but become involved in creating celebrities to bolster their own prestige. For example, the appearance of the Beatles on "The Ed Sullivan Show" in February 1964 both enhanced the group's career and doubled the program's ratings.[14]

The central task of all public relations efforts is to project a unique but identifiable image.[15] This public image requires the magnification of the individual's intrinsic qualities—skill, appearance, personality, ideas—and, more importantly, the blending of these traits with imposed invented characteristics. The resulting larger-than-life merger of natural and synthetic attributes is then used to promote the individual and elevate him or her to the ranks of star status. During the postwar period, these ranks greatly expanded. In addition to movie stars, figures from such realms as sports, music, art, literature, business, and politics sought and attained celebrity status.

The media can also work to deflate and destroy those same celebrities it helped create. In the 1950s the premier example was the rise and fall of Senator Joseph McCarthy. Catapulted to national attention by press coverage of his anti-communist activities, McCarthy was later demolished by Edward R. Murrow's explosive broadcast of "See It Now" and the televised Army-McCarthy hearings. A less extraordinary case was that of Charles Van Doren, a fledgling academic who rose to instant fame as a whiz on the TV quiz show "Twenty-One" and fell to oblivion when the press revealed that the games were fixed.

The primacy of television in creating, courting, and breaking celebrities augmented the importance of physical appearance in the star-making machinery. Youthful vitality, complimentary clothing, telegenic manners, and healthy complexions all played well—as Richard Nixon belatedly discovered after his first televised debate with John Kennedy.

For many artists interested in the visual dynamics of American mass culture, entertainment figures and their behind-the-scenes public relations strategies were a key source of inspiration. A cult hero like Elvis Presley, for example, held particular appeal, as evidenced in collages by Ray Johnson and paintings by Andy Warhol.

In *Elvis Presley No. 1* (ca. 1955) [Fig. 127], Johnson has embellished a classic publicity photo with red overpainting and a mosaic of colored cutouts. The added elements are both absurd and suggestive. As a counterforce to the black-and-white photograph, the red paint adds drama and a surface coating that recalls the energizing antics and decorative, often flashy clothes for which Presley was famous. The brightly toned mosaic, fragments of an unknown language spilling forth from the singer's mouth implies a reference to Presley's role as the creator of a vibrantly idiomatic style of music. And the blood-red drips streaming down as tears from the idol's eyes become a visual pun on his renown as a teenage heartthrob whose "Heartbreak Hotel" sold a record-breaking eight million copies in six months. Johnson also considered the drips to be a satiric jab at Abstract Expressionist practice: "I'm the only painter in New York whose drips mean anything."[16]

Combining rhythm and blues with country and western, Presley created a unique amalgam of black and white American musical traditions. The lyrics of his songs were imploring and raw as no popular commercial music had ever been, and his libidinous gyrations transgressed mainstream standards of performance, propriety, and public display. In contrast to the crewcut generation, Presley looked the part of a bad boy or a hell-bent lothario with greased hair and hoodlum's sideburns. As in the publicity photo used by Johnson, Presley's image was sensuous but tough, confident but vulnerable—a far cry from the prevailing masculine model heralded by stars like John Wayne.

Presley rapidly gained an enormous following from his concert tours in 1954–55, and then became a national celebrity after his appearances on the Milton Berle, Steve Allen, and Ed Sullivan shows in 1955–56. These live television performances broadly disseminated not just his voice or name but also his physical appearance and stage image. His movie career, which began in 1956 with *Love Me Tender* and extended through thirty-three box-office hits, furthered his familiarity as did the high-powered public relations campaign waged by his manager, Colonel Tom Parker. Presley's extraordinary media coverage itself opened new doors for the use of mass media as a public relations tool.

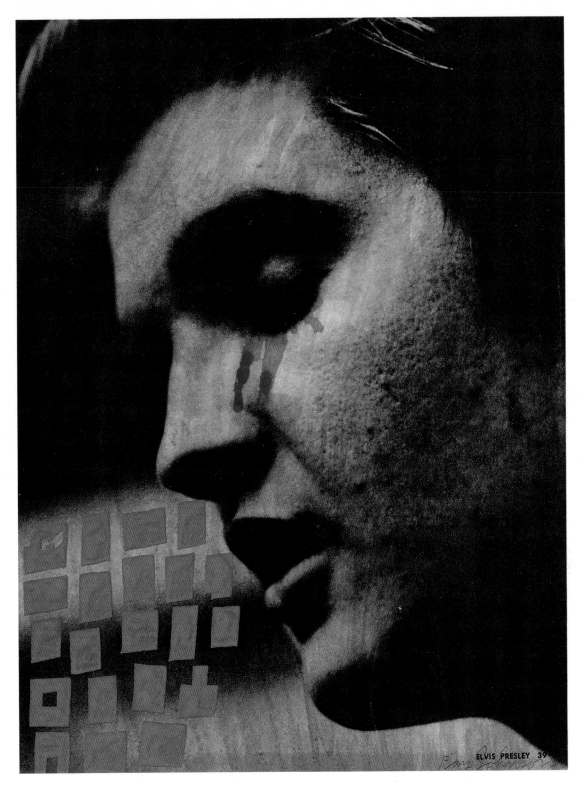

★FIG. 127. Ray Johnson, *Elvis Presley
No. 1*, ca. 1955. Tempera and ink
wash on magazine page, 11″ × 8⅜″.
Collection of William S. Wilson.

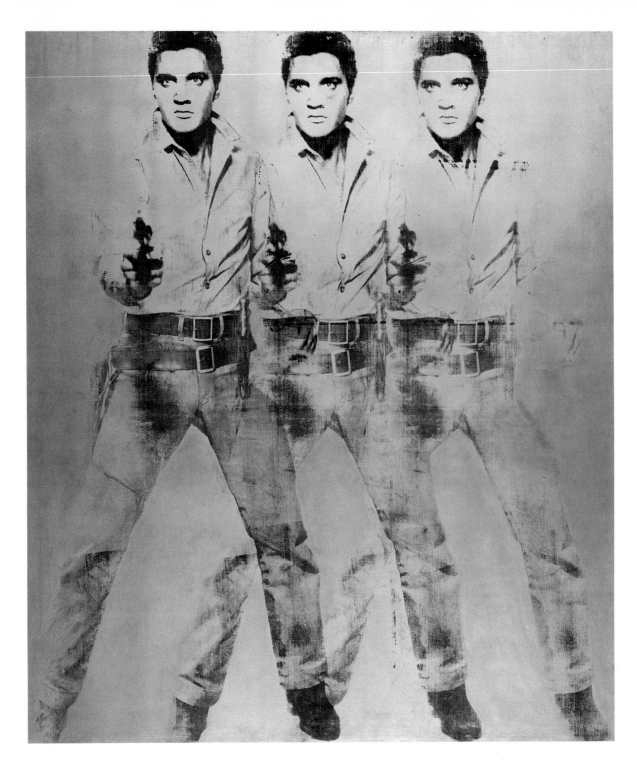

*FIG. 128. Andy Warhol, *Triple Elvis*, 1962. Acrylic and silkscreen on canvas, 82″ × 60″. Virginia Museum of Fine Arts. Gift of Sydney and Frances Lewis.

By the time Warhol created his Elvis paintings of 1962–63, the singer had become enshrined as "The King" and had become a symbol of rebelliousness against staid conventions.[17] His image had also been legitimized by his service in the U.S. Army and by public relations efforts intended to downplay his subversive character and enhance his family appeal.[18]

Warhol's portrayals, like Johnson's, are based on Presley's publicity images, his invented promotional facades. In *Red Elvis* (1962), Warhol selects a photograph that vividly conveys Presley's charisma, his penetrating stare and ambivalently seductive but opaque expression. While Warhol's fiery red coloration adds an element of passion and danger, his repetition of the image, row after row in flawed, thin silkscreen impressions, affirms an artificiality. The image refers to Elvis, the fabricated product designed for mass adulation, the celebrity whose entire being is derived from mass production systems.

For *Triple Elvis* (1962) [Fig. 128], Warhol chooses a pose of Presley as a gunslinging cowboy, a publicity still from the movie *Flaming Star* (1960).[19] Here Warhol uses repetition to create overlapping images that suggest the movement of a film sequence, and he alludes to the movies' silver screen by the silver coloration of his ground plane. The image, slightly larger than life-size and positioned frontally, is dramatically confrontational, with Elvis pointing a gun directly at the viewer. The spread-leg pose adds a decidedly erotic tone to this portrayal of Presley playing Elvis playing the all-American cowboy.

Warhol's depiction of Presley as a pistol-pointing cowboy was quite timely in that westerns were then enjoying extraordinary popularity. Westerns were the stuff of American tradition, history, and legend, providing mythic stories of superhuman courage, aggressive action, and freedom rife with danger. In a 1959 cover story on westerns, *Time* stated: "The western is really the American morality play in which Good and Evil, Spirit and Nature, Christian and Pagan fight to the finish on the vast stage of the unbroken prairie."[20] Beginning with *The Great Train Robbery* (1903), Hollywood had developed the western into one of its most successful formulas, and during the postwar years television injected new life into the genre. The western boom on television began in 1955, and reached a peak by the end of the decade, when thirty prime-time shows, including eight of the top ten, brought rugged American men and the frontier spirit into millions of American homes each week. Television westerns added a contemporary touch to the standard shoot-'em-up by developing psychological or civil rights story lines or creating more explicitly sexual intrigues for their high-in-the-saddle heroes.

Triple Elvis, with its sexually charged portrayal, pays homage to the new American cowboy. The painting also reflects the star system's tactics of role playing and impersonation, of promoting a new image in order to add prestige or diversity to an existing image.

A celebrity who shared Presley's status as a rebel and cult hero, especially among the young generation, was James Dean. Although the actor had starred in only three films before his death at age twenty-four in a car crash in 1955, he had developed a huge following of fervent fans who clamored for anything having to do with him. His first film prompted a story in *Life*, and the front-page news reports of his death only intensified his cult image. In a seven-page article, "Delirium Over Dead Star," published a year after his death, *Life* reported on the scale of memorabilia activity, which included four special-issue magazines, six James Dean records, and a host of souvenir items.[21]

In both *East of Eden* and *Rebel Without a Cause* Dean played the role of a moody, defiant youth whose wild life pitted him against parental and societal authorities. Only a fine line separated Dean's on-screen image and his actual personality—or at least that impression was propagated by his public relations agents. Dean's career, like Presley's, was exemplary of the American star system, and their personas spoke to the rumblings of discontent among the younger generation.

Ray Johnson's collage *James Dean* (1957) [Fig. 129] exploits the emotional and social associations evoked by Dean's image. As in Johnson's Elvis collages, a publicity photo serves as the base of the composition. Dean is posed as a cocky youth whose charisma derives from his lofty detachment and sensuous appearance, his dress and demeanor signifying independence and rebellion. With a cascade of mosaic cutouts that emphasizes Dean's open shirt, Johnson highlights the contradiction between the toughness of Dean's pose and the tenderness of his youthful physique (to wit, his hairless chest). The Lucky Strike emblems, affixed like Mickey Mouse ears, thoroughly undo the seriousness of the actor's image and form a counterpoint to the affected seductive positioning of the cigarette in Dean's mouth. The emblems are abrupt reminders that Dean the rebel was in fact a product of a grand commercial enterprise. Dean, the celebrity, like any consumer product, had been carefully fabricated, packaged, and promoted.

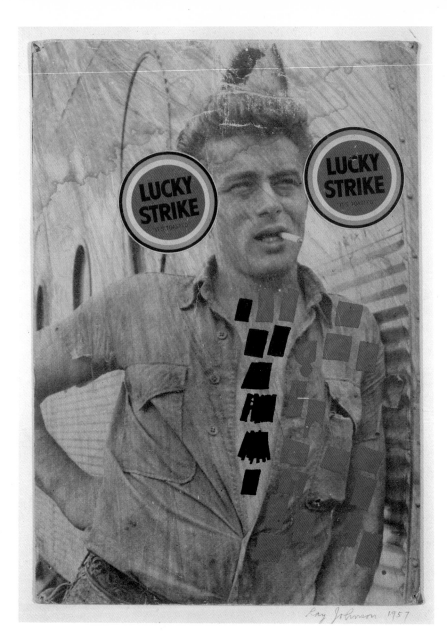

★FIG. 129. Ray Johnson, *James Dean*, 1957. Tempera, collage, and ink wash on magazine page, 11¼″ × 8″. Collection of the artist.

Another well-known example of Hollywood's full-scale construction of a star was Marilyn Monroe. In typical fashion, she was subjected to a complete transformation in order to satisfy the promotion machine. The metamorphosis required a change of name, hairstyle, makeup, physical appearance, deportment, voice, wardrobe, lifestyle, and personality. Once Monroe had been molded into a dumb blonde sex symbol—the archetypal Hollywood role for young female stars—she was cast in movies that restated this image. Her publicity program involved photo sessions, magazine spreads, newspaper interviews, television programs, live appearances, and items in gossip columns. It worked. By the end of 1953 she had made more money for her studio than any other actress in Hollywood, and she was honored as the year's most popular actress. She and her agents were experts at exploiting the media, and the media in turn exploited her to the fullest. The cream of the continuous press coverage of Monroe included a cover story in *Time* and nine *Life* covers (more than anyone except Elizabeth Taylor).

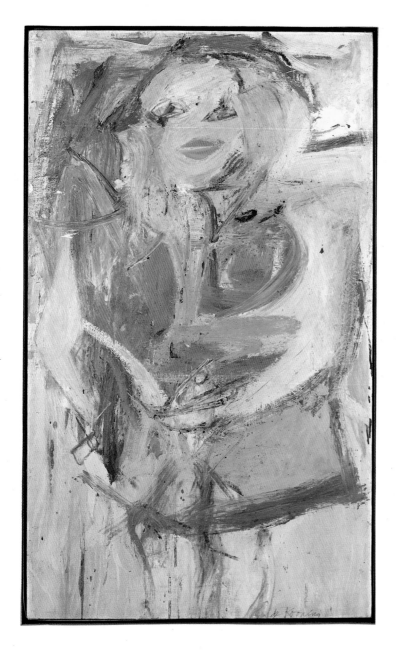

★FIG. 130. Willem de Kooning, *Marilyn Monroe*, 1954. Oil on canvas, 50″ × 30″. Neuberger Museum, State University of New York at Purchase. Gift of Roy R. Neuberger.

Monroe came to epitomize the Hollywood star system of which she was one of the last exemplars. Her success imitated the Hollywood version of the American dream: poor orphan achieves fame and fortune as a fantasy goddess. For many of these reasons, she became a favored subject for artists during the fifties and sixties.[22]

One of the first to be inspired by Monroe was Willem de Kooning, who assimilated her image into his benchmark *Woman* series of the early fifties. Seeking to assert the diverse and often antithetic characteristics of the female image in one compelling iconic presence, de Kooning viewed the Hollywood "pinup girl" as a complement to the figuration of the prehistoric fertility goddess. Both had sensual, buxom bodies and both symbolized sexuality to their respective societies. In *Marilyn Monroe* (1954) [Fig. 130], the full-breasted, smiling blonde embodies the signifying traits of the famed movie idol but also the obscured individuality, the commodity objectification of a generic Hollywood star.[23] De Kooning here manifests an ontological truth about American celebrities, that they are concepts or images rather than actual people.

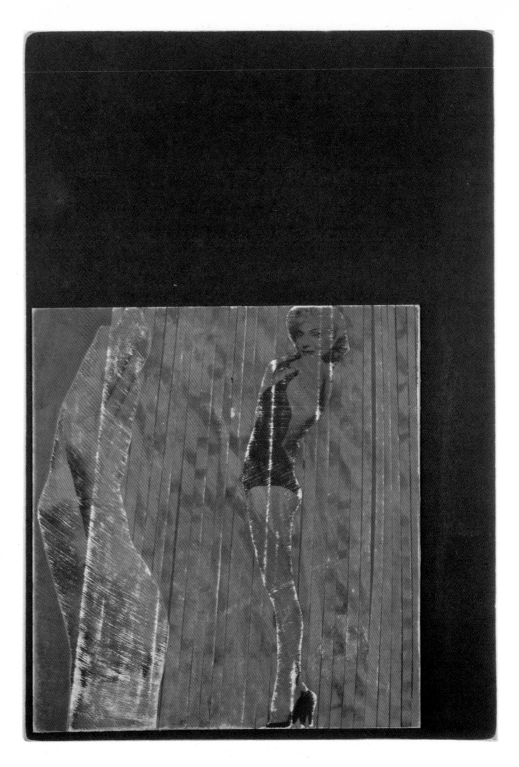

*FIG. 131. Ray Johnson, *Hand Marilyn Monroe*, 1958. Collage with ink wash (sandpapered) on board, 16⅞″ × 13⅛″. Collection of the artist.

FIG. 132. George Segal, *The Movie Poster*, 1967. Plaster, wood, and photograph, 74″ × 28″ × 36″. Private collection.

Ray Johnson's collage *Hand Marilyn Monroe* (1958) [Fig. 131], one of a series based on photographs of the film star, emphasizes the image of her curvaceous form and the notion of sex appeal. While Johnson reveals Monroe's skill in projecting her sexuality, he also parodies it by pairing her profile with that of an upraised hand, positioned as if to caress. The hot-pink coloration, curtain veil of collage strips, and arched hand add allurement, yet as formulated artistic effects they heighten the artificiality of Monroe's posture and demeanor. However, artificiality and reality were hard to distinguish in Monroe's life and career because she and her image tended to merge on camera and off in the best Hollywood fashion. The blurring of such distinctions was a principal concern of artists in the fifties and sixties, who viewed the confusions of contrivance and authenticity as a pervasive aspect of contemporary American culture. Whereas traditional figurative art was premised on mimetic representation, American artists now found themselves in a culture inundated by visual constructs fabricated to make a calculated impression.

It is this concept of the promotional image that makes so much of the art featuring Marilyn Monroe so compelling. In George Segal's *The Movie Poster* (1967) [Fig. 132], a classic publicity poster becomes the object of scrutiny for one of the artist's plaster-cast figures. The poster shows Monroe clad in a slinky low-cut dress that befits her well-endowed body. Her shoulders are thrust forward, her eyes lowered, her mouth open to exaggerate her full lips, and her bleached blond hair is coiffed in a perfect bouffant. She projects the Hollywood rendition of sexuality that such highly contrived superhuman (and inhuman) photographs are meant to insinuate. By pairing Monroe's cutout, flattened, framed photograph with the lifelike form of an ordinary-looking man in a casual pose, Segal reinforces the unreal quality of the poster image. The juxtaposition also incarnates the voyeuristic impulse that the American film industry encouraged.

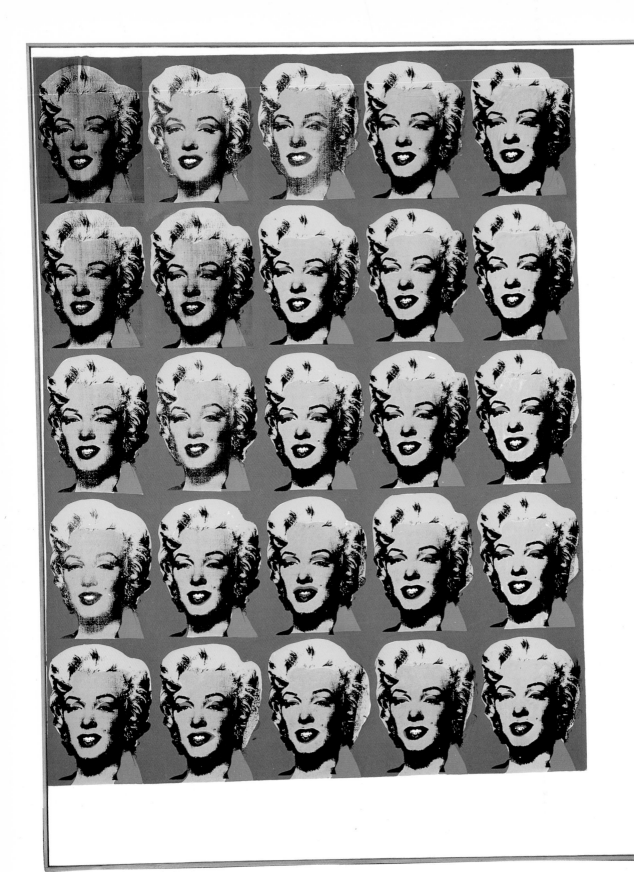

MADE IN U.S.A.

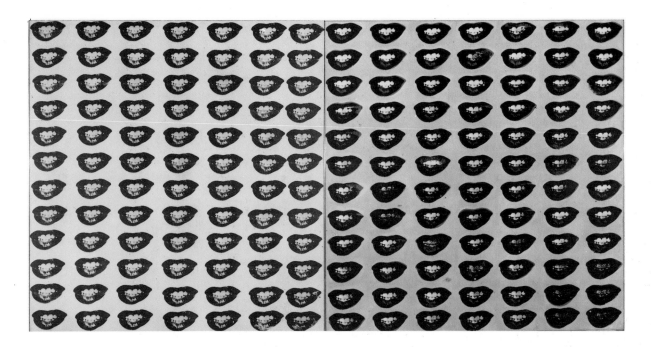

The public was given titillating images that both the publicity agents and mass media hoped would arouse the desire for additional images.

Warhol, in characteristically ironic terms, also makes reference to the self-perpetuating nature of publicity by repeating the same Monroe image in different compositions (enough for a large audience) or within the same canvas. In *Twenty-five Colored Marilyns* (1962) [Fig. 133], he epitomizes the redundancy and insistent garishness of a media blitz. But this imagery demonstrates that the result can subvert the intention, for redundancy often leads to oversaturation, and mass duplication yields unregistered printing with blotchy color masses. Nevertheless, as Warhol (a veteran of the advertising industry) knew, once a successful promotional campaign tantalizes the public, people are willing to accept flawed facsimiles and are stimulated rather than numbed by overexposure.

Significantly, Warhol does not show Monroe's body in his portraits. Her reputation as a sex goddess is expressed by his synecdochic focus on her face, an indirect means of depicting sexuality that adhered to the mass media's self-censorship in the early sixties, when the media still professed a puritanical ethos. In the mainstream media conservatism about the publication of sexual imagery remained strong, often resulting in highly seductive but veiled images. Yet a shift in the media's attitudes toward sexuality and nudity had been foreshadowed by the erotic poses and décolleté dresses that Hollywood and *Life* had parlayed into the pinup phenomenon during World War II. Other early suggestions of a new attitude included *Life*'s publication of a nude calendar photo of Monroe in its first photospread on the starlet in 1952,[24] and *Playboy*'s multiphoto display of the unclothed Monroe in its inaugural issue in 1953.

Warhol captures the media's ambivalent approach to sexuality by chastely showing only Monroe's face but overemphasizing her doe eyes, sensuous lips, and blazing blond hair. Even more telling is his tight closeup of her mouth in *Marilyn Monroe's Lips* (1962) [Fig. 134], which exaggerates into parody both the mass media's titillating mode of sexual expression and Madison Avenue's image of the all-American girl with her full smile and shining white teeth.

FIG. 135. James Rosenquist, *Woman I*, 1962. Oil on canvas, 72″ × 84″. Collection of Anne and William J. Hokin.

James Rosenquist, too, directed attention to the seductive smiling mouth, underscoring its pervasiveness in contemporary American advertising. In *Woman I* (1962) [Fig. 135], the image of glossy come-hither lips dominates, appearing three times, replicating three versions of the promotional cliché. Rosenquist's alignment of the subject Woman and the image of a smiling mouth was undoubtedly inspired by Willem de Kooning's *Woman* series. De Kooning initially derived the smiling-mouth motif from a cigarette ad. After affixing the ad onto a study for *Woman I* (1950), he transformed its decorous smile into the voracious erotic image,

a toothed sexual orifice, that appears in the finished painting.[25] But whereas de Kooning advanced the sexual quotient of an advertising image and subdued the advertising source, Rosenquist did just the opposite. In *Marilyn Monroe, I* (1962) [Fig. 136], for example, the upside-down positioning of the face accentuates such publicity considerations as impeccable form and flawless tonal quality, visible here in both color and black-and-white. In addition, Rosenquist's billboard aesthetic and crisscrossing of the names Marilyn and Coca-Cola imprint an overt commercial tone onto the celebrity's smiling visage.

FIG. 136. James Rosenquist, *Marilyn Monroe, I*, 1962. Oil and spray enamel on canvas, 93″ × 72¼″. The Museum of Modern Art, New York. The Sidney and Harriet Janis Collection.

FIG. 137. Andy Warhol, *The Men in Her Life (Mike Todd and Eddie Fisher)*, 1962. Silkscreen on canvas, 82″ × 82″. The Morton G. Neumann Family Collection.

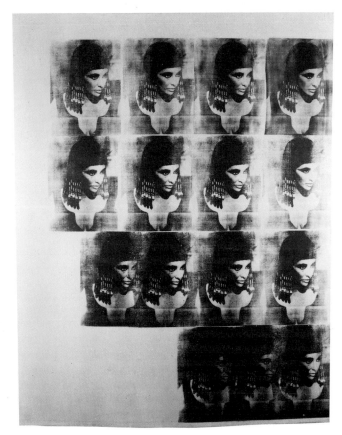

FIG. 138. Andy Warhol, *Blue Liz as Cleopatra*, 1962. Silkscreen on canvas, 82″ × 65″. Private collection.

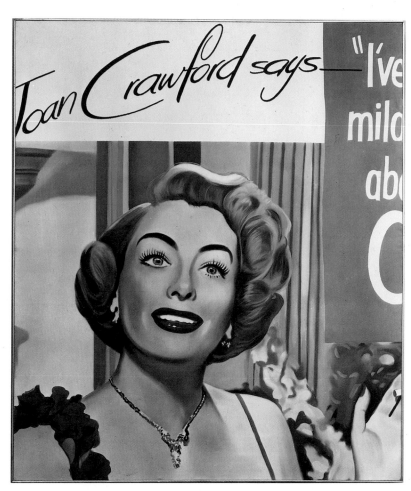

FIG. 139. James Rosenquist, *Untitled (Joan Crawford Says . . .)*, 1964. Oil on canvas, 92″×78″. Museum Ludwig, Cologne.

In his paintings of Elizabeth Taylor, Warhol amplifies the theme of the media celebrity who exploits and is exploited by publicity. Having become a star as a child, Taylor has lived her entire life in the public eye. She has developed her persona as a theatrical individual whose activities warrant media coverage. The media have dutifully reported her various romances, captured by Warhol in *The Men in Her Life (Mike Todd and Eddie Fisher)* (1962) [Fig. 137]; her prima donna status, captured in *Blue Liz as Cleopatra* (1962) [Fig. 138]; and her rapturous beauty, captured in *Liz* (1963). Her life has been as melodramatic as the best Hollywood production and she has seemed costumed, made-up, and coiffed for the camera even (or especially) when she has not been performing on screen. Warhol conveys the cinematic quality of her life in the Mike Todd–Eddie Fisher composition by arranging actual photographs as if in a filmstrip. In the Cleopatra painting he recalls her part in the movie that made history as the ultimate Hollywood extrava-

ganza and achieved notoriety for the well-publicized intrigues surrounding Taylor's on-screen/off-screen affair with her leading man. And in the portrait, a seemingly casual snapshot image, Warhol travesties her makeup, suggesting the absurdity of applying movie standards to life.

Since a certified celebrity's name and face holds great commercial potential for selling all sorts of products, advertisers readily seek celebrity endorsements. As Rosenquist denotes in *Untitled (Joan Crawford Says . . .)* (1964) [Fig. 139], the nature of the product and what the celebrity says about it are irrelevant, for the spokesperson's fame itself sells. Such endorsements purposely confound distinctions between scripted and personal attitudes, between advertising, actuality, and acting. In this way, the mass media began to radically restructure cultural values and establish new standards for image presentation and image interpretation.

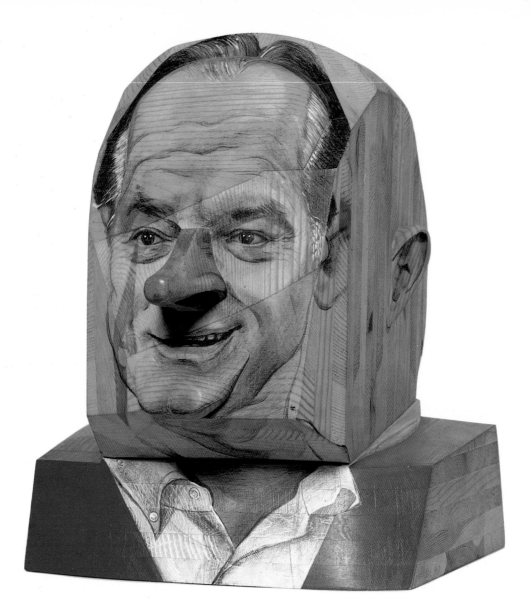

★FIG. 140. Marisol, *Bob Hope*, 1967.
Polychromed wood, 19″ × 15″ × 16″.
National Portrait Gallery,
Smithsonian Institution, Washington,
D.C. Gift of *Time*, Inc.

As such paintings indicate, the publicity system in America created galaxies of celebrities whose images were known to millions of people. The power of formulated, commercialized images exceeded rational explanation, and the media's propensity for constant novelty allowed more people to attain eminence as celebrities, if only momentarily. Warhol's often-repeated statement, "In the future, *everyone* will be famous for fifteen minutes," is particularized in many of the portraits he created. Art dealers, collectors, fellow artists, friends, politicians, *Mr. Nobody*, and the *All-American*—everyone is or can be a star. Crossing the conventional boundaries between the worlds of entertainment, society, and art, Warhol developed a mode of portraiture related to mass media and then ap-

plied it to all his subjects regardless of their specific identities. His silkscreen reproductions of photographs and duplicate images in glitzy colors or black and white place every subject in a Hollywood, newspaper, or television context.

In the sculpture of Marisol, a mass media sensibility merges with folk-art expressiveness to create images that have both a primitivistic and contemporary appearance. On wood totems she has drawn, painted, carved, or modeled incisive caricatures of a panoply of famous people: *The Kennedy Family* (1960), *John Wayne* (1963), *LBJ* (1967), *Bob Hope* (1967) [Fig. 140], and *Hugh Hefner* (1967) [Fig. 141]. The latter two works are especially interesting in that they were commissioned as cover images for *Time* magazine. *Time* honored Hope as a popular comedian, goodwill ambassador, and humanitarian whose Christmas shows brought great pleasure to United States troops stationed abroad. The *Time* essay stressed Hope's image as an easygoing, good-hearted individual with an extraordinary penchant for wit. In her sculpture Marisol embodies this image by exaggerating Hope's trademark features: his laughing eyes, puckish grin, and ski-jump nose. In accordance with folk tradition, which places no value on idealization, she does not hesitate to delineate Hope's facial wrinkles, graying hair, and somewhat tired demeanor. While accentuated woodgrain texture and the spare geometrically shaped forms also borrow from folk art, the photographic quality of the depiction bears the stamp of modernity.

In Marisol's *Hugh Hefner* the primitivistic wood structure provides an even stronger counterpoint to the depicted image. The sculpture includes a projecting head block and a rectilinear torso plank from which Hefner's image literally thrusts outward to accommodate his assertive open-legged stride. The portrayal shows the full figure of a stern-faced, determined person, a self-contained man in control. *Time* described Hefner as "alive, American, modern, trustworthy, clean, respectful, and the country's leading impresario of spectator sex."[26] His achievement with *Playboy* magazine (which had a circulation of four million in 1967), the Playboy clubs (which numbered sixteen that year), and associated Playboy enterprises constituted a major American success story. He also was a media celebrity, his name if not his face becoming well known throughout the country. Marisol's image conveys Hefner's no-nonsense business attitude, especially in his tenacious, crossed-arms pose, while also suggesting his playboy character in his piercing stare, his casual dress, and his ready-for-action stance.

FIG. 141. Marisol, *Hugh Hefner*, 1967. Polychromed wood, 73″ × 9″ × 78″. National Portrait Gallery, Smithsonian Institution, Washington, D.C. Gift of *Time*, Inc.

*FIG. 142. Ed Paschke, *Tightroper*, 1967. Oil on canvas, 40″ × 32″. Collection of Lawrence and Evelyn Aronson.

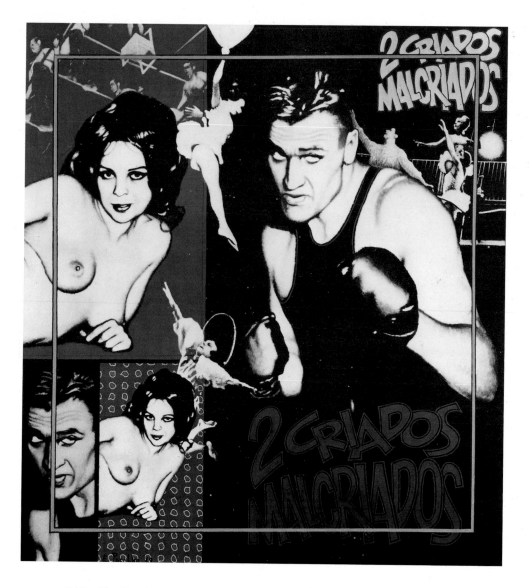

FIG. 143. Ed Paschke, *Dos Criados*,
1968. Oil on canvas, 48″ × 46″.
Collection of Robert H. Bergman.

Outside the mainstream entertainment and communications industries flourished an assortment of low-grade, fringe subcultures indifferent to middle-class taste and aesthetics. Various postwar artists derived inspiration from images from this realm, recognizing their pictorial intensity and sociological significance. Ed Paschke's paintings of cowboys, circus acrobats, pugilists, and porno queens, for example, were inspired by the imagery in grade-B movie posters, sleazy entertainment and sports magazines, and sideshow advertisements. In paintings like *Tightroper* (1967) [Fig. 142] and *Dos Criados* (1968) [Fig. 143], Paschke's discordant, multilayered compositions with their garish dayglo colors, foreign-language copy, and seedy subject matter create an unsettling effect. In showing the seamy side of American culture, Paschke dismisses both the conventions of high culture and the pretense of a uniform, sanitized mass culture. His art reveals aspects of American life that were ignored by academic circles and the popular press, by chambers of commerce and Madison Avenue.

*FIG. 144. Jess, *Tricky Cad—Case I*,
1954. Newspaper collage, 9½″ ×
7½″ × ⅜″. Collection of Robert
Duncan.

As Ruscha suggests in *Flash, L.A. Times*, a primary attraction of American newspapers—often the first section to be read—is the comics. Simple, direct, brief, and pictorial, comic strips are immediately appealing and easily understood. In the early 1960s on any given day more than one million Americans read the comics in the newspaper—three times as many people as read the front-page news. By 1965 there were 300 syndicated strips and panels running in 1,700 newspapers in the United States.[27]

The comic strip was not invented in America, but it was American newspapers' appropriation of the idiom that secured its popularity and elevated its status. As early as 1915 comic strips had entered the realm of big business with the formation of national distribution syndicates. In the early thirties a new market emerged with the publication of newspaper reprints in comic-book format. Then, in 1938, the publication of *Superman*, a comic magazine of original long adventure stories, triggered a comic-book explosion. Here was an inexpensive, low-budget periodical with widespread attraction.

By the mid-fifties readers were purchasing between 500 million and 880 million issues a year, and publishers enjoyed annual sales of over $100 million.[28]

The artistic and technical genius of Walt Disney moved comics into the movie theaters, first as shorts and then as full-length features. Disney filmed the first Mickey Mouse cartoon in 1928 and went on to develop his animated characters into a multi-million-dollar conglomerate. During the mid-fifties Disney's achievements were prominently in the public eye as the result of the opening of Disneyland, his forays into television, and the production of toys, lunchboxes, and other licensed paraphernalia.

American comic strips and animated cartoons were unquestionably a leading cultural product and export. Indeed, European artists preceded their American counterparts in recognizing the comics as a notable art form. Picasso, for example, was an avid reader of American comics and unabashedly admitted his love of the genre well before American artists became enamored with it.[29] By the 1950s and 1960s American artists, too, began to pay

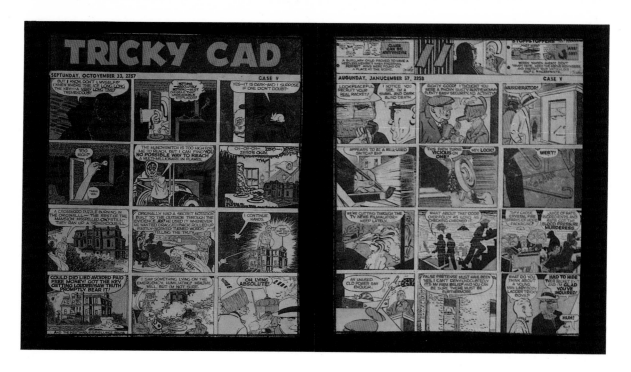

*FIG. 145. Jess, *Tricky Cad—Case V*, 1958. Newspaper collage, 13½″ × 25″. Courtesy of Odyssia Gallery, New York.

homage to this enduringly popular American art form. Their works often call attention to the genre's mass orientation: its stylistic simplicity and visual potency, its mechanical production aesthetic, and its richness as a means of communication.

In many of his early combine paintings, Rauschenberg included comics in his medley of signifiers of the everyday urban environment, the frenzied, disordered world of perpetual change and complexity. Comics appear as but another throwaway piece of material, a touch of humor amid the confusion. And yet they also assert an American identity, an Americanization of newspaper imagery in art.

For Jess, too, comic strips were a rich resource with multidimensional expressive potential. They are the sole materials of his *Tricky Cad* collages, a series created between 1954 and 1959 [Figs. 144 and 145]. Each of the eight parts, or "cases," is a reassembled, scrambled version of image and word fragments taken from episodes of a Dick Tracy strip. *Tricky Cad* is an anagram for the titular protagonist, and word play recurs throughout, as in

the page headings of *Case I*: Ick Tra, Trick D, Dickracy, Tick R, Kid Rat, Icky Tar, Crack I, Ikick Art, Tracky Dit, Kit Cary. Jess's anagrams and juxtapositions subvert the clarity of communication that makes comic strips so popular. The collages present the semblance of a narrative, but the messages are rife with absurdity and pervasive disorder. Even Dick Tracy, the master sleuth, would have trouble deciphering meaning from such chaos and confusion.

But confusion was precisely Jess's intention. Art offered the means to think about the world in ways that were not rational, logical, or objective, and Jess, who was trained as a scientist, sought to create art that was "an antidote to the scientific method."[30] He had worked on the Manhattan and Hanford projects, which produced plutonium for the atomic bomb, but the nightmarish implications of nuclear weaponry caused him to turn away from science in 1949. His art career began just as the United States announced plans to build a "superbomb" (the hydrogen bomb) in January 1950, and he created his initial *Tricky Cad* collage just after

the first American H-bomb was exploded in March 1954.

The tensions and eruptive dynamics of the *Tricky Cad* series give evidence of a world gone awry, a world capable of nuclear self-destruction. Individual components make sense, but the overall picture is utterly incomprehensible. The characters live in an urgent frenetic world and communicate with exclamatory language. Though the investigatory postures and sleuthing attitudes of Tricky Cad arouse hope for resolution, this unrequited hopefulness only reinforces the sense that confusion and uncertainty are ineradicable conditions. As in the Beat poetry of the mid-fifties (for example, Allen Ginsberg's *Howl* or *America*), the spirit of extreme energy and impassioned exuberance suggests that living to the fullest, living on the edge, is the only way to survive in a straitlaced conformist society on the verge of World War III.[31]

Jess's selection of Dick Tracy also allows him to comment on American justice. Chester Gould's Dick Tracy first appeared in American newspapers at the height of prohibition, in 1931, when underworld mobs flourished in the face of an inept, lax, or corrupt law-enforcement system. Gould based his strips on actual newspaper stories about gangsters and their crimes. The plainclothes detective Tracy was a relentlessly probing individual who acted for the good of society by taking the law into his own hands. In scenes of bloody violence and armed confrontation, Tracy's sense of duty, his physical prowess and bravery knew no bounds. Ever vigilant, he was determined to punish evil and to convey the message that crime does not pay.[32]

Jess's compositions demythicize this symbol of law and order by depicting the famed detective as an index of chaos in a world where individual heroics and martial skills prove ineffective. The collages make reference to both McCarthyism's subversion of American justice and to the activities of a second "Tricky Dick," Richard Nixon. During his vice-presidential campaign in the fall of 1952, Nixon had been accused of improper use of a slush fund. He faced his accusers by addressing the nation on television, an appearance that came to be called the "Checkers speech." The candidate regained his stature by setting himself forth as both an honorable citizen who stood for basic American values and a courageous leader who could hold his own in times of adversity. Jess's compositions play havoc with both Dick Tracy's and Tricky Dick's ways of achieving justice.

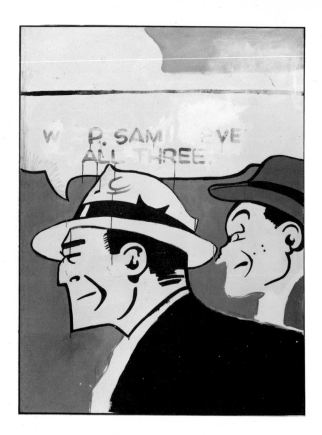

FIG. 146. Andy Warhol, *Dick Tracy*, 1960. Oil on canvas, 70½″ × 52⅛″. Collection of Mr. and Mrs. S. I. Newhouse, Jr.

When Warhol created his *Dick Tracy* (1960) [Fig. 146], he focused on Gould's celebrated caricature style, his masterful techniques of conveying expression through simple, exaggerated delineations. Warhol underscores the dramatic effects of Gould's stark backgrounds, contrasting areas of flat color, and sharp angular contours as well as his protagonist's signature square jaw and hook nose. Warhol thus reveals the visual essence of the Tracy strips, the identifying hallmarks that override the actual content of a particular story. Verbal content—the text in the balloon—is left blurred and unfinished, implying that design, not narrative, is the preeminent tool of communication.

Apart from the interest in comics as subject matter, the choice of Dick Tracy can be related to the surge in America's long-standing fascination with private detectives. As *Time* pointed out in the October 29, 1959, cover story "TV's Private Eyes," the year's fall season included sixty-two network

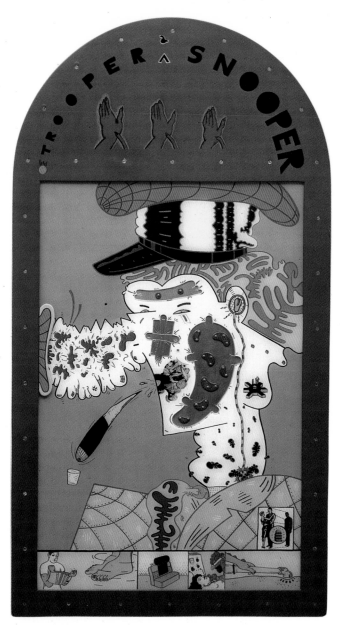

*FIG. 147. Jim Nutt,
Snooper Trooper, 1967.
Acrylic on plexiglas and
enamel on wood,
39½″ × 21½″. Collection
of Claude Nutt.

shows devoted to detectives. These television de-
tectives joined an ever-growing number of law-
and-order scouts in popular whodunit novels and
movies. Most followed in Dick Tracy's shoes as or-
dinary but invincible citizens concerned about law
and order. Like mass media cowboys, their breth-
ren Hollywood legends, mass media detectives dis-
play a magical combination of superhuman tough-
ness, irreverence, and decency.

In an ironic, outlandish way, Jim Nutt parodies
the exemplary American detective in his painting

Snooper Trooper (1967) [Fig. 147]. Although Dick
Tracy's square jaw remains, his hook nose is now a
ragged, bulbous projection, and the flat expanses of
color are overlaid with invading, disfiguring ele-
ments. Deriving inspiration from the comic strip,
Nutt has pushed caricature to the extreme, creating
a grotesque, morbid image of violence and disor-
der. Rather than a tough, invincible hero, this de-
tective appears as a menaced, mutilated creature in-
capable of clear thought or brave action.

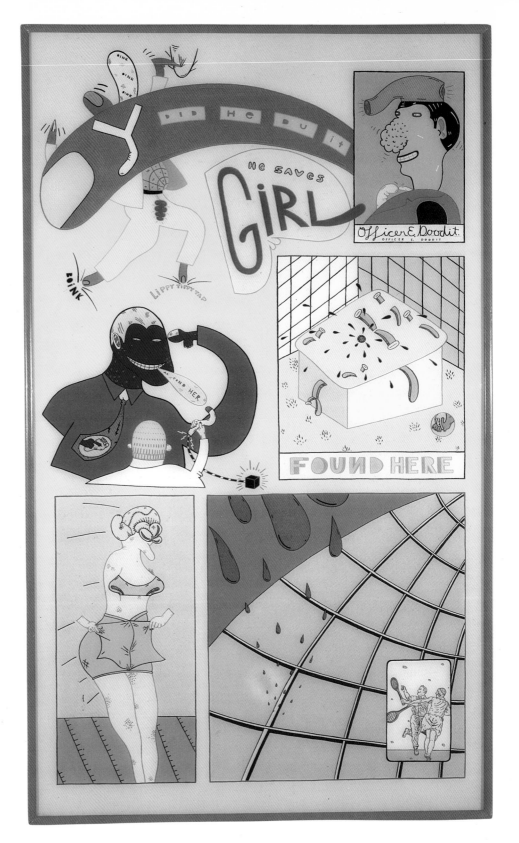

*FIG. 148. Jim Nutt, *Y Did He Du It?* 1966–67. Acrylic on plexiglas, 60⅝″ × 36⅝″. Collection of the artist.

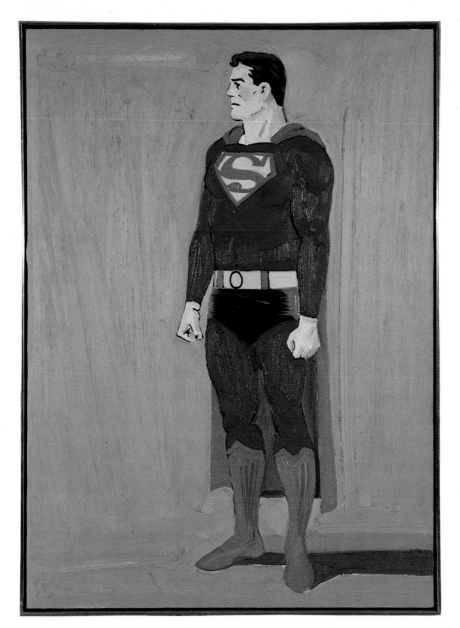

★FIG. 149. Mel Ramos, *Superman*, 1961. Oil on canvas, 46½" × 34". Collection of Scot Ramos.

In *Y Did He Du It?* (1966–67) [Fig. 148], Nutt again ravages the stereotype of the comic-strip superhero by portraying Officer E. Doodit as a physically repulsive personage of highly questionable investigative abilities. Although the subtitle suggest that a girl is saved, this girl is but a shadow of the typical voluptuous rescued maiden, the narrative is ridiculous, and the detective's role is indecipherable. Nutt wholly undermines the persona of the legendary detective and the logic of comic-strip presentation, in which single frames have internal clarity and sequences proceed in a linear fashion.

Central to the American tradition of the superhuman individual who represents a force for good in a world of evil and ensures justice by taking the law into his own hands is Superman.[33] Here, too, is a mass media character who represents a merger of pure fantasy and everyday reality. Born in comic books, Superman became a radio and cartoon sensation in the 1940s, a television star in the 1950s, and later a movie idol. In Mel Ramos's painting *Superman* (1961) [Fig. 149], the caped crusader appears in full regalia. His fisted hands and muscled body emphasize his power, while his costume testifies to his status as an imaginary personage. Ramos enhances the character's theatricality by isolating and spotlighting his figure so he stands out against the ground and casts a stark shadow. The sensuous,

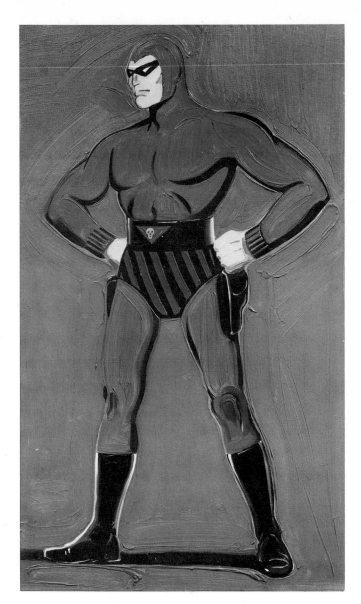

FIG. 150. Mel Ramos, *The Phantom*,
ca. 1963–64. Oil on canvas, 30¼" ×
18¾". Courtesy of Charles Cowles
Gallery, New York.

thickly pigmented surface distances the image from
its source, enabling the painterliness to serve as a
mediation between the contexts of mass and fine
art. Ramos uses this same technique in other com-
positions that also feature superhuman heroes, such
as *Batmobile* (1962), *Flash Gordon* (1962), and *The
Phantom* (ca. 1963–64) [Fig. 150]. Unlike Ramos's
painterly portraits, Warhol's *Superman* (1960) [Fig.
151] and *Batman* (1960) stress the comic-strip
sources in their use of written information and a
flat commercial style. Here calligraphic intensity
and the excessive dynamism of the image and ac-
tivity attest to the superheroes' super power. Simi-

larly, in Warhol's *Popeye* (1961) explosive graphics,
fighting fists, and bursting stars corroborate the
protagonist's pugnacity. Lichtenstein's contempor-
aneous *Popeye* (1961) [Fig. 152] likewise quotes di-
rectly from the comic strip, showing the hero with
his swinging arms landing a punch that knocks the
wind out of his burly opponent. Though Popeye
was but an ugly sailor and burlesque figure, he too
was a defender of the weak who did not hesitate to
exercise force in the face of evil. This recurrent
theme in American action comics becomes a nota-
ble aspect of comic-strip paintings.

FIG. 151. Andy Warhol, *Superman*,
1960. Acrylic on canvas, 67″ × 52″.
Private collection, courtesy of
Thomas Ammann Fine Art, Zurich.

★FIG. 152. Roy Lichtenstein, *Popeye*,
1961. Oil on canvas, 42″ × 56″.
Collection of David Lichtenstein.

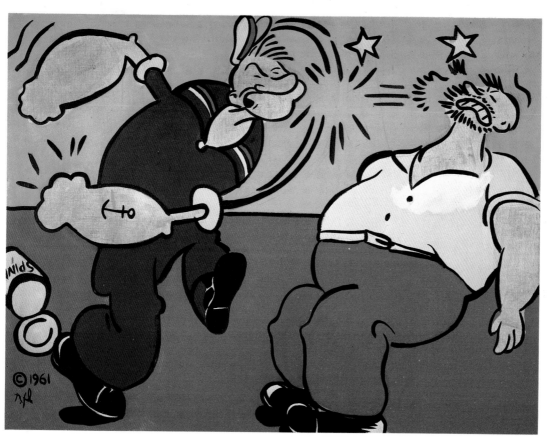

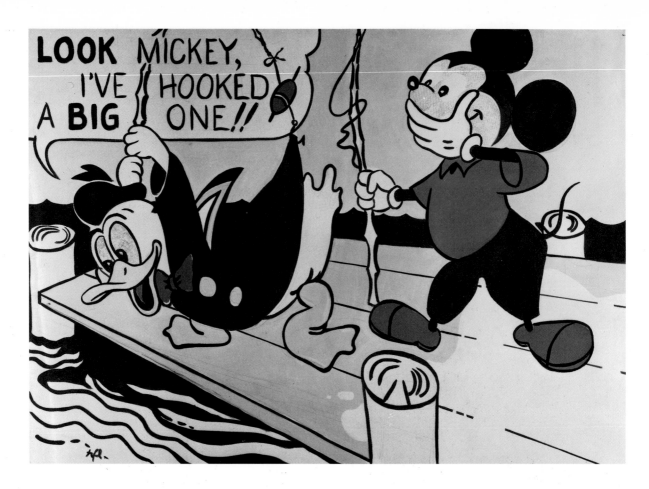

FIG. 153. Roy Lichtenstein, *Look Mickey*, 1961. Oil on canvas, 48″ × 69″. Private collection.

Postwar artists also paid attention to American comic strips that feature children and animals in the lead roles. The classic type of juvenile comic strip presents an utterly uncomplicated humorous narrative.[34] Walt Disney was the master of this genre, and Lichtenstein's paintings of Mickey Mouse, Donald Duck, and Bugs Bunny celebrate his skill. For Lichtenstein these characters formed a continuation of his earlier concentration on cowboys, Indians, and American history themes, affirming his interest in "a purely American mythological subject matter."[35] The cartoon motifs also establish a significant bond with American industrial processes and mass merchandising. In *Look Mickey* (1961) [Fig. 153], for example, the boldly defined figures and simple messages indicate both the power of Disney's aesthetic and the preeminent qualities of commercial design. The imagery typifies the lighthearted tone of juvenile comics,

though it also evinces the boaster and bumbler qualities of Disney's characters, their determination to be successful and the mockery of their failures. Fittingly, the actual source of inspiration for the composition was a bubble-gum wrapper, another example of American businesses' creativity in uniting two popular products to expand the markets of each.

Like Mickey Mouse, "Nancy" became a world-favorite comic strip, typifying the juvenile genre. Warhol's *Nancy* (1961) denotes the essential attributes of the strip, especially Nancy's innocent behavior. But the full meaning of the narrative is ambiguous since Warhol displays only one full frame and a small segment of some additional dialogue. As in *Dick Tracy, Popeye*, and his other comic-strip paintings, Warhol's composition simultaneously amplifies the signifying qualities of the given figuration and deflects concentration on the subject

FIG. 154. Edward Ruscha, *Annie*, 1962. Oil on canvas, 72″×67″. Collection of Betty Asher.

matter. Warhol violates the integrity of a perfect self-contained composition by leaving areas sketchy and blurred, by decentering the main image through the inclusion of surrounding space, and by showing extraneous markings (paint drips and smudges) and fragments of a second frame or newspaper headings. The target image is shown to be part of a larger context, not an entity in its own right but a reminder, a reference, an inexact duplicate. In the spirit of commercial advertising and mass media presentation, Warhol shows that an image functions more as a sign—a flashing, abbreviated force—than as a complete statement.

The conception of a painting as a sign is the essence of Ruscha's *Annie* (1962) [Fig. 154], for here the name alone, displayed in its familiar red color and balloon lettering style, signifies the comic strip and identifies Little Orphan Annie. Through repetition, such a sign comes to displace the image it connotes, just as a familiar package displaces the product it contains. Pictorial communication is thus reduced to the presentation and recognition of an easily identified cliché, logo, or token. This mode of instantaneous transmission and apprehension of visual information (which presumes a widespread familiarity with American mass culture) obviates the need for prolonged contemplation, symbolic analysis, or stylistic originality.

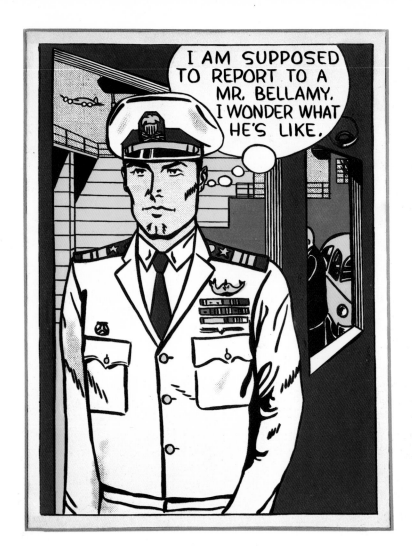

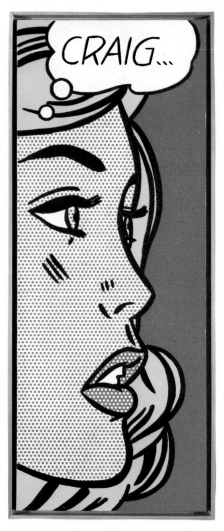

*FIG. 155. Roy Lichtenstein, *Mr. Bellamy*, 1961. Oil on canvas, 56½″ × 42½″. Fort Worth Art Museum. The Benjamin J. Tillar Memorial Trust. Acquired from the Collection of Vernon Nikkel, Clovis, New Mexico.

*FIG. 156. Roy Lichtenstein, *Craig*, 1964. Oil and magna on canvas, 30″ × 12″. Allen Memorial Art Museum, Oberlin College. Gift of Ellen H. Johnson in memory of Ruth C. Roush.

Although detective and juvenile comics remained popular during the postwar period, romance and war comics emerged as new favorites.[36] Lichtenstein makes explicit reference to these excessively melodramatic comics in numerous paintings. Not only does he replicate specific frames from comic books, but he also exaggerates their stylistic and expressive features. The isolation and enlargement of a frame accentuate a situation that is already suspenseful, such as in *Mr. Bellamy* (1961) [Fig. 155], or imagery that is already theatrical, as in *Craig* (1964) [Fig. 156], or a dialogue that is already overwrought, as in *Eddie Diptych* (1962) [Fig. 157]. In addition, the single-frame representation intensifies the comic strips' visual and narrative dynamics, amplifying their intrinsic artificiality. Although a scene of adult anxiety or teenage passion and perturbation might be believable

*FIG. 157. Roy Lichtenstein, *Eddie Diptych*, 1962. Oil on canvas, 44½″ × 53″. Collection of Ileana and Michael Sonnabend.

within the context of a full comic-strip episode, when taken out of context such scenes seem stilted and ludicrous.

Moreover, Lichtenstein's images defy the pervasive idealism of traditional American comics, the mythic sense of the American dream in which things go well or at least end well. In his compositions, malaise and an unresolved uncertainty prevail. This tone, heightened by expressions of fear and danger, also characterizes the paintings based on war comic strips. For example, in *Torpedo . . . Los!* (1963) [Fig. 158], Lichtenstein selects a moment of crisis and tension, turmoil and destruction, a flash of thundering expletives and explosions. There is no indication that good will triumph over evil, or that peace will be attained. By not presenting the happy ending or even offering a small sign of hope, the imagery invokes a vi-

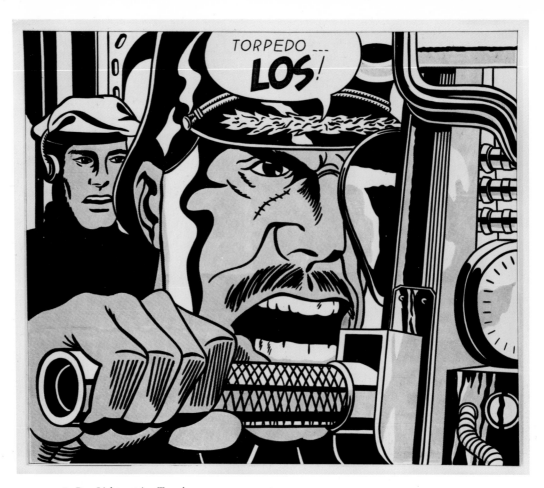

FIG. 158. Roy Lichtenstein, *Torpedo
. . . Los!* 1963. Oil on canvas,
68″ × 80″. Collection of Mrs. Robert
B. Mayer, her son, Robert N. Mayer,
and her daughter, Ruth M.
Durchslag.

sion quite distinct from that common to pre-World
War II war paintings. Kandinsky's apocalyptic im-
agery, for example, includes rainbows and rising
suns or trumpeting angels, and even in Picasso's
Guernica a flower and candle are set in the midst of
the chaos. With Lichtenstein's paintings, in con-
trast, focus lies squarely on the moment of conflict
with no reference to any future. The imagery also
identifies America as an active battle participant, an
exemplar of combat strength.

Although there is an edge of nostalgia in Lich-
tenstein's use of comic-strip sources from the fif-
ties, his romance and war imagery reflect the situa-
tion of the early sixties: the fantasy and collapse of
Camelot, and the resurgence of the Cold War. The
saga of the glamorous Kennedy family, its tri-
umphs and tragedies, seemed almost the stuff of

fiction, and the president's style showed a real pen-
chant for theater. At the same time, assertions of
American and Soviet military might aroused the
specter of global conflict. A series of confronta-
tions between the two superpowers made war
seem imminent, and the on-again off-again disar-
mament talks provided little hope.

In addition to evoking the discrepancies between
the American dream and political reality, Lichten-
stein's paintings allude to a more elemental discrep-
ancy between style and content. His diametric op-
position of a dispassionate mechanical style and
emotionally charged content indicates how style
can effectively undermine or overwhelm content.
Over generations commercial cartoonists had
modified and perfected a vocabulary compatible
with the industrial process and popular tastes.

★FIG. 159. Hairy Who, *Hairy Who
Catalogue*, 1966. Collage, 20″ × 30″.
Collection of Mrs. Ruth Horwich.

They had created a pictorial shorthand that yielded vivid representation. Lichtenstein recognized the visual power of the cartoonists' stenography and sought to adapt it to painting.[37] His aggrandizements of abstract patterns of benday dots, flat color planes, and bold contours articulate the design character of comic-strip imagery.

Lichtenstein also adopted the comic-strip idiom in order to reinvolve art with the everyday world and to instill an acceptance of mechanization as a given aspect of modern life. He did not wish to continue the utopian, inward direction that had come to dominate in art since Cézanne, but rather to manifest forthrightly that industrialism provided *the* aesthetic for contemporary art, and that this aesthetic, which already governed American culture, was fast becoming a universal aesthetic.[38]

Comic-strip forms and styles were also the heart of publications like *Mad* magazine and underground comics like *Zap*. In the mid-sixties a group of young artists in Chicago paired the raucous style of counterculture comic strips with their own nonconformist views and absurdist humor to create ironic put-downs of rationality and mainstream values. The group, initially composed of six members—James Falconer, Art Green, Gladys Nilsson, Jim Nutt, Suellen Rocca, and Karl Wirsum—called itself the Hairy Who. For the first two of their three group shows (1966–68) at the Hyde Park Art Center, they created a communal comic book as an exhibition catalogue [Fig. 159]. Their comics were not duplicates of existing depictions but transmogrified revisions filled with bizarre images and nonsensical content. In their complicated figurations,

convoluted or incomprehensible messages and anonymous nonentities replace the conventional comic-book simplicities and superhero prototypes. Visual disjunctiveness and narrative discontinuity are at an extreme, surpassing the ambiguities of isolated frames or partial dialogues. The whole is made up of disparate entries, each entry in turn a conglomerate of fragmented segments bereft of cohesiveness or progressive logic. The outrageous disorder and subject matter suggest a whimsical attitude, but this mood is punctured by the scattered faceless and deformed figures. The humor verges on a hysteria of despair and frenzy, while communication collapses into gamesmanship or deliberate evasion. The compositions reveal a world beset by confusion despite attempts at escape through fantasy. And the tone of uncertainty that prevails in so much art of the fifties and sixties is here pitched in an urgent key. All questions of comprehension and interpretation dissolve into unintelligibility and madness, as the power and perplexity of mass media dynamics, the richness and vacuity of mass media communication, collapse into their own paradoxical antilogic.

NOTES

1. Early evidence of television's advertising potential was provided by the Hopalong Cassidy toy craze that grossed $100 million in 1950. While manufacturers of consumer goods earned fortunes from television tie-ins and advertising, networks profited greatly from commercials. CBS, for example, recorded gains of $8.9 million from advertising in 1953 and $22.2 million four years later. Douglas T. Miller and Marion Nowak, *The Fifties: The Way We Were* (Garden City, N.Y.: Doubleday, 1977), 347–48.

2. Howard K. Smith, quoted in *Time* 86 (October 14, 1966): 58.

3. For a detailed discussion of changes in the media brought about by the Vietnam War, see David Halberstam, *The Powers That Be* (New York: Dell, 1980), 708–18.

4. On the influence of the Luce publications, see Halberstam, *Powers That Be*, 71–89.

5. In addition to the progressive loss of small television stations, which were unable to survive the competition of the three major networks, the number of daily newspapers plummeted. There were 552 American cities with competing dailies in 1920, but by 1962 there were only 55. And by 1962 twelve managements controlled one-third of the nation's newspapers. Godfrey Hodgson, *America in Our Time* (New York: Vintage, 1978), 138–41.

6. The ballet *Within the Quota* was produced by Les Ballets Suédois and performed in Paris on October 25, 1923, at the Théâtre des Champs-Élysées. Cole Porter's score, like Murphy's backdrop, parodied American mass culture and included such vernacular elements as a Salvation Army chorale, a jazz band, and allusions to New York taxi horns.

7. Murphy also created a flag painting, *Villa America* (1924–25), in this same manner, thus anticipating Jasper Johns's mode of design by some thirty years. The painting served as the signpost for Murphy's house in Antibes, France. Johns and others would not have known of Murphy's flag, for it was lost from 1951 until 1984 and first published by William M. Donnelly in "On Finding a Gerald Murphy," *Arts* 59 (May 1985): 78.

8. For Celmins, images of air disasters recalled her childhood in Russia and Germany during World War II. As an adult she collected old war books, and clippings from these served as the source of her imagery. Susan C. Larsen, *Vija Celmins: A Survey Exhibition*, exhibition catalogue (Newport Beach, Calif.: Newport Harbor Art Museum, 1980), 22–23.

9. In a conversation with the author (July 12, 1984), Kienholz pointed to Americans' unwillingness to understand or face death as a motive for his use of art to provoke the issue.

10. Ibid.

11. Unpublished interview with the artist by Cindy Nemser (1971), quoted by Lawrence Alloway in his introductory essay to the catalogue *May Stevens* (Ithaca, N.Y.: Herbert F. Johnson Museum of Art, Cornell University, 1973), n.p.

12. Halberstam, *Powers That Be*, 83.

13. See C. Wright Mills, *The Power Elite* (New York: Oxford University Press, 1956), 71–93, for an excellent discussion of the concept of celebrity in American society.

14. See *Time* 83 (February 21, 1964): 46–47.

15. Daniel J. Boorstin explores the concept of the image in *The Image: A Guide to Pseudo-Events in America* (New York: Atheneum, 1978).

16. Johnson, quoted in *Ray Johnson Ray Johnson*, ed. William S. Wilson (New York: Between Books Press, 1977), n.p.

17. Lyndon B. Johnson called Presley a "symbol of the vitality, rebelliousness and good humor of the country," and both Eldridge Cleaver (*Soul on Ice* [New York: McGraw-Hill, 1968], 194–95) and Jerry Rubin (*Do It* [New York: Simon & Schuster, 1970], 17–19) acknowledge Presley's importance within the youth rebellion.

18. For a discussion of Presley's image, see Mark Crispin Miller, "The King," *New York Review of Books* 24 (December 8, 1977): 38–42.

19. *Triple Elvis* is one of a series of compositions based on the same publicity still. All were shown for the first time at the Ferus Gallery in Los Angeles, September–October 1963, and installed according to Warhol's instructions as a "continuous surround." See John Coplans, "Andy Warhol and Elvis Presley," *Studio* 81 (February 1971): 49–53.

20. *Time* 73 (March 30, 1959): 52.

21. Ezra Goodman, "Delirium Over Dead Star," *Life* 41 (September 24, 1956): 75–88.

22. A Marilyn Monroe exhibition at the Sidney Janis Gallery, New York, December 6–30, 1967, comprised fifty works by thirty-six artists.

23. De Kooning kept a Monroe pinup calendar in his studio and named her as a source of inspiration. However, the title of the 1954 painting was probably not conferred by the artist. (See Harry F. Gaugh, *Willem de Kooning* [New York: Abbeville Press, 1982], 49 and n. 64.) Another Hollywood bombshell, Mae West, was the subject of a subsequent "woman" portrait in 1964.

24. By accompanying the photograph with a "sympathetic account" of Monroe's circumstances—her need as a struggling, starving model to pose for money—*Life* set the photograph in a human interest context. See *Life Goes to the Movies* (New York: Time-Life Books, 1975), 67.

25. De Kooning used a Camel ad from the back cover of *Time* (January 17, 1949) which outlined a "T-zone"—the area of smoking pleasure—on the smiling model's face. See Thomas B. Hess, *Willem de Kooning* (New York: Museum of Modern Art, 1968), 78.

26. *Time* (March 3, 1967): 76.

27. David Manning White and Robert H. Abel, "Comic Strips and American Culture," in *The Funnies: An American Idiom* (New York: Free Press of Glencoe, 1963), 3 and 7.

28. Joan C. Siegfried, "Art From the Comics," in *The Spirit of the Comics*, exhibition catalogue (Philadelphia: Institute of Contemporary Art, University of Pennsylvania, 1969), n.p.; and Eric F. Goldman, *The Crucial Decade—and After: America, 1945–1960* (New York: Vintage, 1960), 291.

29. In a cover story on Charles M. Schulz, creator of *Peanuts*, *Time* noted that Europeans prided themselves on having "discovered" such American art forms as comics and jazz, and such American authors as Faulkner long before Americans. *Time* 85 (April 9, 1965): 83.

30. Jess, quoted in Michael Auping, *Jess: Paste-Ups (and Assemblies) 1951–1983*, exhibition catalogue (Sarasota, Fla.: The John and Mable Ringling Museum of Art, 1983), 10.

31. The reclusive Jess did not participate in the San Francisco Beat scene, but through his friendship with the poet Robert Duncan he was well aware of Beat views and activities.

32. See statement by Chester Gould in Martin Sheridan, *Comics and Their Creators* (Westport, Conn.: Hyperion Press, 1971), 121–24.

33. Stephen Becker, *Comic Art in America* (New York: Simon & Schuster, 1959), 240.

34. Ibid., 221.

35. Lichtenstein, in John Coplans, "An Interview with Roy Lichtenstein," *Artforum* 2 (October 1963): 31.

36. Siegfried, "Art from the Comics," n.p.

37. Lichtenstein, quoted in John Rublowsky, *Pop Art: Images of the American Dream* (London: Nelson, 1965), 43.

38. Lichtenstein, in an interview with Gene R. Swenson, "What Is Pop Art?" *Artnews* 62 (November 1963): 25, 62.

MADE IN
U·S·A·

The American
Dream / The
American Dilemma

During the 1950s Americans for the most part enjoyed prosperity at home and prestige abroad. America became known as a magical place where things were happening and where future prospects were bright. The American dream of plenty, of hope and opportunity, of freedom and possibility became a reality for millions of people. To be sure, the conceptual idealism of American democracy was diluted as many redefined the dream in terms of material values. A house and a car, bigger and better possessions were tangible evidence of success and a rising standard of living.

America had confidently emerged from World War II with high expectations for the future. Although the Korean War and the spread of atomic weapons loomed large, the watchwords of Eisenhower's inaugural address were peace and promise. America asserted its strength by holding a firm line against communism and by proudly displaying the merits of free enterprise. The fifties began by imparting an aura of stability upon life in America and ended with bold demands for national excellence and dominance. During the Kennedy administration a strident superpower rhetoric revivified and aggrandized the promise of America. Kennedy trumpeted a New Frontier premised on America's historical greatness and future hegemony. With new determination, America went out into the world offering educational, economic, and military assistance. Science and technology provided the potential for boundless resources and limitless expansion, and space exploration also became a national priority.

In 1964 President Johnson reaffirmed the dream, calling his vision the Great Society. He extolled the glories and uniqueness of America but admonished the country to recognize injustices and inequities. To realize the social compact, he proposed a broad package of domestic legislation: the Civil Rights Bill, the Voting Rights Act, Medicare, job training programs and educational aid, and federal pollution standards. Johnson cautioned that resources were not inexhaustible; unrestrained progress was not necessarily productive; money was not a panacea for all ills; and assertions of power in the name of democracy were not always in the nation's best interest.

In the postwar decades the American dream was thus in turn mythicized, critiqued, reassessed, reinvigorated. The touted image of America as a rich and glorious society was countered by an image of America as a violent society rife with prejudice and seething with contradictions. Many postwar artists depicted these tensions between the American dream and the American dilemma. In some of their

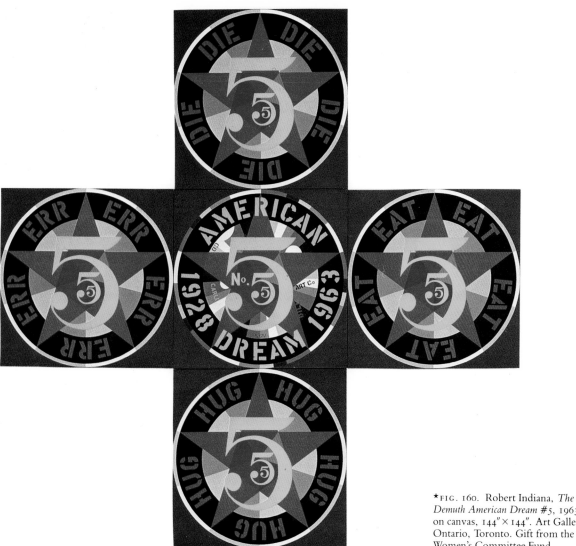

★FIG. 160. Robert Indiana, *The Demuth American Dream #5*, 1963. Oil on canvas, 144″×144″. Art Gallery of Ontario, Toronto. Gift from the Women's Committee Fund.

works a haunting undercurrent disturbs seemingly objective images, or gnawing expressions of doubt emanate from traditional American icons. At times a more unsettling ambivalence is denoted by the juxtaposition of incongruous images, scale disparity, or relentless repetition. Though most artists avoided the polemical tone of Social Realist art, their work provokes a reappraisal of contemporary American culture. Indeed, many compositions overtly address controversial social issues and politically charged subjects.

For the first time in American art, moreover, death is treated forthrightly as a fearful, alienating counterpoint to idealistic conceptions of the American dream. In marked contrast to the abiding ro-

mantic view, stemming from transcendentalism through Abstract Expressionism, in postwar art death is not related to either spiritual or heroic themes nor to future beginnings or godly forces beyond the realm of experience. Rather, death is shown to be a brutal end, a purposeless finality, a haphazard disaster caused not by divine or natural means but by human madness or political strife.

Taking the theme of the American dream as his benchmark, Robert Indiana created a series of paintings that display the conversion of the dream's "optimistic, generous and naive" vision into the forms and formulas of mass culture.[1] In *The Demuth American Dream #5* (1963) [Fig. 160] the dream is represented by a vocabulary of four verbs:

DIE, EAT, HUG, ERR. Each commands a star-spangled circle in the design, and each rules an axis of a cross. The terms denote fundamental aspects of life, all shown to coexist in absurd combinations as if on a wheel of fortune in which fate determines the outcome. While the wheel suggests flux and uncertainty, the cross creates intersections and polarities. And while verbs refer to personal actions, the presentational format—the stenciled lettering, geometric patterning, blazing coloration, repetitive components, and bold emblematic structure—intones anonymity.

Borrowing these stylistic traits from road signs, pinball machines, advertising, and juke boxes, Indiana sets the American dream in the context of the highway and roadside café. This context is even more apparent in other paintings in the series, which feature the words JILT/TILT and JUKE/JACK and rotate the cross to form the X of a railroad danger sign. The series reverberates with references to both the freedom, monotony, and peril of the open road and the banality of life in an environment of flashing signs.

As in advertisements, the subject is reduced to commonplace fundamentals conveyed in a visually arresting manner. The American dream is rendered in a packaged promotional format, its philosophical essence condensed into a game of three-letter words. The notion of plentitude, for example, is pared down to EAT, a cue that imitates the neon signs that flash over hundreds of cheap restaurants. Part of America's glory is the bounty of the fruited plains, yet Indiana observes: "It is pretty hard to swallow the whole thing about the American dream. It started from the day the Pilgrims landed, the dream, the idea that Americans have more to eat than anyone else. But I remember going to bed without enough to eat."[2] DIE and ERR register the underside and uncertainty of the dream, the daily realities that accompany the promises of "life, liberty, and the pursuit of happiness."

Indiana's painting also pays homage to Charles Demuth's Precisionist masterpiece *I Saw the Figure Five in Gold* (1928) [Fig. 161]. Demuth created the painting both as a poster portrait of his friend William Carlos Williams and as an interpretation of Williams's poem "The Great Figure."[3] Indiana's composition reprises the power of Demuth's depiction, exaggerating those features that distinguish Demuth's decidedly American orientation to Cubist aesthetics: conspicuous signs, bright lights, and theatrical display. For Indiana, these prominently American stylistic features, removed from any supporting landscape imagery, become an index of the American environment. American ideals have been displaced by images, and images by signs.

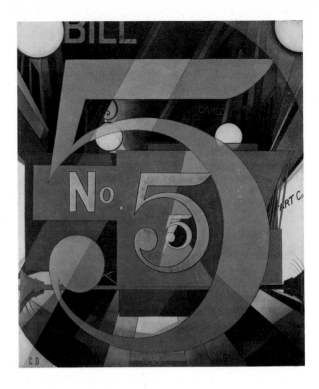

FIG. 161. Charles Henry Demuth, *I Saw the Figure Five in Gold*, 1928. Oil on composition board, 36″ × 29¾″. The Metropolitan Museum of Art, New York. The Alfred Stieglitz Collection.

During the postwar period, artists were concerned not only with restructurings of the American dream but also with the possibility of the dream's—and the nation's—ultimate destruction. In his painting *Can Our National Bird Survive?* (1962) [Fig. 162], Allan D'Arcangelo pointedly raises the question of American mortality and sets it within the context of U.S. militarism. The composition shows two American eagles: one proud, calm imprisoned bird, and one vulturous, aggressive creature who flies freely, though along a path counter to directional arrows. Bars and a star offer the semblance of a landscape as well as of an American flag whose stripes are ominously transformed from white to black and whose stellar field is reduced to a solitary darkened sign.

In April 1962, the month of the painting's creation, the U.S. announced the resumption of atmospheric testing, despite widespread Ban the Bomb demonstrations. This announcement followed the January collapse of test ban talks between the superpowers and the reopening of discussions under

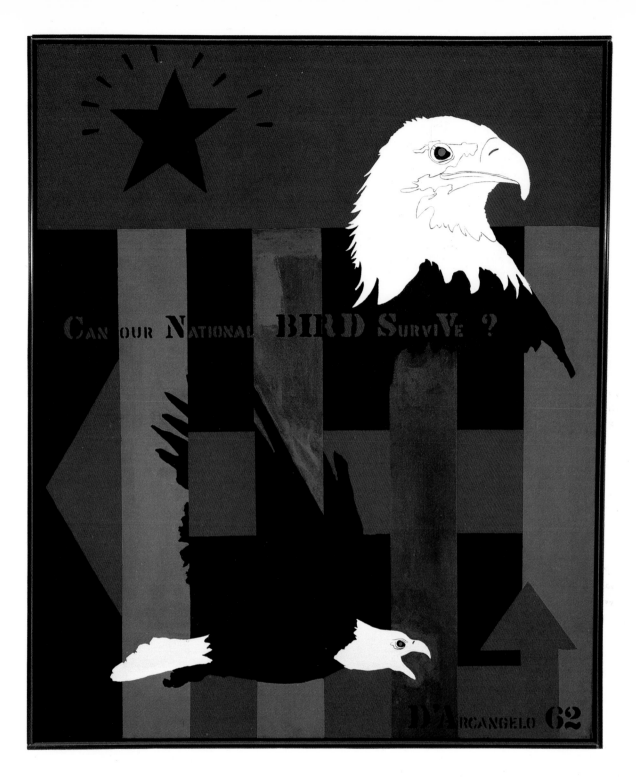

★FIG. 162. Allan D'Arcangelo, *Can Our National Bird Survive?* 1962. Acrylic on canvas, 45″ × 38″. Collection of the artist.

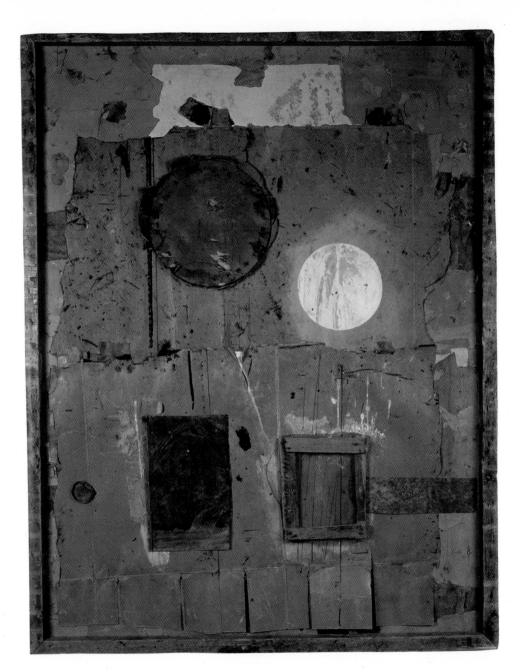

*FIG. 163. Bruce
Conner, *Untitled*
(front and back sides),
1954–62. Collage and
oil on canvas,
60″ × 46½″. Collection
of Robert Shapazian.

the aegis of the United Nations in March. The decision to resume testing intensified the mood of international crisis evoked by recent East-West confrontations over Cuba and Berlin and by the USSR's reinstatement of nuclear testing in 1961. President Kennedy took a hard-line approach to negotiations and proposed an expanded national civil defense program, which included plans for the mass construction of fallout shelters. But for many Americans, fallout shelters and nuclear testing only exacerbated fears, and anxieties about the arms race

escalated. Peace activists, like D'Arcangelo, protested against the administration's strategies, urging that national policy emphasize disarmament.[4] In his painting, D'Arcangelo's focus on the eagle, the archetypal symbol of military strength, both implicates America as a pivotal force in determining the world's future and conjures the possibility of doomsday.

The possibility of nuclear holocaust also haunted Bruce Conner, who fled the country in 1961–62 fearing that "the bomb was going to drop and

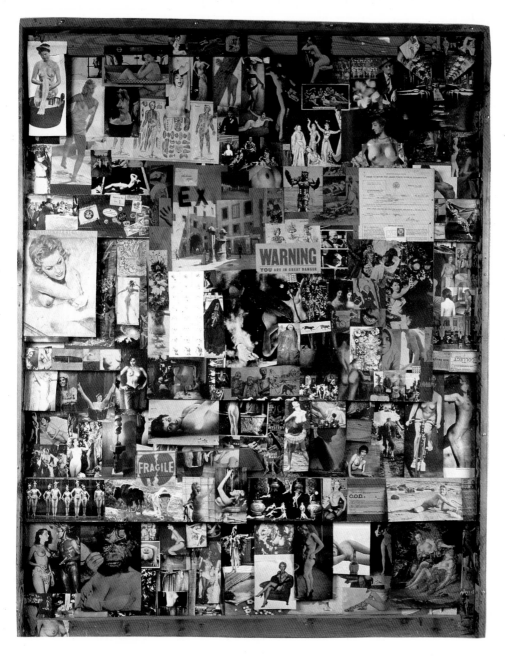

we'd be annihilated."[5] Conner felt strongly that art should not serve as an escape from or denial of the wretchedness of life and the imminence of death. His collage *Untitled* (1954–62) [Fig. 163] treats in detail the seamy, sordid aspects of contemporary culture. The double-sided composition comprises an abstract side, made up of discarded scraps of cardboard, tin, wood, and screening, and a figurative side, cluttered with cutouts, mainly from pulp and pornography magazines. The industrial junk and commercial trash attest to the meaninglessness of conventional standards of order and taste in the face of impending worldwide destruction.

The materials on the front side are worn, dirty, and crudely joined by staples and nails. Though the surface echoes the resourceful creativity of wall coverings in lower-class neighborhoods, the somber tones and dilapidated state of the materials establish an aura of death. In sensibility and approach, Conner's work is comparable to that of the Beat poets, who similarly refused to ignore the dark side of American life. Contemptuous of the

conformist, technological, and capitalistic excess of postwar culture, the Beats posited a new American spirit of freedom, fraternity, and rebelliousness. Conner's jarring combination of themes and images upwell from the same reservoir of outrage, despair, and mordant humor as Allen Ginsberg's *Howl* (1956):

Moloch whose eyes are a thousand blind windows!
Moloch whose skyscrapers stand in the long streets
like endless Jehovahs! Moloch whose factories dream
and croak in the fog! Moloch whose smokestacks and
antennae crown the cities!
Moloch whose love is endless oil and stone! Moloch
whose soul is electricity and banks! Moloch whose
poverty is the specter of genius! Moloch whose fate is
a cloud of sexless hydrogen! Moloch whose name is
the Mind!

· · · · · · · · · · · · · · · ·

Moloch! Moloch! Robot apartments! invisible suburbs!
skeleton treasures! blind capitals! demonic industries!
spectral nations! invincible madhouses! granite cocks!
monstrous bombs!
They broke their backs lifting Moloch to Heaven!
Pavements, trees, radios, tons! lifting the city to
Heaven which exists and is everywhere about us!

While the front side of Conner's collage expresses a *Howl*-like indictment of the American values of newness, cleanliness, affluence, and materialism, the back—or underbelly, as Conner called it—confronts the issues of sexual exploitation, censorship, and moral hypocrisy. A profusion of suggestively posed female nudes fills the entire surface. Although each image occupies its own place, the whole appears as a random, disorderly conglomerate, albeit composed of scrupulously chosen elements. Conner encourages an analogy with stamp collecting by adjoining a small grouping of postage stamps. The analogy turns into a parody of official systems of sanction and judgment with the inclusion of stamps of certification and approval: "Good Housekeeping Seal," "Examined by No. 1," "Certified Washable," "Accepted Committee on Cosmetics," and "The Seal of Quality Sexing Service."

In addition, C.O.D. and COLLECT labels allude to the commercial exploitation of sex within the pornography industry and within the sex parlors and prostitution rings, which continued to thrive despite laws and moral judgments against them. Conner reflects this hypocrisy by exposing an array of pulp photographs prominently marked with bright red signs: WARNING—YOU Are in Great Danger; FRAGILE. The signs bespeak the

innocent, virginal image that America still pretended to sustain.

A stream of obscenity trials attempted to uphold puritanical ethics and enforce sexual taboos through censorship. But the censors' zeal was somewhat restrained in 1960, when a federal court, in ruling that D. H. Lawrence's *Lady Chatterly's Lover* was not obscene, redefined obscenity to exclude works that did not violate prevailing community standards and had redeeming social or aesthetic value. Conner mocks the notion of court-imposed obscenity standards by juxtaposing pulp pinups with suggestively sexual, if not erotic, nude images by Rembrandt, Renoir, Boucher, Rousseau, and Brancusi.

In this collage, as in many of his assemblages and films of the fifties and early sixties, Conner entangles themes of sex, death, and violence, suggesting their conjunction in American culture. His influential film *A Movie* (1958), for example, arranges stock footage from Hollywood productions into a startling bombardment of images, a discordant but penetrating mix of pictures of destruction and seduction. Similar turbulent effects are produced in the collage *Untitled* by the front-back opposition of old deadened materials and youthful animated bodies, and by the violent scale extremes and subject reversals, the sudden directional shifts and sharp contour cuts of the underbelly. Conner also particularizes the theme of death by interspersing with the nudes images of corpses, victimized creatures, and explosions, as well as his own notice to report for an armed forces physical. By juxtaposing such images of death and life within a single pandemoniacal whole, Conner presents an unsettling evocation of contradictions, incongruities, and odd concordances in contemporary American life.[6]

Within the Beat generation and then again in the counterculture movement of the sixties, a focus on the dark side of life was complemented by a search for alternative belief systems. Fear of destruction coupled with an antipathy toward modern technology led many to explore spiritual orientations, such as Zen Buddhism and occult mysticism. These paths offered countercurrents to American materialism, the logic of objectivity and causation, and Western mind-body polarities. Through spiritual practice, the universe could be experienced as a flux of interconnectedness nurtured by the inexplicable.

This spiritual sensibility, fused with an attentiveness to the present, is manifested in a series of verifax collages by Wallace Berman [Fig. 164]. The collages, begun in 1964, are composed of photocopy

★FIG. 164. Wallace Berman, *Untitled*,
1967. Verifax collage, 48″ × 45½″.
Collection of the Grinstein Family.

repetitions of one basic unit, a handheld transistor radio. In the photocopying process and broadcasting of radio signals, Berman saw new possibilities for the transmutation and transmission of information. His compositions emphasize the mystical aspects of receptivity and multiplicity, the potential of the mass media to foster deeper understanding and inspired revelation.

In each collage, Berman places diverse images on the radios' faces. These include American icons, mystic and religious symbols, spiritual leaders, plants, animals, sports figures, body parts, mechanical devices, astronomical structures, and weapons. Within a single composition, the ordering has an arbitrary character: depictions are sometimes repeated, some blank spaces appear, and both

positive and negative printings are used. Similarities between subjects or their shapes establish correspondences, but dramatic contrasts assert dissonances. The whole seems a deck of playing cards or Tarot cards that allows for endless reshufflings and dealings of different hands or readings according to chance. The mixture of images combines mundane and sacred, horrific and glorious, presence and absence, past and future. The American dream/dilemma is specifically intoned by such images as the U.S. Capitol, the Statue of Liberty, a revolutionary soldier, a football hero, and a military bomber plane. These American images are viewed in a macrocosmic context, not just with reference to European or Soviet standards. Berman's vision is neither escapist nor utopian; his concern is to recognize diversity and complexity, to present a broad perspective without losing sight of the particularities and realities of the everyday world.

While mankind has always lived with the fears of natural disasters and wars, nuclear weapons intro-duced the horrifying possibility of global disaster. Modern technology allowed mankind greater control over the environment but also unlimited capacity for destruction and death. The foreboding potential of the bomb and the dark side of industrial expansion and scientific development were sources of recurrent anxieties.

Jess's collage *The Face in the Abyss* (1955) [Fig. 165] offers one nightmarish vision of the future. Elaborate mechanical apparatuses, one set within the Statue of Liberty's crown, and a desolate landscape suggest an apocalyptic moment in which the monuments of human progress outlive their creators. Lady Liberty, the beacon of friendship and enlightenment that once welcomed visitors to a land of plenty, is here an ominous contraption, an agent of surveillance and demolition, ruling over a black chasm of nothingness. Although the composition can be viewed as a parody of technological experimentation or a science fiction hallucination, it is also a serious reflection of Cold War tensions.

Like Jess, Llyn Foulkes represents a desolate landscape that provokes reexamination of the

*FIG. 166. Llyn Foulkes, *Death Valley U.S.A.*, 1963. Oil on canvas, 65″×65½″. Collection of Betty and and Monte Factor.

mythic vision of America the beautiful and bountiful. *Death Valley U.S.A.* (1963) [Fig. 166] is one of a series presenting postcardlike depictions of impoverished, disquieting images bearing the inscription "This painting is dedicated to the American." Here Foulkes pays ironic homage to the nation's most arid, lifeless, and deadly environment. Yet he also marks Death Valley as a metaphor for impending disaster by outlining his image with a yellow-and-black–striped border—a design borrowed from railroad danger signs. Although the warning might refer to the destruction of America's natural splendor because of despoliation, pollution, and waste, a band of spread-winged eagles implicates military action in the death. Through an abstruse allusion to the frontispiece of Ulysses S. Grant's

FIG. 167 (*above*). Larry Rivers, *The Accident*, 1957. Oil on canvas, 84″×90″. Collection of Joseph E. Seagram & Sons, Inc.

★FIG. 168 (*opposite*). Andy Warhol, *Orange Disaster*, 1963. Acrylic and silkscreen on canvas, 30⅛″×30″. Collection of Francesco Pellizzi.

memoirs, Foulkes reinforces this implication while setting it within the context of civil war or, by extension, contemporary civil rights strife. Grant's inscription, written in a calligraphy quite similar to Foulkes's, states: "These volumes are dedicated to the American soldier and sailor."[7]

Death also entered the American consciousness in a more quotidian way as the number of highway fatalities mounted. In 1969 close to 56,000 Americans died in highway accidents (up from 34,000 in 1950), and it was estimated that half of all Americans would be injured on the roads during their lifetime. Although the fatality statistics were well publicized, the national love affair with fast driving continued. Hollywood, moreover, fueled this pas-

sion by glamorizing heroes who drove wildly and experienced libidinous thrills and manly power at deadly speeds. Pictures of disasters also appeared regularly in the daily papers and on the television news, where they were treated as routine occurrences, an acceptable consequence of fast-lane living.

In *The Accident* (1957) [Fig. 167], Larry Rivers depicts the automobile casualty as a commonplace of city life. The accident quite literally dissolves into a haze, becoming a miscellaneous cinematic trifle within the urban flux. An overturned car, flashing lights, blood stains, injured victim, stretcher, ambulance, police car, red cross, bystanders, moving traffic—all the signifying features

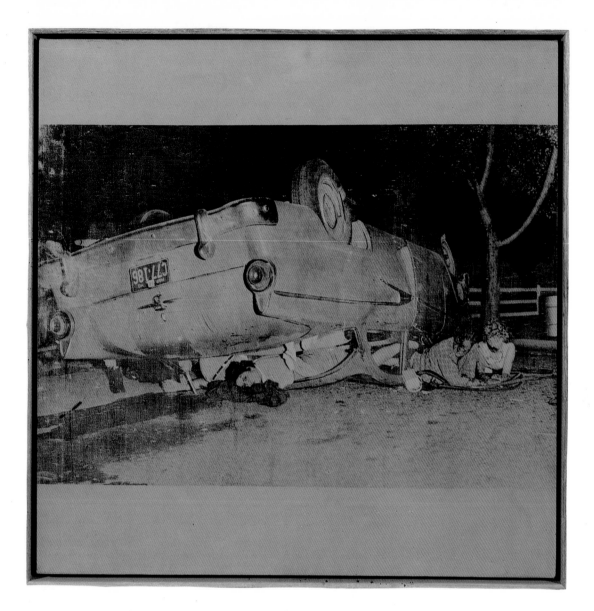

are present, but they seem dispersed notations within an almost dreamlike environment. Frenzy is manifested by the fragmentary, indistinct rendering, but there is no sense of trauma or tragedy. The blurriness that absorbs everything tends to suggest that accidents do not so much disrupt daily life as conform to its usual agitation.

Andy Warhol's car-crash paintings denote a similar routineness in the treatment of the subject but also dramatize the horror. *Orange Disaster* (1963) [Fig. 168], for example, sets a newspaper photograph of an overturned car, the four young victims still pinned underneath, against a ground of fiery orange color. The blown-up isolated image is quite disturbing, yet the poor-quality newspaper illustra-

tion identifies this as but another accident like so many others reported in the news. Warhol was well aware of the anesthetizing effect of media overexposure of such images: "When you see a gruesome picture over and over again, it doesn't really have any effect."[8]

Under the cover of reporting the news, the American media often exploited the public's fascination with images of disaster. Viewer-voyeurs could observe a disturbing reality from a safe, dispassionate, and detached distance. For the viewer-voyeur, the victims are unknown, the circumstances inessential, and the consequences nonexistent. Though Americans prided themselves as a compassionate people concerned about the senseless loss of

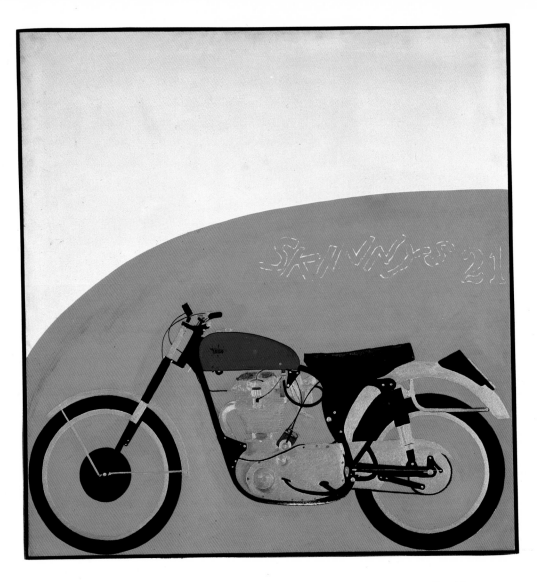

*FIG. 169. Billy Al Bengston, *Skinny's 21*, 1961. Oil on canvas, 42″ × 40″. Private collection.

life, media coverage of car accidents typified a cool, indifferent, curious response to highway carnage. Warhol's paintings refer both to this desensitization and the dark side of the popular myth of on-the-road freedom.

Motorcycles also played an important part in exemplifying the promise and the failings of the American dream. Motorcycle gangs proliferated after World War II and gained cult status through movies like *The Wild One* (1954) with Marlon Brando. In the mid-sixties extensive media attention to the Hell's Angels (including a cover story in the *Saturday Evening Post*), increased the public's

awareness of a rough-riding motorcycle subculture in America. Gangs like the Hell's Angels were portrayed as violent reactionary radicals who sought to uphold law and order by brute power.[9] Another publicized image was the fearless, restless youth for whom the motorcycle symbolized defiance of parental and societal constraints. Alone or as part of a free-spirited group, this freedom-loving individualist saw the highway as his escape route from the narrowness of middle-class values. The movie *Easy Rider* (1969) popularized this image of the motorcycle quester-rebel in love with the open road.

Billy Al Bengston heralded the motorcycle as a

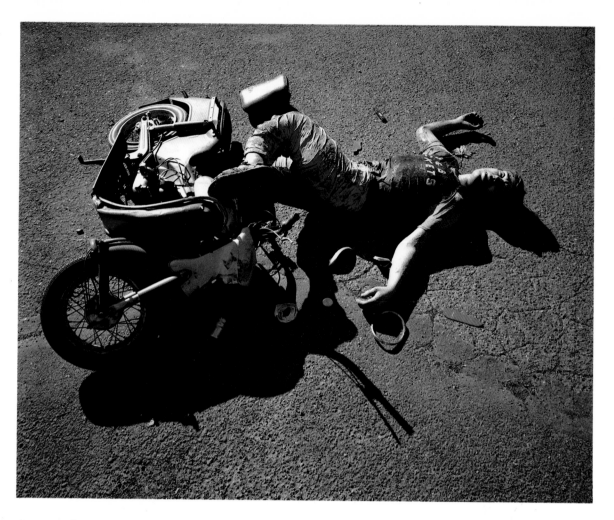

sign of the American dream in *Skinny's 21* (1961) [Fig. 169]. The full profile of a sleek machine, depicted in shiny enamel and industrial paints, is proudly displayed. In the background, a sweeping curve suggesting speed highlights the club's name. The motorcycle is shown as a prized possession—a beautiful machine with pristine surface and precisioned parts—cherished more for its status value than as a mode of transportation. Here and in paintings that focus attention on isolated details, Bengston presents the motorcycle as an object to be admired as the latest in modern technology, an emblem of hedonism, affluence, and carefree mobility. However, as indicated by the prominently defined crossbones on the sales agency insignia in *Back Fender* (1961), the motorcycle also signifies danger and death.

Duane Hanson's sculpture *Motorcycle Accident* (1969) [Fig. 170] graphically depicts one such death. A mangled teenager in a bloody "S and B Rocket" t-shirt lies sprawled out beside his wrecked motorcycle. The figure, a painted fiberglass cast molded from a human body, is jarringly realistic and familiar; he could be the boy next door. Hanson thus reflects a brutal paradox about American culture: An age of prosperity and promise has spawned a thrill-seeking, teenage restlessness that often ends in tragic death. To Americans' zeal for high-speed living, Hanson countered: "There are warning signs in our civilization that should cause us to slow down and take heed."[10] With documentary specificity and metaphoric amplitude, *Motorcycle Accident* enlarges on one of these signs.

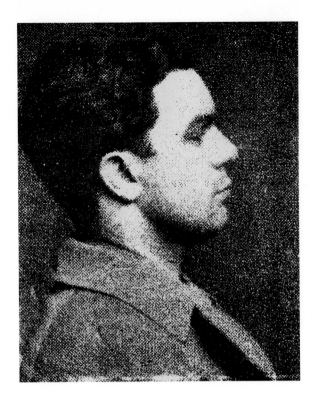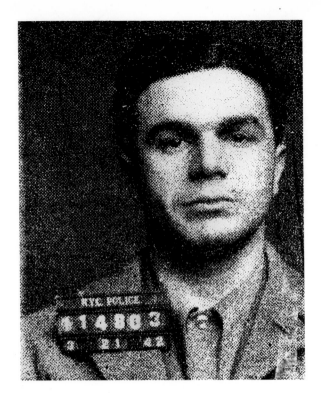

*FIG. 171. Andy Warhol, *Most Wanted Men, No. 1: John M. (Front View and Profile)*, 1963. Synthetic polymer paint on canvas, 49″ × 38″.

Herbert F. Johnson Museum of Art, Cornell University, Ithaca, New York.

America had long exalted the fictional heroism of the gun-toting cowboy, the golden-hearted outlaw, and the avenging superman, but during the postwar period crime and violence became a pervasive component of everyday urban life. In 1955 one crime was committed every fifteen seconds; by 1966 the crime rate was rising five times faster than the population rate.[11] Street crime, cold-blooded felonies, social conflict, political assassinations, ghetto riots, revolutionary terrorism, military aggression, police brutality—America was the most violent of the world's industrial nations.[12] There was a ring of truth to H. Rap Brown's contention that "violence is as American as cherry pie."

Robert Rauschenberg's inclusion of a wanted poster in his combine painting *Hymnal* (1955) is an unsettling reminder that crime is part and parcel of the American experience.[13] The poster appears amid other found objects from the urban environment, ironically asserting itself as both a hallowed element and a commonplace piece of scrap matter. Like the paisley shawl, the section of a Manhattan

telephone book, and the fragments of wood and paper, the notice about a dangerous criminal acquires an aura of solemnity and reverence. The composition collapses distinctions between the sacred and profane, and yet it also raises questions about America's attitude toward criminals and outlaws.

Warhol thrust these questions directly into the public arena with his *Thirteen Most Wanted Men* series (1963) [Fig. 171]. Warhol and other vanguard artists had been commissioned to create works for the New York State Pavilion at the New York World's Fair in 1964. The display was intended to affirm that America was an art-loving nation and to assert New York's position as capital of the international art world. But Warhol chose instead to enunciate America's position as an international seat of crime and violence. His act both undermined the fair's public relations efforts to promote an upbeat, glorious impression of American life and confounded the fair's theme "Peace through understanding." Warhol's massive mugshots, borrowed directly from FBI wanted posters, lasted

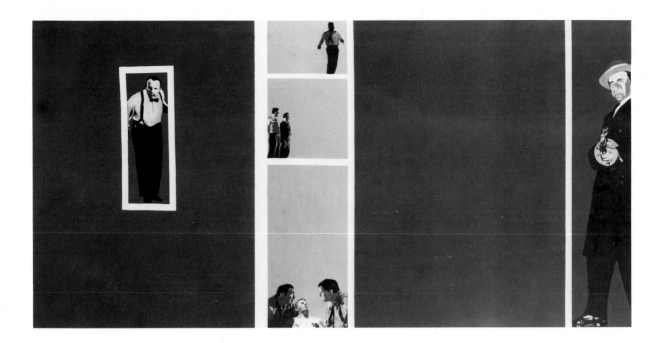

FIG. 172. Rosalyn Drexler, *Home Movies*, 1963. Oil and synthetic polymer, 48"×96". Hirshhorn Museum and Sculpture Garden, Smithsonian Institution, Washington, D.C.

only a few days. On the order of Governor Nelson Rockefeller, who cited fear of Mafia reprisals or lawsuits, the mural was covered over, literally whitewashed.[14]

For Warhol, criminals represented another facet of America's obsession with celebrities: "Nowadays if you're a crook you're still considered up-there. You can write books, go on TV, give interviews—you're a big celebrity and nobody even looks down on you because you're a crook. You're still really up-there. This is because more than anything people just want stars."[15] Criminals on the most-wanted list represent a perverse fulfillment of the American dream. Successful at their chosen "profession," often rich and sometimes famous, they are individuals who have taken full advantage of America's opportunities and resources. Though society loudly condemns crime, it stands in awe of first-class criminals, admiring their creative boldness in bucking the system and escaping capture. The media, moreover, effectively reward criminal masterminds by paying so much attention to them. News coverage turns the spotlight on spectacularly

plotted grand thefts and fearfully brutal killings, and crime novels and films immortalize the most egregious perpetrators. By using mugshots that resemble the close-up, deadpan presentational mode he developed for his celebrity portraits, Warhol establishes another link in the criminal-celebrity bond.

While Warhol focuses attention on the most notorious criminals, Rosalyn Drexler's collage-paintings show criminality and violence to be an everyman phenomenon. The figures in her works have the look of ordinary Middle Americans, the types who live next door and work in downtown offices. Yet, the excessively theatrical poses, familiar stereotypes directly appropriated from movie posters and magazine illustrations, confound fictive and real-life associations. In *Home Movies* (1963) [Fig. 172], Drexler's theme is that "everything that happens is somebody's home movie (whether filmed or not)."[16] Real life has become captive to mass media experience, and violence is a pervasive aspect of both realms.

FIG. 173. Roy Lichtenstein, *Fastest Gun*, 1963. Magna on canvas, 36″ × 68″. Collection of Douglas S. Cramer.

FIG. 174. Roy Lichtenstein, *Pistol*, 1964. Red, black and white felt, 82″ × 49″. The Museum of Modern Art, New York. Gift of Philip Johnson.

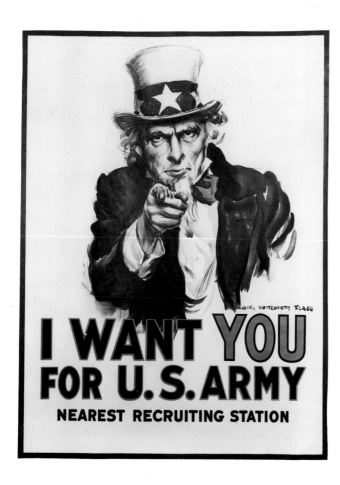

FIG. 175. James Montgomery Flagg, *I Want You for U.S. Army*, 1917. Lithograph, 40¼″ × 29½″. The Museum of Modern Art, New York. Acquired by exchange.

America home of the brave was also home of the world's largest civilian cache of guns, about 100 million handguns, shotguns, and rifles in 1966.[17] Guns were symbols of national sustenance, force, power, protection, and defense; American history and folklore are filled with guns, and television programs and films kept these legends alive. A 1968 *Time* cover story, "Gun in America," noted: "Daniel Boone and Buffalo Bill, Jesse James and Billy the Kid, hero and villain alike, all were men of the gun and all were idolized. 'Have gun, will travel' was more than a catch phrase. It was a way of life."[18] As advocates of gun control repeatedly discovered, many Americans considered owning a gun to be an inalienable American right.

Guns appear repeatedly in the art of Roy Lichtenstein in the 1960s. By depicting them in comic-book style, he establishes a fictional context for them, but their compelling presence as enlarged, isolated, confrontational images vivifies them and thrusts them into the realm of reality. Several paintings from 1963 zero in on the image of a gun about to be fired. In *Fastest Gun* [Fig. 173], for ex-

ample, a dramatically clinical close-up defines a gun handle protruding from a holster, a full supply of bullets lining the belt, and a poised hand ready to clutch the weapon and shoot. The change from a profile view to a frontal perspective in *Pistol* (1964) [Fig. 174] forces the viewer into the position of a victim staring down a loaded barrel. The trigger-ready grasp intensifies the aggressive effect, and the placement of the stark black-and-white oversized image in the center of a blood-red field further dramatizes the visual impact. Lichtenstein's pointed gun also recalls the pointing finger of Uncle Sam in the famous World War I recruitment poster [Fig. 175]. In conflating the victimizing gun with one of the most stirring of patriotic images, *Pistol* captures the prevailing tension that was tearing at the heart of America as the country reckoned with assassinations and fought over the defense of democratic ideals at home and abroad. Lichtenstein appropriately chose this compelling image, adding gunsmoke flames, when commissioned to design the cover for *Time* magazine's story "Gun in America."

While themes of crime and violence were a mainstay of Bruce Conner's early assemblages, the grotesque, offensive images in *Child* (1959–60) and *Homage to Chessman* (1960) [Fig. 176] were particularly meant to express outrage against the death penalty. *Child* shows a shrunken man-child, his brown wax body rotted, burned, and severely mutilated. The body is brutally tied to a high chair, a last cry of anguish caught forever on the open mouth of his thrown-back head. In *Homage to Chessman* the molten, debris-ridden assemblage reeks of death. Though the composition is nonfigurative, Conner's inclusion of a telephone earpiece specifically refers to "the stay of execution which was phoned through to the jail seven minutes before but failed to reach the executioners." This explanation and the statement that "the piece was begun on the day the execution occurred as a protest against the event," are provided at the back of the assemblage on a card written by the artist.

Caryl Chessman's case had stirred worldwide public interest during his twelve years of appeals and eight stays of execution. Many of Chessman's supporters did not question his conviction for robbery and rape, but objected to the application of a kidnapping statute that carried the death penalty. Others were unequivocally opposed to capital punishment under any circumstances. National and international press coverage of the case mounted during the fifties, spurred by Chessman's own statements in numerous articles, a moving autobiography, and three other books.[19] On the eve of the execution, protestors rallied outside San Quentin and in several foreign capitals.[20]

Two other works of vastly different character that make reference to capital punishment are Wayne Thiebaud's painting *Electric Chair* (1957) and Warhol's Electric Chair series (1963–68) [Fig. 177]. Thiebaud's composition features a flaming-red background and a stark profile of a heavy black chair overladen with entangled energized wires, while Warhol shows an austere room, motionless and lifeless, with an ironic SILENCE sign hanging on the wall. In both compositions the chair is an awesome, ominous presence, a reminder of American crime and a decidedly American means of retribution. No other country electrocuted offenders, and many industrial nations had abolished capital punishment. Although the death penalty was imposed less frequently after World War II, in the fifties 717 Americans were executed, and 181 executions took place between 1960 and 1964.

For May Stevens, the American justice system was a convolution of democratic values, an authoritarian

FIG. 176. Bruce Conner, *Homage to Chessman*, 1960. Wax relief, 41″ × 18″ × 7½″. San Francisco Museum of Modern Art. Gift of Irving Blum.

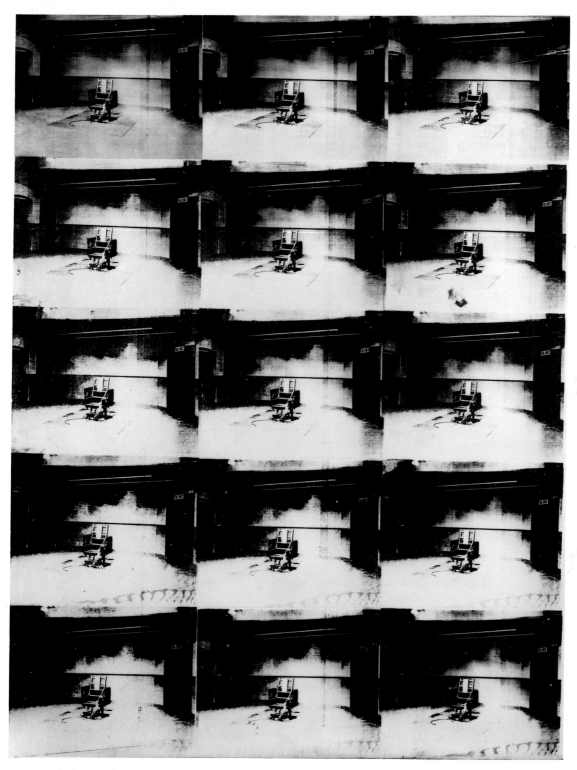

FIG. 177. Andy Warhol, *Orange Disaster*, 1963. Acrylic and silkscreen on canvas, 106″ × 81½″. Solomon R. Guggenheim Museum, New York.

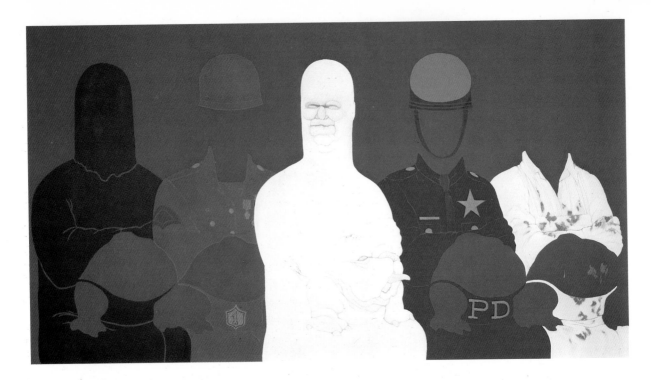

*FIG. 178 (*above*). May Stevens, *Big Daddy Paper Doll*, 1968. Oil on canvas, 60″×120″. Collection of Rudolf Baranik.

*FIG. 179 (*opposite*). Andy Warhol, *Jackie (The Week That Was)*, 1963. Acrylic and silkscreen on canvas, 80″×64″. Collection of Mr. and Mrs. Raymond Goetz.

patriarchy controlled by closed-minded, white males. In her painting *Big Daddy Paper Doll* (1968) [Fig. 178], the omnipotent father figure is a complacent, imperialist personage whose bullet-shaped phallo-projectile head signifies military and sexual dominance. Though the figure is seated, his massive body and odious bulldog face convey strength informed by rigidity and baseness. His clothing, displayed in a row of rank-and-file yeomen, identifies him as a Klansman-executioner, a soldier, a policeman, and a butcher and declares his business to be murder, warfare, law enforcement, and slaughter. The composition, moreover, suggests a reciprocity among these activities and discloses that a single mold shapes them all. Big Daddy's distorted patriotism upholds the establishment's interlocked series of laws and orders. He symbolizes rightness devoid of human compassion, the brute force of oppression that demands compliance.

Stevens developed this Big Daddy imagery in response to racial strife and American aggressions in Vietnam.[21] The skeptical questioning of authority figures and social conformity that became quite

pronounced in the mid-sixties also informs the imagery. Stevens renders this new cynicism using a mode of persuasive presentation borrowed from Madison Avenue. Like a well-designed commercial product, Big Daddy's appearance reflects a concern with packaging, and his regalia of impressive status symbols—an American flag, badges, medals, and insignia—reiterate that surface display often supersedes substantive expression.

The assassinations of John F. Kennedy and Martin Luther King, Jr., brought the issues of crime, violence, and justice to the forefront of national and international attention. The American dream was tarnished if not irreparably shattered by the slayings of these vigorous leaders.

In *Jackie (The Week That Was)* (1963) [Fig. 179], Warhol explores the media's role in manipulating the national mood and memory after Kennedy was shot: "I'd been thrilled having Kennedy as president; he was handsome, young, smart—but it didn't bother me that much that he was dead. What bothered me was the way the television and radio were programming everybody to feel so sad."[22] Warhol's juxtapositions of familiar newspaper

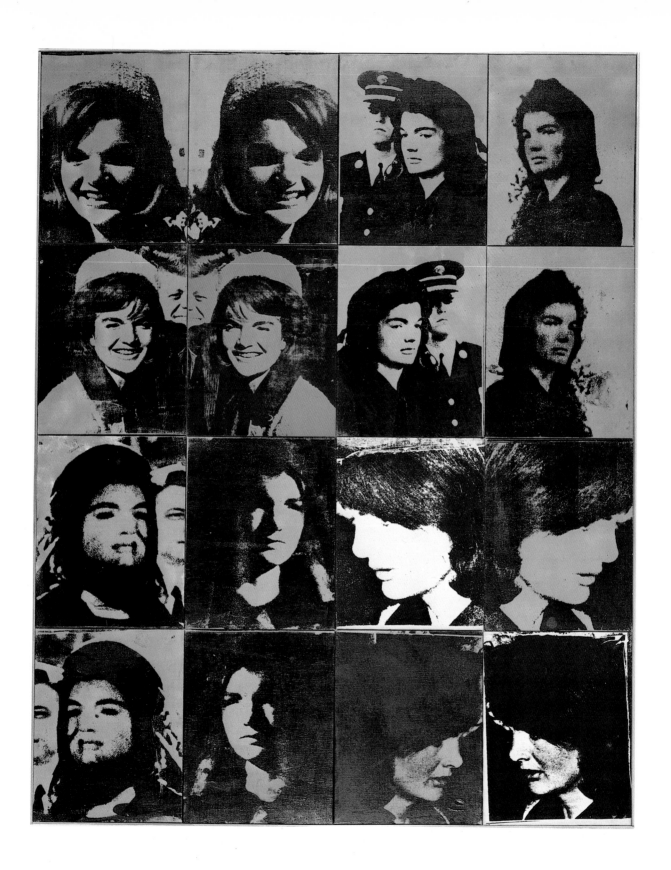

★FIG. 180. Ed Paschke, *Purple Ritual*,
1967. Oil on canvas, 48″ × 32″.
Collection of Robert H. Bergman.

photographs of the first lady before and after the assassination and the rapid-flash shift from one image to another, each a memory bank of associations, effects an agitated response. The power of pictorial display is rendered by the converging and diverging pairings, the shock of one blue- and two white-ground depictions within a field of neutral-toned images, and the theatrics of interruption, difference, and opposition.[23]

The media's focus on Jackie Kennedy exacerbated the reality of the president's death, the end of the Camelot myth. At the same time, the myth was reinforced by the broadcasting of the awesomely self-possessed widow performing all the rituals of a highly ceremonial state funeral. Moreover, focus on Jackie Kennedy diverted attention from the crime itself and the frenzy surrounding the murder investigation.

But images of Lee Harvey Oswald were as much a part of the media coverage as images of the Kennedy family and funeral. Kienholz's *Instant On* assemblage [see Fig. 117] invokes the site of the assassination, and Ed Paschke's painting *Purple Ritual* (1967) [Fig. 180] shockingly affirms the Americanness of the armed assassin:

I intended it to be a symbol of the American way of life. That is why I set Oswald down against the flag and seals. The only literal thing I did in the painting was to color him purple—the color associated with death and official mourning.
But whose death? Oswald's or Kennedy's? Both in a sense. My main concern was not the death of either man but rather the relationship between both incidents and their place in the fabric of our heritage.[24]

Rifle in hand, revolver in pocket, Oswald is the newest member of the American pantheon of gunslingers, the latest image in a national gallery that bestows undifferentiated attention on its heroes and its criminals. Paschke's memorial combines a traditional mode of homage—pictorial enshrinement in an ornamented vintage frame—with its mass media equivalent, the replication of a photograph that has become an icon through its repeated publication.

In the years that had intervened between the assassination and Paschke's creation of *Purple Ritual*, the mass media and the public probed, analyzed, and debated endless details about Oswald as evidence for one or another theory regarding his motives. Had Oswald acted as a lone crank or as part of a domestic or global conspiracy? A photograph showing Oswald bearing the weapons used in the murders of Kennedy and the Dallas policeman and

holding a Trotskyite newspaper—a pose that Oswald had staged half a year before the assassination—appeared on the cover of *Life* (February 21, 1964) and became a prime catalyst for conspiracy theories. The Warren Commission intended to reassure the nation that Oswald acted alone, but its report, issued September 27, 1964, did just the opposite. Considered a whitewash, the report unleashed new floods of speculation.

Intense preoccupation with the assassination reached a new peak in 1967 as the release date neared of a book authorized by the Kennedy family. William Manchester's *The Death of a President* received prepublication contracts for serialization in *Look*, a Book-of-the-Month Club offering, and a paperback edition.[25] Despite the big promotion and a publicized dispute between the author and the Kennedys over editorial control of the text, the book was generally criticized as a biased and mythologized rendering.[26]

In February 1967, Jim Garrison, a New Orleans district attorney, announced that he had evidence to substantiate charges of a conspiracy. His case drew extensive news coverage and increased public anxiety about government cover-ups. But Garrison finally proved only that the murder, the official investigation, and the spin-off studies, ranging from the preposterous to the believable, remained a major topic of public interest. Paschke's portrayal of Oswald as a symbol of American life comprehends both the events of November 22, 1963, and the ensuing years of doubt, confusion, and anxiety.

Like the Kennedy assassination, civil rights violence turned cracks in the American dream into sundering ruptures. Black Americans had been given the right to vote in 1870, but the issue of racial equity and injustice remained largely unexamined, and segregation remained a way of life. After World War II, though, a series of events heralded the beginning of a national reassessment of racism: the appearance of Jackie Robinson in a major-league uniform (1947), an executive order to bar segregation in the armed services (1948), a Supreme Court decision mandating school desegregation (1954), the bus boycott organized by Martin Luther King, Jr., in Montgomery, Alabama (1955–56), the use of federal troops in Little Rock, Arkansas (1957), and the lunch-counter sit-ins in Greensboro, North Carolina (1960).

In May 1963 a small civil war broke out in Birmingham, Alabama. The staunchly segregationist police commissioner, Bull Conner, brandished attack dogs and fire hoses to break up nonviolent demonstrations by schoolchildren and freedom

★FIG. 181. Andy Warhol, *Race Riot*, 1963. Acrylic and silkscreen on canvas, four panels, 30″ × 33″ each. Collection of Sam Wagstaff.

marchers led by King. As the nation and the world watched through the reportorial eye of television and press cameras, the Birmingham police clubbed their way through the crowds. Demonstrators were crushed by blasts of water, bitten by vicious dogs, and brutally beaten.

For his Race Riot series (1963–64) [Fig. 181] Warhol appropriated the news photos of the attack dogs in action, photos that had appeared in *Life*, *Time*, *Newsweek*, and daily papers across the country.[27] Here, again, his use of documentary artifacts exemplifies the mass media's direct power to control public sentiment and opinion. But Warhol dif-

fuses the impact of the imagery by printing poor-quality reproductions, emphasizing the ground color, arbitrarily cropping the content, and creating irregular, repetitive arrangements. The subject matter and presentation provoke a sense of presence and absence, of an image seen and yet unseen, of emotions piqued and numbed.

In many ways Birmingham was a pivotal point in the civil rights movement. The public conscience—black and white—was stirred to action. Several months later, on August 28, over 250,000 people gathered for the March on Washington, the largest civil rights demonstration in history. The

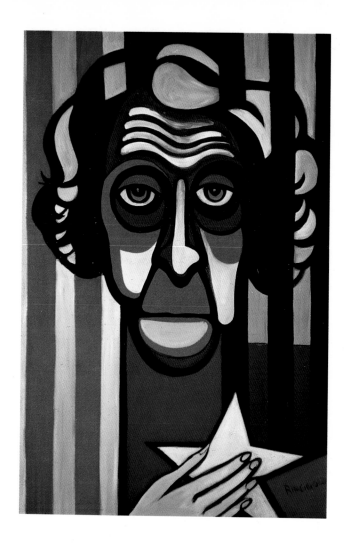

marchers joined in heartfelt choruses of "We Shall Overcome," and King's powerful "I have a dream" speech inspired new hope. Merging the age-old theme of the American dream with clear statements of the black dilemma, King intoned a new vision for the nation:

I have a dream that one day on the red hills of Georgia the sons of former slaves and the sons of former slave-owners will be able to sit down together at the table of brotherhood. . . . I have a dream that my four little children will one day live in a nation where they will not be judged by the color of their skin, but by the content of their character. .

The groundswell of civil rights activism included black artists, who began to question the premises of the American dream in light of the so-

ciopolitical reality of the black situation in America.

Faith Ringgold's *American People Series* (1963–67), for example, underscores the depths of racial tensions embedded within American values and common practices. In the painting *The American Dream* (1964), Ringgold addresses racial economic inequality and Americans' emphasis on wealth as an index of personal value by portraying a half-white, half-black woman proudly displaying a diamond ring. In *The Cocktail Party* (1964), she denotes tokenism and the uneasiness of changing social relationships by showing a single black man attending a formal, otherwise all-white gathering. And in *God Bless America* (1964) [Fig. 182], she forcefully represents patriotism under siege: A white woman is shown imprisoned within the stripes of a flag she dutifully salutes, as those stripes turn from red and white to black and white.

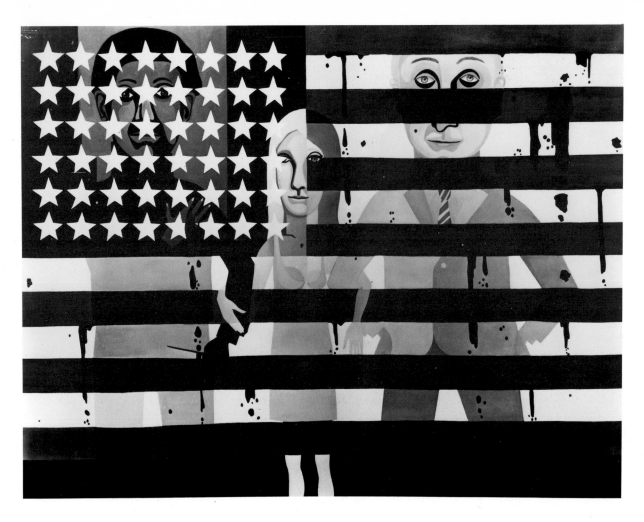

FIG. 183. Faith Ringgold, *The Flag Is Bleeding*, 1967. Oil on canvas, 72" × 96". Collection of the artist.

The injustices of discrimination and the difficulties of integration are more pointedly expressed in *The Flag Is Bleeding* (1967) [Fig. 183], where three solemn figures—a black man, a white woman, and a white man—are joined together behind the stars and stripes. Though they stand arm in arm, resolutely upholding the ideals of freedom and justice, the wounded black man bears a knife, and the flag drips blood. Significantly, too, the woman serves as the binding intermediary between the black and the white man. Though her nurturing attitude establishes her importance, her diminutive stature reflects the subordinate place generally accorded women in American society.

Throughout the series, Ringgold articulates the failures of American democratic ideals and the hopes for a reconstituted American dream that will include minorities. Her imagery also captures the ominous mood and racial tensions of the mid-sixties.

Raymond Saunders's composition *American Dream* (1968) [Fig. 184] also contrasts white America's American dream and the actuality of black Americans' experience. Using newspaper cutouts, Saunders represents the mythic dream as a vision of wealth, leisure, family prestige, and opportunity. A fashionable, Charleston-era couple stands beside an expensive automobile, a sign promotes Nelson Rockefeller for president, and an American flag flies freely. But these cutouts are tellingly outdated or marred, torn, and deteriorating. A red band separates these images, set on a blue-black zone, from a chalky, graffiti-defaced white zone that resembles the whitewashed window of a vacant storefront in

FIG. 184. Raymond Saunders, *American Dream*, 1968. Oil and collage on canvas, 69¾″ × 41¾″. Mount Holyoke College Art Museum, South Hadley, Massachusetts. Gift of the Childe Hassam Fund of the American Academy of Arts and Letters.

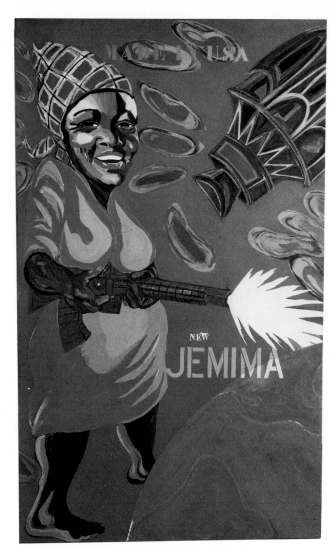

FIG. 185. Joe Overstreet, *New Jemima*, 1964. Construction, 102½″ × 61″ × 17″. Menil Foundation, Houston, Texas.

an urban ghetto. Saunders's composition reverberates with doubts about the dream, its viability, and its availability and relevance to blacks.

Black artists also sought to refute the racist stereotypes that were perpetuated in mainstream literature, films, television, and advertising. *New Jemima* (1964) [Fig. 185] by Joe Overstreet proposes a dramatic reversal of the traditional Aunt Jemima, the concessive, beneficent servant who cooks, cleans, and cares for the children. The new Jemima is a figure conceived in black anger and black pride: a feisty, assertive woman brandishing a machine gun. Both the old image and the new are explicitly American creations, as the MADE IN USA label proclaims.

In the mid 1960s racial confrontations became increasingly violent. The American dream of equality, freedom, and justice became an American nightmare for blacks and whites alike. In August 1964 the bodies of three young white civil rights workers were found near Philadelphia, Mississippi; twenty-one whites were charged with conspiring in the murders. In February 1965 Malcolm X was assassinated; three blacks were later arrested and convicted. In March all eyes turned to Selma, Alabama. Over two thousand civil rights demonstrators had been arrested there in the preceding months. Then, during preparations for a march to Montgomery to protest voting rights discrimination, a young black man was killed by a policeman.

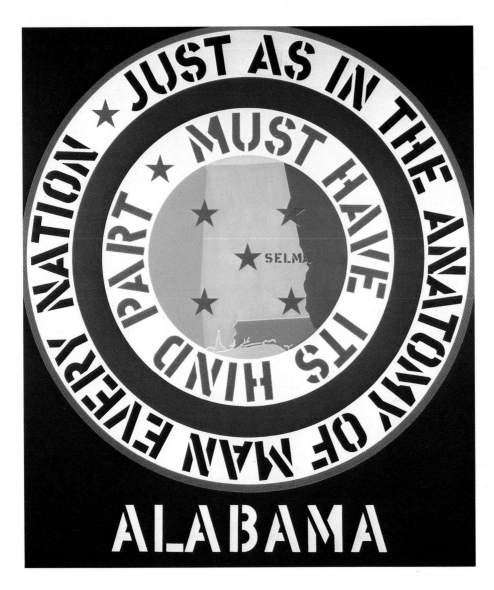

In the ensuing encounter on U.S. Highway 80, a phalanx of two hundred state troopers, armed with clubs, whips, tear gas, and electric prods, charged the demonstrators. The attack sparked nationwide outrage. Sympathies for the protesters mounted as a second person—a white minister—was murdered and local authorities continued to obstruct the marchers. Finally the march began, under the protection of hundreds of federalized Alabama National Guardsmen and two thousand federal troops. But the marchers' victory was quickly shattered by the murder of Viola Liuzzo, a civil rights worker.

Robert Indiana's painting *Alabama* (1965) [Fig. 186] commemorates the nightmarish events by ringing a map of Alabama with the epitaph JUST AS IN THE ANATOMY OF MAN EVERY NATION MUST HAVE ITS HIND PART. Placing Alabama at the center of a target, with Selma marked as the bull's eye, Indiana makes a simple and direct statement of contempt and shame using a reductive, emphatic sign idiom. His design has the visual potency of an advertisement, poster, product insignia, institutional logo, group emblem, or patriotic banner. Indiana's adaptation of a promotional format typifies a new approach to history painting, one quite distinctive from the European tradition of representational documentation or the style of American social commentary art in the 1930s and 1940s.

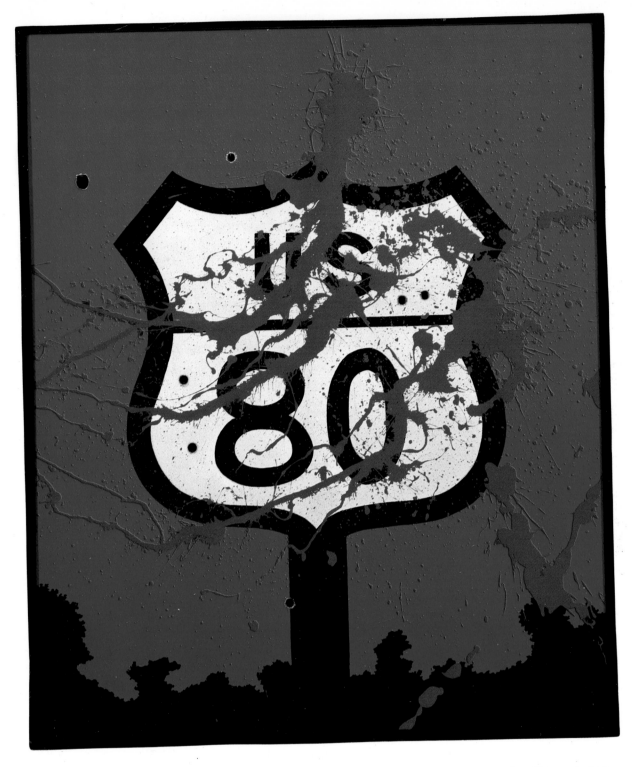

192 MADE IN U.S.A.

FIG. 188. H. C. Westermann, *Evil New War God*, 1958. Brass, partly chrome plated, 16¾" × 9¾" × 10¼". Whitney Museum of American Art, New York. Promised gift of Howard and Jean Lipman.

Allan D'Arcangelo takes a similar approach in *U.S. 80 (In Memory of Mrs. Liuzzo)* (1965) [Fig. 187]. The bold forms, flat color planes, and clear outlines are starkly depersonalized and objective in their intensity. And yet the painting focuses on the wrenching image of a blood-spattered, bullet-ridden Route 80 highway marker. Looming large against a clear blue sky, above silhouetted treetops, the road sign stands as a tombstone, a marker of forcible impact in a culture overflowing with signs.

Five months after Selma, a week of rioting in Watts, a black Los Angeles neighborhood, left thirty-four dead. Bad turned to worse in the summer of 1967, when riots erupted in 31 cities in every corner of the United States; 86 people were killed, 2,056 injured, over 11,000 were arrested.[28] This new form of civil warfare sorely tested the American dream of one nation, indivisible, "with liberty and justice for all."

Another crack in the American dream was effected in 1957 when the Soviets launched *Sputnik*. This was the first challenge to America's technological leadership. Though America's political will had been tested by the Korean War and by Soviet military activities in Eastern Europe, the USSR had never before overtaken the U.S. in a scientific military project. The success of *Sputnik* aroused doubts about America's scientific capability, national security, and dominance in the arms race. The country subsequently began a blitzkrieg effort in all realms of scientific and military endeavors.

H. C. Westermann's *Evil New War God* (1958) [Fig. 188], depicts the apotheosis of the new breed of army commander: a sinister robot of standardized metallic parts, all shiny and precisioned, the phrase IN GOD WE TRUST etched upon its chest. Although the humanoid figure has a face and stands upright, its demonic powers are rooted in military hegemony, the defense budget, and technocratic industrial expertise.

*FIG. 189. Edward Kienholz, *O'er the Ramparts We Watched Fascinated*, 1959. Painted doll parts and electronic parts on wood, 25½″ × 45½″ × 5″. The Stephen S. Alpert Family Trust.

In *O'er the Ramparts We Watched Fascinated* (1959) [Fig. 189], Edward Kienholz articulates the chilling consequences of allegiance to such a god. At this twilight's last gleaming, the Great Seal of the United States presides over an array of jumbled electronic parts and dismembered dolls strewn across a ravaged environment. The modern bombs bursting in air leave a mushroom cloud to rise over a nation that once called itself the land of the free. There is no glory in a nuclear battle, and there can be no national pride in watching and being awed by the impressively obscene sight of technological annihilation.

By 1965, when Rosenquist painted the monumental composition *F-111* [Fig. 190], renewed Cold War tensions and America's escalating commitment to the war in Vietnam had accelerated the arms race. Congress repeatedly approved the Pentagon's requests for new weapons and increased military spending. The F-111 was to be an all-purpose, supersonic fighter-bomber that would incorporate the nation's most advanced technology and would spearhead a military victory in Vietnam. But the F-111 proved a major disaster. Waste and corruption caused scandalous cost overruns,

and the aircraft had serious structural defects. Moreover, the F-111 was useless against the more advanced Soviet missile systems and unsuitable for the guerrilla warfare of Vietnam. Nonetheless, the Johnson administration had faith in American air power and on February 7, 1965, began a new offensive initiative with bombing raids in North Vietnam. The raids, which represented a dramatic escalation of America's involvement in the war, triggered widespread protest at home.

Rosenquist saw the F-111 as more than the newest, latest weapon in America's arsenal. The "war machine" was also "an economic tool" that kept people employed and prosperous; it was the apex of America's indulgent obsession with leviathan extravagance, shattering speed, and instant obsolescence.[29]

Rosenquist depicts the fighter-bomber soaring across a surface that is thirteen feet longer than an actual F-111. The plane dominates a random panorama of the products of American affluence, leisure, and technology: a piece of angel cake, a Firestone tire, canned spaghetti, light bulbs, a smiling child under a hairdryer, an atomic blast covered by an umbrella, and a helmeted deep-sea diver emit-

FIG. 190. James Rosenquist, *F-111* [detail], 1965. Oil on canvas with aluminum, 120″ × 1032″. Collection of Ethel R. Scull.

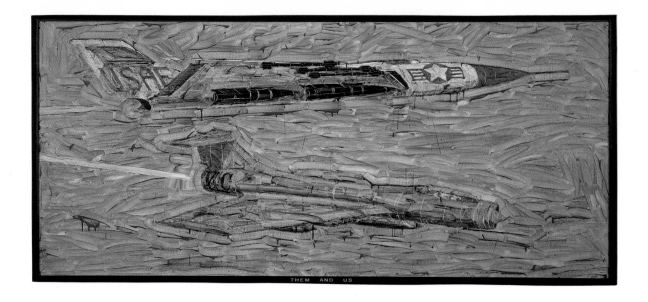

THEM AND US

★FIG. 191. Neil Jenney, *Them and Us*, 1969. Synthetic polymer paint on canvas with pencil, 61″ × 135″ × 3⅜″. The Museum of Modern Art, New York. Gift of Louis G. and Susan B. Reese.

ting a gush of air bubbles. All these images, like the F-111, are depicted in grand scale, in acid colors and the artificially slick photographic style common in the mass media.

For Rosenquist the imagery and mode of presentation was a visual equivalent of the "economy of surplus," a "conveyor belt" presentation of the rampant waste within the military-industrial complex and of the American romance with new ideas and new inventions—the ideology of newness. The images pass by quickly, in spasmodic arrangements that allow little opportunity for reflection or integration. Yet the visually disorienting juxtapositions—a girl in the midst of a fighter-bomber—establish a not so unlikely relationship between innocent life and death by air bombing. The displacements are both absurd and horrific. The atomic blast sheltered by an umbrella, for example, suggests the ironic possibility of protection from fallout and the notion of the blast as a beautiful sight one might see while strolling under a parasol.

Above all, Rosenquist considered the painting as "an antidote to the new devices that affect the eth-

ics of the human being" and as "an extravagance that would relate to the extreme power" of American society.[30] He did not view the painting as a remedy for social ills, but he hoped that its forcefulness and excess would encourage people to begin thinking "in terms of humanity again."

In *Them and Us* (1969) [Fig. 191], Neil Jenney extends the fighter plane iconography by pitting an exemplar of American technology against a Soviet bomber. While the composition suggests comparative, competitive display, the title intones a perpetual state of conflict, reminding us that oppositional relationships are basic to human interaction. Neither harmony nor apocalyptic eruption prevails but rather a sustained polarization intensified by the awesome escalation of weaponry and violent confrontation.

Adopting a very different approach to warfare, Peter Saul began a series of Vietnam paintings in 1965 [Fig. 192]. The compositions focus on violence and torture, sex and death. Saul's aim was to offend middle-class taste and propriety, to express unqualified repugnance for establishment politics,

FIG. 192. Peter Saul, *Saigon*, 1967.
Oil on canvas, 92¾″ × 142″. Whitney
Museum of American Art, New
York. Purchased with funds from the
Friends of the Whitney Museum of
American Art.

and to repudiate American involvement in Viet-
nam. In dayglo colors, his canvases disgorge dis-
torted anatomies and obscure displays of perverse
sexuality, grotesque brutality, and manic hysteria.
As much as the imagery has an air of surreality—
reality pushed to the edge of unbelievability—it is
imprinted with themes derived from press reports
about Vietnam that excoriated idealized impres-
sions of the war and American actions.

A similar approach underlies Red Grooms's black
comedy construction *The Patriots' Parade* (1967)
[Fig. 193]. American goodwill and national pride
abound in the bright waving flags, and a confident
President Johnson is flanked by a saluting military
officer, a war veteran, and a beauty queen in the
guise of the Statue of Liberty. But the beauty is

Miss Napalm, a skull peers forth from within the
cowboy hat that Johnson exuberantly waves, and a
heap of dead babies lies at his feet. The celebratory
outlook befits the administration's repeated insis-
tence in the mid 1960s that America was winning
the war, even as both the press and Congress had
begun questioning the official rosy assessments.

The credibility gap, the grave discrepancies be-
tween the administration's optimistic statements
and independent reports from Vietnam, had wors-
ened in 1965. The televising of Morley Safer's film
footage of U.S. Marines leveling a village and the
broadcast hearings of the Senate Foreign Relations
Committee, headed by William Fulbright, gave the
lie to the administration's version of the war. Saf-
er's tapes provided the American people and the

American media with images of violent acts of de-
struction perpetrated by American troops against
Vietnamese civilians. Although it would be several
years before the media commonly challenged the
administration's reports, Safer's footage was sem-
inal in marking a new direction, as David Halber-
stam explains:

Some print reporters might and did write about atroci-
ties, and there would be a mild reaction from the elite, a
senator or two offended, a brief flurry of deadlines, but
this was something different, this was like watching a
live grenade going off in millions of people's homes.
Watching American boys, young and clean, *Our* boys,
carrying on like the other side's soldiers always did, and
doing it so casually. It was the end of the myth that we
were different, that we were better. In the American
myth, born of a thousand Westerns, it was the cowboys
who saved women and children, it was the Indians who
were savages and committed terrible indecencies on the
helpless; and now here was just the opposite.[31]

This refutation of the mythic image of the Ameri-
can military as a righteous and virtuous agent of
peace and democracy thus laid open to question the
nature of America's ethical commitments. The
works of Grooms and Saul look beyond the partic-
ularities of the war to ask what America's involve-
ment in Vietnam said about the nation's heart and
mind.

Vietnam was also television's first war; indeed, it
was often called the "living room war." By the end
of 1967 the three major networks each had well-

staffed bureaus in Saigon that provided nightly on-the-spot coverage. Though occasional reports offered in-depth analyses, more typically the video-tapes featured bloody combat stories and an audio track of statistics. Few efforts were made to explain anything about Vietnam's history, culture, or ideological disputes. No one on network television openly challenged the administration's Cold War logic. And until 1968 the networks dutifully reported the official position that America was winning the war.

Kienholz's *The Eleventh Hour Final* (1968) [Fig. 194] underscores the extraordinary role of television in bringing the Vietnam War home, while it also suggests the distance between a televised war and a real war. He presents a classic middle-class

living room, a television set its centerpiece. But the console is concrete, like a tombstone, and the never-changing screen shows a dead headless child and the week's body count: AMERICAN DEAD—217, AMERICAN WOUNDED—563, ENEMY DEAD—635, ENEMY WOUNDED—1291. In this living room, it is always the eleventh hour, the time of the late-night news and the metaphoric hour before doom.

Television magnified the brutality of war, yet it also mediated the effect of death, translating slaughter into a viewing experience and a scorecard of contrived numbers. It was a remote, distorted impression of the war that reached the American public, an impression more in line with a Hollywood spectacle or a public relations campaign than with documentary news coverage.

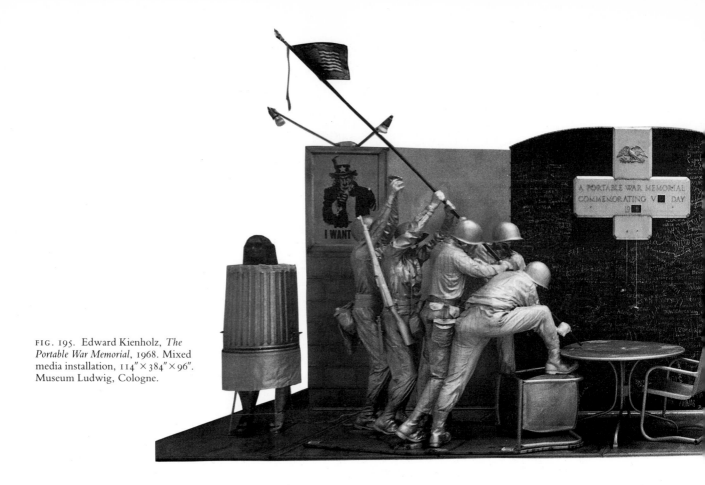

FIG. 195. Edward Kienholz, *The Portable War Memorial*, 1968. Mixed media installation, 114″ × 384″ × 96″. Museum Ludwig, Cologne.

The Eleventh Hour Final effectively establishes the television set as a fitting tombstone for the Vietnam War. In another work of 1968, *The Portable War Memorial* [Fig. 195], Kienholz explores the idea of a more generalized monument, a commemoration of past and future wars and American ideas about war.

The tableau is divided into two halves, the left termed by the artist "propaganda devices" and the right "business as usual."[32]

Highlighting the left half is a replication of the famous image of U.S. Marines raising the American flag at Iwo Jima.[33] Kienholz depicts the icon quite exactly—except that his soldiers are faceless and are raising the flag atop a patio table. Behind them hangs another eminent war image, James Montgomery Flagg's recruitment poster of the pointing Uncle Sam [see Fig. 175]. The arousing patriotic fervor is complemented by an assemblage sculpture portraying Kate Smith, best known

for turning Irving Berlin's "God Bless America" into an unofficial national anthem. Within the tableau, the song plays continuously, emanating from a tape hidden within the garbage can that represents Smith's rotund body.

In front of the marines, standing center stage, is a large blackboard covered with the chalked names of 475 once-independent nations that no longer exist. An attached eraser and piece of chalk facilitate additions or corrections to this giant international tombstone. At the top of the board, on an inverted cross emblazoned with an American eagle, is the inscription A PORTABLE WAR MEMORIAL COMMEMORATING V— DAY 19——. Like the blackboard and empty faces of the soldiers, blank spaces invite future generations to complete the details as warranted.

Separately and together, the "propaganda devices" articulate a world history of ongoing warfare that is glorified in perpetuity by national war

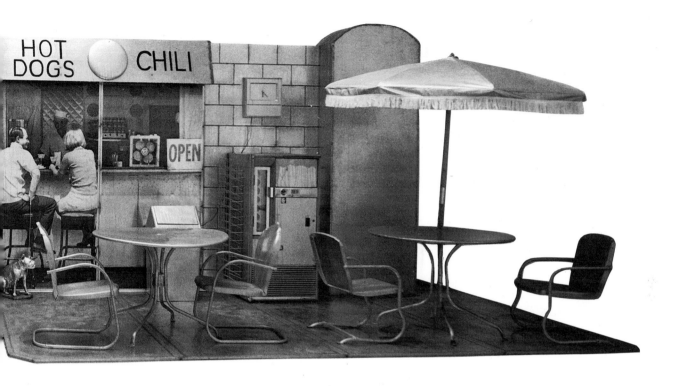

memorials. Erected to commemorate fallen heroes and their patriotic cause, war memorials are also potent political tools for national aggrandizement. Kienholz undercuts the notion of glorification by proposing one all-purpose tableau that makes the particulars of name, place, cause, and time insignificant. By situating the memorials in everyday contexts—a backyard table, a schoolroom chalkboard—Kienholz suggests that despite all the speechifying and memorializing, modern societies have a blasé attitude toward war. War is, in the terms Kienholz uses to describe the second half of his construction, "business as usual."

The "business as usual" portion of the work is a typical American snack bar, replete with a fast-food counter advertising hot dogs and chili, a Coke machine, and more patio furniture. The setting, composed of actual functional objects, is a cliché of on-the-go, mass produced, populist American comfort. But within the otherwise placid environ-

ment, at the back of the snack bar, Kienholz has placed a tombstone. Unlike the more ostentatious "propaganda" memorials, this tombstone is utterly simple, devoid of any inscription and bearing only one tiny figure: a crucified man with burned hands. Kienholz has referred to it as "the last tombstone," identifying the burns as "mankind's nuclear predictability and responsibility."[34] Its presence amid the daily clutter of "business as usual" portends that this all-American scene may become the next and final link in the chain of portable war memorials.

Like Kienholz, Claes Oldenburg became preoccupied with the concept of public monuments. But Oldenburg seized upon the notion of erecting massive statues of utilitarian objects as witty ironic tributes to everyday American life. Though his proposals were not conceived as political comments, *Lipstick (Ascending) on Caterpillar Tracks* (1969) [Fig. 196] became a symbol of defiant anti-

war sentiments. The monument was commissioned by dissident students at Yale University in response to an exhortatory remark by Herbert Marcuse about the subversive potential of satirical art.[35] The colossal column is at once a woman's cosmetic and a towering phallus, emerging from an object used both for farm production and military aggression. The sexual innuendos suggest a theme of love, but the machine treads, exemplary of roughshod treatment, transfigure the lipstick into a bullet or missile. The oppositional structuring and emphatic materiality of the oversized objects provoke thoughts about power, violence, oppression, and exploitation—the exploitation of women by the cosmetic industry, the exploitation of women by men, and the exploitation of Vietnam by American combat forces. In its way, *Lipstick* captures the polarities of a period in which "Make love not war" became a rallying cry that divided the nation. In the late sixties people took to the streets both to proclaim a peace-loving rebellion in favor of sexual freedom and to stage an angry revolt against establishment politics and American imperialism in Vietnam. The unrest signaled both deepening fissures in the American dream and the possibility of a new American vision that would disavow militarism, materialism, and puritanism.

Oldenburg's *Lipstick*, Rosenquist's *F-111*, Kienholz's *The Portable War Memorial*, and other politically sensitive works of art stirred public controversy about the place and purpose of art in American society. Artists argued among themselves about the role of political conscience and responsibility in creative life. Various individual artists designed posters and donated their works for benefit auctions, and groups of artists organized to participate in demonstrations, to stage protest exhibitions and special projects, and to run newspaper ads.[36] Among the most notable collective activities were the "End Your Silence" ad in the *New York Times* (June 27, 1965) signed by five hundred artists, the creation of the *California Peace Tower of 1966* in Los Angeles, and the *Collage of Indignation* in New York (January 29–February 5, 1967).

Controversy over activist art moved into the realm of courtroom debate when the Stephen Radich Gallery on Madison Avenue exhibited a series of sculpture constructions by Marc Morrel (December 1966–January 1967). Morrel, a Vietnam veteran, had shaped American flags into cadavers, bound flags in chains, and slung flags from nooses in order to arouse concern about American atrocities in Vietnam and to protest the country's involvement in an undeclared, immoral war. Despite his intentions, the sculptures were attacked as dese-

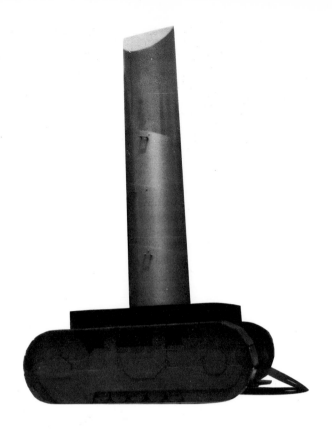

FIG. 196. Claes Oldenburg, *Lipstick (Ascending) on Caterpillar Tracks*, 1969. Corten steel, plastic, and wood, painted with enamel, 288" × 252" × 204". Yale University Art Gallery, New Haven, Connecticut.

crations of the flag, and gallery-owner Radich was arrested, tried, and convicted for showing them. The case sparked a fury of reaction in the national press and in the art world.[37] At issue was the censorship of artistic expression and artistic display, an artist's right to use the flag and a gallery's right to exhibit the flag in or as art. After years of appeals, Radich was acquitted in the fall of 1974, but not before a wave of further appropriations of the flag by antiwar protestors and the passage of a flag-desecration bill by the U.S. Congress (June 20, 1967) tested the limits of freedom in the use of the flag.

Though few artists had an overt political program, many created works imbued with a political

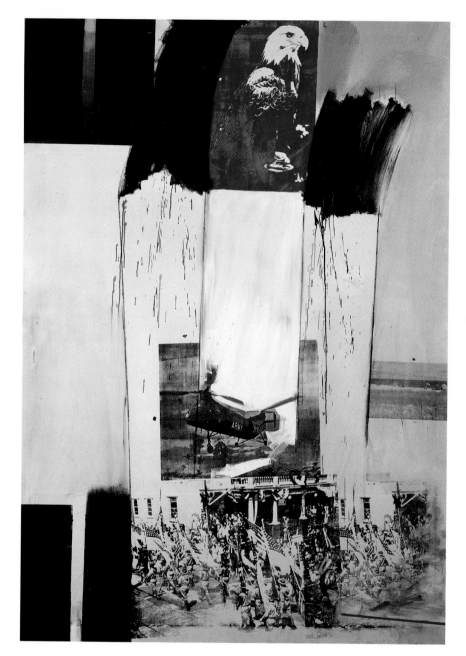

★FIG. 197. Robert
Rauschenberg, *Kite*,
1963. Oil and
silkscreen on canvas,
84″ × 60″. Collection
of Ileana and Michael
Sonnabend.

sensibility or works that responded to the tensions
in American culture. By repeatedly choosing
charged or potentially charged images and present-
ing them in ways that encouraged thinking about
American life, they captured the dynamics of a na-
tion in flux, a nation whose revered dream was
being impugned by domestic protests and interna-
tional geopolitics. Rather than express longing for
a paradise lost or hope for a new utopia, artists of

the 1960s delineated the stalemating of the Ameri-
can dream.

In Rauschenberg's *Kite* (1963) [Fig. 197], for ex-
ample, an American flag parade and bald eagle in-
tone patriotism, but these assertions of national
glory are eclipsed by evidence of dissension created
by flag and troop collisions within the parade and
the appearance of a hovering army helicopter
poised to bring assistance or to quash an opposing

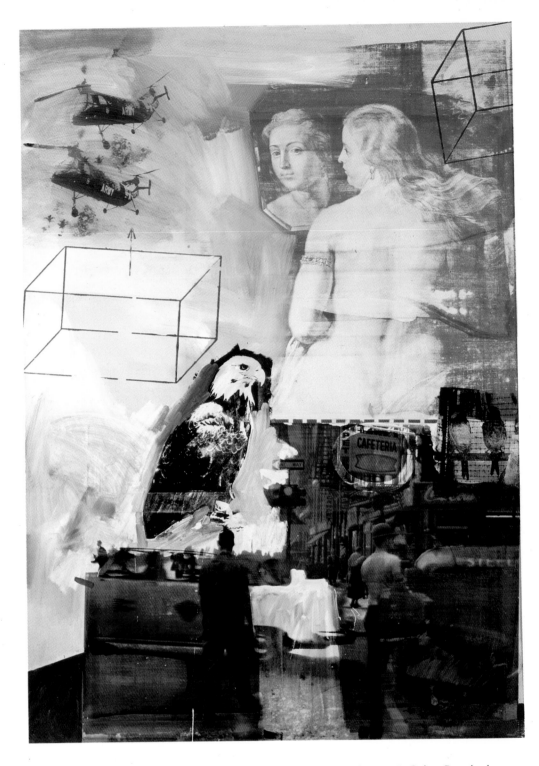

*FIG. 198. Robert Rauschenberg, *Tracer*, 1963. Oil and silkscreen on canvas, 84″ × 60″. The Nelson-Atkins Museum of Art, Kansas City, Missouri. Nelson Gallery Foundation Purchase.

power. The image recalls the use of military squadrons in Little Rock, Birmingham, and Selma, as well as in Korea and Cuba. The blood-red eagle, perched atop a stream of vertical thrusts that resemble rocket blasts, also has an inauspicious cast as it suggests global autocracy and a will to dominate outer space. And although the pale sky and zone of purifying whiteness evoke a quietude, they are smattered with black markings and dramatically juxtaposed by opaque ominous planes of darkness. Rauschenberg's depiction thus presents an image of discord and tension, an America seething with aggressions, torn by strife at home, and driven by an imperialist quest abroad and to spheres beyond.

Similarly, Rauschenberg's *Tracer* (1963) [Fig. 198] is a composition strained and dichotomized. Areas of black, some underlined by a bloody-red coloration, contrast with airy white and blue realms. The black adds a foreboding note to the images of army helicopters, an American eagle, and a typical American street. Rauschenberg's disjunctive juxtapositions and overlappings convey a sense of societal turmoil, which is compounded by two inexplicable hollow cubes that float in the surrounding space. In the midst of this disorienting environment is a Rubens nude—Venus, the goddess of beauty, posed before a mirror in serene, vain self-contemplation. Her mythohistoric ancestry and subsequent refined, European lineage would seem the antithesis of the modern American vernacular. Yet, with due irony, Rauschenberg establishes a visual dialogue between her regal posture and that of the proud American eagle, between the grandeur of European art and the chaos of contemporary America. Venus, symbol of beauty and love, stares into her mirror even as the American public goes about its everyday business and the army helicopters prepare for another round of warfare. What does she see in her mirror? Perhaps America's sense of itself as a glorious, even vainglorious, nation.

In many ways, *Tracer* epitomizes the quandaries of postwar American art. Though artists asserted the American identity of their work, they raised questions and aroused doubts about the nature of that American identity. Their work manifests cultural pride, yet subjects American icons and the American dream to a re-viewing. Much of their work celebrates its Americanness even as it exposes the underside, the polarities, the inconsistencies, and the failures of the nation's promise. Postwar art was, in sum, an art quite in tune with its time—an era of American exuberance and anxiety, confrontation and unmasking, change and ambivalence.

NOTES

1. See statements by Indiana in an interview with Gene R. Swenson, "What Is Pop Art?" *Artnews* 62 (November 1963): 27, 63.

2. Indiana, quoted in "Commanding Painter," *Time* 83 (May 22, 1964): 72.

3. For a probing discussion of Demuth's painting and Williams's poem, see Dickran Tashjian, *William Carlos Williams and the American Scene, 1920–1940*, catalogue for an exhibition at the Whitney Museum of American Art, New York (Berkeley and Los Angeles: University of California Press, 1978), 71–72.

4. D'Arcangelo discussed his involvement in the test ban protests in an interview with the author, October 25, 1984. For a discussion of Kennedy's civil defense program, see William L. O'Neill, *Coming Apart: An Informal History of America in the 1960s* (Chicago: Quadrangle, 1971), 44–46.

5. Rebecca Solnit, "Bruce Conner: The Assemblage Years," *Expo-see* 14 (January–February 1985), n.p.

6. For a good discussion of Conner's art, see Philip Leider, "Bruce Conner: A New Sensibility," *Artforum* 1 (November 1962): 30–31.

7. Grant, *Personal Memoirs of U. S. Grant*, vol. 1 (New York: Webster and Co., 1885). I am grateful to Betty Factor for informing me of this source.

8. Warhol, quoted by Swenson, "What Is Pop Art?" 60. In this interview Warhol also stated that the car-crash paintings were a response to headlines like "The Wreck That Made Cops Cry" and news broadcasts that casually reported extraordinary statistics, especially on holidays, where "every time you turned on the radio they said something like, '4 million are going to die.'"

9. The landmark account of the Hell's Angels is Hunter S. Thompson's *Hell's Angels: A Strange and Terrible Saga* (New York: Random House, 1966). For a summary of Hell's Angels activities, see O'Neill, *Coming Apart*, 272–74.

10. Quoted by Martin H. Bush in *Duane Hanson*, exhibition catalogue (Wichita, Kans.: Ulrich Museum of Art, Wichita State University, 1976), 6. See also Bush's essay, "Hyper-Realist Sculptures of Duane Hanson," in *Duane Hanson*, exhibition catalogue (Tokyo: Asahi Shimbun, 1984), 73–79.

11. *Time* 87 (April 29, 1966): 52.

12. "Violence and History," *Time* 91 (April 19, 1968): 44.

13. Rauschenberg's inclusion of this image may have been inspired by Marcel Duchamp's *Wanted, Ready Made* (1923), in which a wanted poster shows Duchamp as the sought-after criminal.

14. See statements by Philip Johnson, the pavilion's architect, in Rainer Crone, *Andy Warhol*, trans. John William Gabriel (New York: Praeger, 1970), 30. Although the original series was whitewashed, Warhol made a second set of paintings from the screens, which he had kept.

15. Andy Warhol, *The Philosophy of Andy Warhol (From A to B and Back Again)* (New York and London: Harcourt Brace Jovanovich, 1975), 85.

16. Statement by Drexler, in the archival records of the Hirshhorn Museum and Sculpture Garden, Smithsonian Institution, Washington, D.C.

17. "A Gun-Toting Nation," *Time* 88 (August 12, 1966): 15.

18. *Time* 91 (June 21, 1968): 13.

19. Chessman published an autobiography, *Cell 2455, Death Row* (1954); two works of nonfiction, *Duel by Ordeal* (1955) and *The Face of Justice* (1957); and a novel, *The Kid Was a Killer* (1960).

20. As noted by O'Neill, *Coming Apart*, 277, *Osservatore Romano*, the Vatican's offical newspaper, called the execution barbaric.

21. For comments by the artist, see Lucy R. Lippard, "May Stevens' *Big Daddies*" in *May Stevens Big Daddy, 1967–75*, exhibition catalogue (New York: Lerner-Heller Gallery, 1975); and Lawrence Alloway, *May Stevens*, exhibition catalogue (Ithaca, N.Y.: Herbert F. Johnson Museum of Art, Cornell University, 1973).

22. Andy Warhol and Pat Hackett, *POPism: The Warhol '60s* (New York and London: Harcourt Brace Jovanovich, 1980), 60.

23. According to the present owner, this 1963 version was the first composition devised for the Jackie images and the only one assembled by Warhol. The artist's arrangement was documented in a diagram by Eleanor Ward, owner of the Stable Gallery and Warhol's dealer at the time. Unlike most other *Jackie* paintings, this version includes all eight variants of the portrait and their reversals. The title, which appears in Crone's *Andy Warhol*, was probably given to the composition by Leo Castelli.

24. Paschke, quoted by Robert Glauber in *Violence in Recent American Art*, exhibition catalogue (Chicago: Museum of Contemporary Art, 1968), n.p.

25. O'Neill, *Coming Apart*, 98.

26. Edward J. Epstein used the term "mythopoeic melodrama" in his review "Manchester Unexpurgated," *Commentary* 44 (July 1967): 25–31.

27. *Life* 54 (May 17, 1963): 30–31; *Time* 81 (May 10, 1963): 19; *Newsweek* 61 (May 13, 1963): 27.

28. *Time* 90 (August 11, 1967): 11.

29. All quotations and paraphrases of Rosenquist's views are from Gene R. Swenson, "An Interview with James Rosenquist," *Partisan Review* 32 (Autumn 1965): 589–601; and Henry Geldzahler, "James Rosenquist's *F-111*," *The Metropolitan Museum of Art Bulletin* 26 (March 1968): 277–81.

30. Rosenquist, quoted in Richard F. Shepard, "To What Lengths Can Art Go?" *New York Times*, May 13, 1965, p. 39.

31. David Halberstam, *The Powers That Be* (New York: Dell, 1980), 684.

32. Edward Kienholz, "Letter to the Editor," *Artforum* 7 (Summer 1969): 4–6. For a detailed identification of the imagery in the tableau, see Dieter Ronte, "Le monument aux morts transportable d'Edward Kienholz," *L'Oeil* 216 (December 1972): 22–29.

33. In 1945 Associated Press photographer Joe Rosenthal recorded the flag raising. His photograph appeared in countless newspapers and magazines of the day and subsequently in posters, stamps, and films. Felix de Weldon's translation of the image into a bronze monument stands in Arlington National Cemetery.

34. Kienholz, "Letter," 4.

35. For a complete discussion and history of this work, see *The "Lipstick" Comes Back*, exhibition catalogue (New Haven, Conn.: Yale University Art Gallery, 1974), essay by Susan P. Casteras.

36. For a discussion of political activism, see Therese Schwartz, "The Politicization of the Avant-Garde," parts 1 and 2, *Art in America* 59 (November-December 1971): 97–105; 60 (March–April 1972): 70–79.

37. See Carl R. Baldwin, "Art and the Law: The Flag in Court Again," *Art in America* 62 (May–June 1974): 50–54; "A Test Case for Old Glory," *Life* 62 (March 31, 1967): 18–25, 65–66; and Hilton Kramer, "A Case for Artistic Freedom," *New York Times*, March 1, 1970, section 2, p. 25.

In 1962 when George Herms included a flag assemblage, *Macks*, in an exhibition at the Pasadena Art Museum, it met with outspoken protest from the American Legion. The museum closed in reponse, but reopened after its board agreed to stand behind the artist. But someone had ripped the flag from the assemblage in protest. Herms decided to leave the "desecrated" work on display with the following note in place of the flag: "The piece has been raped by a madman. Despite this degradation the forces of creation will go on. Love, G. H."

The 1950s and 1960s were decades of extraordinary economic, social, and political change in the United States, and the nation's artists captured both the celebratory aura and the sociopolitical tensions that marked the era. Artists were inspired or affected by new forms of housing and transportation, the enhanced power of mass communications and promotional strategies, the pervasiveness of standardization and conformity, the omnipresence of commercialism and consumerism, the expansion of mechanization and mass production, and the emergence of a shared national identity. As never before, art explored and exposed the lineaments of American culture.

In setting forth an original American iconography and asserting innovative attitudes toward image presentation, postwar American artists challenged prevailing canons of subject matter and taste and renounced the universalist, purist conceptions embraced by modernist theory. They abandoned the modernist search for a sublime symbol, the quest for a glorious redemptive myth, and disavowed the modernist faith in utopian idealism. The artists who succeeded the Abstract Expressionists in establishing an internationally renowned American vanguard focused on the actuality of the present, including its most banal and irrational elements. They looked at the world as it was, with no expectation that it would be something other. And unlike their predecessors, they did not by reflex disdain commercialism or spurn mass culture. Whereas earlier generations of modern artists had hinted at esoteric messages encoded in private metaphors and obscure allusions, this generation of postwar American artists offered accessible images drawn from the reservoir of mass culture.

The practices of these postwar American artists challenged not only the modernist sense of individual expression but also its definition of artistic originality and creativity. The advent of the electronic and print technologies and advancements in computers and photocopiers thoroughly subverted traditional distinctions between primary and secondary experience, between one-of-a-kind originals and machine-produced replications. The instantaneity of the new systems of communication provided a semblance of freshness and uniqueness but also facilitated rapid obsolescence and the prospect of endless duplications and repetitions of the well known and already seen. In postwar art the long-hallowed reverence for originality and the modernist exaltation of innovation and singularity gave way to an aesthetic predicated on replications of borrowed mass-produced images.

Epilogue

The means and methods of mass media communication, moreover, dispelled the modernist idea of an absolute and the conception of images as bearers of essential, momentous, certain, sacrosanct, or symbolic meaning. Media-conscious artists did not engage in a search for the perfect form of conveying the quintessential truths of life, but rather revealed the dualities and paradoxes in contemporary society and concerned themselves with the vicissitudes of image appearance and perception. They discerned the potency of the presentational mode as a signifier of meaning, and they observed the influence of advertising and public relations activity in shaping the meaning, perception, and interpretation of images. Their art attests to the varied effects of image repetition and saturation, while also giving vivid evidence of how scale, color, and compositional design reinforce, alter, or altogether obscure meaning.

These postwar American artists also defied the central premise of art for art's sake. Rather than asserting the autonomy of art, they set forth compelling dialogues that relocated art within life—everyday life—and they used materials and images from life for or as part of their art. In doing so, they overturned hierarchical assumptions about high and mass culture and repudiated elitist views about the privileged status of art. As Claes Oldenburg declared:

I am for an art that is political-erotical-mystical, that does something other than sit on its ass in a museum.
I am for an art that grows up not knowing it is art at all, an art given the chance of having a starting point of zero.
I am for an art that embroils itself with the everyday crap & still comes out on top.
I am for an art that imitates the human, that is comic, if necessary, or violent, or whatever is necessary.
I am for an art that takes its form from the lines of life itself, that twists and extends and accumulates and spits and drips, and is heavy and coarse and blunt and sweet and stupid as life itself.[1]

The art of Warhol, Ruscha, Kienholz, Johns, Lichtenstein, Bechtle, and others thus marks the collapse of modernism and announces the initial phase of a counterpulse that has come to be called postmodernism. With the perspective of time, it is increasingly apparent that this art is neither an aberrant phase of modernism nor an isolated novel phenomenon, but the forefront of a new orientation. This is an art that does not pay heed to the conceptual, iconographic, and aesthetic paradigms of modernism, but offers an alternative more suited to a mass culture, nuclear-age society. It is an art full of the richness and anxieties of the postwar era, an art whose historical significance is only now attaining its due as critics and historians accommodate the postmodernist sensibility.[2]

During the 1970s attitudes now identified with postmodernism evolved, and an American iconography was sustained, especially in the flourishing of photorealist paintings of suburban and urban environments, and of verist sculpture of Middle Americans and commonplace manufactured objects. But the main innovations of seventies art had no specific reference to American mass culture, and reactions against mass production, mechanistic aesthetics, and a commodity orientation abounded. Some artists turned to craft techniques; others developed art concerned with process, direct experience, or pure ideas. A resurgence of interest in nature and physical systems was most notable in monumental earthworks, which were situated in remote locations far from the banalities of urban life, the commercial ambiance of galleries, or the public spectacle of museums. Moreover, many artists turned away from mass culture to explore questions of individual identity on the basis of sex, race, class, or ethnic distinctions. For example, artists inspired by the burgeoning feminist movement created compositions that asserted a feminist point of view and commented on the role of women in society. Notably, this art had a decidedly personal tone and an overtly political character.

The return of figuration in the late 1970s brought a new interest in the semiotic power of images and presentational modes, which developed in the early 1980s into a rigorous concern with the dynamics of visual communication. Artists again began to borrow images and techniques from the mass media, though the primary emphasis now fell on the issue of appropriation and on the deconstruction of cultural messages subsumed within media imagery. By manipulating and exaggerating quotations from advertising, movies, and television, artists like Barbara Kruger, Cindy Sherman, Robert Longo, and David Salle revealed underlying layers of implicit codified meaning. In their juxtapositions of words and images, and in their bold displays of isolated figures, these artists reinvigorate presentational strategies developed by artists like Rosenquist, Ruscha, Lichtenstein, Warhol, Thiebaud, and Wesselmann. The newer generation's art, moreover, is also grounded in a vernacular that reasserts a connection between art and

American mass culture. But whereas postwar artists focused mainly on objects and environments, the eighties artists focus mainly on people—not nameable people but stereotyped American figures shown in stereotyped mass media roles. The new emphasis on narrative, for example in the work of Eric Fischl, Robert Yarber, and Sue Coe, includes references to American values and resumes the postwar reassessment of the American dream and the American dilemma.

Much of the art of the eighties deals with middle-American culture and the corporate world of signs and experience, but there is a revival of attentiveness to the urban environment and fringe street life as well. Such subject matter is most pronounced in the paintings of artists like Keith Haring, Kenny Scharf, and Jean Michel Basquiat, works that feature graffiti scrawls and figurations inspired by comics and other sources outside the realm of high art. In their expressive vitality and irreverence, their disjunctiveness and rawness, these compositions recall the early art of Rauschenberg, Jess, Saul, or the Hairy Who.

Just as an American focus has resurfaced in American art, artists abroad have turned to their own countries' heritages in order to come to terms with history or present circumstances. The most vivid example of this self-examination occurs in contemporary German painting, with artists like Jorg Immendorf, Anselm Kiefer, and A. R. Penck confronting such issues as Nazism, cultural disintegration, and East-West polarities. As in American art of the 1950s and 1960s, German art of the 1980s forthrightly depicts cultural images that are evocative of disturbing realities. Neither idealizing nor obscuring their situation, these artists determinedly raise issues of national import and use images particular to their own culture. As they seek to avert generalities and face the complexities of a known, experienced life, they counter anew the universalist, utopian pulse of modernism.

Thus in recent years a new generation of artists is revivifying many of the issues, images, and presentational modes explored by American artists of the fifties and sixties. Critical interest in postmodernism is also spurring new appreciation of American postwar art, encouraging serious reconsideration of its attributes and contribution to art history. Too, the continued strength and creative growth of individual artists—Artschwager, Kienholz, Oldenburg, Ringgold, Arneson, Nutt, and Paschke, for example—give added resonance to the conceptual and iconographic richness of the work they produced at the beginnings of their careers.

NOTES

1. Claes Oldenburg, *Store Days* (New York: Something Else Press, 1967), 39.
2. See especially, Frederic Jameson, "Postmodernism and Consumer Society," in *The Anti-Aesthetic: Essays on Postmodern Culture*, ed. Hal Foster (Port Townsend, Wash.: Bay Press, 1983), 111–25; and essays by Lawrence Alloway, Donald B. Kuspit, Martha Rosler, and Jan van der Marck in *The Idea of the Post-Modern* (Seattle: University of Washington, Henry Art Gallery, 1981).

Other Perspectives:

Literature and

Mass Media

MADE IN U·S·A·

James E. B. Breslin

Frank O'Hara, Popular Culture, and American Poetry in the 1950s

I want to be / at least as alive as the vulgar.
Frank O'Hara, "My Heart"

"Poetry was declining / Painting advancing / we were complaining / it was '50."[1] Frank O'Hara wrote these lines in 1957—by which time both painting and poetry were advancing. In 1956 Allen Ginsberg had dramatically announced the presence of a new generation of young poets who would revitalize American poetry; at the same time young painters such as Larry Rivers, Robert Rauschenberg, and Jasper Johns had boldly begun to push American art away from Abstract Expressionism. Appropriately, O'Hara's flip but accurate assessment of the state of the arts in 1950 was written for the first of a series of lithographs, "Stones," on which he collaborated with Larry Rivers. Titled "US," the first lithograph suggested a personal and artistic bond ("us" = O'Hara and Rivers) and a shared commitment to vernacular materials ("US" = United States). In the late 1950s both poetry and painting were energized by a new and complex relation to specifically American materials; and at least some of the poets—O'Hara in particular—were directly affected by the painters.

Surely, the history of American poetry between 1920 and 1950 had been one of decline. The modernists—the generation of T. S. Eliot, Ezra Pound, William Carlos Williams, H. D., Wallace Stevens, Marianne Moore—had joined literary rebellion, social dissidence, and monumental achievement. To be a "modern" poet, to be of the "present," meant accepting nothing from the literary tradition as given. The past became a "souvenir," as Wallace Stevens wrote in "Of Modern Poetry"; or as Williams more defiantly put it, "Nothing is good save the new." Modern poetry had begun with Imagism, which stripped the lyric to its most elementary constituent part—the image. Pound titled his epic poem *The Cantos* not for its subject but for its basic formal unit, and his efforts to redefine poetic form extended (as did Williams's) to the poetic line itself: "to break the pentameter, that was the first heave." It was not just that the modernists wished to move beyond certain Romantic and Victorian styles that they believed had been played out; their aims were more radical—going to the root. They displaced attention from overarching wholes to constituent parts because they wanted to rebuild their medium from the ground up.

Such experiments were not narrowly literary investigations into the possibilities and limits of poetic form, for modernism was a literary response to a broad cultural crisis. All ways of ordering and interpreting experience had become suspect in the aftershock of what Stevens called "the annihilation of the gods." The modern moment was a secular moment, into which man was thrown "unspon-

sored"—without the protection of final ends or stable values. Modernist writers were challenged, then, to find forms for an era in which the act of forming had become highly self-conscious and problematic. "These fragments I have shored against my ruins," Eliot wrote at the close of *The Waste Land*, making, as did many of his generation, the struggle to write the poem part of the meaning of the poem. These poets were aware of themselves *as* moderns, and that self-awareness also became a subject of their work—as in Stevens's "Of Modern Poetry." Many of the modernists attached salvationist hopes to poetic order; Stevens, for one, wrote eloquently of the "blessed rage for order," a rage that was generated by the perceived lack of order but that did not inspire him to imagine an order that was absolute—full, fixed, and final. Rather Stevens's idea of order was provisional, tentative, and shifting. Eliot's *The Waste Land*, Williams's *Spring and All*, Pound's *Cantos*, Stevens's "Sunday Morning"—each of these innovative works confronts cultural disintegration. These poets tried to absorb as much of the chaos and flux of the contemporary world as they could—pushing poetry very close to the breaking point.

By 1950, however, the modernist rebellion had degenerated into a genteel academicism. Surveying the "present state of poetry" as late as 1958, Delmore Schwartz declared that "what was once a battlefield has become a peaceful public park on a pleasant summer Sunday afternoon."[2] With this image of a tranquil, orderly, cultivated space isolated from sordid urban realities and disruptive psychic energies, Schwartz accurately characterized both the diminished achievement of American poetry in the 1950s and the poetic theory that produced that pleasant malaise. The once-provocative principles of modernism were now assumed as the comfortable starting point for young poets and critics. No longer scandalous, no longer *modern*, these principles now generated a poetry that was more polite than passionate, more respectful than revolutionary. Modernism had been domesticated.

The younger poets of the 1950s were far more eager to placate than to displace authority. Writers such as James Merrill, W. S. Merwin, Adrienne Rich, Peter Viereck, Richard Wilbur—all of whom began their careers in the decade following World War II—adopted an avowedly conservative program. Accepting the designation New Formalists, they aspired to complete the modernist revolt by returning poetry to precisely those traditional means—accentual meters and predetermined forms—that the more adventurous modernists had sought to abolish. In what amounted to an ars po-

etica, Richard Wilbur asserted that "every poem begins, or ought to, by a disorderly retreat to defensible positions."[3] The aim was no longer to stretch literature to include the fragmented, discordant materials of modern life, but to pull back to what poetry could safely absorb. The new idea of order stressed stability: form was a pre-existing order that served as a defense against chaos. As Adrienne Rich later recalled, "In those years formalism was part of the strategy—like asbestos gloves, it allowed me to handle materials I couldn't pick up bare-handed."[4] The modernists had struggled to wrench order out of chaos, but the New Formalists did not confront the social and psychic forces that might contest their poetic orders. As a result, their poems were well-tooled and pleasant to read but hard to care about.

In their caution and withdrawal these emerging poets were supported by a powerful generation of literary fathers—the New Critics. In the 1950s, criticism dictated to poetry; practice was particularly governed by such New Critical eminences as Allen Tate and John Crowe Ransom. Their technique of close reading implicitly admonished young poets to be scrupulous rather than adventurous, controlled rather than extravagant. But the New Critics' allegedly neutral techniques of reading and interpretation were also a means to enforce a particular and rather narrow poetic ideology. The New Critics distinguished between prose (or science), which is rational, abstract, and discursive, and poetry (or art), which combines thinking and feeling in a seamless artistic whole. A work of art thus becomes a "well-wrought urn" or "verbal icon," an autonomous and self-enclosed space (like Schwartz's public park) that has been purified of all personal, social, or political bias. The true artist, then, is to take the only "defensible position"— which is no position at all. The only values allowed the poet are the revered New Critical triumvirate: irony, paradox, and ambiguity. The New Critics' notion of art as autonomous and transcendent represented an effort to free art from the contaminations of ideology, but separating the aesthetic from the historical turned out to be a prescription for the enervation that marked American poetry in the fifties.

Modernist art had been critical of both its own procedures and the social values that gave authority to those procedures; the poetry of the 1950s, claiming to transcend the contingent and the historical, simply reflected the social values of its historical moment. The skepticism of ideology, the emphasis on control over freedom, the eager compliance, the flight from history itself—all were literary versions

of attitudes widely held in American society in the fifties. Cold War politics, seemingly validated by America's economic prosperity, set the domestic agenda: social conformity, intellectual timidity, and rule by consensus. In "The Present State of American Poetry," Delmore Schwartz asserted that the writer's consciousness of "the growing spectre of the totalitarian state," along with "the growing poverty and helplessness of Western Europe," had made America, not Europe, "the sanctuary of culture." This view worked, implicitly, to repress dissent: "to criticize the actuality upon which all hope depends thus becomes a criticism of hope itself."[5] Who will venture to criticize hope? The inhabitants of the American sanctuary are clearly expected to speak in hushed, grateful tones—not in an angry "howl" of protest.

The twin themes of a reconciliation with and a withdrawal from America—of America as a sanctuary for culture, and of High Culture as a sanctuary from America—pervaded the now notorious *Partisan Review* symposium of 1952, "Our Country and Our Culture." According to the editors' opening statement, "most writers no longer accept alienation as the artist's fate in America; on the contrary, they want very much to be a part of American life."[6] All but a few of the contributors agreed with this observation, with Richard Chase, for example, dismissing "estrangement" as either a "literary pose or the product of a personal neurosis." American artists no longer needed to turn to Europe. Yet the symposium's contributors, many of them reformed leftists, were careful to establish that their acceptance of America was not unequivocal. What they chose to criticize, however, was not the politics of the Cold War, not the problems created by advanced capitalism or by racism, but the dangers of "a mass culture which makes [the artist] feel that he is still outside looking in."

Along with a good deal of complacency, the symposium generated a strong sense of crisis. The crisis, however, was not defined as political or social or economic, but as aesthetic and cultural. The artist, matured beyond adolescent rebellion, wished to be part of American life, but mass culture displaced him, kept him outside looking in. None of the symposium's participants stopped to analyze mass culture; they merely evoked its specter in highly mythicized and grimly apocalyptic language:

Its tendency is to exclude everything which does not conform to popular norms; it creates and satisfies artificial appetites in the entire populace; it has grown into a major industry which converts culture into commodity. Its overshadowing presence cannot be disregarded in any evaluation of the future of American art and thought.

Invasive and engulfing, mass culture usurps High Culture; it annihilates differences and levels; it stimulates desire; it corrupts. Liberal remedies tended to emphasize the need to elevate the populace through education—a kind of cultural imperialism; Newton Arvin proposed to "master and fertilize it." As this language suggests, some of the *Partisan* crew imagined mass culture to be a passive female body that required the dominance of a male creative elite to bring it to fullness. Most of the contributors, however, preferred a stern aloofness. Irving Howe concluded that "the least we can do is to keep apart and refuse its favors," implying that mass culture was a temptress too dangerous to even approach. And all agreed that the relation between High Culture and mass culture was necessarily antagonistic. High Culture, in fact, was a refuge and defense against mass culture.

Most of the participants in the symposium had no doubt been affected by Clement Greenberg's "Avant-Garde and Kitsch," which *Partisan Review* published in 1939.[7] According to Greenberg, the avant-garde artist turns from the capitalist marketplace to achieve purity and authenticity by exploring "the disciplines and processes" of his own medium; kitsch appropriates the discoveries of the avant-garde and converts them into easily consumed commodities for a mass market. What begins as authentic ends up a stereotyped and mass-produced simulacrum. Greenberg's tidy polarization of avant-garde and kitsch conveniently ignored the numerous instances in which a decadent high art was energized by an encounter with popular culture. His schema fails to consider, for example, the case of Cubist collage, with its newspapers, wallpaper, cigarette papers, oilcloth, and the like. Of course, neither the *Partisan Review* symposium participants nor the literary establishment of the fifties constituted an avant-garde: they were an academy. Greenberg goes on to point out that since kitsch loots the genuinely new, "all kitsch is academic; and conversely, all that's academic is kitsch. For what is called the academic as such no longer has an independent existence, but has become the stuffed-shirt 'front' for kitsch."

The assumption of an inevitable antagonism between high and low, then, derived from an uneasy sense of a powerful resemblance between them. In the 1950s artists and intellectuals were no longer bohemians or popular-front radicals; they were solidly bourgeois. The poetry produced by the literary hegemony was easily marketable, watered-down, derivative work, delivered in prepackaged forms. The mythic threat of mass culture sustained the illusion among accommodating artists and intellectuals that they were indeed still on the outside

looking in; *they* had not been deceived or corrupted. At the same time, the bogey of mass culture established High Culture as a sanctuary (a *male* sanctuary) from the perils or wiles of popular America. The creative elite who participated in the *Partisan Review* symposium were actually defining *their* country, *their* culture.

The insistence on excluding the historical and the social from the aesthetic produced a poetry that, as Robert Lowell observed, displayed "tremendous skill" yet was "divorced from culture somehow," "purely a craft."[8] In the 1950s poetry also remained separate from the other arts. Although Greenberg proclaimed modern art to be self-critical, with each of the arts committed to determining "the effects peculiar and exclusive to itself,"[9] modernism had thrived in part because of the extraordinary interaction between painting and poetry. The modernist proposal that a work of art was not an imitation of something but a thing itself had been appropriated, in part at least, from the Cubist painters; Pound was one of the founders of Vorticism, a movement designed to embrace all the arts; and Williams and Stevens were both deeply affected by the developments in painting from Cézanne to Picasso. Yet neither the young formalist poets nor their slightly older contemporaries (the "middle" generation that included Lowell, John Berryman, and Randall Jarrell) looked across artistic boundaries for stimulation—as if cultural provincialism were a necessary part of making poetry stick to defensible positions.

Ironically, the formalists' myopia worsened at the very moment that American "painting was advancing" into a heroic age with the radical breakthroughs of the Abstract Expressionist generation—Jackson Pollock, Mark Rothko, Franz Kline, Robert Motherwell, and others. The career of Frank O'Hara illustrates how forcefully the impact of painting stimulated one young poet to open his work to some of the energies in American culture and thus to find a way out of the period's poetic malaise. O'Hara's knowledge and understanding of the visual arts was intimate and sophisticated. He was a prolific and brilliant art critic, as two collections of his writings attest (*Art Chronicles, 1954–1966* and *Standing Still and Walking in New York*). From 1960 to 1966 he was a curator at the Museum of Modern Art; he counted many artists among his closest friends; and he collaborated on poempainting projects with Larry Rivers and Norman Bluhm.

In particular, O'Hara venerated the generation of Pollock—partly because they served as exemplary models of artistic risk-taking: "The Abstract Expressionists decided, instead of imitating the style of the European moderns, to do instead what they had done, to venture into the unknown, to give up looking at reproductions in *Verve* and *Cahiers d'Art* and to replace them with first-hand experimentation."[10] For the dissident young poet, the painters were, moreover, an early and enthusiastic audience: "When we all arrived in New York or emerged as poets in the mid 50s or late 50s, painters were the only ones who were interested in any kind of experimental poetry and the general literary scene was not." Most important of all, O'Hara was "inspired by American painting . . . not in the sense of subject matter . . . but in the ambition to be that, *to be the work yourself*" [my emphasis]. Identifying the work with the self that produced it provided O'Hara with an idea of creativity that could be transferred from a visual to a verbal medium—as shown by "Digression on 'Number 1,' 1948," a poem that O'Hara inserted into the text of his monograph on Pollock:

I am ill today but I am not
too ill. I am not ill at all.
It is a perfect day, warm
for winter, cold for fall.

A fine day for seeing. I see
ceramics, during lunch hour by
Miró and I see the sea by Léger;
Light, complicated Metzingers
and a rude awakening by Brauner,
a little table by Picasso, pink.

I am tired today but I am not
too tired. I am not tired at all.
There is the Pollock, white, harm
will not fall, his perfect hand

and the many short voyages. They'll
never fence the silver range.
Stars are out and there is sea
enough beneath the glistening earth
to bear me toward the future
which is not so dark. I see.[11]

O'Hara does not attempt to describe Pollock's work; instead his poem, like Pollock's painting, is "a venture into the unknown." "Digression on 'Number 1,' 1948" is about seeing—about seeing as an unfolding process of discovery. Rather than making poetry the occasion for controlling experience, O'Hara casually records the movements, the shifting, contradictory moods, the unforeseen discoveries of a lunch hour. At first he views beautiful objects (the ceramics by Miró, the small table by Picasso) from a pleasurable distance. But when he suddenly comes upon the Pollock, the distance dis-

solves and he is swept up into the work. His earlier "I see the sea," now gives way to a direct apprehension of the sea as experienced by a venturesome voyager: "Stars are out and there is sea / enough beneath the glistening earth / to bear me toward the future." The closing monosyllables stress not the object of sight but the process of seeing: "I see." At a time when poetry sought to "fence in" experience, Pollock thus provided the young O'Hara with a liberating alternative.

Yet O'Hara's closest affinities were with the second generation of the New York School—most notably with Larry Rivers. From 1950 on, O'Hara and Rivers were friends, sometimes lovers, sometimes collaborators in multimedia projects. Their friendship inspired several of Rivers's works: a portrait of O'Hara in 1951, many drawings of O'Hara in the mid-fifties, a well-known paining of O'Hara from 1954, a collage that served as the cover art for O'Hara's *Collected Poems*, and an illustration of O'Hara's "For the Chinese New Year and for Bill Berkson" for the commemorative volume *In Memory of My Feelings*. On O'Hara's side, there were several poems, an essay, a memoir about Rivers, and a published interview with him. The two also issued a mock manifesto, "How to Proceed in the Arts."

An excellent definition of their shared aesthetic appears in O'Hara's "On Seeing Larry Rivers' *Washington Crossing the Delaware* at The Museum of Modern Art":

Now that our hero has come back to us
in his white pants and we know his nose
trembling like a flag under fire,
we see the calm cold river is supporting
our forces, the beautiful history.

To be more revolutionary than a nun
is our desire, to be secular and intimate
as, when sighting a redcoat, you smile
and pull the trigger. Anxieties
and animosities, flaming and feeding

on theoretical considerations and
the jealous spiritualities of the abstract,
the robot? they're smoke, billows above
the physical event. They have burned up.
See how free we are! as a nation of persons.

Dear father of our country, so alive
you must have lied incessantly to be
immediate, here are your bones crossed
on my breast like a rusty flintlock,
a pirate's flag, bravely specific

and ever so light in the misty glare
of a crossing by water in winter to a shore
other than that the bridge reaches for.
Don't shoot until, the white of freedom glinting
on your gun barrel, you see the general fear.[12]

Rivers's painting parodies the heroic idealization of Washington in Emanuel Leutze's *Washington Crossing the Delaware*. As Rivers told O'Hara in their interview:

The last painting that dealt with George and the rebels is hanging at the Met and was painted by a coarse German nineteenth-century academician who really loved Napoleon more than anyone and thought crossing a river on a late December afternoon was just another excuse for a general to assume a heroic, slightly tragic pose. . . . What could have inspired him I'll never know. What *I* saw in the crossing was quite different. I saw the moment as nerve-wracking and uncomfortable. I couldn't picture anyone getting into a chilly river around Christmas time with anything resembling hand-on-chest heroics.[13]

Rivers's choice of Leutze's painting, which exemplifies Greenberg's notion of the academic as kitsch, was intended to scandalize the reigning authorities in American painting in 1953, the Abstract Expressionists. Rivers explained: "I was energetic and egomaniacal and what is even more important, cocky and angry enough to want to do something no one in the New York art world would doubt was *disgusting, dead, absurd*. So, what could be dopier than a painting dedicated to a national cliché—Washington Crossing the Delaware."

Rivers's use of a corny national cliché led some critics to designate him as the first Pop artist. But the label Pop is better reserved for artists like Andy Warhol, who took mass-manufactured objects—Coke bottles, Campbell's soup cans—and rendered them with the slick impersonality of commercial art. Pop Art's images came not from the artists' psyches but from the public domain. In this way Pop Art constituted an affront to the inwardness, spontaneity, and High Art pretensions of Abstract Expressionism. But Pop's impersonality implied a social comment—identifying the consumer's mind, in late capitalism, as blank and anonymous. Ironically, Warhol's art reiterates the view of mass culture espoused in the *Partisan Review* symposium. Rivers's painting, however, mocks both the academic and the avant-garde—and draws on both. Its clash of styles creates a work that is human, immediate, alive, and specifically American. Culture is no longer a sanctuary.

Indeed, both Rivers's painting and O'Hara's poem make art a discomforting experience. Generals cannot neatly control history in the way that Leutze's Washington does, and artists cannot neatly control their material or their medium in the way that Leutze appears to. In Rivers's pastiche Washington remains a focus, but the viewer's attention is dispersed around the canvas (to what may be multiple images of Washington). In the absence of stable hierarchies—stable selves—there is a universal ("general") fear shared even by generals and artists. Yet this anxiety humanizes and animates, bringing even the stagey, clichéd figure of Washington to life. Rivers's Washington looks cold and leads an army in disarray; O'Hara's Washington is cold, afraid, an incessant liar, and a killer. No longer a historical abstraction, their founding father is a person, a hero in our "nation of persons." Once we admit the "general fear," the American past can become a truly "beautiful history."

Rivers's Washington, already missing a right arm and leg, is threatened by the painter's cold, invasive, abstract white; O'Hara's Washington is threatened by the poet's irony and verbal play. But in both works the general survives, asserting a human presence against the cold, the fear, the chaos, the abstraction, and the mockery. In the early 1950s both O'Hara and Rivers were making a "nerve-wracking and uncomfortable" crossing of their own, as their work moved away from the established formulas for recognition. In their playful, yet serious, revisions of American history, Washington becomes at once a realistic person and a mythic hero, a "dear" revolutionary "father," a source of innovative creative energy.

New Critical dogma identified poetic expression as metaphoric; in his crossing O'Hara pushed poetry toward the "bravely specific": "I want to be / at least as alive as the vulgar." His "lunch poems" are rapid, clear-eyed voyages of discovery not into the self but into the animate, shifting life of New York City at noontime. They are filled with things that remain literal, objects that are not metaphors but themselves:

It is 12:20 in New York a Friday
three days after Bastille day, yes
it is 1959 and I go to get a shoeshine
because I will get off the 4:19 in Easthampton
at 7:15 and then go straight to dinner
and I don't know the people who will feed me

("The Day Lady Died")

There are several Puerto
Ricans on the avenue today, which
makes it beautiful and warm. First
Bunny died, then John Latouche,
then Jackson Pollock. But is the
earth as full as life was full, of them?
And one has eaten and one walks,
past the magazines with nudes
and the posters for BULLFIGHT and
the Manhattan Storage Warehouse,
which they'll soon tear down. I
used to think they had the Armory
Show there.

("A Step Away from Them")

How funny you are today New York
like Ginger Rogers in *Swingtime*
and St. Bridget's steeple leaning a little to the left

("Steps")

O'Hara's precise, quick-moving poems—alternately funny and melancholy, comfortable and anxious—are less concerned with staking out a defensible position than they are with greedily taking in all kinds of American *stuff*—high and low, Jackson Pollock and bullfight posters, churches and movies.

Movies provided the source of O'Hara's most productive venture into American popular culture. Since their inception, the visual mass media—film and later television—have most often been regarded by those manning the literary armchairs as foreshadowing the collapse of literacy. The modernist poetic technique of juxtaposing parts without connectives may have been influenced by cinematic montage, but modernist poets generally viewed the new medium with a melancholy eye. Pound lamented that the modern "'age demanded' chiefly a mould in plaster, / Made with no loss of time, / A prose kinema, not, not assuredly, alabaster / Or the 'sculpture' of rhyme" ("Hugh Selwyn Mauberley"). The film medium was "prose," rapidly produced for mass markets—the antithesis of the classical high arts of sculpture and poetry. In one of the *Spring and All* poems William Carlos Williams wrote that "the decay of cathedrals / is efflorescent / in the phenomenal growth / of movie houses." Eliot would have made the substitution of movie houses for cathedrals a symptom of social decay, but Williams presents the change as part of a natural process. Yet even for him movie houses merely unmasked what has always gone on in cathedrals: the "dynamic crowd" worshipping an illusion. For Pound and Williams the movies were not a social or artistic institution worthy of explo-

ration, but a symbol of what troubled them most about modern society.

In a characteristic provocation, Frank O'Hara declared that "after all, only Whitman and Crane and Williams, of the American poets, are better than the movies" ("Personism: A Manifesto"). A poet interested in painting, dance, music, theater, and film, O'Hara eagerly participated in interdisciplinary artistic collaborations. But he was also concerned with formulating the specific character of each medium—as he did with painting and poetry in "Why I Am Not a Painter" and with writing and film in "An Image of Leda." "The cinema is cruel / like a miracle," the poem begins, attributing to the movie screen the force of a divine assault, like the swan's rape of Leda. The cinematic image has an overpowering immediacy, but an immediacy purified of meaning: Not created "by / the hand that holds / the pen," the moving pictures carry "no message." Films, rather, are created by a "machine," the swan in this version of the story of Leda; and movies' immediacy is a technological illusion—which leads to the poem's closing paradox:

Our
limbs quicken even
to disgrace under
this white eye as
if there were real pleasure
in loving
a shadow and caress-
ing a disguise!

The cinema is a cruel illusion, but it can create real feeling. Moreover, as O'Hara suggests in his poem about the movie version of *The Three-Penny Opera*, the very illusoriness of film makes it lifelike, "an image of the times," which are themselves shadowy, theatrical, filled with masks and disguises. "Mothers of America / let your kids go to the movies!" O'Hara urges in "Ave Maria," a tongue-in-cheek account of the movie theater as a social institution. "It's true that fresh air is good for the body," O'Hara concedes, "but what about the soul / that grows in darkness, embossed by silvery images," not to mention "the darker joys" of going home "with a pleasant stranger whose apartment is in the Heaven on Earth Bldg / near the Williamsburg Bridge." The movie house, no longer an easy symbol for a degraded modernity, here becomes a place that permits "glamorous" illusions and illicit sexuality. One of the leading institutions of American popular culture has been freed for poetry.

Beyond the miraculous power of the cinematic medium and the permissive freedom of the movie theater, film most engaged O'Hara as the vehicle for people's partaking in a popular national mythology. Hollywood provides a modern American pantheon of stars—our eternal deities. The death of James Dean, for example, inspired three of O'Hara's poems, though none of them all that successful. In his best work O'Hara continually turns on himself, mocking his own attitudes and postures; but in "For James Dean"—an angry outpouring against the sadistic Hollywood machine that persecuted Dean—O'Hara is merely posturing. At the other end of his range and talent, "To the Film Industry in Crisis," a Whitmanesque celebration of the Hollywood stars, possesses a wonderful complexity of tone. It is part tribute and part mockery, like the poem on Rivers's *Washington Crossing the Delaware*:

Not you, lean quarterlies and swarthy periodicals
with your studious incursions toward the pomposity of
 ants
nor you, experimental theatre in which Emotive Fruition
is wedding Poetic Insight perpetually, nor you,
promenading Grand Opera, obvious as an ear (though
 you
are close to my heart), but you, Motion Picture Industry,
it's you I love!

And O'Hara goes on to extol

Richard Barthelmess as the "tol'able" boy barefoot and
 in pants,
Jeanette MacDonald of the flaming hair and lips and
 long, long neck,
Sue Carroll as she sits for eternity on the damaged fender
 of a car
and smiles, Ginger Rogers with her pageboy bob like
 sausage
on her shuffling shoulders, peach-melba-voiced Fred
 Astaire of the feet,
Eric von Stroheim, the seducer of mountain climbers'
 gasping spouses,
the Tarzans, each and every one of you (I cannot bring
 myself to prefer
Johnny Weissmuller to Lex Barker, I cannot!), Mae West
 in a furry sled,
her bordello radiance and bland remarks, Rudolph
 Valentino of the moon. . . .

O'Hara really does "love" these figures, as the precision of his details shows. His long declamatory lines, elevated diction, and heroic epithets create a tone that is neither heroic nor mock-heroic but a little bit of both. "Poetry is not instruments,"

O'Hara wrote in "To Gottfried Benn," "poetry's part of your self," and the gods of Hollywood were part of O'Hara.

O'Hara mocked even his own revolutionary pretensions: "to be more revolutionary than a nun / is our desire." But O'Hara was a ground-breaking poet—most so when he opened his work to *our* country, *our* culture.

NOTES

1. O'Hara, quoted in Marjorie Perloff, *Frank O'Hara: Poet Among Painters* (New York: George Braziller, 1977), illustration 3.

2. Delmore Schwartz, "The Present State of Poetry," in *Selected Essays of Delmore Schwartz*, ed. Donald A. Dike and David H. Zucker (Chicago: University of Chicago Press, 1970), 44.

3. Richard Wilbur, "The Bottles Become New, Too," *Quarterly Review of Literature* 7 (1954): 189.

4. Adrienne Rich, "When We Dead Awaken: Writing as Re-Vision," in *Adrienne Rich's Poetry*, ed. Barbara Gelpi and Albert Gelpi (New York: Norton, 1975), 94–95.

5. Schwartz, "Present State of Poetry," 46.

6. This and subsequent quotations are from *Partisan Review* 19 (May–June 1952).

7. Clement Greenberg, "Avant-Garde and Kitsch," in *Art and Culture* (Boston: Beacon Press, 1961), 11. This essay originally appeared in *Partisan Review* 6 (Fall 1939).

8. Robert Lowell, "The Art of Poetry: Robert Lowell," in *Robert Lowell: A Collection of Critical Essays*, ed. Thomas Parkinson (Englewood Cliffs, N.J.: Prentice-Hall, 1968), 19.

9. Clement Greenberg, "Modernist Painting," in *The New Art*, ed. Gregory Battcock (New York: E. P. Dutton, 1966), 101.

10. Frank O'Hara, *Art Chronicles, 1954–1966* (New York: George Braziller, 1975), 69–70.

11. Ibid., 30.

12. Frank O'Hara, *The Collected Poems of Frank O'Hara*, ed. Donald Allen (New York: Random House, 1971), 233–34. All subsequent quotations from O'Hara's poetry are from this volume.

13. Frank O'Hara, "Larry Rivers: 'Why I Paint As I Do,'" *Art Chronicles*, 111–12.

Thomas Schaub

Caricature and Fiction in the Affluent Society

In a discussion held at a private residence in Manhattan on a Tuesday evening in July 1955, several editors and writers—among them Jean Stafford, William Styron, and Ralph Ellison—reflected upon the question, What's wrong with the American novel? In the midst of this informal and for the most part uninteresting conversation, Ellison made the observation that the "individual man" in contemporary society experiences the contradictions of "a whole chaotic world existing within the ordered social pattern." "Though he might be only vaguely aware of it," Ellison claimed, "his sense of reality is affected. He is more apt to get a sense of wonder, a sense of self-awareness and a sharper reflection of his world from a comic book than from most novels."[1] Beneath the homogenized narcosis of what was then called "mass society," Ellison sensed the presence of chaotic elements that the placid veneer only obscured or encased. In describing or reflecting the contradictory relations of this chaotic order, the comic book, Ellison contended, is likely to succeed where the novel fails.

At first one is perhaps tempted to take this remark as a clever hyperbole intended to confirm the general motive for the gathering—the American novel is in trouble—with Ellison selecting the comic book to exaggerate the current inadequacy of the novel. Certainly this is part of his meaning, but his use of the comic book as a term of comparison and measurement is much more precise than it at first appears. Like many of his contemporaries, both writers and critics, Ellison recognized the virtues of caricature—of exaggeration, distortion, typing, and accentuation—as a tool for analyzing a society variously described as "conformist," "other-directed," and "affluent." After 1945 many writers believed that to question and critique the apparent abundance and self-congratulation of American culture for readers who constituted a mass society required broader strokes than those afforded by the narcissistic images of the realist's mirror. Whether or not these assessments were accurate, the prevalence of caricature in the characterization and plotting of narrative fiction during the fifties and sixties is due, at least in part, to such convictions about mass society and the role of the artist in it.

The seriousness with which Ellison compared the novel and the comic book may be gauged by reference to the book he had published three years earlier. In *Invisible Man* he made extensive use of caricature in the large parodic lines that define the successive zones of Invisible Man's social and political environment. From the School and its surrounding Rural Black Country, to Northern Indus-

trial Capitalism (locked in battle with the Unions), to the Hospital and the Brotherhood, Invisible Man's journey is a kind of *Pilgrim's Progress*, and the characters with whom he contends—Bledsoe, Norton, Brother Jack (with one glass eye), Rinehart—are similarly drawn to accentuate and isolate the essential qualities of their types. The stage paint is applied to all the novel's features with a garish, clownlike severity, as if the audience were at a great distance and Ellison feared they might not get the point. (Since he was writing some years before the Supreme Court overturned the doctrine of "separate but equal," Ellison had good reason for this suspicion.)

But caricature is not only a means of underscoring a point; it is a popular mode, with the accessibility and wide appeal of cartoons and comic books. One of Ellison's purposes in writing the novel was to insist that Invisible Man's proper sources of identity were his local and popular roots—not the elite white culture he sought to enter. Thus Ellison's use of caricature in narrative scene, character, and plot represents the choice of a popular form of expression in direct opposition to canons of high seriousness. This form and theme interact marvelously throughout the novel, but one example will illustrate the point. After Invisible Man is released from the Factory Hospital, he is lured by the smell of baked yams that an old man is peddling on the streets of New York. In his desire to rise in the world, Invisible Man has earlier attempted to deny the appetites native to his Southern rural black culture. But now he is sufficiently free of those fears to purchase several yams and smother them in butter: "To hell with being ashamed of what you liked," he exults. "No more of that for me. I am what I am!" In this declaration, Ellison skillfully addresses both high and popular culture, for Invisible Man's words allude to Yahweh's answer to Moses ("I AM THAT I AM," Exodus 3:14) and at the same time invoke the cartoon figure of Popeye, who liked to say, "I am what I am. I'm Popeye the Sailor Man!" Of course, Popeye ate spinach, rather than baked yams, but for both characters familiar food is a source of self-confidence and strength.

Another aspect of caricature's forcefulness in affecting a mass audience resulted from the proliferation of realistic images in everyday life. The public had access to as many photographs, audio recordings, and video documents of itself as it wished to have. At the beginning of the century Paul Valéry had concluded that "the direct expression of things and the direct stimulation of the sensibility by new means—motion pictures, omnipresent music, etc.—is being rendered useless or ineffective for the art of language." Further, "the growing precision of the sciences will render it difficult to treat freely [a] whole category of subjects—psychological, sociological, etc."[2] By the late 1940s the photojournalism of the Luce publications and the development and popularity of television had further encroached on the terrain of realistic fiction. The mass society had many other means to inspect itself. As Flannery O'Connor declared in 1960: "A literature which mirrors society would be no fit guide for it, and one which did manage, by sheer art, to do both these things [mirror and guide] would have to have recourse to more violent means than middlebrow subject matter and mere technical expertness."[3]

During the Eisenhower era many writers were intent upon penetrating America's prosperous silence (which Thomas Pynchon later described as "the cheered land") and giving voice to the tics and twitches that subtly betrayed the denials and repressions of the affluent society. As a mode of expression, caricature offers a means to expose quirks and idiosyncrasies, to reveal the unnoticed or hidden. For stylistic accentuation and distortion subvert perceptual tendencies to absorb and integrate visual data into conventional wholes. Instead, caricature focuses the audience's attention on particular characteristics, and yet, somewhat curiously, conveys the impression of having laid open to view not the atypical blemish or unconscious gesture, but the essential, the core of the depicted person. The English term *caricature* is derived from the Italian *caricare* ("to load" or "surcharge"), which in turn may be related to the Italian *carattere* ("character") and the Spanish *cara* ("face"). And, indeed, "the face is the point of departure for most caricatures."[4]

American writers in the fifties and sixties tended to incorporate and caricature the "face" of America—its characteristic and telling images—the society's undeniably "real" countenance that, however, often concealed truths which refuted its self-image. By distorting the "illusion of reality," writers were able to express a deeper truth, "the illusion of life"—to use the distinction E. H. Gombrich makes in "The Experiment of Caricature," a chapter in his study of the psychology of representation, *Art and Illusion*.[5] Gombrich notes the success with which, for the audience, "the illusion of life . . . can do without any illusion of reality." His argument leads him to emphasize the development of caricature from Daumier to Munch and Picasso as contributing to the autonomy and increased abstraction of artistic expression.

But here I want to retain a focus on the comic and analytical nature of caricature, in which the audience is expected to set the narrative image beside reality, to experience the one in terms of the other. Of special interest in this connection is a treatise published by Rodolphe Töpffer in 1845, titled *Essay du physiognomie*. Töpffer's intention, Gombrich explains, was to describe the means of drawing "picture stories" of human figures, stories that would serve as an educative tool for mass culture. Töpffer described the didactic value of these picture stories, the forerunners of modern comic strips: "The picture story to which the criticism of art pays no attention and which rarely worries the learned . . . has always exercised a great appeal. More, indeed, than literature itself, for besides the fact that there are more people who look than who can read, it appeals particularly to children and to the masses, the sections of the public which are particularly easily perverted and which it would be particularly desirable to raise."[6] Töpffer's distinction between literature and pictures is applicable to narrative fiction, in which one may also speak of pictures and caricatures. While realistic fictions attempt verisimilitude, stylized fictions make use of exaggeration, reduction, and distortion in order to affect the audience.

Among the masters of narrative caricature in the fifties is Flannery O'Connor. She describes the children's mother in "A Good Man Is Hard to Find," as "a young woman in slacks, whose face was as broad and innocent as a cabbage and was tied around with a green head-kerchief that had two points on top like a rabbit's ears." And the face of Mrs. Freeman, the deadpan counterpoint to the fatuous Mrs. Hopewell in "Good Country People," is compared with a truck: "Besides the neutral expression that she wore when she was alone, Mrs. Freeman had two others, forward and reverse, that she used for all her human dealings."[7]

William Burroughs's Dr. Benway has no face at all, but he is a character who comes directly from the hospital skits in vaudeville and burlesque. He often appears in *Naked Lunch* in a dramatic script for such a skit:

Dr. Benway: "All the skill is going out of surgery. . . . All the know-how and make-do. . . . Did I ever tell you about the time I performed an appendectomy with a rusty sardine can? . . . "

As the surgery proceeds, the patient's heart stops, but Dr. Benway is without adrenalin. He decides to use a toilet-bowl plunger:

Dr. Limpf: "The incision is ready, doctor."

Dr. Benway forces the cup into the incision and works it up and down. Blood spurts all over the doctors, the nurse and the wall. . . .

Nurse: "I think she's gone, doctor."

Dr. Benway: "Well, it's all in the day's work."[8]

The Benway skits probably owe something of their inspiration to James Thurber's "The Secret Life of Walter Mitty," published in *The New Yorker* in 1939. One of Mitty's fantasies involves taking over in the operating room for a Dr. Renshaw and a Dr. Benbow, described as a "craven figure" who "drank." When the new anesthetizer shows signs of giving way, Mitty calls for a fountain pen and replaces the machine's faulty piston with it. Of course, Burroughs's skit is a parody of the vaudeville routine, a caricature that has an analytical motive. In Burroughs's satiric distortion of Thurber's playful fantasy, Mitty's resourcefulness—the American fantasy of pragmatic, inventive capacity—falls under the writer's knife. Thus the "craven" Benbow reappears as the figure of control, Dr. Benway, whose manipulations serve to enforce a "way" that is far from "benign."

In one of the most influential essays on postwar fiction, "Mass Society and Postmodern Fiction" (1959), Irving Howe criticized the work of the fifties for its failure to depict the "surface tone, manners, the social patterns of recent American life" and its preoccupation with "moral criticisms of its essential quality."[9] Howe was not alone: The moral concerns of many postwar writers did not conform to the political orientation of many critics, who remained convinced that the realist tradition of narrative portraiture—in which fiction is compared to an undistorting mirror or a transparent window—was the soundest means of altering mass society, which seemed to them both intractable and threatening.

Howe assumed that contemporary writers were unable to provide the requisite realism because mass society offered none of the class distinctions and opportunities for social analysis that earlier writers had exploited: "Modern novelists tended to assume that the social relations of men in the world of capitalism were established, familiar, knowable. . . . Without some such assumption there could not occur the symbolic compression of incident, the readiness to assume that X stands for Y, which is a prerequisite for the very existence of the novel."[10] But one has every reason to argue the re-

verse of Howe's position. Such assumptions *were* operating, for caricature, parody, and travesty assume that X equals Y and then distort the presumed likenesses, relying for their political, satirical, and comic effects on the audience's familiarity with the original. The assumption of a common store of national imagery, for example, enabled Ellison to flood his novel with racial dichotomies, Burroughs to lampoon pragmatism and capital punishment, and O'Connor and Walker Percy to address a vapid national Christianity.

This fiction is flush with "surface tone" and "manners," though the details and artifacts of American culture find their images distorted and decontextualized—as when Pynchon creates a character named Stanley Kotex. Caricature, Gombrich points out, forces the reader to "see reality in terms of an image."[11] This essentially ironic intent informs the depiction of modern America, a world in which spray cans, Florida vacations, existentialism, rumpus rooms, and electric chairs—to name but a few items—seem as natural and unremarkable as dirt; through irony, these items become back-lit with the glow of implication and meaning. Rather than appealing to caricature in desperation, writers in the fifties adopted caricatural techniques as one strategy by which they could address and awaken the mass society. In their commentary, truth is pursued by exaggeration rather than mimetic similitude.

To his own account of the mass society, Howe had added in apology: "Now this is a social cartoon and not a description of American society; but it is a cartoon that isolates an aspect of our experience with a suggestiveness that no other mode of analysis is likely to match. . . . the value of the theory lies in bringing to our attention a major historical drift."[12] Here the critic is using the language and argument of the writer. "The novelist with Christian concerns," O'Connor wrote, "will find in modern life distortions which are repugnant to him, and his problem will be to make these appear as distortions to an audience which is used to seeing them as natural." Like many of her contemporaries, O'Connor found it necessary to break with realist conventions of fiction, and like them she sought a form that would have the effect of reality upon her readers. The "realism of fact" could not, in her view, accomplish the "deeper kinds of realism"—by which she meant that the whole assumption of what constitutes reality (and therefore realistic representation) was obscured for her audience: "To the hard of hearing you shout, and for the almost-blind you draw large and startling figures."[13]

O'Connor began writing short stories in imitation of the psychological interiority she had learned from Joyce and Faulkner. In one of her earliest stories, "The Train," the main character—Hazel Wickers—is introduced through the interweaving of an exterior narrative voice and the character's own colloquial voice: "The man in the station had said he could give him a lower and Haze had asked didn't he have no upper ones." By blending the voices, O'Connor retains narrative control while giving the reader sympathetic access to the character: "His mother had always started up a conversation with the other people on the train. . . . My mother was a Jackson."[14] When O'Connor revised the story, using it as the first chapter of the novel *Wise Blood* (1952), this sympathetic realism is entirely obstructed. No longer privy to Haze's consciousness, we are forced to view him as a strange object, so that we share the irritated puzzlement of the woman seated facing him on the train: "She wanted to get close enough to see what the suit had cost him but she found herself squinting instead at his eyes, trying almost to look into them. They were the color of pecan shells and set in deep sockets. The outline of a skull under his skin was plain and insistent."[15] In this description, Haze seems a kind of grotesque Orphan Annie, opaque and mysterious, a caricature of a human figure.

Narratives about the sixties, even ostensibly realist novels such as Walker Percy's *The Moviegoer*, Saul Bellow's *Mr. Sammler's Planet*, and John Updike's *Rabbit Redux*, operate according to a caricatural mode—broad strokes, outlines, exaggerated types, accentuation of isolated features—rather than unfolding according to the organic interaction of character and environment. Consider the following conversation between Binx Bolling, protagonist of *The Moviegoer*, and Nell Lovell, an acquaintance:

Nell Lovell, I was saying, spotted me and over she comes brandishing a book. It seems she has just finished reading a celebrated novel which, I understand, takes a somewhat gloomy and pessimistic view of things. She is angry.

"I don't feel a bit gloomy!" she cries. "Now that Mark and Lance have grown up and flown the coop, I am having the time of my life. . . . Eddie and I have re-examined our values and found them pretty darn enduring. To our utter amazement we discovered that we both have the same life-goal. Do you know what it is?"

"No."

"To make a contribution, however small, and leave the world just a little better off."

"That's very good," I say somewhat uneasily and shift about on the library steps. I can talk to Nell as long as I don't look at her. Looking into her eyes is an embarrassment.

"—we gave the television to the kids and last night we turned on the hi-fi and sat by the fire and read *The Prophet* aloud. I don't find life gloomy!" she cries.[16]

This is caricature, not realistic dialogue, for every phrase of Nell Lovell's clichéd talk alerts the reader to the absolute emptiness of her life—the exhaustion of language (the divorce of word from thing) providing an unmistakeable proof of the gulf between literal assertion ("I don't find life gloomy!") and the denied existential reality.

Though Bellow's *Mr. Sammler's Planet* and Updike's *Rabbit Redux* have been credited with providing a good deal more realistic analysis of American culture than such contemporary books as Pynchon's *The Crying of Lot 49* and Barthelme's *Snow White*, the former are but cartoon sketches of American culture, making covert use of many of the same devices that the latter purposely emphasize. Sammler appears to be a realistic figure only because of the veneer of exquisite (and comic) detail that Bellow applies to the novel's New York setting and to his protagonist's thoughts. All the characters to whom Sammler condescends, however, are caricatures: the Promiscuous, the Wayward Son, the Crude, the Romanticized Criminal, the Compulsive, and the Sadistic. And although Sammler is mildly reproved for his condescension, his judgments are sustained by the book as an analysis of the cultural forces tearing at the social fabric. This polemical analysis achieves its aesthetic and reflective power by means of caricature. Howe's critique of his own description of mass society applies here, too: "a cartoon that isolates an aspect of our experience with a suggestiveness no other mode of analysis is likely to match."

Updike had wanted to be a cartoonist, and in *Rabbit Redux* he succeeds. Among the dense, often elegant, rococo descriptions of everything from evening in Brewer to a hillside of flowers or Rabbit's living room are characters engaged in a plot that caricatures American culture in the sixties. Rabbit Angstrom, the all-American male, finds himself playing host to a cast of characters who resent the central forces that were impinging upon Middle America in the sixties: the flower child (Jill), the television generation (his son, Nelson), and women's liberation and the sexual revolution (his wife's affair with the hirsute Charlie Stavros); the Vietnam War, the War on Poverty, and Civil Rights are nicely compacted into the character of

Skeeter, the black Vietnam veteran. The plot allows each to be brought, physically as it were, into Rabbit's house, so that everything that happens there is a distorted microcosm of what is happening to America. The circus is depicted with realistic detail:

One day in September Rabbit comes home from work to find another man in the house. The man is a Negro. "What the hell," Rabbit says, standing in the front hall beside the three chime tubes.

"Hell, man, it's revolution, right?" the young black says, not rising from the mossy brown armchair.[17]

Despite the detail ("the three chime tubes," "mossy brown armchair"), the work's analytical power relies on exaggeration and distortion, implausibilities (Rabbit does not call the police), and simplified character types.

Criticizing the fiction of the sixties, Daniel Bell used terms similar to those Howe had used twelve years earlier in writing about the fifties: "Despite all the social turmoil of the decade, not one novel by these writers was political; none (with the exception of Bellow's *Mr. Sammler's Planet*) dealt with radicalism, youth, or social movements—yet all were anagogical in one way or another." Like Howe, Bell objected to the "moral" character of the era's fiction, which failed, he contended, to "report the doings of man in a social framework."[18] But anagogical frames, scaffoldings that are mystical or metaphysical rather than social, do not necessarily preclude the writer from supplying readers with a mass of social detail and particularity of custom and manners. Indeed, anagogical references and metaphysical insinuations are legitimate tools for the analysis of social and political subjects. Insistent realists like Howe and Bell, however, raise their eyebrows at departures from mimesis. Explicit social critiques such as Ken Kesey's *One Flew Over the Cuckoo's Nest* and Joseph Heller's *Catch-22* are dismissed as devoid of political substance; Sylvia Plath's *Bell Jar* is not even mentioned.

The objection to the anagogical mode is a variant of the unqualified exclusion of fictional caricature from the realm of "serious" art and suggests how much stronger the cultural bias toward mimetic representation has been as regards narrative compared to painting, sculpture, or music. "Are we mad?" Gilbert Sorrentino asks in an article on the prose of William Carlos Williams. "Fifty years after Joyce and Lewis, Williams and Ford, we search for 'flesh and blood' characters who 'walk off the page.'"[19] Donald Barthelme challenges the realist prejudice by taking exception to Kenneth

Burke's worried warning that "the artist in an otherworldly art that leaves the things of Caesar to take care of themselves" runs the risk of "dependence upon some ruler who will accept the responsibility for doing the world's 'dirty work.'" Barthelme's counterargument follows the direction Gombrich pursues in *Art and Illusion*, citing the virtues of the literary product as an object in the world, in its own right: "Art is not about something but *is* something." James Joyce, Gertrude Stein, and their kin "modify the world by adding to its store of objects the literary object . . . so that the reader is not listening to an authoritative account of the world delivered by an expert (Faulkner on Mississippi, Hemingway on the corrida) but bumping into something that is *there*, like a rock or refrigerator."[20]

This is the familiar doctrine of Modern Art, and Barthelme offers the characteristic argument for the political and social relevance of such art:

[These] creations modify the beholder. I do not think it fanciful, for instance, to say that Governor Rockefeller, standing among his Mirós and de Koonings, is worked upon by them, and if they do not make a Democrat or a Socialist of him they at least alter the character of his Republicanism. Considered in this light, Soviet hostility to "formalist" art becomes more intelligible, as does the antipathy of senators, mayors and chairmen of building committees.

Similarly, Roy Lichtenstein's blown-up comic strips, he suggests, might provoke viewers to ask, "What do you think of a society in which these things are seen as art?"[21]

In fact, however, the more overtly experimental narrative art of the sixties is far more attentive to the world, more referential, than Barthelme's analogies with painting suggest. The transformation from a realistic mode to an expressive mode, so typical of fiction in this period, represents an abstracting process that continues and heightens the exaggeration, the distortion, and the use of cartoonlike flat characters of the preceding decade. The works, for example, of Sorrentino, Barthelme, and Pynchon—while differing in important ways—caricature American culture not only by distorting its image but also by incorporating, not unlike the Pop artists, the very materials and artifacts of that culture in the narrative. The experimental impulse of modernism ("make it new") here allies itself with the moral intentions of the fifties.

Sorrentino's *Imaginative Qualities of Actual Things* (1971) is an antinovel that caricatures the art world of New York in the fifties and sixties. Although the book has historical referents, it insists upon itself as a literary object: "This story is invention only. Put yourself into it. Perhaps you are already in it, or something like it."[22] Sorrentino turns to comic distortion to isolate the characteristic and essential qualities of the painters and writers of the period. At times the act of characterization amounts to no more than a list of what a particular character likes:

Some Things Sheila Henry Liked about Lou Henry, 1963–1967.
Ears.
Desert boots.
He sniffed when he read *Nineteen Hundred and Nineteen*.
The way he tossed salad.
The way he wore his hat.
His poems.
Calling William Carlos Williams, "Doc" Williams.
His admiration for Dick Detective.
His buttocks.
His understanding of D. H. Lawrence.
A crown of Petrarchan sonnets he wrote for her twentieth birthday.
The way he alternately washed and sucked her breasts when they showered together.
Old suede jacket.
The look of his genitals in jockey shorts.
His contempt for his instructors.
The way he sang off-key.[23]

Sorrentino freely admits having borrowed this device from Joyce (a sign of modernist continuity in recent fiction), but he later defended the list as a caricaturist's means of characterization: "In a list," he told an interviewer, "you can boil down to a word or two a character and his motivations, and that word or two often deflates and punctures the pretensions of one's life. The impediments of life inhere in narrative and if you can rip all that garbage away and get the fact, you have an odd, comic quality about a man or woman. . . . You get something that in a curious way approaches the truth of life, even though you have dropped what seems to be the truth of life. It is a selection of materials."[24] The reader is to confront Sorrentino's fiction as an abstract caricatural design with its own invented reality, which at the same time sustains what Gombrich called "the illusion of life."

Like *Imaginative Qualities of Actual Things*, Barthelme's *Snow White* (1967) prohibits and mocks the realist reader's expectations by blurring the line between story-telling and self-conscious remarks about the story: "We are very much tempted to shoot our arrows into them [the girls], those tar-

gets. You know what that means."[25] In his rewriting of the fairy tale, Barthelme refers to the bourgeois world of business and suggests, however subliminally, that the updated tale should reflect the consumer-oriented discontent of our culture. The novel proceeds by taking the phrases and words of colloquial American speech and recontextualizing them in the framework of the popular children's story. Most of the language of the book is appropriated from particular subcultures. The seven dwarves, for example, speak the idiom of utilitarian therapy, of supply-side psychology: Bill "cannot bear to be touched," and others of the seven are disturbed ("it bothers me") to see "all that potential being pissed away . . . when he could be out realizing his potential . . . maximizing his possibilities." By setting before his readers their own language caricatured by the very act of focusing upon it, Barthelme elicits laughter and scores his satiric point. A good deal of the language he attacks is philosophical and literary-theoretical, as when Snow White has "pulled herself together" but complains, "it is still waiting, and waiting, as a mode of existence is, as Brack has noted, a darksome mode"; or when Jane, the wicked Queen figure, threatens: "It may never have crossed your mind to think that other universes of discourse distinct from your own existed, with people in them, discoursing. You may have, in a commonsense way, regarded your own u. of d. as a plenum, filled to the brim with discourse." Here the clichés of advertising ("filled to the brim"), everyday speech ("have crossed your mind"), and philosophical jargon ("universes of discourse") are thrown together in a pastiche that parodies the "trash phenomenon" it embodies.[26] Like Warhol's Campbell's Soup cans, the dialects of American culture are stacked for display.

Pynchon's *The Crying of Lot 49* (1966) offers another response to the affluent society. The book seems a fictionalization of *The Feminine Mystique*: A dissatisfied housewife (Barthelme calls them "horsewives") is lured into a search for America and in the process redefines both her own identity and the nation's. The intentional implausibility of the narrative accentuates the peculiar and penetrating reality the search eventually acquires for both heroine and reader, while flat cartoonlike characters, exaggeration, and a manipulative insinuating narrative voice undermine the placid surface of the heroine's life. Oedipa Maas (a female Oedipus, one more time) lives in Kinneret-Among-the-Pines, a life that affords her all the clichés of the middle-class California housewife:

Through the rest of the afternoon, through her trip to the market in downtown Kinneret-Among-the-Pines to buy ricotta and listen to the Muzak. . . ; then through the sunned gathering of her marjoram and sweet basil from the herb garden, reading of book reviews in the latest *Scientific American*, into the layering of a lasagna, garlicking of a bread, tearing up of romaine leaves, eventually, oven on, into the mixing of the twilight's whiskey sours against the arrival of her husband, Wendell ("Mucho") Maas from work, she wondered, shuffling back through a fat deckful of days which seemed (wouldn't she be the first to admit it?) more or less identical.[27]

Though Pynchon provides a compelling mystery plot that carries the reader and Oedipa in search of Trystero, the principal deductions made by the reader and the housewife-turned-detective concern the medium that composes the novel's world: the materials and artifacts of American culture in the fifties. It is this resistant medium that Oedipa gradually discovers: the ubiquitous and blossoming freeways, the address numbers in "the 70 and then 80,000's" (Oedipa "had never known numbers to run so high. It seemed unnatural"). In the bathroom of the Echo Courts Motel, something breaks in a can of hairspray and "with a great outsurge of pressure the stuff commenced atomizing, propelling the can swiftly about the bathroom." The pharmacopoeia of American culture resounds in the narrator's descriptions: In Oedipa's ignorance of the national life about her "there had hung the sense of *buffering*" (italics mine), and the road taking her into San Narciso appears to her as a "hypodermic needle, inserted somewhere ahead into the vein of a freeway, a vein nourishing the mainliner L.A., keeping it happy, coherent, protected from pain." In the course of her journeys, Oedipa finds an underworld, "invisible yet congruent with the *cheered* land she lived in" (italics mine). Beneath the aspirin, the detergent, the freeways, and the Muzak, Oedipa uncovers a reality quite unlike the distorted surface she had once taken for granted.[28]

From the closing of this circle, caricature achieves its essential unsettling effects. Though caricature begins by presenting a distorted image of an original with which the audience is familiar, it ends by transferring the quality of distortion from the image to the face that it mocks. The fictions of the fifties and sixties are galleries of such images, and the readers who scan the pictures on the wall find they can no longer describe the face of America as "the affluent society."

NOTES

1. "What's Wrong With the American Novel?" *American Scholar* 24, no. 4 (Autumn 1955): 470–72.
2. Valéry, in *Location*, no. 1 (Summer 1964), 14.
3. Flannery O'Connor, "The Grotesque in Southern Fiction," in *Mystery and Manners*, ed. Sally Fitzgerald and Robert Fitzgerald (New York: Farrar, Straus & Giroux, 1969), 46.
4. *Encyclopaedia Britannica*, 14th ed., s.v. "caricature and cartoon."
5. E. H. Gombrich, *Art and Illusion* (Princeton, N.J.: Princeton University Press, 1969), 336, 330–358 passim.
6. Ibid., 338.
7. Flannery O'Connor, *A Good Man Is Hard to Find and Other Stories* (1955; reprint, New York: Harcourt Brace Jovanovich, 1976), 9, 169.
8. William Burroughs, *Naked Lunch* (1959; reprint, New York: Grove Press, 1966), 59–60.
9. Irving Howe, "Mass Society and Postmodern Fiction," *Partisan Review* 26 (April 1959): 266–75; reprinted in *A World More Attractive* (New York: Horizon Press, 1963), 93.
10. Ibid., 80, 82.
11. Gombrich, *Art and Illusion*, 345.
12. Howe, "Mass Society," 86.
13. Flannery O'Connor, "The Fiction Writer and His Country," in *Mystery and Manners*, 33, 39, 34.
14. Flannery O'Connor, *The Complete Stories* (New York: Farrar, Straus & Giroux, 1971), 54–55.
15. Flannery O'Connor, *Three by Flannery O'Connor* (New York: Signet, 1962), 9.
16. Walker Percy, *The Moviegoer* (1961; reprint, New York: Avon, 1980), 83–84.
17. John Updike, *Rabbit Redux* (New York: Fawcett Crest, 1971), 183.
18. Daniel Bell, "The Sensibility of the Sixties," *The Cultural Contradictions of Capitalism* (New York: Basic Books, 1978), 137.
19. Gilbert Sorrentino, "The Various Isolated," *New American Review*, no. 15 (New York: Simon & Schuster, 1972), 198.
20. Barthelme, "AFTER JOYCE," *Location*, no. 1 (Summer 1964): 13.
21. Ibid., 14.
22. Gilbert Sorrentino, *Imaginative Qualities of Actual Things* (New York: Pantheon Books, 1971), 9.
23. Ibid., 15–16.
24. John O'Brien, "An Interview with Gilbert Sorrentino," *The Review of Contemporary Fiction* 1, no. 1 (Spring 1981): 19.
25. Donald Barthelme, *Snow White* (1967; reprint, New York: Bantam Books, 1968), 8.
26. Ibid., 4, 20, 77, 44–45, 97.
27. Thomas Pynchon, *The Crying of Lot 49* (New York: Bantam Books, 1966), 2.
28. Ibid., 14, 22, 10, 14, 135.

U · S · A ·

Ben H. Bagdikian

Endings, Beginnings, and Endings: Media in the 1950s

For the major media, the 1950s were a time of endings and beginnings and endings again, of old media cultures dying, some so gradually that their passing was unnoticed, and some, newly created, rushing onto the public stage with the flamboyance of innocent youth.

Newspapers, once the creation of strong editors who wanted to say something, emerged as large corporate enterprises still beloved by their owners as mouthpieces for their own ideas, but chastened by the realization that if they didn't make too many people angry, the thundering presses could make higher profits than most of the country's glamour industries.

Radio, which had been a living room presence since the 1920s, and the voice of solemn reporting of wartime battles, suddenly found itself, at its height, shockingly drab in the presence of a new electronic box with a tiny screen that not only emanated sounds but living, moving images.

Television, which had been a technological reality since the 1920s, became a household reality so rapidly in the 1950s that it took years before most people realized that it had transformed family life, popular culture, and the nature of cities. In all the other media, the new invention, unexpectedly but inexorably, caused mutations, some of them terminal diseases.

For people in radio, the little TV boxes were at first a cute newcomer whom they chucked patronizingly under the chin, believing, as did theater owners, that nobody would become devoted to the little five-inch screens with snowy images. But the jokes turned quickly to horror as the clumsy infant turned into a giant that threatened radio, which dealt solely in pictureless sound, and movie theaters, which required people to leave home and pay admission.

Newspapers were faster to develop anxieties. Radio had already killed the "Extra!", those unscheduled editions printed quickly whenever a dramatic event occurred. Now people heard the breaking news on the radio. For most papers, the last "Extra!" was the Japanese bombing of Pearl Harbor on December 7, 1941, but even then, most people got the news from a news break in regular Sunday broadcasts ("We interrupt this program . . .").

The press in this century has always harbored an obsessive fear that some little black box will kill printed news. The fear surfaces with every announcement of a telecommunications invention. Nevertheless, it was years before most papers realized that broadcasting would not kill them, but would change their content and their role in society.

World War II changed the mind-set of Americans, but the media understood this only slowly. With 14 million men in the armed services, the public could not get enough reports of battles, of casualty lists, of tactics and strategies. The public read and listened not as entertainment but with profound involvement. The lives of loved ones were at stake. It was not impossible that the Japanese would bomb the United States—coastal cities were blacked out—or that Hitler would win. Newspapers were devoured, radio newscasts were tuned in religiously. (Archibald MacLeish said of Edward R. Murrow, broadcasting for CBS from Europe, "You burned the city of London in our houses and we felt the flames. . . . You laid the dead of London at our doors and we knew that the dead were our dead. . . .") Papers that had used their wartime rationed newsprint to emphasize news instead of ads emerged from the war with less cash in the bank but stronger reader loyalty; those were the papers that survived in the following years, as their competitors failed and many cities became one-newspaper towns.

By the start of 1950 these transformations were proceeding, but, as ever, the old media were impelled by past momentum that concealed the depth of change. That year there were 108 radio entertainment series that had been on the air for ten years and were still popular: Jack Benny, Bob Hope, Amos 'n Andy, Bing Crosby, and "The Romance of Helen Trent" among them. But by 1953 Bob Hope's ratings had dropped from 23.8 to 5.4.

The decade began with a bizarre mixture of chaos and caution, of jarring events and national conformity that would involve the mass media as both actors and reactors to alterations of public thinking. On February 9, 1950, the junior United States Senator from Wisconsin, probing desperately for an issue to win re-election, gave a speech in Wheeling, West Virginia, in which he said he had in his hand a list of 205 people known by the Secretary of State to be members of the Communist party but who were still "shaping policy in the State Department." It was the start of four years of national hysteria, and though Senator Joseph McCarthy would never expose a single spy, his years of wild accusations would shake every major American institution, including the mass media.

Most newspapers for a long time praised the increasingly dubious charges by the Senator and the political groups he inspired. A few major papers assigned staffs to help him carry out his campaign. McCarthyist groups began purging broadcasting of people they said represented "Communist influence on radio and television." Broadcasters began

hiring right-wing Red-hunters to "clear" performers before they were allowed to appear. (The list of those accused of "Communist influence" included Leonard Bernstein, Aaron Copland, Gypsy Rose Lee, William L. Shirer, Howard K. Smith, Orson Welles, and 145 others, most of whom had merely contributed to noncommunist causes disliked by the McCarthyites.)

In that same crucial year, 1950, President Truman approved the development of the hydrogen bomb, the Korean War began, and a small item in some papers, not even printed in others, reported that the United States was sending thirty-five military advisors to a place called Vietnam.

Readers and viewers were absorbing the shock of the turbulent news while their media were simultaneously changing ways the public got their news. Television needed more complex wires than radio to carry live signals, and at first the co-axial cable tied together only the big East Coast cities. Other cities and towns saw network TV shows and news thanks to propeller planes that delivered grainy movie films of the original broadcasts. In bad weather, Alaskans got their national news a few days late. But gradually the cable was extended from coast to coast on utility poles, through underground cables, and by the new microwave dishes that sent signals from hilltop to hilltop. When the cable link was completed to a city, it was hailed by front-page news stories about Milton Berle now coming live into local living rooms. It soon became evident that promoting national television presentations which would be seen across the country at the same moment represented a new power to inform, entertain, or move an entire people.

Less evident than the instant power of live network broadcasting was what it did to the centers of cities. As the co-axial cable reached a new city, families delighted in being able to watch the popular evening shows at the nationally announced time, and they quickly broke with the national habit of going to the movies twice a week. Ornate movie palaces that had been the American entertainment center for almost twenty years were suddenly empty. Fred Allen, popular as a sardonic comedian on radio, said the movie theaters were so empty you could hear the butter trickling through popcorn in the lobby. And when families no longer went downtown to the movies, they no longer stopped for dinner or coffee at a nearby restaurant, no longer stopped at a department store to shop. The availability of the new home entertainment, combined with the flight of the affluent to the suburbs, transformed the centers of American cities

into cold and empty wastelands after the sun went down.

Two events on the new living room appliance notified the image makers that a revolution was at hand.

In 1950 Hazel Bishop, an obscure lipstick company with gross earnings of only $50,000 a year, began advertising on television. The company's annual gross jumped to $4.5 million. The financial phenomenon demonstrated that television would become the greatest merchandiser of commercial products in the history of civilization. The knowledge transformed television itself.

Until the lipstick commercials ran, the major sponsors of television programs were corporations, which used programs to enhance their image as dignified institutions. Philco, Motorola, Goodyear, Texaco, U.S. Steel, and others sponsored original live dramas or comedy hours, one sponsor for the entire program. When the merchandising magic of television was recognized, however, the networks cancelled the current shows, even though they had high ratings and the sponsors wanted to keep them. Instead, the networks and local stations developed their own programs and sold "spots" to a number of different companies, earning higher revenues from a series of the five-second, thirty-second, and sixty-second spots than they had from single-sponsor hourlong programs. Unlike sponsorship, which was intended to buttress institutional reputations, the new commercials were designed to sell goods in a presentation measured in seconds.

These "new" commercials required highly refined imagery without much concrete detail, designed mainly for rapid emotional association. The program in which the brief sales pitch would be imbedded could not be too serious since that would not create a "buying mood" needed to make brief, fantasy-oriented messages about commercial products effective. But enormous profits for both the merchandiser and the stations would come only if the largest possible audience stayed glued to one channel. Furthermore, the spot commercials were not best on serious dramas and other continuous programs that had attracted large audiences in the early years of television. The industry needed a new way to attract and fix attention. For this, the medium turned to the sovereign attention-getters in human history, sex and violence. Thirty years later, sex and violence remain the devoted partners in American commercial television, a partnership that decades of complaints and endless indictments by psychological studies could not dissolve. Alfred Hitchcock, the movie director, said

mordantly, "Television has brought murder into the home, where it belongs."

The merchandisers of consumer goods were not alone in recognizing the new power. One could sell fabulous quantities of deodorants and detergents through the new medium. But one could also sell political ideas and candidates.

The political use of television was inevitable, given its huge reach, its moving imagery, and its capability for creating highly polished and well-choreographed studio recordings that had the appearance of candor and spontaneity. On television a speaker could reach millions simultaneously and intimately, seeming to be speaking to each individual viewer from a few feet away. Neither a Hitler nor a Caesar could have commanded so large an audience with such total control.

The year 1952 launched that political lesson. A national military hero, General Dwight Eisenhower, was the Republican candidate for president; an intellectual governor of Illinois, Adlai Stevenson, was the Democratic candidate. It was almost inevitable that Eisenhower would win, television or not, but the campaign established what would become the standard medium of politics for the next generation.

Eisenhower's first live press conference was a disaster. He was ill at ease, did not have answers for the reporters' questions, and seemed unable to impart a sense of purpose or familiarity with the issues. From then on, his managers concentrated on short television commercials that blended imagery and capsule remarks by the General. Released only after hours of shooting, editing, and refining, these twenty-second commercials had little real content. To mention ideas or programs, it was feared, would risk offending voters who might differ with the candidate, and there was no one to ask unrehearsed questions.

That same year, the General's vice-presidential candidate, Senator Richard Nixon, was embarrassed by disclosure of a secret fund that had permitted California businessmen to finance his political career. Many Republican party leaders said that Nixon should resign in order to prevent loss of the election. General Eisenhower reserved judgment until Nixon had a chance to reply. Richard Nixon and his wife appeared in a special half-hour appeal to the public that has since been called the "Checkers speech" because of an emotional statement by Nixon that one of his gifts, a dog named Checkers, had been from a little girl, and would never be divested by the Nixon family. It was a speech that unsympathetic viewers derided as filled with contrived emotion and bathos, but it had the effect of

keeping Nixon in the campaign and salvaging a career that would bring him to the presidency. It left no political manager in doubt about the future technique for political campaigning in the United States.

A society fearful that being unusual might be seen as subversion, observing that liberals and radicals were called before congressional committees on national television, led in government by conservative businessmen, and centered around a population cohort feeling middle-class affluence while building families and careers, was soon seen, not surprisingly, as rigidly conformist.

It was a time when corporate job recruiters hiring the brightest college graduates noted whether applicants had proper regimental ties, proper attitudes, and proper wives. Advertisements and commencement addresses tended to salute career achievement and proper company life.

Nevertheless, there were growing murmurs that condemned conformity and quoted Emerson and Thoreau. There was a fulcrum in this see-saw of orthodoxy and change. The fulcrum year was 1954. Joseph McCarthy was finally censured by the United States Senate, and the United States Supreme Court declared that school segregation was unconstitutional. It was the start of a new spirit, of change directed at equality and equity. Like any genuine social change, it released bitter antagonisms. It would be three more years before a decisive event made clear that the country was about to change race and social patterns, with all these implied for everything else, in the Deep South, and then everywhere.

The moment was in 1957 at Central High School in Little Rock, Arkansas, where, in a tense historic moment, the governor called out his National Guard to stop agents of the United States government from carrying out a federal court order to integrate the school. There were nervous jokes about firing on Fort Sumter. In the end, President Eisenhower called out federal troops, who stood almost shoulder-to-shoulder with bayonetted rifles, to surround the school. More than two hundred correspondents from around the world, and Americans at their television sets, observed while a company of the 101st Airborne Infantry of the United States Army accompanied nine black students into the previously all-white high school.

In journalism, literary life, and academia, there was a parallel ferment resisting the smothering conformity. In 1950 David Riesman published *The Lonely Crowd*, on alienation in modern society. The next year a whole generation of young middle-class Americans were drawn to J. D. Salinger's *Catcher in the Rye*, a private world of the young who were uncomprehended by their elders. By 1956 William H. Whyte had published *The Organization Man*, aiming at the lockstep of proper college graduates shaping themselves to be acceptable to their corporate employers, a book complete with an appendix explaining how to cheat on the psychological tests given by companies to new junior executives. The next year Jack Kerouac published *On the Road*, a precursor of 1960s hippiedom and its satirization of bourgeois propriety and familiar media symbols like advertisements and melodramatic comic strips.

In newspapers, there was a new, impersonal corporate structure like conventional industries. But it was inhabited by a body of new journalists who were increasingly serious. In previous generations, American journalists were characterized by a small number of serious reporters and editors concentrated in a few newspapers, the majority of reporters were required mainly to be fast on their feet and on the keyboard. Many were talented and skilled, but few had gone to college and most were seldom asked to do more than write stereotyped stories of crimes, lurid court trials, and hijinks at City Hall. Novels about American journalism in the late nineteenth and early twentieth centuries often featured a sensitive reporter on a simplistic newspaper, the trap called "the newspaper-as-cemetery."

But the postwar population was increasingly college educated and no longer smug about imagined isolation from the rest of the world. Postwar families raising school-age children and voting in their communities were less tolerant of flippant news.

Advertising became more important as a source of revenue to newspapers and, as in broadcasting, revenues depended on the size of the audience. Newspapers once interested in devoting as much of their space as possible to pursue their owners' personal and ideological interests now wished to attract as many different people in the community as possible, so objectivity in news writing became the style, leaching out subjective expression and judgmental adjectives that might delight some readers but offend others. There was a more businesslike collection of serious news that not only was more profitable but was less likely to cause public resentment at the new pattern of local monopoly. Owners' personal predilections still prevailed, but more subtly, in selection and display of news rather than in open advocacy in the reportage.

Furthermore, the American audience had other sources of information. The public had near-

universal access to radio and television for news, to books and texts and the growing number of magazines. When the Soviet Union launched *Sputnik* into space in 1957, it shocked the United States into raising the rigor of all its schools. High schools got tougher textbooks and colleges accelerated their studies. Where once only winning quarterbacks seemed to get their pictures in the local papers, now it was the local winners of the National Merit Scholarships. Daily printed news had to improve and so did journalists. Conventions of systematic training and codes of conduct developed. Reporters no longer wore their hats in the office, and they were forgiven by their older peers if they read books or even wrote them.

Television news was at its best when done by the former network reporters from radio like Edward R. Murrow and Walter Cronkite, but most of it was skimpy and frivolous. The shift from radio to television occasionally embarrassed the old techniques. Prize fights had been popular on radio, partly because they encouraged a breed of radio fight announcer who created a verbal scene of relentless slaughter in the ring. When the fights were first televised, the same announcers were used, giving staccato, manic descriptions of a scene of uncontrolled savagery. But the cameras were transmitting a real scene, usually of two very large, tired men shifting from foot to foot and taking indifferent swings from great distances.

Another radio art form, the recreated baseball game, also symbolized the change of news from the spoken word to the moving image, and signaled the start of something approaching a national mania, televised sports. In the past, an imaginative announcer watched a teletype machine send inning-by-inning statistics of distant games, but the announcer would pretend to be on the scene and fill in the events with excited step-by-step imaginary descriptions as though directly observed. The most popular of these "recreators" was Gordon McLendon in Dallas, but the one who would ultimately become even more famous was an announcer named Ronald Reagan.

By the late 1950s television had begun to take its present form: images of reality as defined by the live camera on the scene with intermittent examples of what was fast becoming the most expensive, ubiquitous, and polished art form in society, the television commercial.

Radio became the wallflower of broadcasting, alive for the moment because it could be easily introduced on the workbench, in moving cars, and in the new handheld transistor receivers, but still

years from its later resurgence as a medium for news and for specialized categories of music.

The newspapers, ever fearful of the black box, initially did what most irrationally fearful victims tend to do—they began imitating their enemy. They assumed that since television seemed to gain popularity because of pictures, newspapers would compete best by running lots of photographs. The newspapers of the 1950s blossomed with huge photographs and, in the same kind of mistaken compulsion, increasingly brief news items. Since broadcasting can transmit only one item at a time, no one piece of news can be so long as to bore those uninterested in that particular kind of news. When the broadcast consumer gets bored or irritated, he turns the dial and the station owner has lost a customer. Most newspapers had forgotten that if they ran stories that bored or irritated a reader, the reader could turn the page and the publisher had not lost the customer. Most publishers were also slow to realize that when the bored reader turned the page looking for news of his particular interest, he did not want a brief, six-line summary, but plenty of interesting detail. But fear is a powerful propellant of fashion, and the fashion became oversized photographs and miniature news items.

The lust for TV-like photographs, while ultimately futile as a way to compete with broadcasting, produced a welcome change in public photography and in the public's sophistication in graphics. The traditional newspaper photograph was taken by a bulky instrument like the boxlike Speed Graphic, illuminated by a flash. The typical newspaper photograph was a rigid line of committee members arranged by height or status, grinning frozenly into the lens, details of their faces washed out by the blinding flashbulb. A newly efficient device, the 35-millimeter camera, using more sensitive film and better lighting, combined with editors' desire for better photographs with which to defeat television, produced photographs that were both more versatile and artistic, and displayed people and scenes closer to candid reality.

Until the 35-millimeter camera and fear of television struck newspapers, the public's main source for good photographs with some degree of unplanned reality was *Life* magazine, the spectacularly successful weekly launched by Henry Luce in 1936. *Life*'s cadre of the best photographers in the country raised the national level of the art and in the 1950s set the standards for news pictures. By the early 1970s, however, *Life*, *Look*, the *Saturday Evening Post*, and other national magazines of gen-

eral circulation had died. It had become clear that broadcasting with its huge reach and moving ads, could reach each American household more cheaply than even the big national magazines at the height of their circulations.

It dawned only gradually on the press that broadcasting had not killed it but transformed its role. No longer the original announcer of dramatic news, newspapers dealt with an audience who already had heard the top of important events and looked to the press to confirm and add details and background. In a sense, broadcasting increased the public hunger for news by reaching more people with current events than had ever before been included in the news net. The papers that satisfied this hunger for detail and background did better than the ones that continued as in the past or persisted in the illusion that they could be more photographically graphic and briefer than the broadcasters.

The change in the news became clear to me during the winter of 1960–61. As a Washington correspondent, I covered the last press conference of the outgoing President Eisenhower. It was held in the cramped, baroque Indian Treaty Room of the Executive Office Building, next to the White House. Television cameras were present, but their film was released only hours later, after the White House had examined it for passages it thought might be harmful to the public interest or its own. The old order prevailed: after about thirty minutes of questions and responses, the senior wire service reporter present concluded with the ceremonial, "Thank you, Mr. President," followed by an unceremonial ritual. As the doorkeeper opened the door, correspondents for wire services and major papers ran—they did not walk—toward the nearest telephones, mentally composing their stories, which they shouted into their telephones. At the other end, their home offices transmitted the shouted stories, word by word, to a waiting public.

The next press conference I covered, a few weeks later, was the first by the new president, John F. Kennedy. Kennedy decided that his press conferences would be transmitted live as they occurred. He knew that he was effective in that setting and the immediacy of a live vision of the young, attractive president would make the press conferences, and the president, popular. This press conference was not held in the Indian Treaty Room—too many correspondents now wanted to attend, and the setting was too drab. It was in the relatively new, decorator-cool State Department Audi-

torium. At the end of this first, fascinating thirty minutes, the senior wire service correspondent, as usual, said, "Thank you, Mr. President," turned, and, as usual, ran toward the lobby, as did the other correspondents with instant deadlines. But as they rushed pell-mell through the door, they froze in sudden, embarrassed paralysis. They realized, with sheepish grins, that no one in the home office was waiting breathlessly for word from them—the home office had watched on its own television set and transmitted the news as it happened in real time. Besides, a large part of the voters had seen the conference instantly.

It was clear that from then on the most important print journalists would be valued not for their legs and fast composition, but for what they might add to what the public already knew.

This was more than a poignant moment for a few specialized correspondents. It was a reminder that television could reach practically everyone instantaneously and do it over the heads of mediating journalists, overriding the power to put the leader's words in the context of history or the voices of the opposition. That had been true of radio, of course, but television was qualitatively different: It projected the moving image of the speaker and, as inevitably would happen, leaders would learn how to present themselves as compelling and credible, at least for that moment. It was a powerful new way to stimulate instant national consensus. American politics and the creation of popular values would never be the same.

Chronology

1950

Alger Hiss convicted of perjury in his denial of espionage charges

Truman approves development of hydrogen bomb

Sen. Joseph McCarthy begins anti-communist campaign

Dr. Klaus Fuchs convicted of espionage; Julius and Ethel Rosenberg arrested for espionage

North Korea invades South Korea. U.S. and United Nations send troops to aid South Korea. Chinese communist forces join North Koreans

U.S. sends 35 military advisors to Vietnam

First computer is marketed

U.S. minimum wage rises to $1 an hour; gross national product up 11% for the year

Arshile Gorky, Jackson Pollock, and Willem de Kooning included in U.S. Pavilion at Venice Biennale

Young Painters in the United States and France, Sidney Janis Gallery, New York

1951

Passage of 22d amendment to U.S. Constitution, limits president to two terms

Julius and Ethel Rosenberg convicted and sentenced to death

U.S. federal budget shows $6 billion surplus, but consumer prices jump 7.9%; gross national product up 15% for the year

Influences on a Young Painter: Wayne Thiebaud, first solo exhibition, E. B. Crocker Art Gallery, Sacramento, Calif.

Robert Rauschenberg, first solo exhibition, Betty Parsons Gallery, New York

Abstract Painting and Sculpture in America, The Museum of Modern Art, New York

Common Art Accumulations, Place Bar, San Francisco

Roy Lichtenstein, first solo exhibition, Carlsbach Gallery, New York

Duane Hanson, first solo exhibition, Museum of Art, Cranbrook Academy of Art, Bloomfield Hills, Mich.

All About Eve wins best picture Oscar. Movies released include *Born Yesterday, Sunset Boulevard, The Gunfighter, No Way Out, Annie Get Your Gun, Father of the Bride, The Jackie Robinson Story, Destination Moon*

9% of U.S. homes have TV sets

Sen. Estes Kefauver's hearings on Frank Costello's crime activities are nationally televised

"Your Show of Shows," "The Jack Benny Show," "You Bet Your Life," "Masterpiece Playhouse" premiere on TV

Ray Bradbury, *The Martian Chronicles*

David Riesman et al., *The Lonely Crowd*

An American in Paris wins best picture Oscar. Movies released include *A Streetcar Named Desire, The Whip Hand, The Marrying Kind, Quo Vadis, I Was a Communist for the FBI, I'll See You in My Dreams, The African Queen, The Day the Earth Stood Still*

First color telecast by CBS

Walt Disney releases fully animated *Alice in Wonderland*

"The Amos and Andy Show," "Dragnet," Edward R. Murrow's "See It Now" premiere on TV

Rachel Carson, *The Sea Around Us*

James Jones, *From Here to Eternity*

Norman Mailer, *Barbary Shore*

Marshall McLuhan, *The Mechanical Bride*

C. Wright Mills, *White Collar*

J. D. Salinger, *The Catcher in the Rye*

Mickey Spillane, *One Lonely Night*

Herman Wouk, *The Caine Mutiny*

1952

Truman and steelworkers clash over right to strike

Richard Nixon's Checkers speech on TV and radio

First successful U.S. test of hydrogen bomb in the Marshall Islands

Dwight D. Eisenhower elected president

B-52 bomber developed

Robert Rauschenberg, Merce Cunningham, and John Cage collaborate at Black Mountain College, N.C. Premiere of Cage's *3′33″*

Formation of Hansa Gallery, artists' cooperative gallery, in New York

Andy Warhol: Fifteen Drawings Based on the Writings of Truman Capote, first solo exhibition, Hugo Gallery, New York

1953

Joseph Stalin dies, Nikita Khrushchev becomes First Secretary of USSR

U.S. Department of Health, Education and Welfare created

Julius and Ethel Rosenberg executed at Sing Sing

Korean War truce signed at Panmunjom; U.S. casualties reach 54,000 dead, 103,000 injured

USSR explodes hydrogen bomb

Earl Warren appointed chief justice of the U.S.

U.S. unemployment rate 2.9%, postwar low; federal price controls removed

Willem de Kooning: Paintings on the Theme of the Woman, Sidney Janis Gallery, New York

Larry Rivers's *Washington Crossing the Delaware* exhibited at Tibor de Nagy Gallery, New York

Dada 1916–1923, Sidney Janis Gallery, New York

Raymond Saunders, first solo exhibition, Pittsburgh Playhouse Gallery, Pittsburgh, Pa.

1954

Puerto Rican nationalists shoot five U.S. Congressmen

French troops leave Vietnam

U.S. Supreme Court declares school segregation illegal (*Brown* vs. *Board of Education*)

Sen. McCarthy censured by U.S. Senate for inappropriate investigative activities

Dow Jones industrial average breaks 400

Collage and Object, Institute of Contemporary Arts, London

Jess, first solo exhibition, Place Bar, San Francisco

Two Centuries of American Painting, Metropolitan Museum of Art, New York

MASS MEDIA	BOOKS
The Greatest Show on Earth wins best picture Oscar. Movies released include *High Noon, Singin' in the Rain, My Son John, The Steel Fist, This Is Cinerama*	Ralph Ellison, *Invisible Man*
First issue of *TV Guide*	John Kenneth Galbraith, *American Capitalism*
Partisan Review publishes symposium "Our Country and Our Culture"	Ernest Hemingway, *The Old Man and the Sea*
Retrospective of Terrytoons cartoons at Museum of Modern Art, New York	Bernard Malamud, *The Natural*
"Adventures of Ozzie and Harriet," "The Today Show," "Adventures of Superman," "Dragnet" premiere on TV	Marianne Moore, *Collected Poems*
	Reinhold Niebuhr, *The Irony of American History*
	Flannery O'Connor, *Wise Blood*
	John Steinbeck, *East of Eden*

The Greatest Show on Earth wins best picture Oscar. Movies released include *High Noon, Singin' in the Rain, My Son John, The Steel Fist, This Is Cinerama*

First issue of *TV Guide*

Partisan Review publishes symposium "Our Country and Our Culture"

Retrospective of Terrytoons cartoons at Museum of Modern Art, New York

"Adventures of Ozzie and Harriet," "The Today Show," "Adventures of Superman," "Dragnet" premiere on TV

Ralph Ellison, *Invisible Man*

John Kenneth Galbraith, *American Capitalism*

Ernest Hemingway, *The Old Man and the Sea*

Bernard Malamud, *The Natural*

Marianne Moore, *Collected Poems*

Reinhold Niebuhr, *The Irony of American History*

Flannery O'Connor, *Wise Blood*

John Steinbeck, *East of Eden*

From Here to Eternity wins best picture Oscar. Movies released include *Stalag 17, Shane, Calamity Jane, How to Marry a Millionaire, Gentlemen Prefer Blondes*

First issue of *Playboy*

Saul Bellow, *The Adventures of Augie March*

Alfred C. Kinsey, *Sexual Behavior in the Human Female*

Russell Kirk, *The Conservative Mind*

Arthur Miller, *The Crucible*

Peter Viereck, *The Shame and Glory of the Intellectuals*

On the Waterfront wins best picture Oscar. Movies released include *The Creature from the Black Lagoon, Them!, Dial M for Murder, Living it Up, The Wild One, Rear Window*

55% of U.S. homes have TV sets

"Father Knows Best," "Walt Disney," "Lassie" premiere on TV

Army-McCarthy hearings nationally televised

First issue of *Sports Illustrated*

Elvis Presley's first recordings

First TV dinner marketed

Samuel Beckett, *Waiting for Godot* (English translation)

William Golding, *Lord of the Flies*

Aldous Huxley, *The Doors of Perception*

Wright Morris, *The Huge Season*

Tennessee Williams, *Cat on a Hot Tin Roof*

Ernest Hemingway awarded Nobel Prize for literature

1955

U.S. begins sending foreign aid to South Vietnam

U.S. and USSR end 10-year occupation of Austria

Geneva summit conference yields no agreements

Dr. Martin Luther King, Jr., leads a 54-week bus boycott in Montgomery, Ala.

The New Decade: 35 American Painters and Sculptors, Whitney Museum, New York

1956

Khrushchev denounces Stalin personality cult

U.S. hydrogen bomb test at Bikini atoll

Egypt nationalizes Suez Canal; Israel, Britain, and France invade

Eisenhower reelected president

National Defense Highway Act authorizes construction of interstate highway system

Dow Jones industrial average breaks 500; U.S. federal budget shows $4 billion surplus

George Segal, first solo exhibition, Hansa Gallery, New York

This Is Tomorrow, exhibition of British Pop Art, Whitechapel Art Gallery, London

1957

Eisenhower pledges foreign aid to Middle East nations to fight communism

Eisenhower sends federal troops to Central High School, Little Rock, Ark., to enforce desegregation

USSR launches *Sputnik*

Creation of SANE (National Committee for a Sane Nuclear Policy)

U.S. space satellite explodes at Cape Canaveral

Contemporary Bay Area Figurative Painting, The Oakland Museum, Oakland, Calif.

Wallace Berman, first solo exhibition, Ferus Gallery, Los Angeles

Leo Castelli Gallery opens in New York

Marty wins best picture Oscar. Movies released include *The Man with the Golden Arm*, *The Blackboard Jungle*, *The Rose Tattoo*, *Rebel Without a Cause*

First televised presidential press conference

Disneyland opens in Anaheim, Calif.

"The Mickey Mouse Club," "The Ed Sullivan Show," "Gunsmoke," "The $64,000 Question," "The Ernie Kovacs Show," "The Honeymooners" premiere on TV

James Dean dies in car crash

Hit records include Bill Haley, "Rock Around the Clock"; Fess Parker, "Ballad of Davey Crockett"

Rudolf Flesch, *Why Johnny Can't Read*

Herbert Marcuse, *Eros and Civilization*

Arthur Miller, *A View from the Bridge*

Flannery O'Conner, *A Good Man Is Hard to Find and Other Stories*

Robert Penn Warren, *Band of Angels*

Sloan Wilson, *The Man in the Gray Flannel Suit*

Herman Wouk, *Marjorie Morningstar*

Around the World in 80 Days wins best picture Oscar. Movies released include *Baby Doll*, *The Trouble with Harry*, *Patterns*, *Giant*, *Picnic*, *Love Me Tender*

Hit records include Elvis Presley, "Heartbreak Hotel," "Hound Dog"; Little Richard, "Tutti-Frutti"

John Ashbery, *Some Trees*

Saul Bellow, *Seize the Day*

Allen Ginsberg, *Howl*

John Keats, *The Crack in the Picture Window*

Grace Metalious, *Peyton Place*

C. Wright Mills, *The Power Elite*

William H. Whyte, Jr., *The Organization Man*

The Bridge on the River Kwai wins best picture Oscar. Movies released include *The Three Faces of Eve*, *Edge of the City*, *Islands in the Sun*, *Paths of Glory*, *And God Created Woman*, *Twelve Angry Men*

"Leave It to Beaver," "Perry Mason," "The Real McCoys," "Wagon Train" premiere on TV

Hit records include Elvis Presley, "All Shook Up," "Jailhouse Rock"

James Agee, *A Death in the Family*

John Cheever, *The Wapshot Chronicle*

John F. Kennedy, *Profiles in Courage*

Jack Kerouac, *On the Road*

Bernard Malamud, *The Assistant*

Frank O'Hara, *Meditations in an Emergency*

Vance Packard, *The Hidden Persuaders*

Ayn Rand, *Atlas Shrugged*

Max Schulman, *Rally Round the Flag, Boys*

Nevil Shute, *On the Beach*

Alan Watts, *The Way of Zen*

1958

U.S. satellite Explorer I orbits earth

Creation of NASA (National Aeronautics and Space Administration)

U.S. troops sent to Beirut at request of Lebanese government

Congress passes National Defense Education Act

John Birch Society founded

U.S. unemployment rate reaches 6.8%, postwar high

Jasper Johns, first solo exhibition, Leo Castelli Gallery, New York

Allan Kaprow, environment, Hansa Gallery, New York

H. C. Westermann, first solo exhibition, Allan Frumkin Gallery, Chicago

Billy Al Bengston, first solo exhibition, Ferus Gallery, Los Angeles

Robert Rauschenberg, combine paintings, Leo Castelli Gallery, New York

Bruce Conner, first solo exhibition, East-West Gallery, San Francisco

Marisol, first solo exhibition, Leo Castelli Gallery, New York

Red Grooms, first solo exhibition, Sun Gallery, Provincetown, Mass.

Guggenheim Museum opens new building in New York

1959

Cuban dictator Fulgencio Batista flees; Fidel Castro becomes premier

Alaska and Hawaii granted statehood

Selection of first seven U.S. astronauts

"Kitchen debate" between Nixon and Khrushchev telecast live from Moscow

Khrushchev visits U.S.

Eisenhower invokes Taft-Hartley Act to combat steelworkers' strike

Dow Jones industrial average breaks 600

Allan Kaprow, 18 Happenings in Six Parts, Reuben Gallery, New York

Sixteen Americans, The Museum of Modern Art, New York

Below Zero, Reuben Gallery, New York

New Images of Man, The Museum of Modern Art, New York

Robert Bechtle, San Francisco Museum of Art

Edward Kienholz, first solo exhibition, Ferus Gallery, Los Angeles

Gigi wins best picture Oscar. Movies released include *Cat on a Hot Tin Roof, Touch of Evil, The Left-handed Gun, The Defiant Ones, The Tunnel of Love, A Movie*

"Popeye the Sailor" premieres on TV

First stereo records

Everly Brothers, Ricky Nelson, Kingston Trio top record charts

Lawrence Ferlinghetti, *A Coney Island of the Mind*

John Kenneth Galbraith, *The Affluent Society*

Lorraine Hansberry, *A Raisin in the Sun*

Jack Kerouac, *The Dharma Bums, The Subterraneans*

Martin Luther King, Jr., *Stride Toward Freedom*

William J. Lederer and Eugene Burdick, *The Ugly American*

U.S. Postmaster General seizes copies of D. H. Lawrence's *Lady Chatterly's Lover* claiming book is obscene

Ben-Hur wins best picture Oscar. Movies released include *Some Like it Hot, The Fugitive Kind, Compulsion, On the Beach, Pull My Daisy*

Rigged TV quiz shows scandal

"The Twilight Zone," "Bonanza" premiere on TV

Frankie Avalon, Paul Anka, Bobby Darin top record charts

Saul Bellow, *Henderson the Rain King*

Norman O. Brown, *Life Against Death*

William S. Burroughs, *Naked Lunch*

Allen Drury, *Advise and Consent*

Langston Hughes, *Selected Poems*

Norman Mailer, *Advertisements for Myself*

James Michener, *Hawaii*

Vladimir Nabakov, *Lolita* (English translation)

Vance Packard, *The Status Seekers*

Philip Roth, *Goodbye, Columbus*

1960

Four black students sit-in at a segregated lunch counter in Greensboro, N.C.; similar protests around the nation

Cuba signs a trade agreement with the USSR. U.S. begins training forces to invade Cuba

Caryl Chessman executed at San Quentin

U.S. U-2 spy plane shot down over USSR

Civil Rights Act of 1960 provides for federal referees to safeguard the rights of black voters

Oral contraceptives approved for sale in U.S.

Kennedy-Nixon debates televised nationally

John F. Kennedy elected president

Creation of SNCC (Students NonViolent Coordination Committee) and SDS (Students for a Democratic Society)

Claes Oldenburg, The Street, first solo exhibition, Judson Gallery, Judson Memorial Church, New York

New Media—New Forms, Martha Jackson Gallery, New York

New Media—New Forms, Version II, Martha Jackson Gallery, New York

John Baldessari, first solo exhibition, La Jolla Museum of Art, La Jolla, Calif.

Ceramics and Sculpture by Robert Arneson, The Oakland Museum, Oakland, Calif.

Rosalyn Drexler, first solo exhibition, Reuben Gallery, New York

Green Gallery opens in New York

1961

U.S. breaks diplomatic ties with Cuba

Creation of Peace Corps

Passage of 23d amendment to U.S. Constitution provides voting rights for residents of District of Columbia

USSR cosmonaut safely orbits earth

U.S. invasion of Cuba (Bay of Pigs) fails

First U.S. plane hijacked to Cuba

Freedom Riders attacked by mobs in several Southern cities

Alan Shepard is first American in space; Kennedy vows to put a man on the moon before 1970

Dominican Republic dictator Rafael Trujillo killed by CIA-backed assassins

East Germany erects Berlin Wall

U.S. and USSR resume nuclear weapons testing after three-year moratorium

U.S. sends military advisors to Vietnam

Dow Jones industrial average breaks 700

Environments, Situations, Spaces, Martha Jackson Gallery, New York

The Art of Assemblage, The Museum of Modern Art, New York

Claes Oldenburg: The Store, 107 East Second Street, New York

Tom Wesselmann, Great American Nude, first solo exhibition, Tanager Gallery, New York

Doom Show, March Gallery, New York

Llyn Foulkes, first solo exhibition, Ferus Gallery, Los Angeles

George Herms, first solo exhibition, Batman Gallery, San Francisco

Peter Saul, first solo exhibition, Allan Stone Gallery, New York

Edward Kienholz, Pasadena Art Museum, Pasadena, Calif.

The Apartment wins best picture Oscar. Movies released include *Psycho, Exodus, G. I. Blues, The Bell Boy, Please Don't Eat the Daisies*

87% of U.S. homes have TV sets

Winter Olympic games televised live (from Squaw Valley, Calif.) for the first time

Jack Paar walks off "The Tonight Show" to protest censorship

Elvis Presley, Everly Brothers, Brenda Lee top record charts

First business photocopier marketed

Daniel Bell, *The End of Ideology*

Leslie Fiedler, *Love and Death in the American Novel*

Paul Goodman, *Growing Up Absurd*

Herman Kahn, *On Thermonuclear War*

Harper Lee, *To Kill a Mockingbird*

C. Wright Mills, *The Causes of World War III*

Charles Olson, *The Maximus Poems*

Gary Snyder, *Myths and Texts*

John Updike, *Rabbit, Run*

Federal court rules D. H. Lawrence's *Lady Chatterly's Lover* is not obscene

West Side Story wins best picture Oscar. Movies released include *The Misfits, Hustler, Splendor in the Grass*

"Ben Casey," "Dr. Kildare," "CBS Reports," "Wide World of Sports," "The Dick Van Dyke Show," "Saturday Night at the Movies" premiere on TV

Chubby Checker, Del Shannon, Bobby Lewis top record charts

Edward Albee, *The American Dream*

James Baldwin, *Nobody Knows My Name*

Amiri Baraka [LeRoi Jones], *Preface to a Twenty Volume Suicide Note*

Allen Ginsberg, *Kaddish and Other Poems*

John Griffin, *Black Like Me*

Robert Heinlein, *Stranger in a Strange Land*

Joseph Heller, *Catch-22*

Henry Miller, *Tropic of Cancer* (first legal U.S. publication)

Walker Percy, *The Moviegoer*

J. D. Salinger, *Franny and Zooey*

T. H. White, *The Making of the President: 1960*

Ernest Hemingway commits suicide

1962

John Glenn is first American to orbit earth

Adoph Eichmann executed in Israel for war crimes

SDS National Convention at Port Huron, Mich.

U.S. Supreme Court bans prayer in schools

Cesar Chávez founds United Farm Workers union

Cuban missile crisis

Pope John XXIII convenes Vatican Council II

James Meredith denied admission to University of Mississippi; federal troops suppress riots when he registers

James Rosenquist, first solo exhibition, Green Gallery, New York

Roy Lichtenstein, cartoon images, Leo Castelli Gallery, New York

1961, Dallas Museum for Contemporary Arts

Wayne Thiebaud, M. H. de Young Memorial Museum, San Francisco

Robert Indiana, first solo exhibition, Stable Gallery, New York

The New Realists, Sidney Janis Gallery, New York

My Country 'Tis of Thee, Dwan Gallery, Los Angeles

A Symposium on Pop Art, The Museum of Modern Art, New York

The New Painting of Common Objects, Pasadena Art Museum, Pasadena, Calif.

Directions in Collage: California, Pasadena Art Museum, Pasadena, Calif.

Andy Warhol, Campbell's Soup paintings, Ferus Gallery, Los Angeles

Joe Goode, first solo exhibition, Dilexi Gallery, Los Angeles

Phillip Hefferton, first solo exhibition, Rolf Nelson Gallery, Los Angeles

Robert Arneson: Ceramics, Drawings and Collages, M. H. de Young Memorial Museum, San Francisco

Claes Oldenburg: The Store, Green Gallery, New York

Lawrence of Arabia wins best picture Oscar. Movies released include *The Miracle Worker*, *The Manchurian Candidate*

First live telecast using Telestar communications satellite

Jackie Kennedy gives televised tour of the White House

Johnny Carson begins hosting "The Tonight Show." Walter Cronkite begins anchoring "CBS Evening News"

Chubby Checker, "The Twist"; Ray Charles, Four Seasons, Bobby Vinton top record charts

Edward Albee, *Who's Afraid of Virginia Woolf?*

James Baldwin, *Another Country*

Rachel Carson, *Silent Spring*

Buckminster Fuller, *Untitled Epic Poem on the History of Industrialization*

Ken Kesey, *One Flew Over the Cuckoo's Nest*

Dwight MacDonald, *Against the American Grain: Essays on the Effects of Mass Culture*

Marshall McLuhan, *The Gutenberg Galaxy*

John Steinbeck, *Travels with Charley: In Search of America*

Alan Watts, *The Joyous Cosmology* (Foreword by Timothy Leary)

Tennessee Williams, *The Night of the Iguana*

John Steinbeck awarded Nobel Prize for literature

1963

Harvard dismisses Richard Alpert and Timothy Leary for LSD experiments

A Buddhist monk sets himself on fire to protest religious persecution in South Vietnam

Civil rights leader Medgar W. Evers assassinated in Mississippi

USSR puts the first woman in space

U.S. Post Office introduces zip codes

U.S., USSR, and Great Britain sign nuclear test ban treaty

March on Washington; Martin Luther King, Jr., delivers "I have a dream" speech

Bomb kills four black girls in a Birmingham church

John F. Kennedy assassinated by Lee Harvey Oswald in Dallas. Oswald murdered by Jack Ruby. Lyndon B. Johnson becomes president

Marcel Duchamp, retrospective, Pasadena Art Museum, Pasadena, Calif.

Six Painters and the Object, Solomon R. Guggenheim Museum, New York

Robert Rauschenberg, retrospective, The Jewish Museum, New York

Popular Art: Artistic Projection of Common American Symbols, Nelson Gallery and Atkins Museum, Kansas City, Mo.

Pop! Goes the Easel, Contemporary Art Museum, Houston

The Popular Image, Washington Gallery of Modern Art, Washington, D.C.

Pop Art USA, The Oakland Museum, Oakland, Calif.

Andy Warhol, Elvis Presley paintings, Ferus Gallery, Los Angeles

Americans 1963, The Museum of Modern Art, New York

The NO Show, Stein Gallery, New York

Mixed Media and Pop Art, Albright-Knox Art Gallery, Buffalo, New York

Six More, Los Angeles County Museum of Art

Robert Arneson: Recent Ceramic Sculpture, Richmond Art Center, Richmond, Calif.

Jake Berthot, first solo exhibition, Finer Gallery, New York

Edward Ruscha, first solo exhibition, Ferus Gallery, Los Angeles

Tony Berlant, first solo exhibition, David Stuart Gallery, Los Angeles

Bruce Conner, Wichita Art Museum, Wichita, Kans.

Three Centuries of Popular Imagery, Des Moines Art Center, Des Moines, Iowa

Allan D'Arcangelo, first solo exhibition, Fischbach Gallery, New York

May Stevens, Freedom Riders, first solo exhibition, RoKo Gallery, New York

Black artists group, Spiral, formed in New York

Tom Jones wins best picture Oscar. Movies released include *The Birds*, *Cleopatra*, *How the West was Won*, *Scorpio Rising*; Andy Warhol's *Sleep, Kiss, Blow Job*

Julia Child introduces "The French Chef" to TV

"American Revolution 1963," documentary on civil rights, is one of the first three-hour TV specials

Evening network TV news expands from 15 minutes to 30

Marilyn Monroe dies of a drug overdose

Hit records include Beach Boys, "Surfing U.S.A."; Jan & Dean, "Surf City"; Beatles, "I Want to Hold Your Hand"

James Baldwin, *The Fire Next Time*

Betty Friedan, *The Feminine Mystique*

Michael Harrington, *The Other America*

Mary McCarthy, *The Group*

Jessica Mitford, *The American Way of Death*

Sylvia Plath, *The Bell Jar*

Kurt Vonnegut, *Cat's Cradle*

William Carlos Williams, *Pictures from Brueghel*

1964

USSR begins to buy U.S. wheat

U.S. Surgeon General declares cigarette smoking hazardous to health

World's Fair opens in New York

24th amendment to U.S. Constitution abolishes poll taxes

Jimmy Hoffa, president of the Teamsters Union, convicted of jury tampering

Three civil rights workers murdered in Mississippi

Civil Rights Act of 1964 protects voting rights and prohibits racial discrimination in housing and employment

U.S. Senate passes Gulf of Tonkin resolution authorizing bombing of North Vietnam

Creation of VISTA (Volunteers in Service to America)

Warren Commission concludes that Oswald acted alone

Martin Luther King, Jr., awarded Nobel Peace Prize

Leonid Brezhnev becomes First Secretary of USSR

China explodes its first atomic bomb

Johnson reelected president

Berkeley Free Speech Movement protests, 796 arrests

Dow Jones industrial average breaks 800

Four Environments by Four New Realists, Sidney Janis Gallery, New York

Boxes, Dwan Gallery, Los Angeles

Jasper Johns, retrospective, The Jewish Museum, New York

Jasper Johns, Robert Rauschenberg, and Claes Oldenburg included in U.S. Pavilion at Venice Biennale. Rauschenberg wins first prize

Robert Bechtle, San Francisco Museum of Art

Mel Ramos, first solo exhibition, Bianchini Gallery, New York

The American Supermarket, Bianchini Gallery, New York

My Fair Lady wins best picture Oscar. Movies released include *Dr. Strangelove, A Hard Day's Night, Lord of the Flies*

The Beatles perform on "The Ed Sullivan Show" and tour U.S.

First issue of *Los Angeles Free Press*

"Daniel Boone," "Man from U.N.C.L.E.," "That Was the Week That Was," "Peyton Place" premiere on TV

Beatles, Roy Orbison, Supremes top record charts

Amiri Baraka [LeRoi Jones], *Dutchman*

Saul Bellow, *Herzog*

Ernest Hemingway, *A Moveable Feast*

Richard Hofstadter, *Anti-Intellectualism in American Life*

Stanley Kubrick, *Dr. Strangelove*

Herbert Marcuse, *One-Dimensional Man*

Marshall McLuhan, *Understanding Media: The Extensions of Man*

Frank O'Hara, *Lunch Poems*

1965

Voting rights demonstrations in Selma, Ala.; over 2,000 arrests

Johnson orders large-scale bombing of North Vietnam

Malcolm X fatally shot in New York

Johnson mobilizes National Guard to protect freedom marchers in Selma

First Vietnam antiwar teach-in at University of Michigan

U.S. Marines sent to Dominican Republic

Edward White is the first U.S. astronaut to walk in space

Medicare enacted

Voting Rights Act of 1965

Race riots erupt in Watts, Los Angeles

United Farm Workers strikes California grape growers

Power failure blacks out the Northeast

Johnson halts Vietnam bombings for Christmas season; U.S. troops in Vietnam exceed 184,000

Cultural Revolution begins in China

Dow Jones industrial average breaks 900

Richard Artschwager, first solo exhibition, Leo Castelli Gallery, New York

Prints, Drawings, and Paintings by Wayne Thiebaud, San Francisco Museum of Art

The New American Realism, Worcester Art Museum, Worcester, Mass.

Larry Rivers Retrospective, Rose Art Museum, Brandeis University, Waltham, Mass.

Robert Rauschenberg Paintings 1953–1964, Walker Art Center, Minneapolis

New York, the Second Breakthrough, 1959–1964, Art Gallery, University of California, Irvine

James Rosenquist's *F-111* at Leo Castelli Gallery, New York

Romare Bearden, Corcoran Gallery, Washington, D.C.

Pop Art and the American Tradition, Milwaukee Art Center

Word and Image, Solomon R. Guggenheim Museum, New York

Jasper Johns Retrospective, Pasadena Art Museum, Pasadena, Calif.

Ray Johnson, Collages, Willard Gallery, New York

Bruce Conner, Rose Art Museum, Brandeis University, Waltham, Mass.

Andy Warhol, Institute of Contemporary Art, University of Pennsylvania, Philadelphia

The Sound of Music wins best picture Oscar. Movies released include *Help!*, *A Patch of Blue*, *The Sandpiper*, *Dr. Zhivago*

"The F.B.I." premieres on TV

Bob Dylan, *Highway 61 Revisited*; Rolling Stones, "Satisfaction"; Beatles, Supremes, Herman's Hermits, Beach Boys, Byrds top record charts

The Autobiography of Malcolm X

John Berryman, *77 Dream Songs*

Frank Herbert, *Dune*

Pauline Kael, *I Lost It at the Movies*

Norman Mailer, *An American Dream*

Herbert Marcuse, *Culture and Society*

Ralph Nader, *Unsafe at Any Speed*

Robert Odenwald, *The Disappearing Sexes*

Arthur Schlesinger, Jr., *The Thousand Days*

1966

U.S. resumes bombing North Vietnam

Federal government declares LSD illegal

First conviction for draft-card burning

International Days of Protest against Vietnam War

U.S. Supreme Court rules that all suspects must be read their rights (*Miranda* vs. *Arizona*)

Race riots in Chicago, Brooklyn, Cleveland, and Baltimore

Richard Speck murders eight Chicago nurses

Bombing of Hanoi

Black Panthers organize in Oakland, Calif.

NOW (National Organization of Women) founded

Emergence of Hippie movement

U.S. unemployment rate declines to 3.8%

Contemporary Urban Vision, The New School for Social Research, New York

The Hairy Who, Hyde Park Art Center, Chicago

Artists organize Peace Tower in Los Angeles as part of antiwar protest

Vija Celmins, first solo exhibition, David Stuart Galleries, Los Angeles

Works by Roy Lichtenstein, Cleveland Museum of Art

Flag Constructions by Marc Morrel, Stephen Radich Gallery, New York

Ten from Los Angeles, Seattle Art Museum

The Art of the American Negro, Harlem Cultural Council, New York

Edward Kienholz, Los Angeles County Museum of Art

Andy Warhol, Institute of Contemporary Art, Boston

Whitney Museum opens new building in New York

A Man for All Seasons wins best picture Oscar. Movies released include *Blow Up*, *The Fortune Cookie*

Senate Foreign Relations Committee Hearings on Vietnam, chaired by William Fulbright, televised nationally

National Football League games televised in prime time

"Batman," "The Dating Game," "Mission: Impossible" premiere on TV

Last Beatles concert; Barry Sadler, "Ballad of the Green Berets"; height of popularity for Motown recordings; Simon & Garfunkel, Righteous Brothers, Mamas & Papas, Rolling Stones, Lovin' Spoonful top record charts

John Barth, *Giles Goat-Boy*

Truman Capote, *In Cold Blood*

Konrad Lorenz, *On Aggression*

Masters and Johnson, *Human Sexual Response*

Thomas Pynchon, *The Crying of Lot 49*

Susan Sontag, *Against Interpretation*

Hunter Thompson, *Hell's Angels*

1967

Three U.S. astronauts die in launch-pad fire

Arab-Israeli six-day war

Thurgood Marshall sworn in, first black U.S. Supreme Court justice

Race riots in Newark, N.J., 26 dead; 43 die in Detroit riots

Bolivia confirms death of Che Guevara

Antiwar demonstrators march on Pentagon

U.S. minimum wage rises to $1.40 an hour

The Hairy Who, Hyde Park Art Center, Chicago

Roy Lichtenstein, Pasadena Art Museum, Pasadena, Calif.

Memorial Exhibit for Martin Luther King, Jr., The Museum of Modern Art, New York

Claes Oldenburg, Projects for Monuments, Museum of Contemporary Art, Chicago

Protest and Hope: An Exhibition of Contemporary American Art, The New School for Social Research, New York

Bruce Conner: Sculpture, Assemblages, Collages, Drawings, and Film, Institute of Contemporary Art, University of Pennsylvania, Philadelphia

Roy Lichtenstein: An Exhibition of Paintings and Sculpture, Contemporary Art Center, Cincinnati

Environment USA: 1957–1967, Museu de Arte Moderna, São Paulo, Brazil

American Sculpture of the Sixties, Los Angeles County Museum of Art

Faith Ringgold, first solo exhibition, Spectrum Gallery, New York

Ellen Lanyon, Fort Wayne Art Museum, Fort Wayne, Ind.

Homage to Marilyn Monroe, Sidney Janis Gallery, New York

Robert Bechtle, San Francisco Museum of Art

Collage of Indignation created as part of "Angry Arts Against the War in Vietnam," New York University

Karl Wirsum, first solo exhibition, Dell Gallery, Chicago

In the Heat of the Night wins best picture Oscar. Movies released include *Cool Hand Luke, The Graduate, Bonnie and Clyde, Guess Who's Coming for Dinner?, Accident*

First Super Bowl

Carnegie Commission issues report on public television. Public Broadcasting Act of 1967 establishes federally funded corporation for Public Broadcasting

Aretha Franklin, "Respect"; Beatles, *Sgt. Pepper's Lonely Hearts Club Band*; Monkees, The Doors, Young Rascals top record charts

John Barth, *Sot-Weed Factor*

Donald Barthelme, *Snow White*

Stokely Carmichael, *Black Power!*

Marshall McLuhan, *The Medium is the Message*

William Manchester, *The Death of a President*

William Styron, *The Confessions of Nat Turner*

1968

North Korea seizes U.S. *Pueblo*

Viet Cong launch surprise Tet offensive

Poor People's Campaign; Resurrection City, Washington, D.C.

Martin Luther King, Jr., assassinated in Memphis; violence erupts around the nation

Civil Rights Act of 1968 prohibits racial discrimination in housing

Student demonstrations at Columbia University

Robert F. Kennedy assassinated in Los Angeles

U.S. and USSR sign treaty for nonproliferation of nuclear weapons

Miami race riots

USSR invades Czechoslovakia

March on Washington for Jobs and Freedom

Antiwar demonstrators clash with police at Democratic Convention in Chicago

Two U.S. runners expelled from Olympics for giving black-power salute

Richard M. Nixon elected president

Vietnam peace talks continue in Paris; U.S. troops in Vietnam exceed 520,000

U.S. minimum wage rises to $1.60 an hour

Wayne Thiebaud, Pasadena Art Museum, Pasadena, Calif.

George Segal: 12 Human Situations, Museum of Contemporary Art, Chicago

Robert Indiana, Institute of Contemporary Art, University of Pennsylvania, Philadelphia

The Hairy Who, Hyde Park, Chicago

Realism Now, Vassar College Art Gallery, Poughkeepsie, N.Y.

Andy Warhol shot by Valerie Solanis

Richard J. Daley Exhibition, protest against violence by Chicago civil authorities at Democratic National Convention, Richard Feigen Gallery, Chicago

Violence in Recent American Art, Museum of Contemporary Art, Chicago

Romare Bearden: Paintings and Projections, Art Gallery, State University of New York, Albany

H. C. Westermann, retrospective, Los Angeles County Museum of Art

The West Coast Now, Portland Art Museum, Portland, Ore.

Paste-ups by Jess, San Francisco Museum of Art

Wallace Berman: Verifax Collages, Jewish Museum, New York

Assemblage in California, Art Gallery, University of California, Irvine

Duane Hanson, Ringling Museum, Sarasota, Fla.

Robert Indiana, Institute of Contemporary Art, University of Pennsylvania, Philadelphia

Richard Estes, first solo exhibition, Allan Stone Gallery, New York

Oliver! wins best picture Oscar. Movies released include *The Good, the Bad and the Ugly, Rosemary's Baby, 2001: A Space Odyssey, The Green Berets, Funny Girl, The Fox, Night of the Living Dead*

"Sixty Minutes," "The Mod Squad," "Rowan & Martin's Laugh-In" premiere on TV

Jimi Hendrix, Simon & Garfunkel, Janis Joplin, Fifth Dimension top record charts

Eldridge Cleaver, *Soul on Ice*

Joan Didion, *Slouching Towards Bethlehem*

Joe McGinniss, *The Selling of the President*

Norman Mailer, *Armies of the Night*

John Updike, *Couples*

James D. Watson, *The Double Helix*

Tom Wolfe, *The Electric Kool-Aid Acid Test*

1969

Harvard students strike over black studies and ROTC

People's Park riot in Berkeley

Warren Burger appointed chief justice of the U.S.

Nixon announces withdrawal of 25,000 U.S. soldiers from Vietnam

Weatherman faction creates split at SDS convention

Neil Armstrong is first man to walk on the moon

Manson family murders Sharon Tate and four others

University of California, Los Angeles dismisses Angela Davis

March Against Death, antiwar protest, in Washington, D.C.

Native Americans seize Alcatraz Island in San Francisco Bay

Gay Pride movement emerges in New York

Artworkers Coalition formed

Harlem on My Mind: Cultural Capital of Black America, 1900–1968, The Metropolitan Museum of Art, New York

Pop Art Redefined, Hayward Gallery, London

Roy Lichtenstein, Solomon R. Guggenheim Museum, New York

The Spirit of the Comics, Institute of Contemporary Art, University of Pennsylvania, Philadelphia

Don Baum Sez "Chicago Needs Famous Artists," Museum of Contemporary Art, Chicago

Human Concern / Personal Torment: The Grotesque in American Art, Whitney Museum of American Art, New York

Edward Ruscha, La Jolla Museum of Art, La Jolla, Calif.

Raymond Saunders, Beaumont-May Gallery, Hopkins Center, Dartmouth College, Hanover, N. H.

West Coast 1945–1969, Pasadena Art Museum, Pasadena, Calif.

The Highway, Institute of Contemporary Art, University of Pennsylvania, Philadelphia

Midnight Cowboy wins best picture Oscar. Movies released include *The Wild Bunch, Butch Cassidy and the Sundance Kid, Easy Rider, Alice's Restaurant, Take the Money and Run*

Woodstock, N.Y., and Altamont, Calif., music festivals

CBS cancels "The Smothers Brothers Show" after disputes over censorship

"Monday Night Football," "Sesame Street" premiere on TV

The Doors, Creedence Clearwater Revival, Rolling Stones top record charts

Lillian Hellman, *An Unfinished Woman*

Laurence J. Peter and Raymond Hall, *The Peter Principle*

Mario Puzo, *The Godfather*

Philip Roth, *Portnoy's Complaint*

Kurt Vonnegut, *Slaughterhouse-Five*

Bibliography

Adams, Hugh. *Art of the Sixties*. Oxford: Phaidon, 1978.

Albright, Thomas. *Art in the San Francisco Bay Area, 1945–1980*. Berkeley and Los Angeles: University of California Press, 1985.

Alloway, Lawrence. *American Pop Art*. Exhibition catalogue. New York: Collier Books in association with the Whitney Museum of American Art, 1974.

————. "Art as Likeness." *Arts Magazine* 41 (May 1967): 38–39.

————. "Marilyn Monroe as Subject Matter." *Arts Magazine* 42 (December 1967): 27–30.

————. *May Stevens*. Exhibition catalogue. Ithaca, N.Y.: Herbert F. Johnson Museum of Art, Cornell University, 1973.

————. "Popular Culture and Pop Art." *Art International* 78 (July 1969): 17–21.

————. *Robert Rauschenberg*. Exhibition catalogue. Washington, D.C.: National Collection of Fine Arts, Smithsonian Institution, 1976.

————. *Roy Lichtenstein*. New York: Abbeville Press, 1983.

————. *Six More*. Exhibition catalogue. Los Angeles: Los Angeles County Museum of Art, 1963.

————. *Six Painters and the Object*. Exhibition catalogue. New York: Solomon R. Guggenheim Museum, 1963.

————. *Topics on American Art Since 1945*. New York: W. W. Norton, 1975.

Amaya, Mario. *Pop Art . . . and After*. New York: Viking, 1965.

Arnason, H. H. *American Abstract Expressionists and Imagists*. Exhibition catalogue. New York: Solomon R. Guggenheim Museum, 1961.

Art International 7 (January 1963): 23–48. Special issue, "The New Realism, Neo-Dada, Common Object Painting, etc." Articles by Barbara Rose, Pierre Restany, Sonya Rudikoff, Ellen H. Johnson, and Allan Kaprow.

"Art: Something New Is Cooking—Joining Blend of Billboard Pieces." *Life* 52 (June 15, 1962): 115–20.

Richard Artschwager Theme(s). Exhibition catalogue. Texts by Suzanne Delehanty, Linda L. Cathcart, and Richard Armstrong. Buffalo, N.Y.: Albright-Knox Art Gallery, 1979.

Ashton, Dore. *The New York School: A Cultural Reckoning*. New York: Viking, 1972.

Atkinson, Tracy. *Pop Art and the American Tradition*. Exhibition catalogue. Milwaukee: Milwaukee Art Center, 1965.

Auping, Michael. *Jess: Paste-Ups (and Assemblies) 1951–1983*. Exhibition catalogue. Sarasota, Fl.: John and Mable Ringling Museum of Art, 1983.

Bagdikian, Ben H. *The Information Machines.* New York: Harper & Row, 1971.

Barnouw, Erik. *The Image Empire.* Vol. 3 of *A History of Broadcasting in the United States.* New York: Oxford University Press, 1970.

————. *Mass Communications.* New York: Rinehart, 1956.

————. *The Tribe of Plenty.* New York: Oxford University Press, 1975.

Barr, Alfred H., Jr., *The New American Painting.* Exhibition catalogue. New York: International Council of the Museum of Modern Art, 1958.

Barrett, William. "The Painter's Club." *Commentary* 73 (January 1982): 42–54.

Battcock, Gregory, ed. *The New Art.* New York: E. P. Dutton, 1966.

————. *Super Realism: A Critical Anthology.* New York: E. P. Dutton, 1975.

Becker, Stephen. *Comic Art in America.* New York: Simon & Schuster, 1959.

Bell, Daniel. *The End of Ideology.* Glencoe, Ill.: Free Press, 1960.

Belz, Carl. *Mel Ramos: A Twenty-Year Survey.* Exhibition catalogue. Waltham, Mass.: Rose Art Museum, Brandeis University, 1980.

Benezra, Neal. *Robert Arneson: A Retrospective.* Exhibition catalogue. Seattle: University of Washington Press, 1986.

Billy Al Bengston. Exhibition catalogue. Text by James Monte. Los Angeles: Los Angeles County Museum of Art, 1968.

Wallace Berman Retrospective. Exhibition catalogue. Texts by Walter Hopps and Robert Duncan. Los Angeles: Otis Art Institute Gallery, 1978.

Boorstin, Daniel J. *The Americans: The Democratic Experience.* New York: Vintage, 1974.

————. *The Image: A Guide to Pseudo-Events in America.* New York: Atheneum, 1978.

Bourdon, David. *Works by Ray Johnson.* Exhibition catalogue. Roslyn Harbor, N.Y.: Nassau County Museum of Art, 1984.

Bowman, Russell. *Jim Nutt.* Exhibition catalogue. Rotterdam: Rotterdamse Kunstichting, 1980.

Breslin, James E. B. *From Modern to Contemporary American Poetry, 1945–1965.* Chicago and London: University of Chicago Press, 1984.

Brogan, D. W. "The Problem of High Culture and Mass Culture." *Diogenes* 5 (Winter 1954): 1–13.

Brooks, John N. *The Great Leap.* New York: Harper & Row, 1966.

Burner, David, Robert D. Marcus, and Thomas R. West. *A Giant's Strength: America in the 1960s.* New York: Holt, Rinehart and Winston, 1971.

Bush, Martin H. *Duane Hanson.* Exhibition catalogue. Wichita, Kans.: Edwin A. Ulrich Museum of Art, Wichita State University, 1976.

Cage, John. *Silence: Lectures and Writings.* Middletown, Conn.: Wesleyan University Press, 1961.

————. *A Year from Monday: Lectures and Writings by John Cage.* Middletown, Conn.: Wesleyan University Press, 1969.

Calas, Nicholas, and Elena Calas. *Icons and Images of the Sixties.* New York: E. P. Dutton, 1971.

Campbell, Mary Schmidt. *Tradition and Conflict: Images of a Turbulent Decade, 1963–1973.* Exhibition catalogue. Essays by Vincent Harding, Benny Andrews, and Lucy R. Lippard. New York: Studio Museum of Harlem, 1985.

Canaday, John. "Pop Art Sells On and On— Why?" *New York Times Magazine,* May 31, 1964.

————. *Richard Estes: The Urban Landscape.* Exhibition catalogue. Boston: Museum of Fine Arts, 1978.

Carter, Paul A. *Another Part of the Fifties.* New York: Columbia University Press, 1983.

Vija Celmins: A Survey Exhibition. Exhibition catalogue. Essay by Susan C. Larsen. Newport Beach, Calif.: Newport Harbor Art Museum, 1979.

Claridge, E. *Mel Ramos.* London: Matthews Miller Dunbar, 1975.

Cockcroft, Eva. "Abstract Expressionism: Weapon of the Cold War." *Artforum* 12 (June 1974): 39–41.

Cohen, Stanley, and Lorman Ratner. *The Development of an American Culture.* Englewood Cliffs, N.J.: Prentice-Hall, 1970.

Compton, Michael. *Pop Art.* London: Hamlyn Publishing Group, 1970.

Coplans, John. "The New Paintings of Common Objects." *Artforum* 1 (November 1962): 26–29.

————. *Pop Art USA.* Exhibition catalogue. Oakland, Calif.: Oakland Museum, 1963.

————. *Wayne Thiebaud.* Exhibition catalogue. Pasadena, Calif.: Pasadena Art Museum, 1968.

————, ed. *Roy Lichtenstein.* New York: Praeger, 1972.

Crichton, Michael. *Jasper Johns.* Exhibition catalogue. New York: Harry N. Abrams in association with the Whitney Museum of American Art, 1977.

Crone, Rainer. *Andy Warhol.* Translated by John William Gabriel. New York: Praeger, 1970.

Daedalus 89 (Spring 1960). Special issue, "Mass Culture and Mass Media." Statements by Hannah Arendt, Edward Shills, Ernest van den Haag, Oscar Handlin, Leo Rosten, Frank Stanton, James Johnson Sweeney, Randall Jarrell, James Baldwin, Stanley Edgar Hyman, H. Stuart Hughes, and Arthur Schlesinger, Jr.

Allan D'Arcangelo: Paintings, 1963–70. Exhibition catalogue. Interview with Stephen Prokopoff. Philadelphia: Institute of Contemporary Art, University of Pennsylvania, 1971.

Allan D'Arcangelo: Paintings of the Early Sixties. Exhibition catalogue. Purchase: Neuberger Museum, State University of New York, College at Purchase, 1978.

Allan D'Arcangelo: Paintings, Prints, Drawings. Exhibition catalogue. Essay by Dore Ashton. Richmond: Institute of Contemporary Art, Virginia Museum, 1979.

Degler, Carl N. *Affluence and Anxiety.* Glenview, Ill.: Scott, Foresman, 1968.

Dickstein, Morris. *Gates of Eden: American Culture in the Sixties.* New York: Basic Books, 1977.

Donaldson, Scott. *The Suburban Myth.* New York: Columbia University Press, 1969.

Doty, Robert C. *Human Concern / Personal Torment.* New York: Whitney Museum of American Art, 1969.

Ewen, Scott. *Captains of Consciousness: Advertising and the Social Roots of the Consumer Culture.* New York: McGraw-Hill, 1976.

Finch, Christopher. *Pop Art: Object and Image.* London: Studio Vista and New York: E. P. Dutton, 1968.

Forge, Andrew. *Robert Rauschenberg.* New York: Harry N. Abrams, 1969.

Fox, Stephen. *The Mirror Makers: A History of American Advertising and Its Creators.* New York: Morrow, 1984.

Francis, Richard. *Jasper Johns.* New York: Abbeville Press, 1984.

Frascina, Francis, ed. *Pollock and After: The Critical Debate.* New York: Harper & Row, 1985.

Friedman, B. H. *School of New York: Some Younger Artists.* New York: Grove Press, 1959.

Friedman, Martin, and Graham W. J. Beal. *George Segal: Sculptures.* Exhibition catalogue. Minneapolis: Walker Art Center, 1978.

Gablik, Suzi. "Protagonists of Pop." *Studio International* 178 (July–August 1969): 9–16.

Galbraith, John Kenneth. *The Affluent Society.* Boston: Houghton Mifflin, 1958.

Gans, Herbert J. *Popular Culture and High Culture.* New York: Basic Books, 1974.

Garver, Thomas H. *Bruce Conner.* Exhibition catalogue. Waltham, Mass.: Rose Art Museum, Brandeis University, 1965.

———. *Tom Wesselmann: Early Still Lifes, 1962–1964.* Exhibition catalogue. Newport Beach, Calif.: Newport Harbor Art Museum, 1970.

Gaugh, Harry F. *Willem de Kooning.* New York: Abbeville Press, 1982.

Geldzahler, Henry. *New York Painting and Sculpture, 1940–1970.* Exhibition catalogue. Essays by Harold Rosenberg, Robert Rosenblum, Clement Greenberg, William Rubin, and Michael Fried. New York: E. P. Dutton in association with the Metropolitan Museum of Art, 1969.

———. *Pop Art, 1955–70.* Exhibition catalogue. International Cultural Corporation of Australia under the auspices of The International Council of the Museum of Modern Art, New York, 1985.

Gitlin, Todd. *Inside Prime Time.* New York: Pantheon, 1983.

Glaser, Bruce. "Oldenburg, Lichtenstein, Warhol: A Discussion." *Artforum* 4 (February 1966): 21–24.

Goldman, Eric F. *The Crucial Decade—and After: America, 1945–1960.* New York: Vintage, 1960.

Goldman, Judith. *James Rosenquist.* New York: Penguin, 1985. In conjunction with an exhibition organized by the Denver Art Museum.

Joe Goode: Work Until Now. Exhibition catalogue. Text by Henry T. Hopkins. Fort Worth, Tex.: Fort Worth Art Center, 1972.

Goodman, Paul. *Growing Up Absurd.* New York: Vintage, 1960.

Gray, Cleve. "Remburgers and Hambrandts." *Art in America* 51 (December 1963): 118–20, 123–29.

Greenberg, Clement. "America Takes the Lead, 1945–1965." *Art in America* 53 (August–September 1965): 108–9.

———. *Art and Culture.* Boston: Beacon, 1965.

Greene, Carroll. *Romare Bearden: The Prevalence of Ritual.* Exhibition catalogue. New York: Museum of Modern Art, 1971.

Red Grooms: Retrospective, 1956–1984. Exhibition catalogue. Essays by Judith E. Stein, John Ashbery, and Janet K. Cutler. Philadelphia: Pennsylvania Academy of Fine Arts, 1985.

Guilbaut, Serge. *How New York Stole the Idea of Modern Art: Abstract Expressionism, Freedom, and the Cold War.* Translated by Arthur Goldhammer. Chicago and London: University of Chicago Press, 1983.

Hacker, Andrew. *The End of the American Era.* New York: Atheneum, 1977.

Halberstam, David. *The Powers That Be.* New York: Dell, 1980.

Harrington, Michael. *The Other America: Poverty in the United States.* New York: Macmillan, 1963.

Hart, Jeffrey. *When the Going Was Good! American Life in the Fifties.* New York: Crown, 1982.

Hartshorne, Thomas L. *Distorted Image: Changing Conceptions of American Character Since Turner.* Cleveland: Press of Case Western Reserve University, 1968.

Haskell, Barbara. *Blam! The Explosion of Pop, Minimalism, and Performance, 1958–1964.* Exhibition catalogue. Essay by John G. Hanhardt. New York and London: W. W. Norton in association with the Whitney Museum of American Art, 1984.

———. *H. C. Westermann.* New York: Whitney Museum of American Art, 1978.

Hauptman, William. "The Suppression of Art in the McCarthy Decade." *Artforum* 12 (October 1973): 48–52.

Hess, Thomas B. *Willem de Kooning.* Exhibition catalogue. New York: Museum of Modern Art, 1968.

Hodgson, Godfrey. *America in Our Time.* New York: Vintage, 1978.

Holmes, John Clellon. "The Philosophy of the Beats." *Esquire* 35 (February 1958): 35–42.

Hopps, Walter. "An Interview with Jasper Johns." *Artforum* 3 (March 1965): 33–36.

Horizon 93–94 (October 1947): 1–45. Special issue, "Art on the American Horizon." Part 1: The Problem Defined. Articles by Cyril Connolly, William Phillips, Clement Greenberg, and William Barrett.

Howe, Irving. *Politics and the Novel.* New York: Horizon, 1957.

Hunter, Sam. *Masters of the Sixties: From Realism to Pop Art.* Exhibition catalogue. New York: Marisa del Re Gallery, 1984.

———. *Larry Rivers.* New York: Harry N. Abrams, 1971.

———. *Selections from the Ileana and Michael Sonnabend Collection: Works from the 1950s and 1960s.* Exhibition catalogue. Princeton, N.J.: The Art Museum, Princeton University, 1985.

Irwin, David. "Pop Art and Surrealism." *Studio International* 171 (May 1966): 187–91.

Jaffe, Harold, and John Tytell, eds. *The American Experience: A Radical Reader.* New York: Harper & Row, 1970.

Johnson, Ellen. *Claes Oldenburg.* Baltimore: Penguin, 1971.

———. "The Image Duplicators—Lichtenstein, Rauschenberg and Warhol." *Canadian Art* 23 (January 1966): 12–19.

Kaprow, Allan. *Assemblage, Environments and Happenings.* New York: Harry N. Abrams, 1966.

———. "'Happenings' in the New York Scene." *Art News* 60 (May 1961): 37–39, 58–61.

Karp, Ivan C. "Anti-Sensibility Painting." *Artforum* 2 (September 1963): 26–27.

———. *Radical Realism.* Exhibition catalogue. Chicago: Museum of Contemporary Art, 1971.

Karp, Ivan C., and Susan McKillop. *Robert Bechtle: A Retrospective Exhibition.* Exhibition catalogue. Sacramento, Calif.: E. B. Crocker Art Gallery, 1973.

Kelly, Edward T. "Neo:Dada: A Critique of Pop Art." *Art Journal* 23 (Spring 1964): 192–201.

Edward Kienholz: 11 + 11. Exhibition catalogue. Stockholm: Moderna Museet, 1970.

Kostelanetz, Richard, ed. *The New American Arts.* New York: Horizon Press, 1965.

Kozloff, Max. "American Painting During the Cold War." *Artforum* 11 (May 1973): 43–54.

———. *Jasper Johns.* New York: Harry N. Abrams, 1974.

———. *Renderings: Critical Essays on a Century of Modern Art.* New York: Clarion, 1969.

Kultermann, Udo. *New Realism.* Greenwich, Conn.: New York Graphic Society, 1972.

Larrabee, Eric. *The Self-Conscious Society.* Garden City, N.Y.: Doubleday, 1960.

Lasch, Christopher. "The Cultural Cold War." In *Towards a New Past, Dissenting Essays in American History,* edited by Barton J. Bernstein, 322–59. New York: Vintage, 1967.

Leider, Phillip. "Bruce Conner: A New Sensibility." *Artforum* 1 (November 1962): 30–31.

Lerner, Max. *America as a Civilization.* New York: Simon & Schuster, 1957.

Leuchtenburg, William E. *A Troubled Feast: American Society Since 1945.* Boston: Little, Brown, 1973.

Roy Lichtenstein. Exhibition catalogue. Essay by Richard Morphet; interviews by Gene R. Swenson and John Coplans. London: Tate Gallery, 1968.

Lipman, Jean, ed. *What Is American in American Art?* New York: Art in America, 1963.

Lippard, Lucy R. *Pop Art.* Contributions by Lawrence Alloway, Nicholas Calas, and Nancy Marmer. New York and Washington, D.C.: Praeger, 1966.

Lipton, Lawrence. *The Holy Barbarians.* New York: Messner, 1959.

Lucie-Smith, Edward. *Image, Reality, and Superreality.* Exhibition catalogue. London: Arts Council of Great Britain, 1973.

———. "Pop Art." In *Concepts of Modern Art,* edited by Anthony Richardson and Nikos Stangos, 224–34. New York: Harper & Row, 1974.

MacAgy, Douglas. *Pop! Goes the Easel.* Exhibition catalogue. Houston: Contemporary Arts Museum, 1963.

McCoubrey, John W. *Robert Indiana.* Exhibition catalogue. Philadelphia: Institute of Contemporary Art, University of Pennsylvania, 1968.

Macdonald, Dwight. *Against the American Grain.* New York: Random House, 1962.
———. "A Theory of Mass Culture." *Diogenes* 3 (Summer 1953): 1–17.
McKelvey, Blake. *The Emergence of Metropolitan America, 1915–1966.* New Brunswick, N.J.: Rutgers University Press, 1968.
McLuhan, Marshall. *The Mechanical Bride: A Folklore of Industrial Man.* New York: Vanguard, 1951.
———. *Understanding Media: The Extensions of Man.* New York: McGraw-Hill, 1964.
Made in Chicago. Exhibition catalogue. Essays by Donald Baum, Whitney Halstead, and Dennis Adrian. Washington, D.C.: National Collection of Fine Arts, Smithsonian Institution Press, 1974.
Magazine of Art 42 (March 1949): 83–102. Symposium, "The State of American Art." Edited by Robert Goldwater; statements by Walter Abell, Alfred H. Barr, Jr., Jacques Barzun, John I. H. Baur, Holger Cahill, Alfred Frankenstein, Lloyd Goodrich, Clement Greenberg, George Heard Hamilton, Douglas MacAgy, H. W. Janson, Daniel Cotton Rich, James Thrall Soby, Lionel Trilling, John Devoluy, Patrick Heron.
Marcuse, Herbert. *One-Dimensional Man.* Boston: Beacon Press, 1964.
Mathews, Jane de Hart. "Art and Politics in Cold War America." *American Historical Review* 81 (October 1976): 762–87.
Meding, José Ramón. *Marisol.* Caracas: Ediciones Armitano, 1968.
Meisel, Louis K. *Photo-Realism.* New York: Harry N. Abrams, 1980.
Meyers, William. *The Image-Makers.* New York: Time Books, 1984.
Miller, Dorothy C., ed. *Americans 1963.* Exhibition catalogue. New York: Museum of Modern Art, 1963.
Miller, Douglas T., and Marion Nowak. *The Fifties: The Way We Were.* Garden City, N.Y.: Doubleday, 1977.
Mills, C. Wright. *The Power Elite.* New York: Oxford University Press, 1956.
Mixed Media and Pop Art. Exhibition catalogue. Text by Gordon M. Smith. Buffalo, N.Y.: Albright-Knox Art Gallery, 1963.
Morphet, Richard. *Warhol.* Exhibition catalogue. London: Tate Gallery, 1971.
Muse, Benjamin. *The American Negro Revolution: From Nonviolence to Black Power, 1963–1967.* Bloomington: Indiana University Press, 1968.
My Country 'Tis of Thee. Exhibition catalogue. Essay by Gerald Nordland. Los Angeles: Dwan Gallery, 1962.

The New American Realism. Exhibition catalogue. Introduction by Martin Carey. Worcester, Mass.: Worcester Art Museum, 1965.
New Forms—New Media. Exhibition catalogue. Texts by Martha Jackson, Lawrence Alloway, and Allan Kaprow. New York: Martha Jackson Gallery, 1960.
The New Realists. Exhibition catalogue. Texts by Sidney Janis, John Ashbery, and Pierre Restany. New York: Sidney Janis Gallery, 1962.
Nordland, Gerald. "Pop Goes the West." *Arts Magazine* 37 (February 1963): 60–62.
O'Doherty, Brian. *American Masters: The Voice and the Myth.* New York: Random House, 1973.
———. "Art: Avant-Garde Revolt." *New York Times,* October 31, 1962, p. 41.
———. "Pop Goes the New Art." *New York Times,* November 4, 1962, p. 23.
Oldenburg, Claes. *Store Days.* New York: Something Else Press, 1967.
O'Neill, William L. *Coming Apart: An Informal History of America in the 1960s.* Chicago: Quadrangle, 1971.
Packard, Vance. *The Hidden Persuaders.* New York: David McKay, 1957.
———. *Status Seekers.* New York: David McKay, 1959.
Partisan Review 19 (May–October 1952): 282–326, 420–50, 562–97. Symposium, "Our Country and Our Culture." Statements by James Burnham, Allan Dowling, Leslie A. Fiedler, Norman Mailer, Reinhold Niebuhr, Philip Rahv, David Riesman, Mark Schorer, Lionel Trilling, William Barrett, Jacques Barzun, Joseph Frank, Horace Gregory, Louis Kronenberger, C. Wright Mills, Louise Bogan, Richard Chase, Sidney Hook, Irving Howe, Max Lerner, William Phillips, Arthur Schlesinger, Jr., and Delmore Schwartz.
Ed Paschke: Selected Works, 1967–1981. Exhibition catalogue. Essays by Dennis Adrian, Linda L. Cathcart, Halliday T. Day, and Richard Flood. Chicago: Renaissance Society, University of Chicago Press, 1982.
Podhoretz, Norman. *Making It.* New York: Random House, 1967.
Poets of the Cities: New York and San Francisco, 1950–1965. Exhibition catalogue. Essays by Neil A. Chassman, Robert M. Murdock, Lana Davis, Robert Creeley, John Clellon Holmes, and Debra Anne Payne. New York: E. P. Dutton in association with the Dallas Museum of Fine Arts and Southern Methodist University, 1974.
"Pop Art—Cult of the Commonplace." *Time* 81 (May 3, 1963): 69–72.
"Pop Pop." *Time* 82 (August 30, 1963): 40.

Popular Art. Exhibition catalogue. Essay by Ralph T. Coe. Kansas City, Mo.: William Rockhill Nelson Gallery and Atkins Museum of Art, 1963.

Quinn, Edward, and Paul J. Dolan, eds. *The Sense of the Sixties*. New York: Free Press, 1968.

Ratcliff, Carter. *Andy Warhol*. New York: Abbeville Press, 1983.

————. *Red Grooms*. New York: Abbeville Press, 1984.

Real, Michael R. *Mass-Mediated Culture*. Englewood Cliffs, N.J.: Prentice-Hall, 1977.

Reichardt, Jasia. "Pop Art and After." *Art International* 7 (February 1963): 42–47.

Richardson, John Adkins. "Dada, Camp, and the Mode Called Pop." *Journal of Aesthetics and Art Criticism* 24 (Summer 1966): 549–58.

Riesman, David with Nathan Glazer and Reuel Denney. *The Lonely Crowd*. 1950. Rev. ed. Garden City, N.Y.: Doubleday Anchor, 1953.

Faith Ringgold: Twenty Years of Painting, Sculpture and Performance (1963–1983). Exhibition catalogue. Essays by Terrie S. Rouse, Moira Roth, Freida High-Wasikhongo, Eleanor Munro, Lucy R. Lippard, Michele Wallace. New York: Studio Museum of Harlem, 1984.

Rivers, Larry, and Carol Brighton. *Larry Rivers: Drawings and Digressions*. New York: Crown, 1979.

Rose, Barbara. "Americans 1963." *Art International* 7 (January 1963): 23–28.

————. *Claes Oldenburg*. Exhibition catalogue. New York: Museum of Modern Art; Greenwich, Conn.: New York Graphic Society, 1970.

————, ed. *Readings in American Art Since 1900: A Documentary Survey*. New York: Praeger, 1968.

Rose, Barbara, and Irving Sandler. "Sensibility of the Sixties." *Art in America* 55 (January–February 1967): 44–57.

Rose, Thomas, ed. *Violence in America*. New York: Random House, 1969.

Rosenberg, Bernard, and David Manning White, eds. *Mass Culture: The Popular Arts in America*. Glencoe, Ill.: Free Press, 1957.

————, eds. *Mass Culture Revisited*. New York: Van Nostrand Reinhold, 1971.

Rosenberg, Harold. *The Anxious Object: Art Today and Its Audience*. New York: Horizon, 1964.

————. *The De-Definition of Art: Action Art to Pop to Earthworks*. New York: Horizon, 1972.

————. *The Tradition of the New*. New York: Horizon, 1959.

Rosenblum, Robert. "Pop and Non-Pop: An Essay in Distinction." *Canadian Art* 23 (January 1966): 50–54.

Roszak, Theodore. *The Making of a Counter Culture*. Garden City, N.Y.: Doubleday, 1969.

Roth, Moira. "The Aesthetic of Indifference." *Artforum* 16 (November 1977): 46–53.

Rublowsky, John. *Pop Art: Images of the American Dream*. London: Nelson, 1965.

Rudikoff, Sonya. "New Realists in New York." *Art International* 7 (January 1963): 38–41.

The Works of Edward Ruscha. Exhibition catalogue. Essays by Anne Livet, Dave Hickey, and Peter Plagens. New York: Hudson Hills Press in association with the San Francisco Museum of Modern Art, 1982.

Russell, John. "Persistent Pop." *New York Times Magazine*, July 21, 1974.

————. "Pop Reappraised." *Art in America* 57 (July–August 1969): 81–88.

Russell, John, and Suzi Gablik. *Pop Art Redefined*. New York and Washington, D.C.: Praeger, 1969. Published in conjunction with an exhibition at the Hayward Gallery, London, 1969.

Saarinen, Aline B. "Explosion of Pop Art: A New Kind of Fine Art Imposing Poetic Order on the Mass-Produced World." *Vogue*, April 15, 1963.

Sandler, Irving. "The New Cool-Art." *Art in America* 53 (January 1965): 96–101.

Peter Saul. Exhibition catalogue. DeKalb: Swen Parson Gallery, Northern Illinois University, 1980.

Schudson, Michael. *Advertising, the Uneasy Persuasion*. New York: Basic Books, 1984.

Schulze, Franz. "Chicago." *Art International* 11 (May 1967): 42–44.

————. *Chicago Imagist Art*. Exhibition catalogue. Chicago: Museum of Contemporary Art, 1972.

————. "Chicago Popcycle." *Art in America* 54 (November–December 1966): 102–4.

————. *Fantastic Images: Chicago Since 1945*. Chicago: Follet, 1972.

Schwartz, Therese. "The Politicization of the Avant-Garde." Parts 1,2. *Art in America* 59 (November–December 1971): 97–105; 60 (March–April 1972): 70–79.

Seckler, Dorothy Gees. "Folklore of the Banal." *Art in America* 50 (Winter 1962): 56–61.

Seitz, William C. *The Art of Assemblage*. Exhibition catalogue. New York: Museum of Modern Art, 1961.

————. "Assemblage: Problems and Issues." *Art International* 4 (February 1962): 27–34.

————. *São Paulo 9: Environment U.S.A., 1957–1967*. Exhibition catalogue, IX Biennial, Museum of Modern Art, São Paulo, Brazil. Washington, D.C.: National Collection of Fine Arts, Smithsonian Institution Press, 1967.

Selz, Peter. "A Symposium on Pop Art." *Arts Magazine* 37 (April 1963): 36–44. Includes statements by Henry Geldzahler, Hilton Kramer, Dore Ashton, Leo Steinberg, and Stanley Kunitz.

Shapiro, David, and Cecile Shapiro. "Abstract Expressionism: The Politics of Apolitical Painting." *Prospects* 3 (1977): 175–214.

Shulman, Leon. *Marisol.* Exhibition catalogue. Worcester, Mass.: Worcester Art Museum, 1971.

Siegfried, Joan C. *Bruce Conner: Sculpture, Assemblages, Collages, Drawings, Film.* Exhibition catalogue. Philadelphia: Institute of Contemporary Art, University of Pennsylvania, 1967.

———. *The Spirit of the Comics.* Exhibition catalogue. Philadelphia: Institute of Contemporary Art, University of Pennsylvania, 1969.

Slater, Philip. *The Pursuit of Loneliness: American Culture at the Breaking Point.* Boston: Beacon Press, 1971.

Solomon, Alan R. *Jasper Johns.* Exhibition catalogue. New York: Jewish Museum, 1964.

———. *Four Germinal Painters, United States of America, XXXII International Biennial Exhibition of Art, Venice, Italy.* Exhibition catalogue. New York: Jewish Museum, 1964.

———. "The New American Art." *Art International* 8 (March 1964): 50–55.

———. *New York: The Second Breakthrough, 1959–1964.* Exhibition catalogue. Irvine: Art Gallery, University of California, Irvine, 1969.

———. *Painting in New York: 1944 to 1969.* Exhibition catalogue. Pasadena, Calif.: Pasadena Art Museum, 1969.

———. *The Popular Image Exhibition.* Exhibition catalogue. Foreword by Alice M. Denney. Washington, D.C.: Washington Gallery of Modern Art, 1963.

Sontag, Susan. *Against Interpretation.* New York: Farrar, Strauss & Giroux, 1966.

Spiller, Robert E., and Eric Larrabee, eds. *American Perspectives: The National Self-Image in the Twentieth Century.* Cambridge, Mass.: Harvard University Press, 1961.

Stealingworth, Slim. *Tom Wesselmann.* New York: Abbeville Press, 1980.

May Stevens: Ordinary, Extraordinary: A Summation, 1977–1984. Exhibition catalogue. Essays by Donald Kuspit, Lucy R. Lippard, Moira Roth, and Lisa Tickner. Boston: Boston University Art Gallery, 1984.

Swenson, Gene R. "What Is Pop Art?" Parts 1, 2. (Interviews with Jim Dine, Robert Indiana, Roy Lichtenstein, Andy Warhol, Stephen Durkee, Jasper Johns, James Rosenquist, and Tom Wesselmann.) *Artnews* 62 (November 1963): 25–27, 61; 62 (February 1964): 40–43, 62–67.

Taylor, Joshua. *America as Art.* New York: Harper & Row, 1976.

Tillim, Sidney. "Further Observations on the Pop Phenomenon." *Artforum* 4 (November 1965): 17–20.

Toffler, Alvin. *The Culture Consumers: Art and Affluence in America.* New York: St. Martin's Press, 1964.

Tomkins, Calvin. "Art or Not, It's Food for Thought." *Life* 57 (November 20, 1964): 138–44.

———. *The Bride & the Bachelors: Five Masters of the Avant-Garde.* New York: Viking, 1965.

Trachtenberg, Alan. *The Incorporation of America.* New York: Hill & Wang, 1982.

Trachtenberg, Alan, Peter Neill, and Peter C. Bunnel, eds. *The City: American Experience.* New York: Oxford University Press, 1971.

Trilling, Lionel. *The Liberal Imagination.* New York: Viking, 1950.

———. *The Opposing Self.* New York: Viking, 1955.

Tsujimoto, Karen. *Wayne Thiebaud.* Exhibition catalogue. Seattle and London: University of Washington Press in association with the San Francisco Museum of Modern Art, 1985.

Tuchman, Maurice. *Art in Los Angeles: Seventeen Artists in the Sixties.* Exhibition catalogue. Essays by Anne Bartlett Ayres, Susan Larsen, Christopher Knight, and Michele D. DeAngelus. Los Angeles: Los Angeles County Museum of Art, 1981.

———. *Edward Kienholz.* Exhibition catalogue. Los Angeles: Los Angeles County Museum of Art, 1966.

Tuchman, Phyllis. *George Segal.* New York: Abbeville Press, 1983.

———. "Pop! Interviews with George Segal, Andy Warhol, Roy Lichtenstein, James Rosenquist, and Robert Indiana." *Artnews* 73 (May 1974): 24–29.

Tucker, Marcia. *James Rosenquist.* Exhibition catalogue. New York: Whitney Museum of American Art, 1972.

Turnbull, Betty. *The Prometheus Archives: A Retrospective Exhibition of the Works of George Herms.* Exhibition catalogue. Text by Thomas H. Garver. Newport Beach, Calif.: Newport Harbor Art Museum, 1979.

Tytell, John. *Naked Angels: The Lives and Literature of the Beat Generation.* New York: McGraw-Hill, 1976.

Van Bruggen, Coosje. *Claes Oldenburg: Mouse Museum Ray Gun Wing.* Exhibition catalogue. Translated by Machteld Schrameijer. Cologne: Museum Ludwig, 1979.

Van der Marck, Jan. *George Segal*. New York: Harry N. Abrams, 1975.

A View of a Decade. Exhibition catalogue. Texts by Stephen Prokopoff, Martha Friedman, and Peter Gay. Chicago: Museum of Contemporary Art, 1977.

Violence in Recent American Art. Exhibition catalogue. Essay by Robert Glauber. Chicago: Museum of Contemporary Art, 1968.

Waldman, Diane. *Roy Lichtenstein*. Exhibition catalogue. New York: Solomon R. Guggenheim Museum, 1969.

Warhol, Andy. *The Philosophy of Andy Warhol (From A to B and Back Again)*. New York: Harcourt Brace Jovanovich, 1975.

Warhol, Andy, and Pat Hackett. *POPism: The Warhol '60s*. New York and London: Harcourt Brace Jovanovich, 1980.

Washington, M. Bunch. *The Art of Romare Bearden*. New York: Harry N. Abrams, 1972.

Who Chicago? Exhibition catalogue. Essays by Victor Musgrave, Dennis Adrian, Russell Bowman, and Roger Brown. Sunderlund, England: Ceolfrith Gallery, Sunderlund Arts Centre, 1980.

Whyte, William H., Jr. *The Organization Man*. New York: Simon & Schuster, 1956.

Wilson, William S., ed. *Ray Johnson Ray Johnson*. New York: Between Books Press, 1977.

Wood, Robert C. *Suburbia: Its People and Their Politics*. Boston: Houghton Mifflin, 1958.

Index

Designer: Steve Renick
Mechanicals: Ina Clausen
Compositor: Wilsted & Taylor
Text: Linotron 202 Bembo
Display: Bembo & Glaser Stencil Bold
Printer: Toppan Printing Co., Ltd.
Binder: Toppan Printing Co., Ltd.
Editorial Coordinator: Marilyn Schwartz
Production Coordinator: Ellen M. Herman